TEN YEARS IN NEVADA

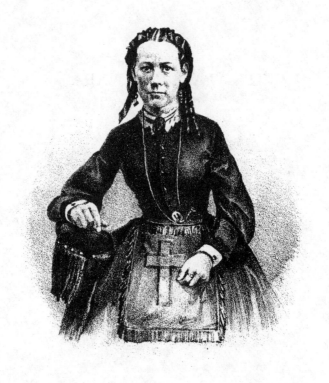

Mary McNair Mathews.

TEN YEARS IN NEVADA

OR,

LIFE ON THE PACIFIC COAST.

BY

MRS. M. M. MATHEWS.

Foreword by Mary Lee Spence and Clark C. Spence

University of Nebraska Press
Lincoln and London

First Bison Book printing: March 1985
Most recent printing indicated by the first digit below:
1 2 3 4 5 6 7 8 9 10

Library of Congress Cataloging in Publication Data
Mathews, M. M. (Mary McNair), 1834–1903.
 Ten years in Nevada.
 "Bison."
 Reprint. Originally published: Buffalo : Baker, Jones,
1880.
 1. Mathews, M. M. (Mary McNair), 1834–1903.
2. Pioneers—Nevada—Biography. 3. Women pioneers—
Nevada—Biography. 4. Nevada—Biography. 5. California—
Description and travel—1869–1950. I. Title. II. Title:
Ten years in Nevada. III. Title: Life on the Pacific
coast.
F841.M16 1985 979.3'02'0924 [B] 84-20813

ISBN 0-8032-3089-3
ISBN 0-8032-8124-2 (pbk.)

CONTENTS.

CHAPTER VII.

CHAPTER VIII.

CHAPTER IX.

CHAPTER X.

CHAPTER XI.

CHAPTER XII.

CHAPTER XIII.

CHAPTER XIV.

CHAPTER XV.

Foreword
by Mary Lee Spence and Clark C. Spence

Mary Mathews, author of *My Ten Years in Nevada,* is an elusive
figure. Most of what is known about her is contained in her
autobiography, which covers only a relatively brief period. De-
tails of the remainder of her life are sketchy, to say the least.

Mary Matilda McNair was born in Livingston County, New
York, in 1834, probably at Oakland in the township of Portage,
a thriving community that developed to exploit the water power
of Keshequa Creek. She was one of eight children of Charles W.
and Mary Tozer McNair, a farm couple who had long resided in
the county. Little is known about the early life of the blue-eyed,
brown-haired Mary, except that she attended Oberlin College in
Ohio. Although she states that she spent four years there, rec-
ords indicate she was in residence three years, 1853–54, 1854–
55, and 1855–56, enrolled as a first-year student each time. A
brief sketch printed in a Virginia City newspaper in 1874 ex-
plains that she did not complete her work because of eye prob-
lems, and returned to Portage.

Sometime in the next three or four years, Mary McNair
married, but local history sources and county records give nei-
ther the date nor the name of her husband, except for the
surname Mathews. About 1860 a son, Charles W., was born. By
the time Mary embarked on her Nevada adventure she was a
widow, but strangely enough, in her 342-page account of nearly
ten years of her life, she makes no reference whatever to her
spouse. Conjecture is borne out by the 1874 sketch that her
husband was a casualty of the Civil War, although we have been
unable to cast any additional light on him and his career.

Sometime, either before her marriage or after her husband's

death, Mary opened a hoop-skirt factory in her hometown, an example of the entrepreneurial drive characteristic of the woman. But in 1869 the family received news of the death in Nevada of her younger brother, Charles W., "a petted and idolized son and brother," according to his sister. Charles, a fire-eating Unionist, had been shot and killed in the spring of 1865 by a secessionist he was threatening to assault. To ascertain the accuracy of this report and to determine whether or not the mining property and millsites in his estate were of value, Mary decided to go to Virginia City herself.

Selling her hoop-skirt business to obtain funds, scant though they were, she tore herself away from her family and departed for Nevada in August 1869, accompanied by her nine-year-old son. En route, in Illinois, the two were joined by James McKown, an old family friend who agreed to leave behind his wife and escort them to their destination.

When she reached the Comstock after nineteen days of travel, she was almost broke, but within a few hours she found a sewing job in Virginia City. Together with nearby Gold Hill, Virginia City in 1869 was a bustling mining town of more than twelve thousand people. The raw, wild days were over and by now the town showed a split personality: it was part industrial and part frontier. In a year or so, the Virginia and Truckee Railroad would tie Virginia City to the transcontinental link at Reno and railroad yards would be added to lumber mills, foundries, machine shops, and the massive mine and milling plants that dotted the slopes below Mount Davidson. A squalid Paiute encampment on the outskirts and a bustling Chinatown on the city's northwest side were evidences of a cosmopolitan community, and the census of 1870 showed almost as many foreign- as American-born residents. At the same time, a substantial red-light district and countless saloons and gambling dens proclaimed that this was yet partially untamed territory.

Virginia City in 1869 was between bonanza and borrasca. The lush days of the early sixties had given way to leaner pickings. Many of the mines had exhausted their pay ore or were closed because of water, although Adolph Sutro's visionary "coyote hole"—a four-mile-long tunnel—was already underway to provide drainage. By the time Mary Mathews arrived, the control of

the Bank of California over the Comstock mines had been broken and the likes of John Mackay, James Fair, James C. Flood, and William O'Brien were in the saddle. But silver production in 1869 was only about half that in 1865; all of the eleven bonanzas opened before that time were nearly exhausted and efforts to locate new ones failed until 1873, when the fabulously rich Big Bonanza was struck on the Consolidated Virginia—a find that gave the Comstock a new if temporary lease on life and boosted its population to nearly twenty-five thousand. In five years the Big Bonanza yielded nearly $105,000,000, more than a third of the entire amount of bullion taken from the Comstock from 1859 to 1880. But by 1878, when Mary Mathews headed back to New York, the days of the Big Bonanza were numbered and its output would drop sharply within a year or two. With the decline of the silver output came a twenty-year depression.

Thus Mary Mathews's ten years (actually it was less than nine) spanned both good times and bad. She lived frugally with limited income from sewing, washing clothes, letter writing, and baby-sitting. For fifteen months she kept her own school, charging fifty cents a week per child. In time, she rode the crest of the silver boom, investing in mining stocks with some success and plowing her gains back into a boardinghouse and other property. But she also knew what the great fire of 1875 meant, as it roared across the town and swept away two thousand buildings. She was a worker and a plugger, a woman of dogged determination and self-reliance who believed in helping those in real need but who insisted on paying her own way.

Though a woman of better-than-average education, Mary Mathews was skeptical of the medical profession. She did her own nursing with considerable success and combated various ailments with concoctions that smacked both of Macbeth's witches and nineteenth-century folk medicine. (To make sure her son's severed finger would never cause the stub to bother him, she pickled it in brandy.) She was a believer in dreams and more than once mentioned events and persons previewed in dreams. Perhaps because of her own experiences, she had limited tolerance for topers, lawyers, and railroad conductors and was even more outspoken in her blatant anti-Semitism. If, like most of her

Comstock contemporaries, she was highly critical of the local Paiute Indians, she was vitriolic in her opposition to the Chinese.

Bigoted, fiercely proud, and independent, Mary was in her own way something of a reformer. She was an active member of the Sons and Daughters of Temperance, which had plenty of worlds to conquer; in 1876, there were one hundred retail liquor dealers in Virginia City and thirty-seven more in Gold Hill, not to mention ten wholesalers and five breweries. When she encountered a case of child abuse, she brought it to the attention of town authorities and testified against the accused. When Virginia City was experiencing heavy unemployment in 1877, she and her close friend, Rachel Beck, wife of a hardware-man, solicited food and funds and almost single-handedly established a soup kitchen for the unfortunate.

At the same time, there was much about Mary Mathews that was Victorian, beginning with her belief that the trip to Nevada should not be made without an escort. When she established a boardinghouse, one of her twenty-six boarders had to be a woman in order to prevent loose talk. Her frequent fainting spells and her incensed reactions to the suggestive proposition of a churlish waiter in Sacramento seem to have come directly from a nineteenth-century novel.

With a respectable income from mining stock and real estate, Mary and her son, Charley, returned to their New York home early in 1878, leaving her business in the hands of an agent. Soon, with mining depressed, her investments began to go sour and she made a quick trip to Virginia City, traveling back to Portage in January 1879. After the publication of her book in the following year, she seems to have remained in the family home, which she inherited along with other property at her father's death in 1891. She never remarried, and eventually she returned to the West with her son. She died at Ukiah, California, on May 15, 1903.

Ten Years in Nevada is an interesting book, but factual accuracy is not always its strong point. Its author includes much that is hearsay and unsubstantiated. She garbles the story of Henry T. P. Comstock's sale of his portion of the lode that would bear his name. She passes along a variety of old wives' tales about tarantulas, the causes of shingles, and the inhabitants of China-

town—"a loathsome filthy den," she calls it. Her descriptions, unlike those of her compatriot Dan De Quille, are perfunctory and do not crackle with life and color. Her ideas about geography are often primitive and superficial. Even though she had lived in its shadow for nearly nine years, she never bothered to determine the altitude of Mount Davidson, but passes on somebody's guess that it was more than three miles high, twice its actual height. Her knowledge of mining was minimal and her explanations sometimes simplistic. She thought a donkey pump was really powered by longeared "Washoe canaries," not by a steam-driven donkey engine, so called.

Why, then, read Mary Mathews? Read her because she was in many ways a typical middle-class woman of her era, with the foibles and strengths of her kind. The agony of her taking leave of her family in New York might have been that of Everywoman. Her presence in Virginia City belies the old idea that women went west only with their husbands or as prostitutes or school teachers. She went with a mission, to sort out her dead brother's affairs, which she did. But she also made her own way as a small-scale entrepreneur and businesswoman. In that, she was not unique, but seldom have such women recounted their experiences. To be sure, *Ten Years in Nevada* is but one slice of the life of Mary Mathews and it leaves much that is incomplete and obscure even about her stay on the Comstock. But at the same time, it is valuable for its details and for its portrayal of the actions and reactions of its author in the complex environment of one of the richest mining towns of the nineteenth century. What Mary Mathews thought and did, how she responded to everyday problems of health, business, personal relationships, raising a child—all are important in understanding what made nineteenth-century America tick.

PREFACE.

I HAVE been frequently requested by my Eastern and Western friends to write up my life in Nevada, and tell them how I managed to sustain myself and child, carry on law, and lay up property. They wish to know something of Pacific life; the manners and customs of the people; all about the Chinamen, the Piutes, and the mines of the Comstock. They wish to know all I can tell them of the Pacific Coast after a ten years' sojourn in California and Nevada.

All have persuaded me that such a book would be very interesting, and have an extensive circulation.

I shall endeavor to write nothing but facts gathered from my own observation and experience, or from other reliable sources. My readers will see I had but one purpose in going to Nevada—that of ascertaining the facts concerning my brother's death and his business affairs, and, if possible, to bring his murderer to justice, and to prove to his friends that he did not die a beggar, as was represented by Mr. G. G. Waters, the man who took charge of his papers.

They will also see with what tenacity I clung to my purpose, never allowing any obstacle to hinder or fear deter me. They will see that while accomplishing it we had to endure a great deal of sickness, privations, trials, and hard work. We did not shrink from honest labors, but engaged in anything that would further our purpose, regardless of the opinion of the *high-toned*. We took *Conscience* for our guide, and left the rest to God.

Our vocations were as checkered and numerous as those of P. T. Barnum; for we have been seamstress, nurse, laundress, school-teacher, and letter-

writer; have kept a lodging-house, and been our own chamber-maid ; kept boarders, and did our own cooking.

My son shared privations and trials with me without a murmur, and did his part of the work; for, besides attending school and keeping up with all his classes, he carried the *Evening Chronicle*, and had a route of his own, consisting of several of the best New York and San Francisco papers. He had also been an employee in the N. P. Telegraph Office; had played for benefits, and finally went on the stage as an actor, and has continued to follow the business ever since.

Although we engaged in so many kinds of business, endured privations, hardships, losses; though we were swindled and robbed, our life on the Pacific Coast has been far from unpleasant; for few people ever enjoyed life more than we did. Few ever made more true and lasting friends than we did in the same length of time. We took life as it came—enduring its trials, and enjoying its pleasures.

CHAPTER I.

IT was the eleventh day of August, the year sixty-nine, a day long to be remembered by me, for I was to leave home, parents, and sisters—all I hold dear, save my little boy, who was to accompany me to the land of gold—to be a stranger in a strange land. I arose from a sleepless pillow, and, hastily dressing myself, I drew aside the curtain. As I gazed on the landscape before my window my heart grew sad at the thought of leaving so much loveliness for an uncertain future. The glorious sun was just peeping its head above the eastern horizon, setting his golden crown in a background of crimson and purple clouds, casting his bright rays over garden and meadow. The dew sparkled on the bright green grass; the shrubs and flowers in the garden bent their blooming heads beneath the weight of its crystal drops. Yes, I was to leave all this for months, perhaps for years; what wonder that my heart grew sad, and silent tears chased each other down my cheek! but this would never do; those loved ones must never know the struggle it cost me to leave them.

I bathed my face, and descended to the breakfast-room; the table was already set; we gathered around it silent and sad; the food was hardly tasted. We left the table to make our final preparations for the journey. Each familiar haunt was hastily visited—the orchard and the garden. Choice fruits were gathered for my basket.

I then returned to the house to spend the remainder of the time with my family; the time is consumed in giving counsel and warnings till the team drives to the door.

The trunks, satchel, and basket are soon stowed away; then came the parting. My darling sister Nettie threw her arms around my neck, and, bursting into a flood of tears, said:

" I shall *never* see you again on earth!" One moment she held me thus, kissing me passionately; then, gathering Charley in her arms, pressed him to her heart, kissed him, and hastily left the room.

Little, then, did I think her prophetic words were true. Alas! they were too true: for I never looked upon her sweet face again. Kind reader, let me draw a veil over the remainder of the parting scene—'tis too sacred for curious eyes.

We are soon seated in the wagon, the whip snaps, the horses start. Charley calls out, good-bye Grandpapa, Grandmamma, and Aunt Nettie! good-bye everything! don't worry; we will come back all right.

As we reached the top of a long hill in front of our house, I looked back to take a last look of those loved forms; but I looked in vain, for they had gone away to weep.

An old friend of my father, Mr. Yencer, took us to the depot, and as we speeded on our way, he tried to make us forget our parting by drawing us into conversation, till we reached the station. We were not a moment too soon, for the cars came steaming along just as we had procured our tickets and checked our trunks.

We bade good-bye to our kind friend, took our seats, and the cars were again bounding along the track towards Buffalo, each familiar village passing in rapid succession from my view.

As things became less familiar, I gave myself up to thought, till the conductor put his head in the door and called out Buffalo. I gathered up my things and descended to the platform, leaving all our things in the baggage-room. We took a street-car up Main as far as Eagle Street, and a few moments' walk brought us to my sister's, Mrs. Miles Moffatt.

They were just eating dinner. We took them by surprise; but sister told Charley she had been waiting for him.

He told her she could not fool him, for he got up too early that morning. So more plates were added, and we all sat down together.

While we are eating and enjoying the dinner, we will ask the reader to go back, some three months before the time this chapter opens, to my home.

I was moving noiselessly about the room, lest I should disturb the slumbers of my mother, who had not slept well during the night; my father came in with a letter from my brother Miles, in Wisconsin, and as he opened it a small piece of paper fluttered to the floor. He picked it up and read it, turned deadly pale, looked towards the bed on which my mother laid, read it again, and then giving it to me, he said: "See what you think of that; it is something about your brother Charles!"

I took the paper and read these words: " I do not know a B. F. McNair; but I did know a Charles McNair, who was killed in a political quarrel on American Flats. I have his papers, and can give information to his friends.

"G. G. WATERS."

This was all it contained. After I had finished reading it I took up my brother's letter to see if I could gain any information concerning the papers. His letter stated that Cousin Jefferson had written to the post-master of Virginia City, Nev., making inquiries for his brother Frank, who

also had been gone a long time from home, and had received this scrap of paper in reply.

Jefferson, knowing my brother was somewhere on the Pacific Coast, and that we were anxious to hear from him, had sent it to Miles, and he, forming the same opinion, had forwarded it to our father. He said in his letter that he would write to Mr. Waters for further particulars.

As we were holding a consultation whether to tell my mother until we had heard more particulars, she parted the curtains around her bed and looked out, and asked, " who have you a letter from?" We said from Miles. "Are they all well?" Yes, both families, I said. "Well, what is wrong, then?"

But seeing we still hesitated, she said: "It is about Charley; you need not tell me; he is dead." And she lay back on the pillow, and covered her face with her hands as if she were praying for strength to bear her great bereavement.

Let the reader go back still farther, twelve years before Charles (named for his father) or Charley, as we all called him, a petted and idolized son and brother, had taken the gold fever, as many others at that time had.

And when my parents (who had never crossed him in a single wish, or allowed him to be struck a blow since the death of his baby brothers) saw how his whole heart was set on this journey, they could not withhold their consent, although it was with great reluctance they gave it, for he was their youngest, their best beloved child.

He possessed a very happy, pleasant disposition; had no bad habits, always shunning bad company; honest in all his dealings, fearless and brave; a true friend, loving son and brother.

He was beloved by all who knew him. He loved and honored his father, but he idolized his mother; her word was his law; her counsel his guide. Such was our household pet.

His health was not good, and he took the journey as much for his health as for gold.

Their consent gained, preparations were soon made, and when the parting came he kissed his sister, held his mother in a silent embrace, for neither could speak a parting word; he wrung his father's hand, and drove away, never to return, although he knew it not. He was but eighteen years of age; his principles being good and firmly rooted, they did not fear to trust him. He said he would return or write within ten years, but would never return till he was rich.

He said fifty thousand is well off, but a hundred thousand was rich; but he wanted health more than money.

He had a great desire to be large and stout like his brother Hugh. Thank God, he got both his wishes, although he was not permitted to return.

The reader will see it was no family quarrel that sent my brother from his home, as has been represented by Mr. Waters.

We will now go back to the time when we received that little scrap of paper which told us Charley was no more.

My mother, unlike most people, could never shed a tear when oppressed with sorrow or trouble, no matter how great it might be; this boon was denied her by nature.

Now for twelve long years she had waited for the return of her darling boy, and for the last six years had aired his room, and had a nice supper prepared on the anniversary of his departure from home, hoping, praying that he might return; and hope had sustained her through all these years. But now that he was dead, and hope fled, she took no notice of anything save the letters we wrote to Mr. Waters and his answers, for we did not wait for Miles to write, but wrote ourselves that very day; also several others, which he answered. In one we requested him to send Charley's papers. This he refused to do, unless satisfied it was Charley's parents who wanted them. We then

had our attorney, E. W. Packard, Esq., of Nunda, send for them.

They came by steamer, and it was some two months before we received them.

We had no through railroad then as we had two months later.

By Charley's papers we discovered he owned several pieces of mining property, a mill site, and mining stock; also notes and money orders. This did not look much like a beggar, and on comparing his letters, found them a bundle of contradictories; and to prove that I am not making any false statements, I will publish the letters here that the reader may see and judge for himself. After comparing notes, I think you will agree with me.

<div style="text-align:right">GOLD HILL, STOREY COUNTY.
NEVADA, February 5, 1869.</div>

MR. McNAIR:

Yours of January 22, 1869, received to-day. In answer to inquiries regarding Charles McNair, or B. F. McNair, I can state what I know of Charles McNair. I never knew him by any other initials. He was a young man about twenty-four or twenty-six years of age, about five feet eight or ten inches in height, round face, light hair, in good flesh, generally holding his head a little down when walking; light complexion; a deep thinker, and somewhat erratic in his conversation; radically Union; temperate in his habits. His father, as he often spoke of it, must have been a drinking man. I think he came to Gold Hill, Nev., in 1861 or 1862; has worked for me on the American Flat Toll Road at different times until his death, in a lamentable manner, in the summer of 1865, having been shot, with a shot-gun, through the lower portion of the abdomen. Mortification set in, causing death on the third day after the shooting. Mrs. Waters and myself attended him frequently;

was not with him when he died, but saw him decently buried in the Gold Hill Cemetery. His papers are in my possession. Some old mining-deed receipts, and one piece of mining stock, fifty shares Kentucky, are of no immediate or probable future value. This knowledge I obtained to-day from looking over them for the first time. Among them is a memorandum book, date 1859. The first entry, January, Monday 3, in pencil, thus: "Alpheus. ———, Charlotte Phillips, Marshaltown, Marshal County, Iowa. I promised to write her a letter on March 10th. January 4th my out-fit for the mines." (Giving the items.)

"February 1, 1859. I started to-day, at one o'clock, for Pike's Peak, from Minneapolis, Hennepin County, Minnesota." Continuing memoranda to July 3d; every day written in pencil, and dim.

He was very uncommunicative in regard to his family, his father excepted, as before named, and then only when drinking was the subject. Had a brother a store-keeper, well off; did not wish to let them know of his roughing it out here. The day before he died we pressed him to give their address and settle up his matters. He laughed at the idea of his dying, but would when he got well off. My idea was, he or his family was formerly from New York State. I may be wrong. He was honest to a fault; industrious and visionary; had no enemies, and really brought on his own death by attempting to drive a Secessionist from a garden while at his work. Having made previous threats and warning to leave, the man prepared himself for defense. Charles McNair got over the fence to drive him from his work, or thrash him. The gun was fired when he was advancing upon the party who shot him. The party ran away; no arrest made. I never knew the name of this man, but could learn by inquiry.

I have given you all the information in my possession. Will send on all papers, and should this prove to be your

brother, you can learn of him and also of me by hunting
up Mr. Ruggles, Helm, Tama County, Iowa. He is in the
lime-burning business. He is one of our old Washoe pio-
neers; knew Charles McNair well. It is just possible, from
what I know of him, and his desire to prevent any knowl-
edge of him reaching his family, that he might have changed
his initials. I think he was called Charley on the plains.
Should you look up, Mr. Helm, take this with you. Any
further information will be given without delay.

Yours, etc.,

GEO. G. WATERS.

P. S.—Charles McNair, shot by Elgin, May 29, 1865,
died June 2d following; buried same day; lived in Cali-
fornia; a portion of the time of his being on the coast.

GOLD HILL,

NEVADA, March 22, 1869.

MR. C. W. MCNAIR,

SIR:—Yours of February 13th to P. M., Virginia City, and
also one of same date to me, received. Nearly all of the
numerous questions you have propounded in the two let-
ters before me I have already answered in quite a lengthy
letter of a previous date, directed to a Mr. McNair, at Wash-
ington, Iowa, he or yourself receiving that letter, and I in-
fer it has been received. It seemed to me it covered nearly
the whole there was to be said in the matter. Charles Mc-
Nair was killed by Elgin, May 29, 1865, by his own unwar-
ranted act. He was shot while rushing towards Elgin to
whip him and make him leave the garden, having previ-
ously threatened Elgin, that if he did not leave by a certain
time, he would thrash him. Elgin immediately left; has
not been here since the shooting. The shot lodged in the
lower portion of the abdomen and pelvis. He was attended
by Dr. Webber, and died the third day after the shooting;
was buried by subscription among a few who knew him.

He died at the house of E. F. Glover, in American Flat, two miles south of Gold Hill. He worked on the American Flat Toll Road for me. Had no means, but left some debts behind him, owing M. Yost eighty or more dollars, myself forty or more. His papers are in my desk, of no possible value to any one any further than to identify him, which I consider doubtful, as I have written before all I knew of him. He was Union to fanaticism; light complexion, light hair, light blue eyes; honest to a cent; from twenty-five to twenty-eight years old; he always signed his name Charles McNair; left the States, I think, in 1859; was changeable in his disposition. I wished him to make a will, believing he must die. He would not hear to anything of the kind, and died sooner than we expected, as mortification set in rapidly. He did not wish his friends to know of his condition until he made means to gratify some feeling he entertained. His father, he said, drank too much liquor. He would not taste it on any account. Judge E. Strother, Gold Hill; M. Yost, ditto; James A. Rigby, American Flat; M. Gladding, Gold Hill, all knew him.

You do not subscribe yourself as a relative of his, or that one of your family or relatives came out here. I do not know your object in making those inquiries, as this is the third instance I have endeavored to give information to some one on the same subject. I am no more enlightened than when commencing. You can learn from the governor of Nevada my standing here since 1861, or from the postmaster of Gold Hill. His papers will be forwarded to any of his family who prove themselves such to my satisfaction. Had brothers and sisters. Was formerly from New York.

Yours respectfully,

G. G. WATERS.

P. S.—My impression from his conversation was he had friends in New York, and a brother somewhere West that was well off, and could or would help him if he made the

request, but would rather suffer than ask assistance. I have repeatedly asked him to state where his friends lived, as his mother would be anxious. "Not yet," was his answer. "If I am poor, I do not want them to know it." When better off he intended returning. Suffered no pain whatever. Sure of recovery.	G. G. W.

GOLD HILL, April 27, 1869.

MR. PACKARD,

DEAR SIR:— Yours of the same month received to-day. From what you state you are satisfied he is the son of the family now residing in New York State.

The package forwarded is all that came to our possession. Mining deeds would be of some importance if the Atlantic was worth anything. I know he owned in this mine, which is now incorporated. I believe he never signed the trust deed ; there has been no work done upon it for five years. The Kentucky piece of stock inclosed is worthless ; the mine has been bought up by the Water Company chiefly under assessment sales. I think he has been sold out at one dollar per share. If necessary, I can be referred to at any time while residing here. I have forwarded by Pacific Union Express Company a small package directed to Charles W. McNair, Nunda, Livingston County, N. Y., care E. W. Packard. The charges to be paid by the parties receiving the same.

Yours respectfully,

GEO G. WATERS.

Parcel goes by steamer. Acknowledge receipt thereof, and oblige	G. G. W.

GOLD HILL,
NEVADA, May 8, 1879.

MR. MCNAIR,

DEAR SIR:—Yours of 26th ultimo received. In answer thereto I have written quite explicitly to members of his

family in regard to the death of Charles McNair, who was killed by Elgin, in May, or rather died June 6, 1865. I have some days since forwarded by steamer, to his parents in New York State, all the effects owned by him at the time of his death. He bought a suit of clothes to appear at Mr. Lincoln's funeral procession. They were stolen from his cabin, as he told us, some weeks before his death. He had no trunk to my knowledge. Had been roaming around California considerable. He had worked for me on the American Flat Toll Road, but had not been for three months previous to his death. I went to him with material to write his will; he would not listen to anything of the kind; was sure to get well. Mrs. Waters went to him each day, a distance of one and one-half miles. She saw him at six o'clock in the evening. He had watchers with him all the night Mortification set in. He wished to be left to sleep. Died the easiest death possible. Dr. Webber attended him. From your description I have no doubt he is your brother. I am quite positive he had a brother Hugh in Wisconsin, and several sisters; also his father was very intemperate. He was very visionary; had streaks of good sense above the average; his business faculties were not good; he was honest, and wanted a friend to lean upon; said he would not write or return to his people until he got rich; his parents lived in New York State; would never say where; he would not give their address after being shot. How he heard his brother was a merchant and well off, I do not know. I knew him since 1861. He had no property except what I have forwarded. He had a survey and location made of mill sites, in American Ravine, in partnership with me. I advanced the money to locate and survey. There was nothing ever done upon the ground after the year expired from date of record. The ground, so far as I know, is worthless, and still unclaimed by me or any one else. He owed Mr. Yost, as I ascertained last week,

$100. Mr. Yost still works for me. He owed me $48. His
funeral expenses were paid by his friends, each giving
something. The doctor was never paid. If you will write
to Ruggles, Helm, Tama County, Iowa, and learn if he is
there, as I believe he is, you can then go and see him,
learning perhaps more of Charles McNair than you could
of me. He knew him well; also his means and everything
connected with him, after he became acquainted with him.
I have written so repeatedly to different McNairs in regard
to his death, that I do not wish to repeat it here. I think
my last to E. W. Packard, in April last, ought to close the
matter. I liked C. McNair for his honesty and simplicity.
See Mr. Helm, as directed, and learn all you can from him;
he may have told him of his family, but I think not. I have
done in this matter no more than I would hope to have
done for me in like circumstances. His parents, no doubt,
are anxious. He was well cared for, and received Christian
burial, by an Episcopal minister, in the Gold Hill Grave-
yard. I suppose there is not one who thinks of him now, ex-
cept ourselves. We often go to his grave. Life here is so fast
and fleeting; the mines kill many; the saloons and team-
ing on these mountains do their share. It is not like your
Eastern country. He deserved a better fate.

Yours respectfully,

GEO. G. WATERS.

My mother never recovered from the shock or seemed
to rally after the news came, but wandered around her gar-
den and house in a listless mood, taking no notice of any-
thing, not even her choice flowers, till I could endure the
sight no longer; and one morning I astonished the family
by telling them I had something to tell them, and did not
want any of them to oppose me, for it will make no differ-
ence; all you can say will not change my mind in the least,
no matter how wild you may think me. By this time all
eyes were upon me; even my mother raised her eyes with

interest, and, looking straight at her, I said: Mother, I am going to California as soon as I can possibly get ready; I have nothing to hinder me from going, and the railroad now runs through trains.

I am going to find Charley, if he is alive, and bring him back to you. If he is dead, I will find his grave, and learn the full particulars concerning him.

This had the desired effect; she seemed to rally at once, and took an interest in all my plans. I was keeping a hoop-skirt factory at the time, and doing a good business. I immediately sold out my goods at cost, or any price I could get for them—all that I had made up. The balance I left with my sister to do what she pleased with them. I collected all the debts standing out. I turned everything into money that I could This took only three weeks.

I now packed my trunks, bade my friends good-bye, and I believe I had got as far as Buffalo, where I was taking dinner. My niece had just been married, and as I did not get there in time for the wedding, I decided to stay a week with them, for I had a little business to transact in the city. I had only consulted with one lawyer on my business, and I decided to call on one of the best in Buffalo.

I was directed to ex-President Fillmore; I found him at his office. He examined my papers and letters and said: "I think your brother had property, and I think you will get it if you get a good lawyer; there is nothing to hinder you. I only wish I was young again, I would go with you and see that you had your rights. I would not ask a better show to make a fortune, both for you and myself. Persevere, and you will come out all right. It is a great undertaking for a lady, but I see you have a great deal of firmness and resolution about you, and I have no doubt you will conquer; but do not let the lawyers out there cheat you. Have you money to carry on a suit, or how do you intend to manage?" I told him I had enough to last me a few months, after I got there, till I got work.

"What kind of work?" said he.

Sewing, teaching, or washing, said I. If I cannot do better, then anything I can get to support myself and child, and accomplish the purpose for which I am going.

"Spoken like a true woman," said he; "may you be prospered in your undertaking."

I talked about an hour with him. When I arose to go he shook my hand, and as he did so he slipped a ten-dollar bill in it, saying: "Take that to remember me by; it is small, but all I happen to have; it may come handy after you get there. I give it to show you how truly I wish you success, and now may God bless you."

I should judge the President about sixty-five; he was light complexioned, dark expressive blue eyes; his hair was silvery white; he wore it combed to one side, and tossed back from his full, intellectual forehead; he was about five feet nine; rather stout built; he was a very fine looking gentleman. You have here a pretty good description of President Fillmore.

The week soon passed; another parting came, and we are again seated in the cars which are bearing us along on our journey.

CHAPTER II.

OUR journey to Chicago was very pleasant, as we passed
through many towns and villages, seeing a great many
interesting sights. At 9:40 we reached Oberlin. The first
free college for the education of white and black alike
ever erected in the United States was erected here; and
as it is the place where I spent four years of my school
life, I raised the window to see if I could catch a glimpse
of one familiar face in all that vast throng which crowded
the platform. Before I had time to recognize a person the
whistle blew, and off we started again.

The rest of the journey is passed in darkness. We
reached Chicago at six in the morning, and had to wait
till the nine o'clock train left. We got breakfast, then I left
Charley to watch our baggage till I went and bought our
tickets for Omaha, and get my baggage checked. At the
ticket office they wanted me to pay as much for my ticket
as a through ticket from New York would cost. I would
not buy it, but went to the Central Depot; saw Mr. St.
John, the general agent; he made the deduction. He was
a very kind, gentlemanly person. He gave me a letter to
the agent at Omaha, requesting him to let me have my
ticket from there on at the same rates. After checking my
baggage I took a stroll about the city as far as I dared go
from the depot. At 9:40 we took the train again. All
that day we passed over beautiful prairies, large fields

of grain and corn, and some of the largest pumpkins and tallest corn I ever saw growing in my life. Again we pass off into the open prairies, dotted with beautiful wild flowers. Now we pass a smart little town, and then fields of grain ; then strike the open prairie again until we reach Altona, Ill. Here we stop to see an old friend, James McKown. He was a man who, when a boy, had lived with my father for several years, and had left home when Charley did ; and they had traveled together as far as this place, and he had stopped here to see his brother, and Charley had gone on to Iowa to see his brother Hugh.

They intended to meet again on the plains, but by some accident they never met again, although both reached California. James staid till 1861, then came back and made us a visit as soon as he landed in New York. He then went to Iowa. From there he went to the army, had passed through it safe, and on returning home had married the lady of his choice, and was now living here in Altona, carrying on the blacksmithing business.

My mother did not like to have me go alone to California, and I, to please her, had written to James and asked him if he would go with me if I would pay all expenses. He wrote he would do all in his power to assist me in hunting up Charley, or news concerning his affairs. And I was to stop for him on my way. When I got there I found he was a married man. He introduced me to a very nice little woman, who received me more as a sister than a stranger. I liked her very much. I told James he need not go if it was not convenient.

He said, " I will ; for if anything should happen to you I could never look your mother in the face again ; but I cannot start under three days."

I had a very pleasant visit with them. The night before we left, his brother Elie came in and said he was going with us ; said he was all ready. We then made an addition to

our lunch-basket. In the morning we bid adieu to his wife and child, and again resumed our journey.

Nothing of note occurred till we reached Council Bluffs. It was about ten o'clock at night, and in the most terrific thunder storm I ever witnessed in my life, and I think it lasted the longest. It was the last I witnessed for ten years.

The bridge had been carried off by a flood, and we had to cross the river by boat. We were beset by hotel-runners to take their free cabs. We selected one, and took our seats. The cab drove on the deck of the steamer, and we had a double ride over to Omaha; the steamer rocking and pitching, the horses rearing and jumping, and taking all the strength of the driver to hold them. We could only see where we were going by the flashes of lightning. We finally reached the other side, and we drew a long breath of relief as the boat touched the shore, when we drove off on *terra firma*.

The horses now trotted off at a brisk pace, which soon brought us to the hotel. As we stepped upon the pavement the rain descended in sheets. We were glad to beat a retreat to the sitting-room, but there was no fire there, and our outer garments were wet. We called for rooms. We got two adjoining, that we might be near each other in case of accident.

Charley was tired and sleepy. I laid him on the bed, but did not undress him, for I expected the house to be struck at every flash of lightning. I lay down beside him, after putting my shawl up to the window. I thought to rest a little if I could not sleep, when, to my horror, something commenced to crawl on my face and neck. I took the light, and found the bed swarming with bugs. I shook them from us both, and laid Charley on a sofa at the other side of the room; but he had not lain there long before they were fairly eating him alive.

I took him up, brushed him thoroughly, and sat down

with him in my lap, put my feet on another chair, and my dress tucked up to prevent the bugs from crawling upon us.

About this time my light went out, and there I had to sit till morning, while the storm continued to rage without. Most of the time the house seemed on fire, so frequent were the flashes of lightning.

The storm spent its fury towards morning. The day broke calm and clear.

I met James in the hall. He asked how I had rested. Said he and Elie had not slept any all the night for bugs. Just then he caught sight of Charley's face covered with red spots, and said: "What ails the child; has he the measles?" I told him it was bugs.

"Well, let's get out of this as soon as possible." The waiter came and asked us if we would have breakfast. "No," said James; "I have had enough of this house."

He went to the desk and called for his bill. "What have you had?" said the clerk. James looked him straight in the face and said: "Bugs for four!" *"Is that all,"* said the clerk. "Your bill is $5." "What is the extra dollar for?" "For the cab." "I thought it was free!" said James "It was, from the river to the hotel; but not across the river; 25 cents apiece for the ferry."

James paid the bill, and went out and got an express to take us to the depot.

There we ate our breakfast from our basket. I then gave James money to buy his ticket with, while I bought my own and checked my baggage.

Just as he was going to buy it, he met a friend, an old Californian he had not seen for years, and he forgot everything. When the whistle blew he had no ticket.

The conductor soon came around for tickets. James paid him the money, and he charged him $3 more than I had to pay.

James asked him how that was?

He said it was their law—if a person neglected to get a ticket, to charge extra.

He and James had some words about it, which attracted the attention of all the passengers; and in the fuss he forgot to take a ticket of the conductor, who did not remain on the train all day; but a new one took his place, who immediately called for tickets.

When he called for James' ticket, he was as bad off as before. He told the conductor how it was, but he refused to believe him, and told him that the story would not do him, for he must have the money or the ticket.

Mr. John Warwick, a man well known on the Pacific Coast, happened to be in the car just back of our seat, and, having discovered that James was a Mason, like himself, took up the case at once, and told the conductor he had seen him pay the money, and $3 more than he ought to have paid; "and not only I but all the passengers saw him pay it," said he. "That is nothing to me," said the conductor; "he must pay me, or off he goes in ten minutes." The passengers all said they had seen the same; but he was determined to have the money.

James rose up, told the conductor he would go back and get his money or he would whip nim. But I would not listen to this, and paid for a ticket, and gave it to him.

After this he and Mr. Warwick became fast friends. He went out and tried to talk the conductor out of the money; he told him it was nearly every dollar I had. He said he could not help that; people should not travel without plenty of money.

Mr. Warwick told him it was wholesale robbery to make a man pay twice for his fare from Omaha to San Francisco. He replied: "That is my business, not yours," and passed on to another car.

Mr. Warwick told the passengers they should all remember to take plenty of money before any of them started out

on another journey; "for," said he, "it seems every con-
ductor wants the price of a ticket." The passengers said
they would look out and come prepared to accommodate
them all.

The reader will remember this was when the road was
first finished, and the fare was very high, just about double
what it is now.

Mr. Warwick had a talk with James. He told him I was
paying the fare, and he was afraid I had not much money
left. He told him why he was accompanying me, and Mr.
Warwick felt so sorry to see how we had been robbed by
the conductor that he went around among the passengers
and collected about $10, and presented it to Charley.

Charley said he would go and ask his mamma if he should
take it, but could not be persuaded to until he had first
asked me, much to the amusement of the passengers.

Mr. Warwick came with him, and said: "He has been
so particular, you must not refuse him; besides, it is our
duty, under the circumstances, to assist you. The passen-
gers all feel very sorry for you."

I thanked him, and told Charley to take the money. He
put it in my lap, and went off with Mr. Warwick to thank
the passengers who had so kindly donated it.

After this he was a sort of pet among the passengers.

We now decided to get no more warm meals, as we had
now but $35 left. We thought we would need that when
we landed in Virginia City. As soon as a new conductor
got on the train at Ogden, he asked me for my child's
ticket. I told him I did not have to pay for him, and he
passed on.

But a short time after he observed Charley talking with
some men, and, coming to me, said: "Madam, that child
talks too mature for a five-year-old. I know he is pretty
small, but he must be older." I did not tell you he was but
five, for he is nine; but Mr. St. John passed him to

Omaha, and you are the first one that has asked me his age. "Well, I guess you will have to give me $20 for his fare!" I told him I was only going to Reno, and also told him what bad luck I had already had; but he was like the other two—a regular blood-sucker.

He would have $20; and not one cent less would he take.

James and Mr. Warwick both happened to be out of the car, else we might have got rid of paying it. I now had but $15 left, and we had been two days without a warm meal, and now we got supper. This took $3 more. After this we contented ourselves with our own lunch. As soon as Mr. Warwick discovered this he invited us to go and eat with him. This we declined, but he would not take "no" for an answer. He would take Charley and carry him off in triumph, saying if I did not come he should lose his supper in looking after him; so there was nothing for me to do but follow.

He would seat us and help our plates, and before we could scarcely get to eating, the whistle blew, and we would make all haste to the cars. But Mr. Warwick had no notion of being swindled out of his money. He would invariably take a large newspaper, spread it down on his chair, empty his plate of meat and potatoes, or whatever he had on it, catch up roast beef, boiled ham, cakes, bread, pie, or anything within his reach; roll them all up, drink his coffee, and then run for the cars, just in time to swing aboard.

We soon learned to secure our plates full, and then eat what we could after. Then, if the bell rang, we tumbled it in a paper, and ran back. Soon all the passengers did the same. They said these boarding-houses all belonged to the company, and this hurrying people from their meals was done on purpose.

When we took our seats we spread out our paper, and had our nice, warm dinner. It was equal to a picnic all

over the cars. Some had small boards they had picked up
here and there, and spread their papers on them for tables.

When I did not go with Mr. Warwick he wanted to bring
enough for all of us.

Whenever the train stopped on the prairies, he would
help Charley off, have a run, and gather specimens of stone,
and occasionally wild flowers—for flowers are very scarce
west of Omaha.

In traveling through Nebraska we saw nothing but
prairies covered with tall grass, which had been burned in
many places: and in some places it was still burning.

The Platte River runs along the entire length of the
State and passes into Wyoming. The north branch also
crosses the track in Nebraska. The south branch forked
off on the south side of the track, and runs for some miles
by the side of it, then passes off into Colorado. Several
small branches come very near the track, then dash off in
the prairies, and are lost sight of.

Before we leave Nebraska we strike the north-east cor-
ner of Colorado. Here is where the South Platte leaves us.
The eastern part of this State is all prairies, while the west-
ern half is mountainous.

Now we pass into Wyoming. Here the Black Hills, far-
famed for Indian troubles, loom up at the north of the
track. About midway of the State the Platte River takes
a turn just to the west of the Black Hills, and crosses the
track, and passes off into the mountains. To the south we
are hemmed in by mountains on either side of the track all
through the State, coming very near the track on both
sides in many places. These mountains are rightly named,
for they are nothing but huge boulders, one piled upon the
other, forming all kinds of objects ; and nearly every point
has its own name.

Some of these points are named as follows : The Twins,
The Nuns, and Table Rock, which is a large rock, between

thirty and forty feet square, setting on a long level bank or rock about twenty feet above the river; The Monks, Pulpit Rock, and Castle Rocks, which are a long range, resembling ancient ruins. The Devil's Slide is also a great curiosity; it resembles a long, narrow line hedged in on both sides by a high stone fence, with cap rocks standing up edgeways, just as you often see stone fences built and finished off on the top. Imagine the lane running down the side of a steep mountain instead of a level piece of ground, and you have a perfect picture of the Devil's Slide.

About twenty feet to the west of this is another slide, not quite so wide or high. Some of the passengers on the train asked whose slide that was, when a quick-witted Irishman sang out: "And sure and don't you know; it is Ould Mrs. Divils." His wife said: *"Trew fur you, Mike;* yees always thinking after the women." And we all had a good laugh at Mike's expense. The slide is about four feet wide, and runs from the top to the bottom of the mountain, and is very steep. I do not think it would take his Majesty very long to make the trip.

The Devil's Gate is also a very interesting point. It is a tunnel through the side of a mountain. It is not more than six feet deep. Through this you can see a small lake on the other side.

At this point the rocks come so close to the sides of the cars that you can pick them from the sides through the windows. The trains always move very slowly going through the gate, and the passengers have a good view of the scenery. The thousand-mile tree is found here. I believe it takes its name from its distance from some place along the line.

Ogden is situated at the junction of the Salt Lake City Road, and is the largest place west of Omaha and east of Reno. You stop here to change cars. You can see the lake from this point. In passing around Salt Lake the road

takes a big bend, and brings us very near the boundary line of Idaho, and we get a good view of its mountains.

The ground at their base is covered with broken rock, resembling pumice-stone. They are of different color.

There must have been a volcano, in ages past, which threw out large quantities of lava. While you get a good view of the mountains on one side, in Idaho, you see Salt Lake, in Utah, on the other.

In Utah we find the first cultivated fields since we left the eastern part of Colorado. We also see fine fruit trees, most every farm having a large orchard and nice gardens. Poultry of every description is raised in abundance; also large flocks of sheep, cattle, and horses. They seem to be very thrifty farmers all through Utah.

Passing out of Utah we enter the great desert of Nevada, or the great American Desert. It lies to the west of the lake in Utah, and covers a large portion of Eastern Nevada. Nothing grows on it but sage brush.

When about one-third of the way across the State we strike the Humboldt River, which crosses the track three times. Along this river we see small ranches, whose herds of cattle are pastured in the daytime, and kept in a high inclosure at night—a sort of barracks to prevent the Indians from driving them off. There is no timber growing along these rivers, save a few cotton-wood trees and stunted willows. The traveler can always see large herds of antelopes near these rivers; also the ground-dog or prairie-wolf, which burrow in the ground like the wood-chuck. Wild ducks, prairie-chickens, and grouse are found in abundance. The Reese River also crosses the track. And here, let me say, is the place where the great mining excitement took place some years ago, which caused the ruin of hundreds of people, and the death of many.

Elko is the largest town on the line now till we reach Reno. Many of the little towns along the line have noth-

ing but tent-houses, and the sides and roofs are often blown off in wind storms.

We stopped one day in a town called Summit for a train that was two hours behind time, when one of these storms arose while we were there, and several buildings had their sides, next to the cars, blown away. There stood men measuring cloth at one counter, while at another a man was filling a jug, while others were hastily gathering the pails, baskets, and other things from the sidewalk in front. In another place men were playing cards. A pile of money lay in the center of the table, around which four men sat playing. Each one had a revolver lying by him on the table.

At a bar, which seemed to be the only solid part of the building, several men were drinking, while a man behind the bar kept filling their glasses.

None seemed to be disturbed by the storm. In a boarding-house they were just taking dinner. You could see them passing baked beans and pork, and all laughing and enjoying the dinner as if they were unconscious of the havoc the wind was making around them. There is but one wooden building in this place at this time. It is a store and post-office together.

Now, the train we are waiting for comes dashing up, and soon we are on the move again, and nothing of note occurs until we reach Reno, at one o'clock at night.

This is our nearest railroad point to Virginia City. The stage is waiting, and fourteen grown people and one child are stowed away on the four seats.

The agent puts his head in and calls for the fare, which is $4 a head. I have but $11.25 left. I offered him $10 for three of us; told him the child ought to go for half price, when he said: "I have no half fare."

I told him I had but $1.25. He said: "You will have to stop over, then."

I gave him the last $1.25. He threw back the 25 cents, saying he did not want such money as that. It was 25 cents in scrip.

He said he must have another dollar. One of the passengers said : " You have robbed her of all she has, and what more do you want?" "Another dollar," said he. Just at this moment Mr. Warwick, who was going on to San Francisco, and who came to see us safe aboard the stage, asked the man if taking all we had did not satisfy him ? He said : " None of your d—d business." And, turning to me, said "pile out! "

Mr. Warwick said : " Keep your seat ; " and he gave him the dollar, and asked him his name.

" Never mind that ; I am in a hurry," said he.

But some of the passengers said his name was Chamberlain.

We now shook hands with our kind friend, and he ran off to his train.

Just as we are about to start, here comes the agent with another passenger ; but we are already full, four to a seat, except the one I occupy.

He says : " Madam, you will have to take the child on your lap to make room for this man."

" Oh, yes ; there is always room for another in a stage," said one of the passengers, with a slur. " He said it don't make any difference ; the child does not weigh much." He has just weighed $4, said I. "Can't help that ; this man has got to go, if you stay." James offered to hold him. The driver now mounted his box, cracked his whip, and away we started at a brisk trot.

It was very dark, and the road rough. The stage is drawn by eight horses. The passengers are often pitched into each other's laps, and many bruises they get before morning. Charley got sleepy, and I took him, before we had traveled a mile, and held him till we reached Virginia

City. The outside passengers had the best seats, for they all had straps with which to hold on.

I had an outside seat, and was not tossed about like some others.

We found it very cold riding in this cramped position.

At six o'clock in the morning we were put down before the International Hotel, in Virginia City.

For a few moments we could hardly stand up, we were so completely chilled through. Our baggage was taken into the office, and we all sat by the stove till we were warm. They asked us if we would have rooms. I told them I did not wish for one, but would like to leave my baggage there for a short time. It was now August 30th, and I left home the 11th. I was anxious to let my family know of my safe arrival in Virginia City. I did not like to open my trunk till I got a room, and my paper was in it. I went to the post-office and asked for paper and envelope. I offered the 25 cents in scrip, and they, too, refused it, but said I was welcome to the paper.

I inclosed the scrip, and sent it back where paper money was appreciated. I happened to have two stamps in my purse, so I posted my letter, and started out to look for work and a room. I passed up Union to B Street. Here I got a room in the third story of the Collins House, kept by Mrs. McKinney, for 50 cents a night. I then went back to the hotel for my things.

I found James there waiting for me. He had been out looking for work, and had got a job in Mr. Hemingway's blacksmith shop for $6 a day. He said he was going to sleep in the shop. He assisted me to get my things over to my room, and then went off to work, for he had eaten some lunch while he was waiting for me.

When I came down from my room the lady asked me if I would have breakfast. I told her we had just eaten a lunch, for we had plenty in our basket. She said: " You

had better have a cup of coffee." I told her I did not care for any I was anxious to get work, for my money had run short. I asked her if she had any work. She said she had none, but I must go in and have a cup of coffee. She would take no denial, but sent her little girl to show me the way to the restaurant.

After I had taken a cup of strong tea I went out again to look for work, and also for a small house, for I was anxious to do our own cooking, as board was $1 a day. I could save half by boarding ourselves.

I first called at the house of F. A. Tritte. The lady was sick, so the nurse informed me, and did not wish for help, as she kept a seamstress in the house. The nurse said she thought I might get work of Mrs. Beck, at No. 21 North A Street. Said she is a very benevolent woman, and if she has not any, she may know who has.

I thanked her, and started on, inquiring at every house and street, till I came to No. 21, without getting work. No. 21 was a handsome two-story white house, with French windows and green blinds; a porch with large, white pillars, which supported a very handsome verandah above. Two beautiful bird cages hung suspended from the ceiling with two canaries in them. The door was adorned with a bell, and a heavy door-plate, with the name of H. S. Beck upon it. A neat little yard in front was surrounded by a white fence. The yard had several fruit trees, each loaded with fruit nearly ripe; climbing rose-bushes and several other plants adorned the yard, and a portion of which was covered with young wheat.

Such was the home of the lady who had been so highly recommended to me. I had time to observe all these things while waiting the answer to the bell. I could not help wondering what she was like, when a lady, below the medium size, made her appearance. She was a plump, little woman, very clear complexion, neither brunette nor

blonde, crimson cheeks and lips, sparkling black eyes, in which the deeper feelings of her nature seemed slumbering. Her dark brown hair was brushed plainly back from her broad, German brow, and done up in a chignon at the back, while two glossy curls trailed at its side. She wore a black-and-white calico wrapper, neatly finished at the neck, wrists, and pocket, with a narrow ruffle of the same material; a dainty white apron, stand-up. linen collar, fastened by a carbuncle-pin, with ear-drops to match, completed her toilet.

I have thus minutely described the house and its owner, because both became very dear to me—the house where I spent many happy hours, and the lady as my dearest friend and constant companion.

I found her more than worthy of the high recommend I had received of her. Being dressed so much more plainly than the rich and gaudily-dressed ladies I had met with at the other houses, I took her for hired help, instead of the lady herself. I asked to see Mrs. Beck. She said: "That is my name. Will you walk in?"

I followed her through a hall to a richly-furnished sitting-room, in which every luxury and comfort was seen.

A nice piano stood there, and tables, what-nots, and brackets were loaded with books, shells, vases, and other ornaments. Beautiful engravings, chromos, and family pictures adorned the walls.

We passed through to a neat little dining-room. "You will excuse me for bringing you in here, for we are just having a cup of coffee. Will you have a cup with us?" said she. "This is Mrs. Whittaker, and your name is—" Mathews, said I.

"This is my husband, Mr. Beck," said she. Mr. Beck was a man five feet eight or nine inches high, dark brown hair, and eyes to match, and seemed a very pleasant but quiet man. I thanked her, and told her I had been to

breakfast. I am looking for sewing to do. I am a stranger, just from the East, and out of money, and it is necessary I should get work immediately. I was directed to you by a lady on this street.

"Well, I am sorry, but I have no work at present; but Mrs. Hungerford was wanting some one yesterday, and I think you will suit her; and by the time you get through there I will try and have some for you. I will cut out some underclothes; they are always needed some time. If you do not get work there, come back and get your dinner and supper, and I will see what can be done. There, take this," said she; "it is all the change I have, except four bits (which is 50 cents of our Eastern money), and I will keep that for fear some one might call who would need it, and I would have nothing to give them." She held $3 towards me. "Here is a half; it is the widow's mite. It is all I have by me," said Mrs. Whittaker. "Well," said Mrs. Beck, "if you can afford that, here goes the other half; we will make it even change for luck; it will help you till you do get work."

Mrs. Whittaker was a widow who supported herself by sewing and teaching, and this was really more than she could afford to give, for she had a young son whom she was educating. I thanked them both very kindly, but declined taking their money; told them I preferred to work for my money, as I was perfectly able to do so. "Oh! you must not be so proud as that. I know you have just come from the East, where it would be considered begging, but the people here do not look at it in that light. We are more liberal here. I used to live there once, in New York City, and know all about it; but here they do not stand on ceremony, but take all they can get, and get all they can." Whether they need it or not? said I. "Yes; there is always plenty of poor people to whom you can give what you have to spare," said she. I asked her if she knew of a

house. She said: "I think I know of two rooms in a brick house; I will go with you to-night and see." I now started to go, but she said: "You must drink a cup of coffee; it is all ready." And before I could say a word she had filled my child's hands full of cake. "You had better take the money," said she. No, I said; a person that is able to work is no object of charity.

"I am afraid you won't do for Virginia City," and reluctantly returned the money to her purse. I bade her good-morning, and called on Mrs. Hungerford. She lived with her daughter, Mrs. John Mackey, the wife of the present bonanza king. Yes, she was in want of a seamstress to assist in getting her little daughter ready for school. She engaged me for $1 a day, and board for myself and child. "This is, she said, the same as $3." The price of a seamstress was $3, but she could not afford it; she had rather board us. "You can have the boy in the room with you, if you choose, or he can play in the yard with Ada." This made it very pleasant, and I went to work with a will. At lunch time she invited me down to eat. It was a little side-table in the kitchen. She said: "We always take our lunch here," and sat down and ate with us.

At night she went down some time before she called me. When I went down we were again seated at the side-table, but she was nowhere in sight.

Yet there were three plates, and everything seemed cold. I could hear talking in another room, and thought perhaps she had company. I sat down and ate my supper. The next morning she was still absent. At noon we took lunch together; and when I was called at night to supper, the girl had nothing on the table but dishes and bread and butter. I sat down and waited full ten minutes before she offered to give me anything, and then she brought out a dish of soup scarcely warm; and some potatoes to match were set down before me. It was then that I discovered

the family were taking their meals in the dining-room, and sending their cold victuals out to us when they were through with each course. Cold food was not what I bargained for, neither was I accustomed to eat at the second table. I asked the girl if she could give me a dish of milk for Charley. She gave it to me.

I broke some bread in it, and he ate it. I did not eat anything; but when Charley had done eating his milk, I went out to see if Mrs. Beck had found a house. She was just eating. Said she would soon be ready.

"Won't you have a cup of tea," said she. I told her I would, for I had not been to supper yet, and felt too faint to go any farther without eating something.

She had a nice, tempting plate of soup, of which, when hot, I am very fond. I ate a very hearty supper, and then leaving Charley with her little girl, we went and called on Mr. Moer, the owner of the house. He could not let me know till next day. This was the third time we had called before we saw him.

I took Charley and went to our room. James came up and spent the evening with us. The next day I went to work, after eating a cold lunch of crackers and cheese, and giving the same to my boy from our basket, as we had run out of everything else. When the girl called us to breakfast, I told her I had been to breakfast. At lunch time Mrs. Hungerford said lunch was ready. I told her I had brought my lunch with me.

She said : " The girl told me you did not eat supper nor breakfast. What is the trouble ? "

I told her I had rather board myself, as I wished to bring my child up properly, and I did not think I could by eating at the second table in the kitchen.

She saw my feelings were wounded, and said she did not blame me, but Mr. Mackey would never eat with hired help. Well, I have no desire to eat with him ; but I have

never ate at the second table, and cannot commence now. "Well, I am not to blame, you know, but he is very particular, and if you had rather board yourself, I will pay you in provisions, if that will do." I told her it would suit quite as well. "You shall not lose anything by it," said she; "you can have anything you want." (I suppose Mr. Mackey was more particular now than when he was a common miner, working for his $4 a day and *packing his dinner-bucket.*) She let me have some flour, oatmeal, sugar, and tea, and other groceries, to the amount of $2, and gave me $1 in money per day, and told me I could get more whenever I wanted it, and said I could have a quart of new milk each day.

I went home that night. Saw Mr. Moer, and rented his rooms for $10 a month. I went across the street, bought a second-hand stove, a white pine table, and a bedstead of the same material, and both of them were minus of paint, and both home-made; three old chairs, a straw mattress, and pillows; two sheets and cases, and a second-hand blanket. The whole of them cost $25.

I bought them of a Jew by the name of Greene, and he put up the stove for me. I had sent Charley to watch for James when he came from his work. He soon came, and I borrowed $25 of him. He had brought $25 from home, sewed up in his coat, he said, "for a wet day." My bed was soon made up; and the room set in order, and I sent James and Charley to get the provisions of Mrs. Hungerford.

Mr. Greene promised to take the things back at any time within two months, for 75 cents on a dollar.

The provisions came. In due time I had supper ready, and we three sat down to eat. After supper James brought over our baggage from Mrs. McKenney's, and I paid her for the room.

I now went over to Mrs. Beck's and told her I had got moved.

" Well, I am going over with you to see how you look,"
she said; and she handed me a basket, and asked me to
carry it as far as my house, as she had a bundle to carry,
When we got there she looked around the room, and said:
"Where did you get your things?"

I told her across the way, of a Jew.

" What did you pay for them?"

I told her, and she said: "I am sorry, for I intended to
have you get them of Mr. Beck, and pay him in sewing.
But you can get groceries of him very cheap, and he will
give you work to do whenever you get ready to board
yourself. I told her I had already commenced, and that I
had got some provisions. " Did you buy them of him,
too?" I told her where I had got them, and why.

She said: " Well, you will feel more like living now."
Then she opened her basket.

" Well, here is a few things to keep house with; some
tea, sugar, candles, salt, pepper, a roll of butter, and several
other articles; and here is a pair of sheets and cases for a
change, and a table-cloth," said she, as she opened the
bundle, "and here is some rags for dish-cloths, or anything
you want them for; they are nice and clean."

I was very much surprised, and was about to speak, when
she stopped me with: " There, don't say a word; I am
not going to give them to you; I have got some sewing
for you as soon as I get it ready, and I know you will want
all your money to pay rent with."

It was some days before she brought the work, and when
it was finished and taken home she slipped the pay in my
pocket, saying: " Those few things are not enough to
pay for that work."

She remembered that $5, and took this way to overcome
my scruples.

Her way of doing charity was so delicate, that one could
never take offense.

Since she had promised me work, the little stock of provisions came very acceptable.

The next evening she came and took me to her husband's store. He promised me work; but for fear he might forget, she told me to get some groceries.

I bought a few things, and went home. She said: " I must run home now. Come over whenever you get lonesome. Good-night! " and away she went.

I now boarded James to save his dollar. He could now lay by $6 every day. He still slept in the shop.

Before we left his house in Illinois he told me that, unless he passed for my brother, we would be sure to be talked about, and we had agreed to this. So Charley always called him Uncle James; and I believe they thought as much of each other as if they were relatives.

I was now fairly settled, and each night the cook would give me a pail of fresh milk. I took the milk, and considered it a part of the pay for my work. I got along nicely for several days, and then my little boy commenced to act as if he was sick; would not eat his lunch, nor did he seem inclined to play. I asked him if he was sick. He said: " No; but I feel bad all over." I saw his face looked flushed. I laid him on the sofa in the same room I was at work.

This was about two o'clock, and by five o'clock I was obliged to quit work and take him home. That night he grew worse, and by morning he was out of his head with scarlet fever.

It was raging at the time in the city. I sent James to tell Mrs. Hungerford that I could not come to help her, for Charley was very sick.

She told him to come and get the milk just the same, for I would need it while he was sick. And sometimes she sent me a hot loaf of bread, and a loaf cake for Charley.

She was very kind all through his sickness. Charley continued to grow worse every day, for fourteen days, in spite

of all I could do. He had been sick only two days when Mrs. Beck called to see me. She was surprised to see him so sick, and asked what doctor I employed.

I told her I was doctoring him myself. "You must have a doctor for him, or he will die," said she. I told her I could not think of trusting his life in another person's hands.

She came twice every day, always bringing me something nice to eat, so I need not have to cook, for she saw that I had my hands full.

Sometimes hot soup; sometimes baked meats and vegetables, or a few hot biscuits—always something.

I need not tell the reader how thankful I was for those little acts of kindness, for he was sick three long weeks, and I had no one to do anything but myself, or sit up with him a single night.

I would not allow James to sit up after working all day; but he brought his blankets, and laid on the floor to be near if wanted.

Fourteen days had nearly passed. He seemed hovering between life and death. Mrs. Beck again urged me to get a doctor; said the children were dying all over the city.

That is just why I do not get one; I am afraid they could not cure him. I was a good nurse, and I thought if any-one could save him, I could, for I knew his constitution better than anyone else.

I stood over him watching every breath. James came in, and brought him the largest stem of grapes I ever saw; they were the white musk.

Charley's mouth seemed so dry and parched that I moistened his tongue by squeezing the juice out of several of the grapes in his mouth. In a few moments his tongue became softened so he could speak. He said: "Give me some more." I squeezed more on his tongue, then gave him several to eat. In a few moments he wanted more. I

fed him a dozen, and then he seemed satisfied, laid perfectly still, and dropped to sleep. In about ten minutes the sweat broke in large drops all over his face.

James was standing at the window looking out, when I cried out: Oh! James, he is saved; the fever is broke.

He came and looked at him, felt his face, and said: "Thank God!" I know now that with good nursing he will live, but this would be the most trying night of all.

James said: "He is better now; I will watch him, and you lie down and get some rest."

I told him it was the most particular night of all, and I did not dare to leave him for a moment; told him to go to bed; if I needed him I would call him. He laid down to rest, and I sat down by Charley. About twelve o'clock he called for a drink. I got a cup of water to give him. As I was about to give it to him I fainted, and fell across the bed. The water ran down on the blankets to my face and brought me to. I got up and procured another cup of water, but as I reached the bed I fainted again.

This time I did not revive as soon as the first time, although my face laid in a pool of water. When I came to, I did not dare to try again, so I threw the cup on the floor near James.

The smashing of the dish awoke him. He brought some water, and gave me a drink. As soon as I could speak I told him to give Charley a drink; that I had tried twice, and had fainted both times.

He said: "Then you just lie down and go to sleep. I will watch till daylight."

Tired nature could do no more. I was forced to accept his kind offer. I showed him what kind of medicine to give Charley, and in a few moments I was lost in unconsciousness. I had cooked but a few regular meals in the fourteen days, and should have given out much sooner had it not been for the kindness of Mrs. Beck in bringing me so

many warm meals, for my bed was in the same room with
the stove, and it was impossible to have a fire only at nights
and mornings. My room was a dark room, only lighted
from the hall, and I used it for a store-room.

In the morning I awoke quite refreshed. James had
eaten his breakfast, and made me a nice cup of tea and
some toast, and was giving Charley some hot broth. He
said Charley had not awaked but twice, and then only
long enough to take his medicine, and then dropped off to
sleep again.

He seemed a great deal better. In a few days he sat up.
He now gained very rapidly, as he had the best of care.
He was soon able to go about the room, or sit by the win-
dow and watch the children play in the garden. There was
a select school in the same yard with me. The children
used to call him "big eyes" to tease him. He was very
poor, and his eyes looked very large. This would annoy
him, and he would crawl to the water-pail and get the dip-
per full of water, and set it by him, and when they came
again, he would throw it all over them.

I had to leave him to go out to attend to some business
one day, and when I came in, the floor was all wet, and he
was undressed and in bed.

I asked him what it meant He said those plagued girls
kept coming and saying "what you doing 'big eyes,' peel-
ing yourself? And I tried to throw water over them, but
could not hold it, as my hand shook so, and I got all wet.
I was afraid I would get cold, so I just slipped off my
clothes, hung them up to dry, and got in bed, for I did not
want to get sick again."

He had had so much fever that the outside or cuticle
skin entirely peeled off his whole body. He was as scaly as
a fish. He thought he would be a new boy when he got well.

I went out and told the girls they must not plague him,
for he had been very sick. When he got well he might

come out and play with them. They did not disturb him after this. As soon as he was able to stay alone, James and I went out every day till we had hunted up the locations of all the claims my brother Charles had in Storey and Lyons counties; and it was well that we did, for two months later James had to go home to his family.

CHAPTER III.

AFTER we had found out where the claims were all
situated that my brother's papers called for, I deter-
mined to visit Mr. Waters, and see what I could discover,
but I did not want him to recognize me; so I disguised
myself in a red calico dress, a striped shawl, and pink sun-
bonnet. I had two false teeth; these I took out to change
my voice as much as possible to an oldish woman's; combed
my hair plain back. I was so completely disguised that
James did not know me, for I had added a little artificial
color to my face, as I am naturally pale.

I started out. I had no trouble in finding the house, or
of recognizing Mr. or Mrs. Waters, as I had a perfect pho-
tograph of both in a dream several nights before I left the
East.

I rapped at the door. She bade me enter; I did so, and
found her standing at a table basting work for the machine.
She looked very natural to me, as I had seen her in my
dream. She was tall, slim, of light complexion, gray blue
eyes, spare face.

Her hair, turning grey, had once been brown. She in-
vited me to take a seat. I did so, and asked her if she
wished for a girl. She said: "I do my own work." I
asked her if she wanted any assistance in her sewing. She

said: "No; I take in all the sewing I can get." But being determined to stay, if possible, I asked her if she did not want her fall house-cleaning done. "No," she said, "I do it myself." I then told her I was quite anxious to get work, for I was a lone woman, and had two boys to support.

You see I counted James and Charley both as my boys, just to make my case as pitiable as possible.

She asked me where I lived.

I told her in Virginia City. "Where is your husband?" I have none, said I.

"Oh! I see he died at White Pine some time ago."

Now it happened that some party by the name of Smith had died at White Pine a few months before, and that was the name I had by chance chosen, and she naturally enough took me for the widow.

My first thought was to say No, but the second thought warned me to be silent, for White Pine was a new mining town where people were dying off every day, and I saw her mistake would assist me, so I did not undeceive her. She said: "It is a very common thing to see White Pine widows around begging." I said Yes, but came near laughing outright, for the idea of a White Pine widow was too comical for anything. But I mastered my inclination to laugh, and said: Can you keep me over night; for if I cannot get work in Gold Hill to-night, I may try Silver City in the morning. She said she could not, as she had but one bed-room down stairs. I told her I could sleep up stairs, or anywhere. She said: "I have no room up there." But I knew there were three rooms in her garret, and beds in two of them, or my dream was false to me.

My object in going there was to have a chance to study the character of the man who had taken possession of my brother's papers, and who had kept them in his desk, as he said, for over four years, and had never had interest enough to look them over to see if they were of any value, until

we sent for them. Then he looked at them, you will see by
one of his letters, for the first time.

Although in one of his letters he said Charley owed him
$40 or perhaps more, and in another $80. How little he
must have cared for the loss of $80 or even $40 not to
have examined those papers to see if they were not worth
enough to get his money back, and they lying in his desk
all those years! I think he will have to tell this story to
some one else, for I cannot swallow it, if I may be allowed
the expression.

I now wished to talk with her till her husband came in,
and while we were talking he came (the other photograph
of my dream some two months before). He looked first at
me, then at his wife, and she said : " It is Mrs. Brown, a
White Pine widow ; she has two little boys to support, and
is out of work." He merely gave a sort of grunt, but made
no reply.

I asked several questions to prolong the time, in the hope
he would enter into conversation, but he did not speak, and
when I could find no further excuse, I arose to go. Just
then she went up to her husband and said something low
to him. I thought she was going to ask him to let me stay,
but they whispered so loud that I heard something like,
" I will give it back."

I knew then it was money she was asking for, and I
opened the door and said, good-day! and hurried away as
fast as I could. She said, " Stop!" I pretended not to
hear her, and went on.

She followed me down to the road where I stopped till
she came up, after she called twice for me to wait.

She then offered me "two bits," saying : " Here is
enough to get you a loaf of bread to-night as you go
home."

I told her I preferred to work for what I had. I am not
around begging ; I am looking for work.

" Pshaw ! " said she, " don't be too proud to take money when it is given to you, and she held out the 25 cents again. I thanked her, but told her I would not take it ; I would rather have *my own*, and turned away. I was satisfied with my adventure, for everything about the house was exactly as I had dreamed it was, even to the steps that led down to the road. It was on account of this dream that I wished to visit them first in disguise. I now went immediately home. I told James the conversation I had with Mrs. Waters.

He said he thought he was rather a tall boy for whom I should go around begging. He enjoyed the joke ; said I ought to have taken my children with me, and then I would have received more sympathy.

I had searched the records in Virginia City, and found nothing recorded there.

I told James I would go down to Dayton and see what I could find there on the records. In the morning I took the stage for Dayton.

At the recorder's office I found a very gentlemanly person who showed me the books, and after looking over three or four, we found a mill site of eleven acres, and two deeds. A third deed, which I had in my possession, was not recorded. This I gave to him to have him record, but he said I would have to send it to Carson City, and get one of the witnesses to acknowledge it before a notary public.

Just at this moment the surveyor-general from Carson City came in.

Mr. Crocket said : " Perhaps Captain Day will take it over and see to it, and send it back."

He said he would, and as he looked at the deed he saw my brother's name. He said : " I know that man well. I surveyed some land up at American Ravine for him."

I asked him what kind of a man he was. He said he was very gentlemanly, and I thought he was some rich person by his dress.

I asked how he was dressed.

He said : " In a suit of black, and he looked very nice. He came to get me to go and survey the ground. I agreed to meet him at his cabin, and did so

" When I got there I found him dressed in a common suit of mining clothes, and could not help thinking to my-self that young man has a good deal of pride; how he looks when he is out from home, for he hardly looked like the same person."

Mr. Crocket, the recorder, heard our conversation. I told him Mr. Waters had written that he was poor, and he had to lend him money to get a suit to appear in the procession at the time President Lincoln died.

He said : " I do not believe it, not a word of it; he was too particular about his looks to let his clothes run out till he had not a decent suit."

The Captain said he would get the deed acknowledged and send it back to me, and he would also go up to Silver City and show me the boundary lines the next week, which he did.

After I had got through with my business, Mr. Crocket asked me if I knew of any person in Virginia City he could get to help take care of his child. It had the scarlet fever, and he and his wife were both worn out taking care of it.

I told him I would come, if he wished, for my child had just recovered from it, and I thought to bring him into the country would benefit him; and if they had no objections to the child, I would come. He said they would have none, and wanted to know if I would come the next day. I told him I would.

I went back to Virginia City that afternoon. I went to Mr. Greene and told him I was ready for him to take back the things. I had used them seven weeks. He said : " I do not want them." I reminded him of his promise to take them back for 75 cents on a dollar.

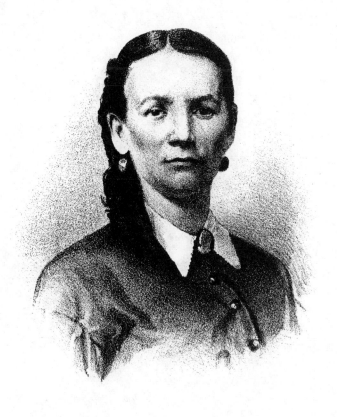

Rachel Beck.

Charles W. Matheus.

"What do I care for my word. Get out, or I will pitch you out!" said he. He was a Jew. I have had considerable dealings since with Jews, and never found one who did care for his word where a bargain was concerned. But I have seen many I thought were nice people, but perhaps if I had had dealings with them, they would have been like the rest.

The man Greene, who did not care for his word, was afterwards obliged to run away for some misdemeanor, but was overhauled at Reno and brought back, and had to settle, whatever it was, and then he left for the good of the city.

I then went to see Mr. Beck. He came and looked at the things; said he could not afford to give but $11 for them; said the only things worth moving were the stove and dishes. I told him to take them along.

He gave me the money, and said: "Shall I take them to-day or to-morrow?"

I told him I was not going till next day, and would like to use them that night.

When James came to supper that night I told him I was going to Dayton to nurse a sick child, and he would have to board out till I came back.

He said it did not make any difference, for he was going on the Divide to work, and would have to board there.

"When will Greene take the things?" he asked. I told him he would not take them, and told him what he had said.

"I will go over and give him a thrashing," said he. "You have been swindled out of enough!" I told him I had sold the things to Mr. Beck, so he had better let it drop. "Well, he deserves to have a good thrashing for his impudence to you, but I suppose you are right, I will only get myself in trouble."

The next morning I bade my friend Mrs. Beck good-bye, and started with Charley for Dayton. On arriving at

Mrs. Crocket's I found the child had grown worse through the night. I took immediate charge of it. I had taken care of it about two weeks when, becoming tired of the close confinement, I offered to change off with her and do housework part of the time.

She was perfectly willing, and it was better for me than to be so confined.

The child was a handsome, interesting little girl, just learning to walk alone, and I grew to love it very much.

I also liked Mr. and Mrs. Crocket. They had a very pleasant home, surrounded by flowers, trees, and a nice garden and yard.

I had been in Dayton but three weeks when my boy met with a serious accident.

I had sent him to the Chinaman's to tell him to bring the clothes home (for she gave her washing out), and in coming back he had met a little girl playing with a hay-cutter, and stopped to look at it. She told him he might cut with it. He took hold of it, and soon cut his forefinger entirely off above the first joint, and again just above the second joint. The last piece hung by a mere thread of the skin. I was sitting with the baby in my lap, when he came and put his head in the door, and said: "Now, mamma, don't faint, for I have cut my finger."

I looked up, and saw his face was like marble, and a large stream of blood flowing from his side, where he was holding his hand with the other.

I said, oh! my child, you are hurt.

But he said: "Don't be frightened; I have only cut my finger off; it does not hurt me any; it is only a little num."

I never knew what I did with the baby, but the next moment I had him in my arms. He was holding the second piece on with his other hand. I wrapped my handkerchief around it, sat him in a chair, and got the little girl to go with me and show me where the machine was. There I

found the end of his finger in the chaff, and brought it back. I then dressed his finger in salve, after putting the end on it.

By this time several of the neighbors had heard of the accident, and called in. They said I ought to send for a doctor; said wounds mortified so easy there; it was different from the East.

And for once I was persuaded, against my will, into getting a doctor.

He came, and said he must have his finger taken off; it would mortify sure unless taken off.

I told him I had heard of their growing on when entirely severed. He said: "Not in this country; it is impossible."

He took off the first piece, and laid it on the window, and was going to take off the other piece; it just hung by a thread. I told him I would not have it taken off; I knew there was no need of it.

He said: "Your boy will lose his finger, and perhaps his hand." I said I will take the chances. He replied: "You will see." He then did it up with splints, put on some liniment, and went home, telling me to leave it for three days, and then send him to his office, and he would dress it again. "But the chances are I shall have to cut off his hand," said he.

Not if I keep my senses, said I.

I left his hand as he directed till the second day. About four o'clock in the morning he seemed in so much pain I looked at it, and discovered proud flesh working in it. I pulverized some burnt alum, and sprinkled it on the part affected, which ate off the proud flesh. I then put on the salve I had first put on. Again I splintered it up, and laid him back in bed.

The end of his finger I had preserved in brandy to prevent his finger ever bothering him after it had healed up.

I dressed his finger three times every day, and it was nearly healed in six weeks.

If he had not had presence of mind to reverse the machine, he probably would have cut off his hand.

I think if I had not sent for a doctor, it would have all grown on and been as well as ever. As it was, the second piece grew on all right, and by a scale of the quick having been left on it, a new nail formed; but as the end was not there to support it, it turned over the end, yet does not disfigure his hand in the least; but he has to favor it. This caused him to hold his hand in rather an awkward position when he first went on the stage, but he soon overcame it.

Before I left Dayton I called on the doctor, and paid him $10. That was my first experience with doctors. I suppose if he had had his own way he would have taken off the hand (just for practice, you know), then he would have charged me $100.

I had been in Dayton but six weeks when James came down and showed me a dispatch from his wife. She and the child both had the fever. I got what money was coming to me and gave it to him, and told him to go home, by all means, to his family. He did not want to take the money; said he had plenty to go home with. I told him he would need it if his family was sick; besides, I promised to pay his fare both ways. "Well," said he, "you have already paid it twice."

I finally persuaded him to take it. But he made me promise if I got out of money I would send to his brother Elie for some, who was now in Sacramento.

He now bade me good-bye, and, with a "God bless you!" hastened away, with tears in his eyes.

After he reached home several letters passed between us, and then for three years I did not hear from him. I wrote. His wife answered it, informing me that her husband was dead; he had died two years before.

I was very sorry to hear of poor James' death, for he seemed like a brother to me.

The little girl now recovered so as to be able to take her out, when, by some carelessness, she took a new cold, had a relapse, and sank so rapidly that one night we all thought her dead. Charley became very much excited, and crept up in my lap, saying: " Mamma, take me away, or I shall die, too!" It was the second time he had ever seen a dead person. The first time he had fainted, so I thought I had better put him to bed. I did so, and lay down by the side of him till he went to sleep.

When I came out they wanted me to try and get the child from the mother, who could not be persuaded to give up her darling; and as I bent over her to speak, I saw the pulse of the neck beating regularly.

I told them the child was not dead, but had only fainted. The fond mother raised her eyes in hope, but some of the women said I was mistaken; it was dead. It was nothing for a pulse to beat in the neck for half an hour after the person was dead. I told them it was a queer way to die. Mrs. Saunders, a lady of good sense, came and looked at the child, and agreed with me. The mother now gave it up to us. We put it in warm blankets, and after a while it opened its eyes. We gave it some warm milk and water, and fed it with a swab till it ate several spoonfuls of the milk. Then we allowed it to rest, giving no medicine, but continued the milk and water at intervals till morning.

The next day the child was quite lively, and seemed to take notice of everything shown it. It had a sinking turn as the disease broke up, and was too weak to show signs of life, and thus, for a time, we had all been deceived.

The child now recovered very rapidly, and hope returned to its grief-stricken parents.

While I was in Dayton there was a large ball given by the citizens, and I was told by parties present that there was one set on the floor dancing, and every man in the set had had every woman in it for his wife, and every woman

had had every man, and each one was then dancing with his own wife. This allowed four marriages and three divorces to each, and now they were all as friendly as though no hard feelings had ever existed between them.

It is a great town for divorces.

It was now about the first of December; the child had got entirely well, and I was not needed any longer.

As I wanted to go over to California to look after some claims at Dutch Flats, I was told I had better go early, as the winter was a bad time to go over the mountains. Just as I was about to pack up, Mrs. Crocket said she wished I would stay a few days longer, as there was to be a great barbecue—a large beef roasted whole. She said the men had hired a French cook, and were to have a big dinner in an open field, and also a speech, and the ladies were to give a dance and supper at night, and she was to be chairman of the evening's entertainment; and as the men expected to have the barbecue go off all right, she was quite anxious the supper should. And it seemed some of the men thought it would be a failure because they had no man to help them. Mrs. Crocket told them they would see, which they did; for the barbecue was a total failure. The beef was so long in cooking that it was tainted, and everything else was spoiled, so I heard one of the committee of arrangements say; but the evening's entertainment was a grand success, and those that were so afraid it would be a failure, and were so confident of their own success, now hung their heads like a whipped politician.

As soon as this spree was over I packed my trunk and went up to Silver City. There I found I had not money enough to take us both, having given James six weeks' wages. I only got $30 a month besides our board. As I did not intend to be gone but two weeks, I asked the lady who kept the boarding-house if she would board Charley till I came back. She was very willing to do so, for she

said she had become very much attached to him, and would like to have me leave him till I came back. I told her I would give her a day's work at sewing when I came back for every three days' board for the child. She was satisfied with the bargain. Charley was satisfied to stay. I never thought she would be unkind to him when she made so much of him. I now kissed him good-bye, and told him to be a good boy till I came back.

I started for Virginia City. When I got there the stage had already gone, but Mr. Hatch's fast freight was about to start, and he said I could go in it if I wished to. He also gave me a letter of introduction to his father-in-law. I gladly accepted his offer, for the snow was falling fast, and I was afraid of a blockade.

We had a cold, raw journey, for it snowed all day. We reached Reno about two o'clock in the afternoon. I bought a ticket for Dutch Flat, but found I could not go on till nine o'clock at night.

I had eaten but one meal that day, for I could not afford it. I now got supper, for which I paid $1, and then, as it had cleared off, I went out to see the town.

Reno is a smart little town, with a railroad passing through the center, with a large depot, and only one hotel at this time. The buildings are mostly one and two-story houses. Each building had a nice little yard and garden, for Reno is well watered by the Truckee River; therefore every person can raise his own garden. It is a very clean and, I believe, healthy town, with about five thousand inhabitants. I believe the nearest mine is two miles off. There is also a coal mine somewhere near this town. The Hot Springs are about two miles off, where a large hotel and cure are erected. Here is where you can get your steam-baths every day in the week, which seems to cure the rheumatism like magic. You can see the steam from the springs full two miles off.

But nine o'clock has come, and so has the cars, and off I start for California. We reach Auburn station about six o'clock in the morning. There is only the depot, and a hotel kept by a Mrs. Black. No other buildings are in sight. Here I took a 'bus for Auburn Village, some two miles up. I went direct to the recorder's office. They told me, after looking through their books, that they could not find what I wanted, and it must be recorded at Ladd's Valley.

I asked how I could get there. They told me I could go in the three o'clock stage from Black's Hotel. I did not stop to see much of Auburn, but decided to walk back to the hotel, as I had learned the road and had plenty of time.

On one side of the road lay a piece of partly-cleared timber land. There were some fine old trees still remaining. They looked as if they might have stood for centuries, were I to judge them from their height and bigness. The ground had been well under-brushed, and the grass was weighted with handsome wild flowers, and everything as fresh and green as if it were summer. The day was warm and pleasant, the air soft and balmy, and not one cloud marred the face of the azure sky.

On the other side of the road were fine residences, surrounded by fine orchards and beautiful yards and gardens. I had a pleasant walk. On reaching the hotel I called for dinner, and then laid down to rest, after leaving word to be called in time for the stage. At three o'clock I started again for Ladd's Valley in a stage drawn by eight spans of horses.

Our road lay for several miles through a level country covered with second-growth timber and mancineta bushes. They grow from five to eight feet high, and are covered with red berries, and resemble the red elder. We now strike a rise of ground, and soon find ourselves winding around the side of the Sierra Mountains. Soon we are three hundred feet above the river which wound around its base. The

road was very narrow all the way, being impossible for teams to pass. I asked the driver how he managed when he met a team.

He said : " We all have bells on our horses, and we hear each other, and we wait in the wide places that are made on purpose for teams to pass each other."

The road was so winding that the two forward teams were out of sight most of the time. We came to a very narrow place, and he pointed down to the river to the remains of a wagon which was shattered to pieces. He said it had been thrown off two weeks before, one woman being killed, another had her arm broken, and one man both legs broken, while another man lodged in the top of a tree, and had to climb down. One horse was killed, and the other, strange as it may appear, was saved.

After hearing this I scarcely dared breathe for fear we might be hurled over this dizzy height and meet a similar fate before we left the mountain side for the more level country towards Ladd's Valley.

Here, on either side of us, were orchards and vineyards loaded with fruit and grapes, and gardens of vegetables, and not a thing gathered yet, although it was December.

It looked more like summer than winter, every yard being filled with lovely flowers, and the ground covered with green grass instead of snow.

It was very easy now to see how the shepherds came to be tending their flocks when they were warned by the angel of the birth of our Saviour.

I thought if the unbeliever could only gaze upon this paradise in all its present beauty, they would no longer doubt the 25th day of December as being the day our Saviour was born.

Yes, while the merry sleigh-bells were ringing, and the sleighs gliding over the crisp snow of old New York, here

I was, to all appearances, riding through flowery beds of midsummer.

I suppose the climate of California is very much like the climate of Palestine; but, having never visited the Holy Land, can only judge from history. It is a very lovely climate, and very prolific. It does not seem possible that fruits and vegetables can grow as large and fair as here, or flowers more beautiful and fragrant than in California. I was surprised at the monstrosity of many kinds of fruits and vegetables, and, asking the cause, was told it was the climate. The trees are the largest I ever beheld, many measuring twenty-five feet in circumference — perhaps larger. The limbs of them would make good size timber in the East, and you would be in big luck to have them to work up.

But to return to my journey. We now entered Ladd's Valley, a beautiful place, through which a large stream flowed, and upon whose banks beautiful flowers grew, and the very air seemed loaded with their fragrance. It seemed to me as if I were only entering another room or field of the Californian paradise.

There was no village here, only a few houses and a mill. It was now five o'clock in the afternoon.

I went direct to the house of Judge Watson, for I had been informed by a Mr. Scott, in the East, before I left home, that he had spent two weeks with my brother at his house, and that my brother had informed him he had some very rich claims near Dutch Flat, and I thought to gain some knowledge of my brother's affairs of the judge. But here, too, I was doomed to disappointment, for he had been dead three years, and the place had passed into other hands, who could tell me nothing, save that the judge's housekeeper lived at Ruby Hill, about a mile off.

I walked over to Ruby Hill to see the lady, but found she had gone to Gold Run. I determined to follow her, as

I had been informed that she had taken care of my brother through a fever, and at a time when he thought he could not live. He had told her all his business, and where to write to his friends.

But she had told him she would not write; that he might get well, and deliver his own message.

Mr. Scott had told me that Charley was waiting for water to work his claim, as the mines of California are mostly gravel, and are washed out by hydraulic pipes instead of digging them, as they do in Nevada.

I could not go back to Auburn that night, so I staid at Ruby Hill. I ate my supper, and then laid down on a sofa in the sitting-room, as their beds were all full. The lady of the house promised to call me when the stage was ready. At twelve o'clock it drove to the door, and the driver holloed, "All aboard!"

I was ready in a few moments, and was helped into the stage, where sat eight other passengers.

The moon had gone down and it was perfectly dark. The driver snapped his whip, and off started the horses at a break-neck speed.

As long as the road was level I did not mind it; but we were all nearly frozen, there being a heavy frost.

We drove about twenty miles, and then stopped to get an early breakfast, and change horses. While there I could look into the bar-room from the open door and see the driver drinking very often. This worried me, for I knew we had got the worst part of our journey yet to go.

I noticed the passengers were all drinking pretty freely, in order to warm up, as they said; and I had as many as five glasses of hot stuff, as they called it, offered to me, for they all said I would freeze if I did not take something hot.

I told them the breakfast would keep me warm enough.

Finally, they all drank around, and then took their places in the stage.

My heart began to fail me for fear we should be thrown off the mountain side into the river.

I told my fear to my nearest neighbor, who told me to never fear, as the driver was all right. One of the passengers said : " Madam, you ought to have taken that hot whisky ; it would have kept you warm."

I told him I had never drank anything in my life.

" Oh ! I see. Cold water," said he.

Yes, said I, cold water.

" I guess you have not been on the coast long ? "

About five months, I said.

" I thought so ; for ladies here are not so particular about drinking when they are out in cold weather. You will get over that whim after a little," said he, with a loud laugh.

We now struck the mountain-pass, and we all remained perfectly quiet. I was thinking of the awful peril we were in—three hundred feet above a raging torrent that I had looked upon by daylight with fear, and now we were in midnight darkness with a half-intoxicated driver.

The horses were not winding slowly around the mountain as they had done the day before, for the driver was acting in harmony with his feelings after drinking hot whisky. He said he was just letting them out a little. " Don't be afraid, lady, I will bring you safe to Auburn Station."

I held my breath in terror, and mentally resolved never to go that road again with a drunken driver. I never want to pass through such another age of agony.

What wonder, then, that my hair seemed to creep and crawl, and a prickly sensation pass through my head, or that, when I reached Auburn Station, and went to bathe my face and comb my hair, I discovered one side of my hair had turned quite gray !

When the driver saw me at the station waiting for the cars, he came up to me, with a smile, and said : " Well,

madam, I brought you safe over the mountain, just as I told you I would." "You were afraid, because I warmed up with whisky, I would run you off the mountain. Ha! ha!"

I told him I had been very much frightened. He laughed and said: " I was afraid, too, and took the whisky to keep up my courage, so I could come around all right."

Well, said I, I would not take the journey again, under the same circumstances, for the price of your sixteen horses, and the stage thrown in.

"Oh! you have not got used to stage," said he, as he walked off with a ha! ha!

The eastern train had now come, and I took my place in a car for Dutch Flat. We were not over an hour in reaching this place.

I had two letters of introduction—one to Mr. Jameson, the father of Mrs. George Hatch, of Virginia City.

I went to his office, and he went with me to his house, and introduced me to his wife. I soon made arrangements to stay with her and sew for my board while in town. They seemed like very nice people, and treated me very friendly.

The other letter was to Mr. Bradley, the president of the Water Company at Dutch Flat.

I called on him. He said: " I remember your brother well; have bought gold dust of him, but I do not know where his claims were. Perhaps they can tell you over to that store (pointing across the street). I often saw him there."

I crossed over to the store, told the merchant my errand, and asked him to look over his books and see if he could find his name. He said: " No need of looking; I remember him well." He then went on and gave a perfect description of my brother, and then asked me if that was the person I was inquiring for.

I said Yes; that is the person.

"Well, he always traded here, but never had his name booked; he was a cash man every time."

"He owned very rich mines near Iowa Hill, or Red Bluffs; but I think they were sold about two years ago, or perhaps they were jumped."

I asked him why he thought so.

"Because," said he, "a man came here two years ago this summer—I think some time in July or August. He came afoot, with his wife. They had a large satchel and a pair of blankets, which they carried between them. I think they had come some distance, and had camped out all the way."

He now called to two men who were in the store, and asked them if they remembered the name of the man that was there making inquiries about Charles McNair's claims about two years ago. He said, "No; but I will tell you where you can find out. Go over to that hotel on the corner; they stopped there three or four days while he was looking for the claim. You will find their names recorded on their ledger, if they gave their right name."

I went over. The landlord gave me the book to look at. I examined it, and found but one man and wife registered in the summer and fall of the year they had mentioned, and that was Mr. and Mrs. Brown, but did not say where from.

I found all the records of this place had been burned several times, and found nothing among what few remained of any interest to me.

My money was now so low that I had only enough to go back to Virginia City with, so I bought a ticket to that place to make sure of getting back.

In going through the town making inquiries, I found a Mrs. Rease, whose daughter was about to be married, and wanted a seamstress to make her outfit. I hired to her for $1 a day, and worked one week, when her neighbor also

wanted me a week, for the same price, to get her children ready for school.

This gave me $12. I could now proceed with my investigation.

A gentleman advised me to go to Little York. It was ten miles off. In order to save my money for stage and car fare, I walked over there. I stopped at the recorder's house, and found he had but a few papers recorded, it being only a temporary office. They were very kind, and invited me to take dinner with them. After dinner he said I might find my brother's claims recorded at Red Dog, and he gave me a letter of introduction to his partner. He also told me he saw the same man, of whom the merchant at Dutch Flat had told me, inquiring about some claims belonging to Charles McNair, and said he probably sold them.

He gave me a good description of him, and I have since spotted my man, and when I get all ready, will bring him to justice.

From Little York I rode with a friend of the family about two miles. This was as far as they were going on my road. " It is only two miles farther to Red Dog," said he ; " and about three-quarters of a mile ahead you will find a log on which you will have to cross the river. The river is pretty high ; be careful you do not fall in."

I thanked him, and walked on till I came to the river. The log had been swept around to the middle of the stream by the high water, and there was no way of crossing. So I sat down on the grass to rest, in hopes a team might come along and take me across.

While I was waiting two Chinamen came to the river, looked up and down the bank till they found a place shallow enough for them to wade.

I watched them to see how high the water was by their rubber boots. The water came just above their knees.

After they got through all safe, I tucked up my skirts and waded in ; for I never turn back for obstacles.

Where there is a will there is a way.

The water was pretty swift, but I managed to reach the other side in safety, and sat down to wring the water from my stockings, when I heard a loud laugh from the other side, and looking up saw the Chinamen still standing on the bank watching me. They seemed to think I had performed some great feat in crossing the river, and I began to think so myself. As soon as I had wrung the water from my stockings, I started on.

Now, reader, just imagine yourself wading a deep river in December, and then walking a mile and a half with wet feet, and see how you would fancy it !

The water was not cold while in it ; and if I had waded through in my bare feet, I would not have minded it, but I was afraid of snakes, and so kept my shoes on.

When I reached Mr. Cozen's house, my feet were nearly frozen, although it was very pleasant weather, everything being nice and green, and the wind blowing quite sharp all along the river.

They had been out to attend a funeral, and had just come home.

It took some time to start a fire for supper. I was now nearly chilled through. It was nearly dark, and much colder than in the day. I asked her if she would let me put my feet in the oven to dry. She said how came they wet? I told her I waded the river. She left the room and soon returned with a pair of new stockings, and gave them to me to put on. I then rinsed my stockings out, and hung them by the fire to dry.

In the morning I proffered her the stockings, but she would not take them, and said I was welcome to them. "You may have to cross the river again," said she, "and then you will need them."

They lived at You Bet, half a mile from Red Dog. I asked some one what the place derived its name from. They said that in early days, when women were scarce here, an old miner had a daughter, and the miners were all after her. The old gentleman warned them to keep away, but one, more bold than the rest, and who was desperately in love with the girl (who returned his affections), often met her; and the fond father, to break up the lovers' meeting, shut his daughter up in her chamber.

At night the young man came with a ladder to her window, and went up to see her and get her to elope. The father, ever watchful, came out with a six-shooter and pointed it at his head, saying: " You had better *get !* " All the reply the young man made was: " *You bet !* " as he went flying out of sight. And from that day the place has been called You Bet.

Nevada City was some four miles off. Mr. Cozens thought I would find something recorded there. I got a chance to ride half way, and walked the other portion. I did not stop here only long enough to search the records. They told me the same old story—that fire had destroyed the records of early days.

I now started back, having seen nothing of interest there, save the big blocks of granite which were being used for monuments and also for building. When finished and polished, it shone in the sunlight, at a short distance, like solid silver.

I got back to Mrs. Cozens before twelve o'clock, and took lunch with her.

They were very kind to me, and requested me to write to them how I succeeded with my affairs. I bade them good-bye, and started back.

I crossed the river again, and then wrung out my stockings, and then went on to Little York. I got there just in time for dinner—or supper, as you Eastern

people call it, having traveled eleven miles that day on foot.

I was too tired to go further till I rested. I went out to see them wash the banks with hydraulic pipes. They showed me about a half-pint of gold specimens they had washed out of the sand, many of them as large as a hickory-nut.

I staid all night, and after breakfast Mr. Cozens got me a chance to ride to Dutch Flat with a neighbor of his. While driving along we saw some very wide boards.

I said they were the largest I had ever seen. "Oh, they do very well," said he. Very well, said I; do you have any larger?

"Oh, yes, plenty," said he.

They must be a show if they are any larger than those.

He laughed, and said: "You never saw the big tree, then?"

I told him I had not.

"You have heard its history?" he asked.

No; I have heard nothing about it.

"Well, said he, "we had a tree near Eureka so large that it took fifteen men a week to chop it down. After it was down they had to put up a steam saw-mill right by it to saw it up into blocks and timber. Nearly everybody has some of it. They sawed off the stump and built a hotel on it; but before they raised the hotel, they had a moonlight dance on the stump."

I said there could not many have danced at the same time.

"Oh, yes, there were four sets," said he. "We had a grand time, you bet!"

He appeared perfectly serious. But of course I cannot vouch for the truth of his story. Although I have since heard a great deal about the big tree, a lady friend in Virginia City says they did surely have a dance on the stump of it, which she attended.

Mrs. Jameson was taken sick, so I was obliged to get a new place, and while hunting one day for a place, a lady told me she thought Mrs. Burkhalter would like to get me. While we were talking a boy about seventeen years of age stepped up, and said: "Auntie, she need not get a place to sew; she can go up to our cabin and take possession. There is plenty of grub there—bread, meat, butter, sugar, potatoes, and everything; just help yourself, while in town, to what you want. Bill and I will go up to mother's and stay."

I thanked him, but said I thought I would rather be in a house with some one, as I would be afraid to stay alone.

"Oh, no one will hurt you; there is a good lock on the door."

He insisted on my taking the cabin.

His aunt finally told him it was because it did not look well that I did not accept his offer.

"Oh, hang the looks!" said he, walking off.

He was good-looking, and appeared like a very nice boy.

I went to see Mrs. Burkhalter, and she hired me. It was at her house I was stopping when I went to Little York. She had a beautiful home, and three fine children. I think she was one of the sweetest dispositioned women I ever saw. I had a very pleasant time while there. I think we visited more than we worked.

Her husband had a large store in Truckee, and only came home to spend the Sabbath with his family. When I came back from Little York he was at home. I found him very pleasant and agreeable.

While I was in Dutch Flat several very exciting instances occurred, some of which I will mention here. First, China-town was burned, and hardly a house left on the patch. What was left were a few that were very near some buildings belonging to some white people.

You could see the Chinamen the next day digging up their gold where they had it buried under their cabins,

one Chinaman having $5,000 in an old oyster-can, so I was told by one who saw him count it.

A few days after this a miner's cabin was robbed of $300.

One morning the whole town was thrown into a state of great excitement over the murder of a young man who was a great favorite in town. It was a very sad affair, and cast a gloom over the place for many days. Gambling and whisky happened to be the cause this time, and *not a woman*. His funeral took place at the house of his brother, who lived across the street from Mrs. Burkhalter. For his friends' sake I suppress his name.

This excitement had not died out before the son of a lady with whom I staid a few days was engaged to a girl, and her sister and brother-in-law broke up the match.

He took it so to heart that he was perfectly beside himself.

His mother found him cleaning his pistol one morning, and asked him what he was doing. He told her he was going to shoot the girl's brother-in-law.

I happened to go in there, and found her in great trouble, when she told me all about it. I was stopping with Mrs. Burkhalter at the time. His mother asked me to go out and talk with him.

I went down to the gate where he stood watching, with revolver in hand, ready for his man whenever he should come that way. He had stood there all the forenoon; it was now eleven o'clock. I went up to him, but he did not stir. I laid my hand on his arm, and called him by name. He looked around at me—and that look will haunt me while I live. It was enough to freeze the blood in your veins. His lips were parted, in order to show his teeth, and from each corner of his mouth, and also oozing from between his teeth, were drops of froth, and his eyes were blood-shot.

I asked him if he loved his mother.

It was some moments before he seemed to comprehend my question. I had to repeat it the second time.

He said: "Yes, very dearly."

Do you know you are going to kill her?

"No," said he, "I am not; I am only going to kill that d—d villain who has stepped between me and happiness."

Well, said I, if you persist in this wicked deed, you will surely be the death of her. You are her only support, her only son, and she loves you very much, and she could never live to see you hung. Besides, what would become of your little sister?

He handed me the pistol, saying, "Take it; you have conquered. I will not shoot him while I have my senses." And he turned away and leaned upon the fence.

I saw I had touched a tender cord, and felt sure the best way to conquer the demon aroused in his breast was to leave him to reflect upon the train of thoughts I had awakened in him. I took the pistol to the house and gave it to his mother.

After I went home I could see him all day long from my window, where I sat sewing, standing there by the fence watching for the man, but a friend had warned the young man to keep away, and he did. There might have been trouble, for it was hard for him to conquer his feelings. But he finally came off victorious, and before I left the place he seemed reconciled to his fate.

A miner was also found murdered in his cabin while I was there, but no clue could be found of the one who did the deed.

I now bade good-bye to my friends, and went to Gold Run, which was four miles from Dutch Flat.

Here I met a very nice family of the name of Craiger. They had three nice little girls, and a two-year-old boy. They were all pretty children, but Theresa was my favorite. The eldest was a very fair girl, with blue eyes and dark red

hair, which hung in a profusion of curls about her neck. The youngest was a blonde, whose fair hair also hung in curls. Theresa was a brunette, with that beautiful black hair which turns to rich purple shades in the sunlight. It did not curl, but hung in waves half way to her waist. She was rather delicate, being troubled with St. Anthony's Fire. I discovered it was brought on by drinking strong coffee. She drank it just as strong as it could be made.

I told her parents what ailed the child, and then I hired her not to drink any more coffee ; and five years after, when I again visited her parents, I found a beautiful girl of sixteen—the picture of health.

I promised to give her one of my books if she did not drink any more coffee and when the work is completed she shall have her book.

I liked the family very much, and have great reason to remember them, for it was at their house that I came very near dying, and only for their untiring efforts I would not now be writing the circumstance. I was at that time sewing for her. It was a very pleasant day, and we had no fire in the room where we were sewing. I did not feel cold, except my feet, which were on the iron foot of the machine. I did not eat any dinner that day, as I did not feel the need of any ; but it would have been better for me if I had, for when supper was ready we had corned-beef and cabbage, and it was too healthy food for one to eat who had not eaten any dinner, especially when I did not feel well.

I had scarcely finished supper and crossed the room, when I fell to the floor in a dead faint.

They sprinkled water in my face, and I soon revived, only to feel the most excruciating pain, which increased to such severity that my screams and groans were heard two streets away. Ginger-tea, pain-killer, pepper, Jamaica-ginger, soda, and mustard were all given, without relief. All thought I

must die, as I was as cold as marble. I had my senses perfectly, and could hear them talking, saying that I could not live long, and that I must soon go.

I asked the lady to take a bowl and put all the different kinds of medicines that she had been giving me into it, stir them up, and fill up the bowl with warm water, and give it to me.

She did so, and held it to my mouth, while some one raised my head.

I drank it, and almost before they could take the bowl away, I threw it up. This relieved me immediately, the color came back to my face, and warmth to my body, and then said the dead was alive again. I was very weak after my two hours' suffering, and soon fell asleep, but did not wake till morning.

Two days later I started for San Francisco, for I had been informed by a lady in Gold Run that Sarah Carey was living in that city.

She was the lady who nursed my brother when he was sick at Ladd's Valley.

Mr. Craiger was going down to the city for goods (he was a merchant in Gold Run), and I accompanied him; and it was well I did, for I do not know what I should have done alone, being surrounded on every side by hack-drivers, past whom we had to fight our way; it was also eleven o'clock at night.

We went to a hotel and left our baggage. We then went to the *Alta* printing office, and called for Mr. John McComb, but were told he had gone home. We then took the number of his house, and found it was too far up town to go that night.

We now went into a restaurant and took supper, and then went back to the hotel.

I called for a room, and bidding my friend good-night, retired to rest. It was quite late the next morning when I

awoke.　I called for breakfast, and after that for my bill, when, to my astonishment, I found it had been settled by my kind friend.

I now took my satchel and started out to find the number on my card.

I had no difficulty in finding it, and was soon seated in Mrs. McComb's parlor, and she was soon busily engaged in reading my letter of introduction from my friend in Buffalo, N. Y.　She finished the letter, then invited me to stop with her while I staid in the city.　I very glady accepted her invitation.

I now went out to see if I could find Mrs. Sarah Carey.

I soon learned that the doctor she had been keeping house for had moved.　I now advertised for her, and got a letter from the doctor, saying he did not know where she was.

I staid in the city eight days.　The lady was very kind, and showed me over the principal part of the city—all the business part.

Of all the lovely hot-house plants I ever saw, none were more beautiful than those I saw growing here in midwinter in flower gardens and private residences—verbenas, heliotropes, geraniums, and southern flowers of every description.　San Francisco was truly a Garden of Eden.

The Birdrey is quite a sight.　It is a place where thousands of birds of every description are kept for sale.　They have, by far, the greatest number of canaries.　It is a very large building, and is kept very cleanly and orderly.

The city is built partly on a hillside, and partly on a flat piece of ground that extends to the bay.　Some of the streets are nearly level, and on these they have street-cars, while other streets are very steep.

The make of the ground is similar to that of Buffalo—perhaps a little more hilly.

The soil is sand-loam, and completely alive with fleas.

I should like to live here but only for those detestable little insects.

They told me that they disturbed new-comers more than old inhabitants.

I spent two weeks there one summer, some two years after, and when I returned home, the girl I left in charge of my house came to my door to hand me a pitcher of water, and seeing my neck and face so completely disfigured by flea-bites, mistook it for small-pox, and rushed down stairs crying: "You have the small-pox! I will go and have you arrested and taken to the hospital! Ouch, you have kilt us all entirely."

I ran after her to the head of the stairs, and told her it was only flea-bites, and could hardly persuade her otherwise.

After she had become convinced, she said: "Bad luck to the durty blackguards to be spiling yer good looks! They ought to be ashamed, so they ought!"

Imitating her brogue, I said: "Thrue for you, Eliza."

Another reason I would not like to live here in any part of California is my fear of a mammoth spider, called the tarantula. It is very poisonous. It has sharp knives in its claws, which cut into the flesh like a lance as it winds its legs around any part of your body. It is about one inch across its back, and it is the largest of all the spider species. The people call its wound biting, but I do not see why they do.

Their bite or stab is deadly poison, and the spot immediately turns green.

If a person is given whisky till thoroughly intoxicated, they may live a few years, but they will never enjoy good health again.

I never went to bed a night, while in the State, without first taking everything off the bed and shaking it, in order to see if any were in the bed, for they often crawled in, and after a person had retired, bite them.

The buildings of the city are mostly very nice, two and three-stories high, and the public, or building places, four and five stories, and on some streets they are all built on the same pattern for two and three blocks, and then another style is found for two or three more blocks; so where they join each other they resemble one building of solid brick or stone of massive size.

The Palace Hotel is by far the largest and handsomest building in the city. I have been told it covers four blocks, leaving a yard or drive in the center of the blocks. In the center of the four sides of this building are large arched gateways or halls leading through this court for carriages to drive through the different streets. It is several stories high, and very nicely finished off. The rooms are large, well ventilated, and richly furnished. The house has all the modern improvements. It was built, and is owned, by the Hon. William Sharon.

The city has a very beautiful fountain. I think it is called the "Lotta Fountain," in honor to the lady (a wealthy actress) who caused it to be erected for the poor. It has several solid silver cups, attached to chains, for people to drink out of. There are other fountains in the city, but none of them are as handsome as this one.

I attended the "Woman's Rights" Convention Society, while I was in the city, with Mrs. McComb, and saw eight members taken into the order at one time. It is, I should judge, quite a strong organization.

When we got back home that night, we were locked out, she having left her key at home. The family, thinking she had it, had retired for the night, and we could not arouse them, so we broke open the basement window and climbed in. "You go in first," said she; "I will follow you. For if I got in first, and a policeman should come along, he might nab you for a robber; he will know me." I went in, and we closed the window and went up to bed.

I had been here eleven days, and had seen all I cared to of the city, therefore I decided to hasten home. I now bade my kind hostess adieu. I took the cars for Stockton, as I wished to visit the Insane Asylum. The doctor, a very gentlemanly person, showed me through the male department, and then sent a lady to show me over the building where the women were kept. They were large four-story brick buildings. They were kept scrupulously clean, every hall being carpeted with white rope-matting. The buildings were surrounded by fine shade trees, and beautiful flower gardens and lawns. The whole was enclosed by a high fence. I spent about two hours going over the buildings and grounds.

I staid in Stockton all night, and took the early train, and reached Sacramento at eleven o'clock.

It was raining quite hard. I was beset by cab-drivers at such a rate that I thought they would literally tear me in pieces. All were determined to take me to their hotel, and to get rid of them I said I had no money for my fare.

This plan worked like magic, for I was immediately left standing alone.

A very nice-looking young man came up to me with an umbrella over his head, and said: "I will show you to a hotel, if you wish."

I told him I had lost my purse, and would have to go out and find a friend that was at work in some shop, and get some money of him.

He said: "Go to the post-office and look at the directory; I will show you the way."

And taking my satchel from my hand, he carried it about four blocks to the office.

I looked at the directory, but did not find his name.

He then said: "Leave your satchel at my hotel, and take a check for it; you can call for it whenever you choose."

I decided this to be my best plan, as I did not know where to find my friend. I might have to visit every shop in the city, and knew I could not carry that heavy satchel with me any great distance; besides, it was still raining quite hard.

I walked along with him till we came to a nice brick hotel.

"Here is my hotel," said he. "Now leave your satchel, and take this check, and then go around to all the shops, and if you do not find him, come here and stay; I will see your bill is paid."

I left my satchel, and went to all the shops I could find, but none of them were open.

It was some day that was kept sacred by them.

It was nearly dark. I did not like to go to a hotel and have a gentleman pay my bill, especially a stranger, so I called for my satchel, and gave up the check.

I went to a hotel near the depot in order to catch the early train.

I thought I would ask the landlady to let me stop all night, and give her a ring, but she was not at home.

It was now quite dark, and I was quite anxious to see her. I asked the person who had shown me the sitting-room to send her to me as soon as she came in.

He said: "She will not be back till four o'clock in the morning. Is there anything I can do for you? I am waiter here."

No, said I. I will see the landlord.

"He has gone, too," said he.

Well, said I, I wish to stop all night, and have lost my purse, but will find a friend in the city to-morrow, and then can pay my bill. That is why I wished to see them.

"Well," said he, "I do not think they will let you stay."

Well, since they are not here, I shall stay till they come, for they won't turn me out in the night.

He still stood in the door.

I sat down on the sofa with my back to him, and took up a book and began to read, when, coming up to me, he said: "I have been in your situation more than once, and did not know what to do, and I feel sorry for you."

Don't bother yourself, said I; it will be all right when I see the landlady.

"But you can't sit up here till she comes. I will pay for your bed if you will share it with me."

It seemed as if an adder had stung me. One moment my amazement held me spell-bound, and my tongue refused to move. Rage was now taking possession of me instead of amazement. I made one bound across the room and reached my satchel.

Villain! said I, do I look like such a person that you dare thus to insult me?

"No," said he, "but you know you have no money."

But I have this, said I, leveling a pocket derringer at his head, and know how to protect myself with it.

"Oh! I beg your pardon, lady; I did not mean to insult you!" said he, cringing before the pistol, and backing out of the door.

Have you a mother or sister, and yet dare insult an unprotected lady? said I.

"Yes, I had such, but she died, and I do not care what I do or say now," said he.

Well, I care, and would send you where she is, only I would not stain my hands with your base blood. Go! and do not trouble me with your disgusting presence again, or I will have you turned out of the house like a miserable wretch, which you are.

He went down stairs on a double-quick move, and I did not see him again.

Just then a servant girl came in. I asked her if the landlady was in the house.

She said : " No, but I think she will be soon."

I told her I wanted to see her when she came.

I then took a book and sat down to try and calm down my feelings, for they were at white heat.

I will now tell the reader how I came by the pistol.

Before I left home my father objected to my going, and I did not gain his consent till the night before I started.

He said : " I have had one child go there and lose his life, and I do not want another."

I told him I had a pistol, and had been practicing at a mark. I intend to take it with me, and if there is any shoot-ing done, I will have a hand in it.

" But you may kill some person, and repent it all your life, even if you are not hung," said he.

I replied : I will only use it in self-defense, and will always think three times before I shoot once.

Thank God! I never had occasion to draw it on a person but twice, and in both cases I thought three times, and therefore did not shoot, although both deserved it. This was one of the times.

I never went out alone without it in my pocket.

The lady came home about seven o'clock. I told her I wanted to stay all night, and had lost my purse, but I would give her a ring. She said : " You can stay. I do not want your ring ; you are welcome to your lodging." She showed me to a room, and I retired to rest.

In the morning I found the shops ·open, but no Mr. McKown worked, in any of them. One man said he did have a person there by that name, but he went to 'Frisco.

I now went back and took my satchel to the depot, as I would not get breakfast when I had not the money to pay for it. I waited for the ten o'clock train, which soon arrived.

I had just taken a seat in the car when a lady came in and took a seat beside me. We traveled some miles together,

when I became faint, and fell over in her lap. She thought I had gone to sleep, and let me lie.

In about ten minutes I began to groan, for I was coming to. She now lifted up my head, and seeing I had fainted, asked one of the passengers to bring some water.

After she had brought me to, she told me to lay my head in her lap.

I laid there till I felt better, and then sat up again.

She took out her lunch now to eat, and said to me: "Have some of my lunch; it will do you good. It will be an hour before you can get any dinner."

I told her I would accept her kind offer, as I had nothing to eat with me, and I thought very likely it would make me feel better. I did not tell her that I had not tasted food in twenty-four hours, and it was that which caused me to faint.

After I had finished my lunch I felt much better.

I now went to look for something I had rolled up in a bundle and put in the bottom of my satchel, and there, in the center of the roll, was my purse. In a fit of absent-mindedness I had taken it from my pocket and rolled it up. I could not account for its being there in any other way.

I assure you, kind reader, I stopped at the first place at which the train stopped, and got a cup of tea, for they did not wait long enough for me to get a square meal.

I reached Gold Run, however, in time to take supper with Mrs. Craiger.

I staid here one day to get recruited, and then started for Virginia City.

I forgot to mention that at the time I thought my purse was lost, I had my ticket in my pocket all safe.

Mrs. Craiger put me up a lunch, which lasted me to Virginia City, for she said if I lost my purse again, I should not go hungry.

I reached Reno at nine o'clock, took the stage and traveled all night, reached Virginia City at six o'clock in the morning, after an absence of five weeks.

I was homesick to see my darling boy.

I left the stage at the International Hotel, and went up Union to A Street, to see if Mrs. Beck had heard from Charley since I left him; also to get a cup of coffee, for I was both tired and hungry.

They were not up yet, and as I did not like to disturb them, I went into the sitting-room and laid down on the sofa and covered myself up with some new quilts that she had been making, and thought I would lie there and rest till the family were up and breakfast ready.

Before I could make my appearance I was soon lost in the land of dreams. I visited Silver City, and found my boy, but he appeared sick and pale and ragged and dirty. I dreamed Mrs. Hosman had treated him very badly. I was very indignant.

She tried to vindicate her conduct, but I would not hear her. I told her the child showed for himself; I did not want a better witness. I told her I would not stay a day in her house.

I finally got so excited that I awoke to find I had been dreaming.

Then I began to think what if my dream were a reality! What if my darling had really been misused all these five long weeks that I had been away from him!

And then I thought of many such cases I had read of, and it seemed as if I should go wild.

Then I resolutely put the thought from me, saying it is only a dream, for she would never dare do such a thing, and I went off to sleep again.

Reader, you will see hereafter how she *did* treat my helpless child.

I had hardly closed my eyes in sleep before one of the

roomers, who also boarded with her, got up and went through the room to the dining-room. He spoke to Mrs. Beck, and told her she had better get up, for he guessed she had company.

" Who ? " said she.

" Some one you do not want. I guess she is drunk," said he.

Now, his passing through the room awoke me, and I heard the entire dialogue between them.

" Go and ask her what she wants," said Mrs. Beck.

" I had rather you would go," said Mr. Jackson, for that was the gentleman's name.

" I am afraid to ; she lies on the sofa with a comforter over her. She is snoring like a steam-engine."

At this I burst into a fit of laughter. Riding all night in the cold made me both tired and sleepy, and I suppose I breathed rather loud.

But men are so apt to get everything about a woman wrong—especially old bachelors. He was one of this class, although not one of the cross, sour kind, as I learned afterwards by further acquaintance with him.

It seemed so funny to me that I, of all others, should be accused of drunkenness (who had never tasted spirits in my life), that I could not help laughing again.

Just at this moment he came to the door, and seeing me, he ran back and told my friend that I was surely drunk or crazy, for I was cramming my handkerchief in my mouth.

This was more than I could bear, and I burst into a loud peal, when I heard Mrs. Beck say : " I will go and help her out. I do not want any drunken women around me."

I went to the door and met her. " I was no drunk, no crazy ; me heap *hogeydie*," said I, looking very sober. [*Hogeydie* means hungry, in the Piute language].

As soon as she saw who it was, she turned to the man and said : " That is a good joke on you. This is the widow

I have been telling you about, and now you have accused her of being drunk, and spoiled everything."

" Yes," said he, " my fat is all in the fire now ; it is just my luck."

We all now had a hearty laugh over the affair.

After breakfast I started for Silver City a-foot.

It is five miles from Virginia City, but the stage did not start till ten o'clock, and I could not endure a longer separation from my boy. I took my satchel in my hand, and started.

I had got as far as Gold Hill, when I met the husband of the woman with whom I had left Charlie. I asked him if Charlie was well. He said, " Sound as a cricket." He then asked me if I would help his wife wait on the table till he got back with a girl. I told him I would, and went on my way rejoicing to think my child was well. I reached there about nine o'clock.

CHAPTER IV.

IT was nine o'clock when I reached the house.

I passed through the dining-room to the kitchen, and did not see my child, or Mrs. Osborne.

I asked the Chinaman where Charlie was.

He said: "Up stairs."

I ran up there, and met a little boy in the hall carrying a pail of slop bigger than he was.

I did not know him, and said to him : Little boy, do you know Charlie Mathews? Can you tell me where to find him? and the next moment that ragged, dirty little fellow was in my arms with his thrown around my neck.

Yes, reader, it was my own loved and idolized child—so dirty and ragged that I did not know him.

Oh! kind reader, pity a mother's heart, for mine was nearly bursting.

"*Oh, mamma !*" he cried, with tears of joy, "they tried to make me think you had gone off and left me for good, but I knew you would come back to me, because you said you would."

Just then Mrs. Osborne came out of a room, and, seeing me, said: "Why, how do you do? Get down, Charlie, you great baby, your mother is tired."

Not quite so much as *he* appears to be, said I, deigning her no other reply, while Charlie still clung tighter around my neck and fairly smothered me with kisses.

He said : " Oh, I am so glad, for I am so tired and sick and dirty ! "

I carried him down stairs, got a dish of water, and gave him a good washing, then combed and cut his hair, put on a night-dress, and put him in bed, for when I got the dirt off of him, he resembled a ghost more than the child I left.

I gave him some medicine, for he was very sick with bowel complaint. I then got him a cup of strong tea and a plate of toast.

I asked Charlie what he had been doing up stairs.

"Oh, mamma ! I have had to sweep, and empty slops, and scour all the knives and forks since you went away, and my clothes are all worn out and dirty."

I asked him why he did not get out his other suit from the trunk. He replied that he did get them, and had worn them out.

I went out and left him to rest.

I took water and soap, and soon had all his dirty clothes drying on the line.

I found them thrown out in the wash-room in a pile.

She had promised to have her squaw do his washing, but had failed to keep her promises in every respect.

It was now dinner-time, and she came to me and said: " I do not know what to do; I have no one to help me wait on the table."

I told her I had promised Mr. Osborne to help her till he got back.

"Oh ! I am so glad," said she. "And can't Charlie scour the knives for me ? "

No, ma'am, said I; he has scoured all the knives he ever will here. I did not leave him here to work for his board. I made a fair bargain with you, and I am ready to fulfill

my part of it, although you have not kept yours. But I
will not talk about it now.

I went to the dining-room to take orders, for I saw the
table was filling up.

I helped her through dinner, but she did not ask me to
help at supper-time. She had got enough of my help, for I
had changed every order that was given me. For mutton-
chop I gave steak; for baked pork and beans I gave roast
beef; for pudding I gave pie; and for tea I gave coffee,
until the whole table was in confusion.

Some laughing, others swearing—some asking Mrs. Os-
borne where she made the *raise* of her new hash-slinger,
while others told her she had better sell out. And thus
they continued to plague her through the entire meal.

Most of the sixty boarders had seen me, and they knew I
was Charlie's mother; and those who knew how she had
treated him mistrusted that I was paying her off, for I
heard their remarks.

But I do not think it ever entered her head, for she was
not the *smartest* woman I ever saw, except to work, for she
could endure more hard work in a day than any one I ever
saw, and she thought everybody else ought to do as much
as she did.

One man gave me back his coffee, and said: Please give
me some tea, for I am in a hurry; get even on the *old
woman* some other way. I do not blame you, though; if
she had had some women to deal with, she would never get a
dime."

When she took my child to board I did not promise to
"sling hash" for her to pay for it, but was to sew for her;
but had she treated my child right, I would willingly have
helped her when she needed it.

But she had not only made him work, but he had worked
when so sick that he should have been in bed. He had had
his meals so irregularly that he was nearly starved. She

kept him waiting till everybody else was through eating,
until the Chinaman felt sorry for him, and gave him pie or
cake, just as it happened, and would tell him to go out in
the shed and eat it.

This is the way she had treated him. She had not even
given him my letters to read (he could read writing, but
could not write). If he had known where I was, he could
have got some person to write to me, but she had kept all
letters from him, and he did not know where to find me.

It was his going without eating till nine and ten o'clock,
together with the hard work he had done, that had brought
him to the skeleton I found him.

And I wished now to pay her up, and then give her a
good letting alone, for I never stoop to quarrel with any-
body.

I sewed for her till she was paid up, and then went to
Virginia City house-hunting.

I was told of a Mr. French who had a house to let.

I called on him. He had just rented it to Mr. Greeley.

While I was trying to rent a part of the house of him, he
asked how long I had been in town. I told him I was from
the East, and had only been there a few months. I then
asked him if he had lived there long.

" Ten or fifteen years," he replied.

I then asked him if he knew my brother.

He remembered the name, but nothing more ; had heard
his cousin speak of him.

He could not give me a decided answer till next week.

I now went to Mrs. Beck, and told her if she heard of a
place, to drop me a note.

I then returned to Silver City, for I had left Charlie at a
neighbor's until I came back.

I had scarcely got back before the stage brought me a
note from Mrs. Beck, stating she had procured a house for
me, and to come up and bring my things.

I took the one o'clock stage and went up to Virginia City.

When I reached Mrs. Beck's house she told me the man that had the house was another Mr. French. "And he was an old friend of your brother," said she.

She went with me to his store. He kept a large grain store on C Street.

He told me he had a house on G Street, already furnished, for $15 a month.

We went and looked at it, and I took it.

I did not move until morning, as I had no wood there, and it was so late. The gentleman said he would send me a load of wood, already cut, in the morning.

I gave him $4, and he sent me the wood.

That night I asked Mrs. Burkhalter how she happened to know about the house.

She said: "Mr. French happened to call on his cousin, Mr. Greeley, and he told him that Charles McNair's sister had just been in to hire the house. Mr. French asked him where you were stopping, and he said at my house. They both came down, and I told them you were in Silver City."

He said: "Send for her. I will let her have a house. I was an old friend of her brother."

The next day I went to house-keeping in good style.

I had a nice kitchen, a table, chairs, stove, a cupboard full of dishes, two wash-boards, three tubs, and any amount of flat-irons.

My sitting-room had a nice three-ply carpet, a hair sofa, six cane-bottomed chairs, and a large rocking-chair; a table, bureau, and a nice spring-bed, and plenty of clothes on it.

I was now comfortably situated for the winter, which had now fairly set in, everything being frozen up in town, and quite a deep snow.

After I was settled I sent my child to school, and then went out to look for work.

I got a little sewing of several, but not enough to pay rent and keep us in food. And the little money I had left of my journey, with the $4 Charlie had earned carrying mail for the boarders while at Mrs. Osborne's, was all I had. He had also bought himself a pair of boots, and a nice worsted dress for a Christmas present for me.

With the $4 I now bought provisions to start on; but, as I said, the money was running low.

The tubs suggested the idea of taking in washing, for the prospects were a hard winter.

Business became dull, and everybody tried to do their own sewing.

I asked Mr. French to give me his washing to do.

He did so, and also got his clerk to send his.

Mrs. Beck got some of her roomers for me, and an old gentleman of the name of French, to whom I had first talked of getting a house, brought me his.

In all I had twelve to wash for, and it brought me about $8 a week. This, with my sewing, just about supported me, for provisions were very high.

Butter $1 a roll—the rolls containing one pound, or a pound and a quarter. Beans were 10 cents a pound. A pound would just fill a coffee-cup. Onions were 6 and 7 cents a pound, and about three would make a pound. Potatoes were 5 cents a pound, and apples the same. In fact, everything sold by the pound.

I have paid $3 and $4 for as many apples as I have seen sold in the East for 25 cents, and have paid 25 cents for no more than four apples, and not large ones either.

Flour was the cheapest article of produce in the market, being $5 and $6 per hundred weight.

I have bought 25 cent's worth of cherries, and found I had paid a penny apiece for them, and plums in the same proportion.

Peaches were 10 cents apiece, unless you bought them by the box.

The Nevadans are no penny-mites.

The smallest change is one dime, which they call a "short bit"—12 cents being a "bit," 15 cents a "long bit," 25 cents "two bits," 50 cents "four bits," and 75 cents "six bits." A dollar is a dollar.

So you see if you just want an apple, peach, or pear, you have to pay 10 cents.

If you want anything that is just 10 cents, and should give 25 cents, they will give you back 10 cents, and keep the 15 cents—giving you the "short bit," and they keeping the "long bit."

On the other hand, if you want anything that is worth 15 cents, and should have but 10 cents, they will take it just as readily. For instance, you wish for a yard of cloth that is 15 cents a yard, you will offer 10 cents, and they will take it. But if you give them 25 cents, they will give you back 10 cents.

At these high figures I had hard work to keep up rent. And wood was from $12 to $25 a cord, and coal $25 a ton.

I did a good deal of sewing. I did some for Mrs. Judge Rising, and before I got it finished I took a severe cold. I sent Charlie home with the work that was finished, and when she learned I was sick, she sent me a basket of jellies and canned fruit, pickles, and other knick-knacks, as much as the child could carry.

I considered it very kind of her, for I was an entire stranger to her, only having done a little sewing for her. She also paid a good price for it.

The first night that I got settled in our new quarters was the happiest I had seen in three months, and we enjoyed our supper more than any we had eaten in the same time.

One cold day Mrs. Beck came down to see me. She went away, but soon returned, bringing me some jelly, pie,

cake, and a pail of hot soup, although the weather was very cold, and I lived several streets from her. Charlie did not have to cook much that day.

I was now very careful, and in a few days got around again; but the washing was too much for me, and wore me out very fast, but I could not give it up just yet.

About three weeks after I had got settled, the water collector called, and while there I made inquiries of him, as I did of everybody, to see if he had known my brother, in hopes to learn something new of him.

He said he did not know him, but he did know Frank McNair, on the Divide.

" Is he a relative of yours? " he asked.

I told him I had a cousin somewhere by that name.

I requested him to let Mr. McNair know where I was stopping. He did so.

The next day he called.

I was not at home, but had left word with a neighbor that if he called, to tell him I would be there at night, for I had to go to Silver City on business.

He called again on Sunday, took dinner with me, and from that time forth I saw him nearly every day.

This took away a great deal of our home-sickness.

One day I sent Charlie to get some milk. When he came home he said: " Mamma, I guess I have spoilt your pail! " I looked at the pail. It looked as if he had used it for a foot-ball.

I asked him how he did it—if he had played foot-ball with it.

" Worse than that," said he; " I whipped a boy with it, and made him run, too. I know you told me not to fight, but I could not help it. A little boy threw me down and choked me, but some other boys put him up to it. I tried to get away, but they surrounded me, and he took me down and choked me. When I got up I was so mad that I

did not care for my finger, whether I hurt it or not. I took my pail, and went for the whole crowd. They all ran, but I caught the boy and thrashed him with the pail until he cried."

I asked the boy's name, and found out where his parents lived.

The next morning I called on the lady. She was a very pleasant person, and quick-spoken.

I told her I had simply called to see if she would be kind enough to keep her boy from stopping Charlie on the street and hurting him, as Charlie had a sore finger, for if he got it hurt, he was liable to have the lock-jaw.

She said: " I am very sorry my boy has hurt your child, but he shall not touch him again."

She was very lady-like, and invited me in, but, being in a hurry, I declined. She then said: " Mrs. Mathews, I am going to move next door to you to-day, and I hope this will not be your last call. I hope we shall be good friends, and the children, too." And she called Sammie to her, and told him he must never hurt Charlie again.

I thanked her, and said that I presumed we should be friends.

I liked her appearance from the first.

She said: " Do not wait for me to get settled, but come right along."

I will, said I, and did call on her the same week that she moved; and from that time the most intimate friendship sprang up between us.

We often laughed over our first introduction, and I think we have even been glad the children had the little spat which brought about our acquaintance.

The children's friendship was true and lasting as ours.

I will here give you a specimen of it. We had been here some three months, when Sammie came and asked me if Charlie might go with him to see some camels up at the

store. They had brought in a load from the desert. Charlie had never seen one, and I told him to go; gave him a piece in his hand to eat till he came back, breakfast not being ready.

They went off, but not finding the camels, followed on after them for seven miles, until they came in sight of a house where Sammie had boarded the summer before. The place was called Lousetown.

They were so hungry that they went to the garden and ate raw onions. The lady was not at home, but came just as they were about to go back, and gave them some dinner, and then sent them back. They got home at nine o'clock at night, tired and hungry, having traveled fourteen miles.

When they did not return to breakfast, I went in and asked Mrs. Calvin if Sammie had returned.

She said : " No ; but I guess he is all right, for his papa is up at the store ; don't worry about them."

And when it was dinner-time and they had not come, I went to the store after him. No one there had seen either of them.

We then became very uneasy, and went over the entire city looking for them.

Every old shaft was examined and looked into, calling on them by name.

Every tunnel was sounded, but no Sammie, no Charlie answered.

We now became frantic. We were sure they were lying at the bottom of one of the many old shafts that are everywhere met with on the Comstock uncovered and unguarded by any railing, exposing the lives of any person who passes by them in the night.

We had all our friends out looking for them. It was now dark.

Mrs. Calvin thought Charlie had gone to Silver City, and got Sammie to go with him. We telegraphed down, but found he had not been there.

Just as we had got the dispatch, Mr. Calvin came into the office and told us our boys had gone home. A man had seen them go.

We now ran instead of walking, for we were afraid it was too good news to be true.

But when I reached her house I went in, and there sat the two lost ones eating supper. Sammie's grandmother had got ready for them, and she sat watching them with tears in her eyes.

Mrs. Calvin said: "Why, mamma, you are crying, and the children are found!"

"I can't help it," said she; "do you know what they have done, and where they have been?"

Of course neither of us knew.

She then said: "The poor little things have been to Merrett's ranche and back—fourteen miles. And when they got to the grade coming into the city, Sammie was afraid his papa would whip him, and he commenced crying, but Charlie Mathews, the dear little child, told him to change clothes with him, and he would come in with his head down and get the whipping, then go down stairs to the shed, where Sammie was to wait for him, and change back clothes."

Sammie told him "No, I will not; for you don't know how hard papa whips!"

"Never mind," said Charlie, "I want to see how it will seem to be whipped."

So they changed clothes, and Charlie came and stuck his head in the door, and I asked him if he knew where Sammie or Charlie was (for I did not know him till he commenced laughing), and told me Sammie was down stairs.

"What is he doing down there?" I asked.

"He is waiting for me to get his whipping," said Charlie, "and then I am going down and change back clothes, and his papa won't know it."

" There, now ! did you ever see anything to beat that in all your life ? " said she.

I told him to go and change back, and get ready for supper.

" I wonder what he would do with Sammie's red hair," said Mrs. Calvin, bursting into a fit of laughter.

"Oh, Charlie ! " said Sammie, "you never thought about my red hair ! "

" Well, it is all right, now ; your papa will be as glad to see you as anybody," said Charlie.

So it turned out that the boy he had whipped with a pail he now liked well enough to be whipped for him, in order that he might be saved. And I think Mrs. Calvin would fight for me, if it was necessary, just as quick, for I am sure I would for her.

We spent many happy evenings together that winter.

After I had sent Charlie to school about three weeks, he caught a severe cold from the window at the school-house being open on his back. I sent word to the teacher, asking if she would not seat him somewhere else, and she told him he might as well sit there as anybody.

When I heard this I took him from school, and taught him myself, as I always had.

Mrs. Calvin came in one day, and after hearing me instruct Charlie in his lesson, asked me why I would not start a select school. I said I would if I could get scholars enough.

" Will twelve do? " said she.

I said it would.

" Well, just keep my baby for me, and I will get you some," said Mrs. Calvin.

She was gone about two hours, and when she came back she had twelve names. The children would commence on the following Monday. This was Thursday. I was to have 50 cents apiece per week.

But one, Mrs. Babcock, always sent me $1.50 a week for her two girls, because she said 50 cents was not enough.

Monday came, and with it twelve as bright-looking children as you would wish to see. They were very smart, and learned very fast.

In time my school numbered twenty. I now was able to lay up a little every week till I had $35 laid by to fee a lawyer, for I had tried nearly every lawyer in the city, but no one would take my case on contingent fee—all wanted money. I could also afford to buy a few knick-knacks for my child, who seemed to have a poor appetite, and pined for such things; but I always had to share, or pretend to share, them with him or they did him no good.

I always had plenty of hearty, substantial food, for I knew I could not do hard work without it.

But Charlie was a dainty child, and could no more go without dainties than I could substantial food.

One day a gentleman, from whom I had rented the first house when I landed in Virginia City, came and brought me a half-barrel of flour, a large twelve-quart can of raisins, a pail of different kinds of spices, a chopping-bowl and knife, a rolling-pin, a ham, and a variety of other things.

Their dwelling was just opposite me, and his wife and myself had become very intimate.

She had just had a little boy killed by the cars, and was nearly insane with grief. But I had done all I could to soothe her aching heart.

She spent many hours at my house, and 1 suppose he felt grateful to me.

They were now going below for her health, and also to get her away from the scene of the accident, and having a good deal of provisions on hand, was giving it to his neighbors.

Among the things he brought us were two bottles of California wine. Well, I was very much obliged for this

little wind-fall, for it was very hard times just then, yet it was very unexpected to me.

With my school, washing, and sewing, I had now laid by $35 towards my law business, but had not yet found a lawyer to take my case on contingent fees, although I had tried eight months nearly every day ; had talked with thirty-two lawyers, but all wanted a retaining fee of from $100 to $500, except one, Mr. Elliott.

He did take the case for awhile on contingent fee, but finally gave it up.

Others promised, and would take the papers for a week and then return them, and say I could not get anything; but if I wished to get out papers of administration, I must give them $500.

Others wanted $300. Now I began to think there was something wrong, for there was quite a difference in the prices, as the most of them told me the money all went to the State.

Mr. Elliott told me to get my papers out. They would only cost what it cost to get them recorded. He could not tell exactly, about $35 or $40 ; not more. He was the second lawyer I went to.

After he gave it up, and the other lawyers said it would cost $200 or $300, I began to think he was a novice in law matters, or the rest great rascals. So I went to the presiding judge, who heard my story. " You had better put your papers in the stove and burn them, and go back East, for it will cost $500, at least, to take out papers of administration, and *then* you cannot get anything," said he. "Our laws are so different here from those in the East."

Well, I made up my mind the man did not know it all, if he was a *judge*, and I could not help hoping his term of office would expire before I had any business done, for I did not think he looked or talked very smart. He was very young, and I thought green-looking.

I did not think he could have made a good judge to decide an important case before I had any business to decide. His term of office expired in a very sad way for his friends. He was killed in a railroad accident, near San Francisco, and I think Judge Rising took his place, and has filled it ever since by the voice of the people.

He is a general favorite. I always took a great interest in reading court items, and I never noticed but two cases where I did not think his decision just, and in both these cases his judgment was, in my opinion, entirely wrong. But I suppose he is not infallible, but liable to error as well as any man some time or other. But I am wandering from my subject.

I called on Judge Campbell, who was said to be at that time the smartest lawyer in the city. He also advised me to burn up my papers. He said: " It will cost $300 before you get your papers out, and that is more than you will get back."

But he was like the rest—something was wrong.

Either their opinions or principles were at fault. I do not know which.

About this time my friend Mrs. Beck went to Gold Hill. While there she met a young man who said he was a lawyer. She told him she had a friend who wanted to get a lawyer to do some business for her, but could find no one willing to take it on contingent fees.

" I will," said he. " It is a shame the way lawyers act— will never take a case for a poor person. Now, *I* would rather assist her than a rich person. I will come up and see her." He got my number of her.

In a few days he called to see me, and asked to look at the papers.

I showed them to him, and said he thought I had a good case; if I would let him look the papers over more at his leisure, he could tell better.

I told him he could take them, but I wanted him to be careful of them, and not lose them, or get them burned.

He said he would be very choice of them, and went away.

I did not exactly like the tone of his voice, or his looks either, for he did not look smart, not even enough to be a rogue, although he talked through his nose, and was very soft-spoken—one of the best signs of a rogue I ever noticed.

I know two brokers in Virginia City who have this peculiar way of speaking, and I think either of them would rob his mother of her last dime. I may be mistaken.

Well, I thought he knew enough to take out the papers, at any rate. He said it would not cost but $35, and I was very anxious to have this much done.

I had, instead of writing to the governor of Nevada (as I had been directed to by Mr. Waters), called on him at his residence in Carson City; told him my business, and showed him the letter.

He said: "I am not acquainted with the man; am not sure I have ever had an introduction, but may have had. I know him by name, that is all."

The governor thought I had a good case, and advised me to make all haste in taking out papers of administration on my brother's estate. Thought very likely he had left considerable property, and he believed I ought to have it, and hoped I would get it. He talked more reasonable and sensible than any man I had talked with in the State.

He said it would only cost me clerk fees, just as Mr. Elliott had told me.

His kind words were very cheering, and I went home quite encouraged to struggle on and lay up money to fight it through.

I had already got $30 laid up when Mr. Hutchinson first came and offered to take up the case.

Let me here give you a description of him, for perhaps some of my readers may perchance meet him in some business transaction. He is about five feet nine, slim, light complexion, pale blue eyes; his hair sandy, and his right eye badly crossed.

After he had the papers a few days, he came and told me he was going to Carson City, and had the papers nearly made out. I asked him if he would be back the next day. He said "Yes."

I said I had a suit I wished him to look after.

He said: "Well, I will be here by the first stage."

But he did not come in three weeks.

When he did come, he was very sorry, but the stage went off, he said, and left him.

Well, I believed him.

He said: "I have the papers ready to record."

I told him I would get ready and go with him to the office.

He said it was not necessary for me to go; I could just give him the money.

Now, I confess I had some misgivings about giving him the money, and finally thought I would have a witness of it, so I told him he would have to go over to Mrs. Beck's with me to get the money.

We went over, but when we got to the door, he would not go in, and said he was in a great hurry.

I then went in, and told Mrs. Beck my fears, and asked her to go to the door with me and see the money paid to him.

She did so, and heard him say to me: "Everything is all ready now, and I will push the thing right along."

"Now," said Mrs. Beck, "I want you to do your best for my friend; if you succeed, you shall have all of my business to do."

"I will," said he, "for I may not have to use all of this. I will try and save as much of it as I can for you."

I did not see him again in three weeks, and then he came in great haste one night and handed me my papers, and said he was through with them for the present. He said Judge Rising had gone to the springs for his health, and would not be back in two weeks, and he did not feel well, and thought he would go, too.

"And I think you had better take charge of these papers for fear of fire," said he.

I took them. And again a strange presentiment came to me, and it seemed as if I must follow him and ask him for the money. I did go to the door to get it back of him, but he was whirling out of sight down B Street, towards the Giger grade, and I have never sat eyes on him since, although two years after a friend of mine saw him in Gold Hill, and told me he had just married, and was going on his wedding tour to the States.

I employed a lawyer to hunt him up. He said he would if he was there, and would let me know what success he had; but failed to keep his promise, and that was the last of my $30.

I was still washing, teaching, and sewing.

Perhaps the reader would like to know how I managed to do it.

I got up early every Monday morning, and got my clothes all washed and boiled and in the rinsing water; then commenced my school at nine. At noon I spent my leisure time sewing; and after school I did the same after I got my supper out of the way. I often sewed till twelve and one o'clock at night. After all was quiet, I could do a great deal of sewing.

Tuesday morning I had my clothes on the line by daylight, and my breakfast ready.

After breakfast my work was soon done up, and I sewed again till nine o'clock.

At noon I starched all my clothes. After school I ironed

as many of them as I could, and at night finished the rest of them. Then I had the rest of the week to sew in; but I could not lay up money very fast.

My friend, Mrs. Beck, was very anxious for me to get started in my law business, for she did not like to see me work so hard; so she proposed to me to raffle a large oil painting I had. It was one my sister gave me to sell should I get out of money. She said: "You will not get half what it is worth if you sell it; but we will get out some tickets, and sell all we can before the raffle comes off."

We got out three hundred, and sold them at $1 per ticket. We sold two hundred and twenty-five.

The $25 I spent in provisions, which was money to me. I put the $200 on interest.

The painting was raffled off, but no one came for the picture, and it naturally fell to me by right.

But the man who raffled it off refused to let it go for six months after that. He said I could have it, but when the time had expired, he said it belonged to him, and he gave it to Mrs. Beck to square some present or debt.

She gave it back to me, for she said it rightfully belonged to me, and I gave her $10, for I did not like to have her lose the whole of her present.

I called on a lawyer about this time.

He told me, after examining my papers, that I had a splendid case on my fifty shares of Kentucky stock, and he would take the case for one-third of what he got. I agreed to this. His name was Williams.

He said: "Call again in three or four days, and I will look over the case, and tell you what the prospects are."

I called in just four days, and he said: "You can't get anything without a great deal of trouble, and I want $500 to begin with."

I was perfectly astonished, and told him I thought he was to take it for one-third of what he got.

He pretended to be surprised, and said: "Well, madam, there is a law in the old country for punishing all persons who take a case on contingent fees, also the party who employs them, and it ought to be so here. I wish it was. Besides, you can't make anything out of the Kentucky; you are *one day too late !* "

I was so indignant I did not stop to ask him what he meant by "one day too late." I told him I was thankful I did not live in the old country; if he preferred their laws, he had better go there.

To think he should first tell me that he would take the case for one-third, and then tell me he must have $500 down, and when he found I would not give it, tell me I had no case!

When he had shown his hand, I was glad he did not take the business, for I was sure he would have managed to cheat me out of the whole. He was the worst of any I talked with.

He was even worse than the thief that robbed me of my $30, for he would have taken $500 instead. But one lesson was quite enough for me.

I got another lawyer to take the case on contingent fees by the name of White. He had done some business at one time for my brother.

I told him I had Mr. Stone, of Silver City, a first-class engineer, measure the water in the ditches leading from the Old Kentucky tunnel, and found it measured forty-seven inches on the level. I had also learned from reliable sources that the water from this tunnel was sold for $1 an inch per month, the whole year through, to each of the mills at American Flats, and also to all the mills between lower Gold Hill and Silver City.

There were fourteen of them in all, and the water had been selling at this rate for five years, and my share of this was lawfully one-twentieth of $1,213,690, counting simple interest.

I told him the water company had it in their possession, having bought it for assessments only thirteen days after my brother's death.

I had been to different members of the company, and they had offered to settle, and gave me three days to decide on what I would take for my share.

I had taken three days, because he (Mr. White) was out of town, and I wished to consult with him.

He said: "I will think it over, and let you know to-morrow."

When I called, he was not in.

I then called on the company, and they each referred me to the other members, all saying they would do what the other members thought was right.

Mr. Fair was the last one, and I told him I should commence a suit immediately if he did not settle with me.

He wished me to wait till Mr. Mackey came from San Francisco, and then they would settle.

I asked him when he expected him.

"In a couple of days, at most," said he.

I told him I would wait. When the time was up I called, and he said he had nothing to settle; if I had money to fight the water company, go ahead.

I called at White's office several times, but could never find him. One day I met him in the hall going to his office. I told him I had called on him several times, but never found him. I told him what Mr. Fair had said.

"Well," said he, "I have seen them and told them they had better give you $25 to get rid of you and let you go home, for you were a poor woman, and they ought to give you something."

I was very indignant when he told me this, and told him I was not poor enough to take $25 for $60,000.

I thought I might as well look for another lawyer, for I

saw a deficiency in this one, either in sense or principle;
but I did not stop to analyze him.

One day, while hunting lawyers, Judge Noyes said he
knew one who was pretty smart, and sometimes came there
to dinner. I asked him to let me know when he came
again. He said he would.

About a month after this I had been sick several days. I
had poisoned my finger with a fish-bone. I was barely able
to sit up at this time. I was sitting on the lounge combing
my hair, when Mrs. Seltzer came to the door with a gentle-
man, and said : " This is the lawyer father spoke to you
about."

I said : I am glad you have come, for you can look over
the papers. But I am not able to attend to any kind of
business to-day. I got the papers and gave them to him to
look over, and sat down again. He looked them over in a
short time, and, laying them down, said : " I do not know ;
I will think of it, but do not see much of a case at present.
I cannot take them, but will run in again, when I have more
time, and look at them."

I said, very well ; and was quite willing he should go, for
I felt very bad, and really thought I was going to faint
again, as I had once that morning. I reached over to the
table for some medicine, when he said : " You look very
pale ; what is the matter ? "

I told him I had been very sick from a poisoned finger,
and was not able to sit up. But he did not take the hint
and go. I got up and crossed over to the table and com-
menced to pile up some books which lay scattered over the
table.

He got up and followed me, and said : " I do not think
I can do anything with those papers to-day." And before
I was aware of his intentions, he attempted to kiss me. In
a second I seemed to possess the strength of a lion ; anger
electrified me and sent the hot blood coursing through my

veins. I sprang back from his would-be embrace before his poisonous lips had polluted my face by their touch. I seized a clothes-brush, and sent it flying at his head.

Go! said I, *contemptible villain,* and *never dare* to enter my presence again! I did not send for you to come and kiss me. *Go!* I can get *decent* lawyers to transact my business.

"What a fury!" said he. "A moment ago you looked as if you were going to faint, and now you look as if you could kill half a dozen."

This impudence roused my temper to white heat, and seizing a pair of scissors, I threw them at his head. He dodged them, and rushed from the room. I picked up the scissors and found them minus one point. I was often asked by my lady friends how the point came off my scissors. I always gave them the same answer—I bit it off one day in a fit.

I have never seen this person since, nor do I wish to. I was so blinded by passion that I did not think of my pistol, and was very thankful I did not, for I fear I should not have stopped three times to think before using it.

For his wife's sake, who, I hear, is a very nice woman, I will suppress the villain's name.

Judge Noyes' family will probably remember the circumstance should they see this.

CHAPTER V.

A Law Suit—A Move to B Street—More Friends—A Move to A Street—A
Deal in Stocks—Buying a House—Moving Again—Sickness and a Broken
Arm—Novelties in Love-making.

WHILE I was teaching on G Street, a colored woman
came to me to get me to teach her to read and
spell and write. She said she would give me $5 a week to
come to her house and teach her one hour each day. I
was very glad to do this, for it was an extra income.

I had taught her three months, and found her an apt
scholar, and good, prompt pay. It was only a short dis-
tance from my house.

This brought me $20 a month extra.

But there is scarcely ever pleasure without pain—some-
thing to break the cord of harmony.

I saw many mysterious things at this house. She was a
great talker, and knew everybody's business as well if not
better than they did themselves. I used often to find a
little white child crying, and shut up in its room ; a tiny
little two-year-old thing, that could speak but two words—
"Mamma," and "No."

I often found it crying, and concluded its mother had
gone out and left it, and it was crying for her.

I used to pet it, but black Lize coming in one day and
finding me holding her, took her and laid her on the bed,
and told her to lie still and go to sleep. Turning to me,
she said : "She is sick."

In a few days I found her again alone, and crying. I took her up, and as I did so, she cried out as if hurt. I untied her apron, and on her chest was a large lump the size of a walnut, all black; it looked as if she had been struck with a club.

I then examined the child's body, and found its back and legs literally covered with welts. I now knew that the child was abused. I did not know what to do, as I had but a few intimate friends, and not many acquaintances. So I went to Bishop Whittaker, and told him how the child was abused. I told him I felt as if the child would die from the treatment, and if I should not let it be known in time to save it, that I would be equally guilty of the crime with her, and I could not sleep nights thinking of it.

" If you feel like that," said he, "you had better go to a justice of the peace, and make a complaint."

I said I did not know where to go.

"Go on C Street, to Judge Livingston, and when you are ready for the suit I will go with you, if you like."

I thanked him, and said I would like to have him go very much, as I was a stranger, and his presence might make a difference, in the case.

The next day I went, as usual, to hear her lesson and get my pay for the last week, as she could not make change, and it had run over a day or two.

This morning I found her on the back porch of the third story with the child standing in a tub of water, and she with a dipper pouring cold water on its head—the poor child screeching and screaming between each breath it caught, for the cold water took its breath quite away. It was fairly purple with cold.

I sprang forward and caught the child from the tub, saying: Don't you see the child is going into a fit? For it had now got past screaming, and was holding its breath.

She threw a shawl over her body, and took her off to another room.

She was gone some time, and when she returned, she said: "I have not time to take a lesson to-day. Here is your money for last week." And she turned and went in the room where she left the child.

I now hastened up to the court-room on C Street, and made my complaint. The trial was set for ten o'clock the next day.

When I was ready to go, I called for Bishop Whittaker.

He said he had thought the matter over, and had decided not to go, for fear she would burn the church.

It was too late then for me to think of getting anybody else, as I had but a few moments to reach the court. When I went in they were all there waiting.

Mr. Woodburn was her counsel. I had no counsel, as Mr. Hutchinson had failed to come back from Carson City.

I told the judge what I had seen the day before; and also that the colored woman had said to me that it was nothing, for she often put it in the water and nearly froze it, and then whipped it till it was warm, to punish it. But I think it was the other way. She whipped it till it was all swelled up, and then put it into the water to take the swelling out.

She threw her shawl over it to prevent my seeing the marks.

The trial was simply a mock trial, nothing more nor less. They asked me where my witnesses were. I told them the child was witness enough for me. Examine her, and you will find plenty proof of my statement.

But they did not do this, but allowed the wench to take the child and expose it in the most obscene manner before the court, and at the same time show no marks.

This was done to mortify and confuse me; and it being the first and only police court I was ever in during my life,

it had the desired effect; for not having any counsel, I did not know what to do. The district attorney was there, but never spoke but once during the court, and that was when the wench went to blackguard me; then he stopped her. With that one exception he might have been a wooden man standing there, for all the good he did.

Mr. Woodburn tried hard to cross me by repeating his question. After I had answered it three times, I told him to answer it himself, if he wanted it answered. *I would not.*

He was very ungentlemanly in his questions and remarks.

"Well," said the judge to her, "take the child home. I guess you know how to take care of her."

Just as he spoke, he happened to see a mark on the child's leg as she was adjusting its clothes.

"How did that happen?" said he, noticing that others saw it, too.

"Oh! she fell and hurt her, or the Chinyman dun it. I dunno which."

The court was now dismissed.

I felt so bad to think that a helpless child must suffer and not have justice, that I could not speak. I thought if that was a specimen of a justice's court, I would never try another.

I went to Mrs. Beck, but my feelings were so wrought up that I could not tell for some time what the matter was. When I did, she put on her hat and went up to the court-house, and asked the judge if that was the way he dealt out justice to the people.

He said: "I did the best I could."

"Well," said she, "you belong to a certain lodge with me, but you will not long, for I will report you there."

"I do not care if you do," said he; and we went back home, and I suppose he went out and took a drink.

He committed suicide a few months after, and I could not help thinking it were better he had done it before.

The child came up missing. I never could learn what became of it, although several people went there to see if they could see it, but could hear nothing.

After the suit, for several nights, I heard some person around my house; heard them try the door.

I told some of my friends about it, and they advised me to get a house nearer my friends, for they thought it was black Lize, as she was commonly called on the Comstock.

I now became afraid to stay alone in a house by myself. I soon found another place, but only one room. It was about forty feet long and very high walls. It was a very nice, warm room, and I took it and divided it into sections —a parlor, bed-room, kitchen, and a school-room. Being so large it answered all purposes.

The room was next door to Judge Noyes' restaurant, and I became very well acquainted with the whole family, which consisted of a wife, one son, Walter, and two daughters. The eldest was my friend, Mrs. Calvin; the youngest, Mrs. Dr. Seltzer, a charming little brunette widow. A handsome passion flower was this youngest daughter. Love and anger, mild and passionate, all in a breath, while Mrs. Calvin was always the same bright, sunny, joyous, laughing companion.

She was capable of making any amount of fun. She was the light and life of any lodge or society to which she belonged.

Her father and mother were both very much like her in disposition, very genial and pleasant.

They were always very kind to me. Mrs. Noyes was a great reader, and every Tuesday night we used to meet at her parlor, and the girls and I would sew or do fancy work, while she would read to us, and the two children would play off at one end of the room.

I spent a great many very happy evenings with them. We were always good friends.

I now took some of the money I had laid up, and bought me a sewing-machine, for I had done all of my sewing by hand. I could now work much faster.

About this time a daughter of temperance came, and wished to propose my name to her lodge. I told her I should like very much to join, but I could not leave my child alone in the house for fear of fire, and I would not let him play in the streets while I was there. She reported the case to the lodge, and they applied to the grand lodge, and got a permit to take him in. I told them I would be responsible for him. The youngest they took in were girls at fourteen, and boys at sixteen.

He was not quite ten years of age at this time, and some feared he might expose the secrets of the order. I do not think they ever regretted taking him in, for he never violated his pledge like many of the older members did.

He was always handy to help at our festivals, and as he grew older, took an active part in our evening amusements by giving us readings, recitations, and songs, and when the lodge adjourned for a time till we could get a house to suit us, the most of the lodge joined a new order, called the "Champions of the Red Cross."

He was the last of the order to join, because he wished to revive his old lodge; but seeing there was no hope, he then became a very active "Champion," and we both remained such till we left there.

While I was a member of the "Sons and Daughters of Temperance," I did everything in my power to build and keep up the lodge. I always took a very active part in getting up entertainments, and whenever I assumed the control of one, I turned over to the lodge a neat little sum.

At one time I turned over $98, if my memory is right; at another, $125; at another, $140, above all expenses.

At one time I made a mammoth ring-cake. It contained one hundred and forty-four pieces of cake, four inches

thick, and one inch square. Each piece had a handsome
ornament on the top of the heavy, white frosting. They
were also made of white frosting, and each piece was num-
bered. The numbers were then sold, all hoping to get the
fortunate one containing the ring.

The pieces sold for "four bits" each, and very rapidly,
some taking a half-dozen numbers. The cake was the at-
traction that evening, for it was, indeed, a very beautiful
cake.

The temperance people worked very hard to get laws
passed at the assembly by sending mammoth petitions.

Several of the ladies of the lodge generally went around
with a petition, each trying to get the most names.

I used to take my paper, and go to the post-office, and
there take names as the people came in for their mail. I
got nearly a thousand names here. I also stood in front of
my house, twice a day, for two weeks, and took names. I
got fourteen hundred names in all.

I also procured about one thousand names for the gamb-
ling bill. This bill was to make all the proprietors of
gambling-houses move their rooms to the second story of
their buildings.

One of our temperance bills was to prevent a dealer from
selling over $5 worth of spirits to one man—if he did, he
could not collect his bill.

Some men were in the habit of spending their whole
month's wages before they were due, and then when they
got their money, they always made it a point to pay their
liquor bills, whether their other bills were paid or not.

Almost everybody signed this bill, for it not only bene-
fited the man himself, but his family, and the community at
large.

I remained on B Street one year. While there the engine-
house, which was two doors below me, took fire, and nearly
consumed the house next to me. Before it was extinguished,

the flames reached the porch over my door. I heard the bell, and throwing a shawl around me, hastened to the door, where they were rapping loudly for me to come out. I saw how things were, and turning the key again, I told Charlie to dress with all speed, while I did the same.

I then took hold of one end of my trunk, he the other, and unlocking the door, we carried it up street out of harm's way. I told him to watch it, while I went back for more things. I carried up my satchel, then went to packing up my most necessary things, and had just got the bed down when the door opened, and in came Charlie with the trunk and satchel, some friend helping him, and said the fire was all out.

In half an hour everything was in its place, and we were in bed, fast drifting into the land of dreams.

Some time in January an old lady was taken sick, and the Rev. Mr. McGrath hired me to take care of her at $3 per day.

I gave my school a vacation, as I had just taught one year with no vacation excepting Saturday of each week, or the holidays.

I took care of her two weeks, when she got better, and I came home.

I intended to commence my school again on Monday, but a lady friend came to me and asked if I would take another patient to nurse.

I said I would if the pay was good. She said it was. She said the man had been twice for her, but she could not go. She had told him of me. If I would go, she would show me the way.

I went, and found the lady very sick. She was blind, and perfectly helpless. It required all my time to care for her. After I had been there one week, I began to feel the want of sleep. She became better, so that I could leave her with another person; but there was no one there but

her young daughter, a child of fourteen. She did not like the confinement of a sick room; she had rather be out to play.

The lady told me to go up stairs and have a good sleep, and let the girl watch by her.

I very thankfully accepted the offer, but had not lain down over half an hour before the girl came and said it was time to get up. I went down, and as soon as the lady heard me, she said: "Why did you get up so soon?"

I told her I had quite a sleep.

When the girl came to my room the next day, she found the door locked. She then commenced rapping on the door until she awoke me. I was afraid she would disturb her mother, and got up and came down. The next day I had scarcely lain down before she came and pulled the clothes off me. This time I had no rest. I did not try it again, but sat up all the time, even to the end of the third week, when I became nearly wild for want of sleep. I would go about the room all night, fast asleep, making the fire, or giving the medicine at the usual time, just as regularly as clock-work, never knowing a thing I had done, until one day the lady said: "You must go and lie down earlier to-day, and get more sleep."

She had thought I had lain down every day while she was asleep, for I had never told her or her husband about the girl having awaked me. I knew it would have annoyed her, for she was very nervous, and I would not have her disturbed, because the doctor had said her life depended on her being kept perfectly quiet.

She said: "Do you know what you have been doing for the last two nights?"

What! said I.

"You have been taking care of me and giving me medicine when you were sound asleep," said she.

I was surprised, and asked her what made her think so.

She told me of things I did at the time she first discovered it. She also spoke of my building a fire very regularly.

I asked her if she was not afraid to take the medicine.

"No," she replied; "for you were punctual to a minute."

I knew this would never do, either for her or myself. I now told her I could not rest good up stairs, and if she had no objection, I would go home for just one hour every day. She had none, and I went home after that every day, and soon had my sleepy spell off.

One day the girl wished to go off and spend the day, but could not go until I had my sleep. She scolded, as girls of that age will, but her mother told me to call in her father. I went to the hall door and looked out, in order to scare her to silence, for I knew her father had gone up town. She sprang after me, and taking hold of my shoulders, shook me violently, and said: "You old Irish hag; don't you dare to tell my father!"

Well, I did not tell him for two reasons: first, because he was not there; and second, because he would have given her a severe whipping, and this would have excited her poor mother.

She never knew how much I put up with from her daughter during the month I staid there.

The girl has since grown to be a young lady; and should she perchance read these lines, she will very readily recognize herself as the girl of fourteen, and I hope at twenty-two. She is very much changed for the better, for she was certainly a very disagreeable girl to me, while her mother was a perfect lady, and one of the most patient sufferers I ever met with. Her father also appeared like a gentleman.

After I went home I commenced my school again, and taught till the first of April. Then I moved to A Street to a house with four rooms. Here I fitted up two rooms to rent, and asked $12 apiece for them. I paid $12 for the

house. The rent of the two rooms, with my sewing
allowed me to drop my washing and school, although I had
not done any washing for five months before I moved, for
I found that it was breaking me down too much, and I had
got over $300 laid by. Besides, I had a sewing-machine that
cost me $30. I could get plenty of sewing. The school
confined me so much that I did not have a good chance to·
attend to my brother's affairs.

I very often had a chance to watch nights with the sick
for $3 a night, and this was more profitable than washing,
or even the school.

I did the washing just ten months, and taught fifteen
months.

Another very lucrative source of income was baby-tend-
ing, and it was also very pleasant, unless the baby happened
to be a cross one—then I earned my money. But as a gen-
eral thing, they were pretty good.

Nearly all of my lady friends had small children, or babies,
and all wanted me to attend theirs, and one would offer
more than the other in order to get me to take care of hers.
There were several rooming at one house just over the way
from my place, and I found it very profitable to go and
take care of them all for $3 apiece. I have had as high as
$5 a night for taking care of one baby.

These ladies were very fashionable, and attended all, or
nearly all, of the parties and balls given.

There is something every night in the week to which
one can go, and the ladies of Virginia City are always
ready for any amusement, and I think enjoy it more than
any class of people among whom I ever lived.

So it was no uncommon thing for a lady to give me $5
for taking care of her baby, in order to be sure that no one
else would get me before her. I have been engaged for
two and three weeks ahead. I only did this for my friends.

Every lady, before she went away, would set a nice little

table for two, with all the luxuries of the season. The table would fairly groan beneath the food, some of which was piled on the table, enough for two of us to eat through the night, with a strong pot of tea to keep me awake.

Another table would be piled full of magazines and periodicals of the day, and one or two evening papers. All I had to do was to undress the children, and put them to bed. If the little ones wanted feeding, I fed them, and perhaps held them awhile.

I always took Charlie with me, as I would not leave him alone, and we sat and read nearly the whole time, till we got hungry, then we would have our little supper. Then Charlie would lie down and sleep till they came home, which was generally four or five o'clock in the morning.

There was more real profit in this than any work I did. Although nursing the sick was profitable, it was hard on the constitution.

While on A Street, I took all the money and invested it in stock. I bought Chollar stock for $52 a share, and drew $3 a month dividend for three months; then $2 for three months more; then $1 for two months, until at last the dividends stopped, and the stock dropped to $20.

My friends advised me to sell, for fear it would go lower, and would lose it all; but it was paid for, and I could afford to keep it, and did.

This was in the fall. In January stocks took a big rise, and Chollar went to $89. I sold. She went on up to $99, and I bought it back, losing $10, as my friends said. But two days later she went up to $320. I then sold it again.

I had now made a handsome profit of $231 per share. I had also bought some Sierra Nevada for $24 the same week, and sold it for $44 in three days' time.

I now had a snug little sum, and I determined to stop paying big rents by buying a place of my own, for in the

three years that I had been on the coast I had paid out just $400 in rents.

I now went in search of a place to buy. I wanted one in a good business location, and fortune again favored me. I found a nice little place on C Street, which is the principal street of the city.

I got it quite cheap, for property was down, and the lady that owned it was very anxious to get away from Virginia City, she having had some great sorrow there. She asked $500 for the place, and it was a big bargain. Although property was very low, I bought it, paid her the money, and moved the next day.

Now, what I earned I could live on or lay up, the house-rent being stopped. My house had but three rooms and a wood-shed. I lived in it two years, when Mr. French, my brother's friend, offered to put up a lodging-house, with a store underneath, and give me time to pay for it by way of my rents.

The house, he first thought, would not cost over $1,000, but after his partner figured on it, he said it would cost more, but not over $1,500, as the work upon it was to be done by the day.

I gave them the job. A contract was drawn up, and they went to work. The house, they said, would not take them over a month to finish.

About this time I found a good, honest lawyer. His name was F. V. Drake, of Virginia City. I had become acquainted with him and his wife at Judge Noyes' house. He took up my case, and got out my papers of administration for me, and charged me only for recording them. But after he had them recorded, he either was too busy or, like the other lawyers, thought there was nothing in it, and so gave up doing anything about it.

It rested in this way for a year, but it did not matter now, as the papers were out. I could wait till I got a

chance to sell before I moved any further in the matter. During the first winter I was on the place, Charlie took quite sick, from fall till spring, with whooping-cough, and was nothing but a shadow. He was nearly starved to death, for nothing would stay on his stomach. In May it left him, and he had scarcely got over it and was picking up, when he came down with the measles. He was very sick, as he always is when he is complaining. I now gave him all my time, for I knew the disease I had to deal with. It generally left some bad effect, such as blindness, deafness, defect in speech, lung difficulty, and often a broken consti- tution. But fortunately he recovered, after eleven days, with none of these symptoms, and began to flesh up again. This was in June.

In July there was a vacation in school, for I had sent him steady to the public school ever since I quit teaching.

He asked me one day if he could not go with one of his mates to his father's stone-quarry, about three miles off. I told him he might go, but to lift no stone, for he was not old enough or stout enough. He was in his twelfth year.

He started off about seven o'clock in high spirits. As soon as Mr. Gault reached his quarry he commenced load- ing, and while he was placing a big stone in the front of his wagon, the boys rolled up another, and Charlie got upon the wagon to steady it, and stood with one foot on the plank, while the other was on the wagon. When Mr. Gault rolled the stone he had in place in the front, it jarred the plank off, and Charlie went with it. The stone he was holding rolled off on his left arm, breaking it above the elbow.

Mr. Gault placed him in the back of the wagon, his feet hanging off, and his son sitting by him and supporting him in his arms till they drove back to town.

He then asked Charlie where he had rather go, whether to his home or to some office, to have his arm set.

Charlie said: " I would like to go to your house and have

a doctor come there, for I want it set before my mother hears of it, for she will faint if she sees it in this way."

So Mr. Gault took him to his house, and sent for Dr. Green, who set the arm all right; but being a man who drank, I was afraid to trust him, and called in another doctor as soon as I got him home.

After it was all set they sent for me. Mr. Holland broke the news very gently to me, and I went immediately to his sister's, Mrs. Gault, and there found Charlie lying on the sofa looking very pale, but otherwise enjoying himself with a dainty little dinner, and one of the boys feeding him. He looked up and smiled, and said: "Don't worry, mamma, I shall be all right in a day or two."

They told me he stood the setting like a hero, never shedding a tear.

I did not move him till sundown, and then I had Dr. White come and look at it. He said it was all right. He dressed it after this several times, and then I took charge of it myself.

Dr. Green charged $50, and Dr. White $25; but when Dr. Green learned that I was a widow, he only charged me $25. So it only cost me $50. But that was a good sum to be earned by the needle, for I only had one room to rent; besides, he was laid up so long that I had to give him most of my time for two weeks. He then sat up after that, and could amuse himself reading; and it was some time in August before I could do any sewing.

A good share of the summer had been spent nursing him in all his sickness. I sat up eight nights with him when he had the measles, and also eleven nights with him when his arm was broken, for he is naturally restless, and I was afraid he would get it out of place.

My friends thought I got off cheap for $50, for they said a broken bone costs from $75 to $100. But my friend, Mrs. Beck, was at the bottom of this good fortune.

Among the many friends I had made was Mr. and Mrs. Charles Rawson. He held the office of county recorder for several years, and I had the records searched several times while there. I also had several documents recorded, and he would never take a cent.

I thought it very strange, and one day while talking with a lady, she said: "He never charges widows anything."

I thought this showed a very noble disposition. His wife was all that was good, being generous and noble, and I always found her a good, kind friend. A brother and sister could not have taken more interest in my affairs than they always did, and I can never think of them now, though I am so far away, without asking God's blessing on their heads, for I think a great deal of them both, and love her very dearly.

Whenever myself or boy was sick, she was sure to send us any delicacy she thought would tempt our appetite. She gave me a great deal of sewing, and never would allow me to name my price, because she thought I did not charge enough. She would always pay a good, round price, and often give the pay in advance, for fear I might want the money to use; and not unfrequently did a present of some kind accompany the work—sometimes a fat chicken, or something else.

She told me one day to send Charlie up sometimes, as she had something for him. He went, and she gave him three hens and a rooster. He thought he was quite a farmer. His hens laid every day till they had quite a quantity of eggs, and then went to setting. He took all but fifteen from each nest, and, strange to say, they brought out forty-five chickens; and when these chickens were two months' old, they commenced laying again, and set them the second time. He had over ninety chickens, but a great many of them got run over, so we had not more than seventy left.

I sold some for $1 apiece, and killed all we wanted for ourselves, and wintered twenty-seven hens.

In Nevada and California hens commence laying at the age of six months. Eggs freshly laid are $1 per dozen. I never sold any less than that. But I had not kept my hens over three years before I built my new house, and after that I could not get any eggs, for somebody got them all. One night I lost fifteen hens. I then concluded to kill them off, and did so.

You Eastern people, with your 6 and 8-cent eggs, may think my dollar eggs a fish story. Nevertheless, it is true, for the people of Virginia City are able to eat dollar eggs, although they can buy them down as low as 25 cents, if they are cracked. So they won't keep longer than one or two days, and that is a big price with you for winter eggs.

When I first went to housekeeping, the prices were so astonishingly high that I could not believe my own ears. When I heard the merchants tell their prices, I used to pass on to something else and inquire the price of that, and after a little while go back and ask the price of the same article, in order to see if I had heard aright, for I could not believe I had.

The reader must not think that because four years had passed before I got a lawyer, that it did not cost me anything to hunt one, for more than twenty took the case, and, after investigating it a few days, gave it up. Many of them said I was welcome to what they had done, and some charging from $1 up to $5 for their trouble.

This counted up in time. I paid a small sum for recording papers, and searching records in different places, and after Mr. Rawson went out of office I did not find another like him in Virginia City. I also had some stage fare, for I was not always able to walk, and sometimes the place was too far off.

You may wonder, if I made so much money sewing, what I did with it; also the balance of my money after paying for my place. You see a good deal went that way. Then I had taxes—both city and county. I had also little bills for sidewalks, sewers, and street-cleaning brought in, it seemed to me, every day. I also had a mortgage of $300 to pay the interest on in the States.

I used to send the money to my father, who paid it for me. I put some of the money back in stock again, on some of which I made double, and on some I lost all. So it was an even thing.

My son, who was now the age of thirteen, carried the *Evening Chronicle,* and also had routes of his own, and attended to them all after school. He made about $15 per month, but this barely kept him in clothes.

I think a person wears out clothes as fast again in this country as in the East, especially shoes and boots. The alkali seems to rot everything.

Speaking of clothes reminds me of buying a suit of clothes for my son at a Jew clothing store. They were recommended to me as a tiptop suit, but were all falling to pieces inside of a month. I was obliged to get him a new suit, and called at the same store and showed the man the clothes.

"Well, didn't I tole you so?" said he.

No, said I; you said they were a tiptop suit.

"So they were. I took them right of from the top here," laying his hand on a pile of clothes.

That won't do, said I; you recommended them to me for a good suit.

"Oh, no; you was mistaken. I tole you they were the poorest in the pile. Now just let me sell you another suit, and I tells you what I do. I gives you this suit worth $35 for $30—coat, pants, vest, and suspenders."

No; I do not want them at that price.

"Well, I throws in a box of collars and a neck-tie."

No; I do not think I will take them. And I started to go.

"Hold on," said he; "I will throw in a handkerchief and a pair of socks."

No, said I, going towards the door.

"Stop!" said he. "I makes you another offer. I lets you have all these things for $25."

I do not want them. And this time I reached the side-walk; but he ran after me, and said: "I puts you in a nice hat, the latest style, worth $3. Just come in back, and see it."

I wanted the clothes, but wanted them low enough to make up for the loss on the other suit. So I went back, and after I had looked the things over, he said: "Now, I gives you the whole d—d lot for $25, and not a cent less. What will you give?"

I will give $20, and not a cent more, said I.

"No!" said he. And he commenced putting the things away.

All right, said I, putting up my money and starting for the door.

This was more than he could well stand.

"Take them; but I would not let anyone else in the city have them for that price but Charlie. And I tells you what—you have got a suit that will wear."

How long? said I.

"Will you try them and see? And Charlie, when you want another suit, come back, and I lets you have them cheap as any man."

"I will, if these prove to be good," said Charlie.

They proved to be the best suit to wear I ever saw, for he outgrew them without ever wearing a hole in them.

This reminds me of the second winter we were in Vir-ginia City. His Sabbath-school teacher, Mrs. Winters, made him a present of a nice suit of clothes. They were

given her by some merchant who refused money for the Christmas-tree, but said he would give her a nice suit for the best boy in her class.

This kind-hearted lady came to me before Christmas-day and asked me if I would be offended if she gave Charlie a nice suit of clothes.

I told her that instead of being offended I should be proud to think he had been selected as being her best scholar, and worthy of them. Besides this present, he had fourteen other presents on the Christmas-tree.

He was always very fortunate in getting Christmas presents as well as myself, for I generally got two dresses, and a host of small presents every year.

I always got one dress from Charlie every Christmas. Since he was nine years old he always laid by enough of his pocket money to buy his mother a dress, and he always showed good taste in selecting handsome ones.

Next to my boy's present, I thought most of my big fat turkey my cousin always brought me; for it seemed like getting it from home to get it from him. He always remembered me on Thanksgiving and New Year's days of each year.

The grocery men sometimes remembered me with a turkey. It seemed to be the custom there for grocery merchants to treat their customers to a turkey on some of the holidays.

Charlie was very fortunate at his birthday parties in getting nice presents. He has a very handsome solid silver napkin-ring, which was presented to him, at one of his parties, by his friend, Sammie Calvin; and at nearly every party he got a nice china-cup and saucer, till he had a set of twelve. He frequently had three or four very nice handkerchiefs given him by the girls and boys, and some brought half a dozen. One little girl brought him a handkerchief-box and a dozen handkerchiefs in it—all very nice.

When Charlie was about twelve years of age the boys and girls commenced a series of surprise parties, and he was generally the ringleader in getting them up. His taking so much interest in them pleased both the girls and boys, and he became a sort of favorite with all.

I do not think he had an enemy in Virginia City and Gold Hill; but on the contrary, he had many warm friends, both among the old and the young.

I once heard a gentleman say he was the only boy in the place that had treated him with respect, and never said a saucy word to him.

I always taught him to treat everybody with respect, and show no difference between the rich and poor. I never taught him to respect a person according to the length of his purse, or the ostrich feathers in his hat, or the quantity of silk with which she could mop the tobacco juice from the sidewalks; and I think he would as soon dance with a respectable girl in a neatly-made calico dress, as one supporting a silk, for which she had paid from $20 to $40 for making, which sum many of the ladies of Virginia City do pay for the making of their dresses. They often pay twice as much for making as the material costs them. A common calico dress costs from $5 to $8 for making.

I remember of making three calico suits for one woman for $8 apiece—$24 for the three—and the cloth and trimmings for the three only cost $10.

I never lived in a place where the people dressed more richly or more extravagantly than in Virginia City. It is not only a few millionaires who indulge in it, but every woman on the Comstock who has a husband earning $4 or $6 a day, up to the superintendent, who gets his $500 or $1,000 a month, as some of them do who have two or three mines to look after. And many families live up to every cent of their wages or salary.

Some of my friends were very extravagant, and I used

often tell them so, and in return they would call me a miser, because I would not follow all of the silly fashions.

I do not wish the reader to think we quarreled, for we were only bantering or joking.

Mrs. Calvin often laughed at me, and said: "If you would go down in that old stocking, and get out some of the gold you have hoarded up, and put it on your back in fine clothes, you would stand some show to get a rich husband, for they would know then that you did have something; and now they don't know you are worth anything."

I would tell her I was not in the market, for I had determined never to bring a stepfather over my child, no matter how good he might be. I told her that if I ever married, it would be after my boy had grown to be a man, and then it would not be a fortune-hunter, but a *man* I could respect.

I do believe that if I could have married every man that she and Mrs. Beck picked out and tried to make a match with for me, I would have had as many husbands as old Brigham Young ever had wives.

They finally gave up all hopes of ever dancing at my wedding, although both offered to be bridesmaids, and furnish the wedding supper. But I told them all that I had too much business on hand to get married. I thought of going back to old New York before I would think of such a thing, for I did not intend that anything should prevent me from accomplishing the business that took me to Nevada.

I do not wish the reader to think I went shabbily dressed, for I did not. I never bought needless finery, as I had other uses for my money; besides, I never believed in dressing to catch a husband. I think this is one reason of so many divorces in California and Nevada. The ladies dress so rich and gaudy, and use so much paint and powder, that they are really not themselves when dressed for church or ball, or for the street, but only painted dolls, dressed in silks

and satins, decorated with expensive jewelry, and, as Brother McGrath used to say, wearing a whole flower garden on the top of their heads.

Admirers of beauty think they are genuine, fall desperately in love, and marry them. After awhile the ladies become careless of home dress. Their market is made, and they can afford to leave off the paint except when going out.

The fond husband, coming in from his office, or other business place, finds his wife, who has been up half of the night, and spent the forenoon in bed to make up for lost time, lounging in an easy chair, her hair in papers for another ball, her face minus both paint and powder; she is dressed in some old slouchy wrapper, reading some periodical, and oh, horrors! he discovers his supposed beauty to be a pale, sallow-looking, freckle-faced woman, not even ordinary-looking in many cases.

The scales fall from his eyes. He now discovers that "All is not gold that glitters"—not even in Nevada and California.

He becomes disenchanted; he sees many faults now which beauty concealed before. He finds she is not fit for the mistress of a house; she does not know how to work, nor even how to order it done. He must keep help at $40 a month, in order that this sham beauty may have time to dress.

He becomes tired and indifferent to his artificial wife, and the first thing you see in the papers is an application for a divorce, either from one side or the other. It makes no difference who is to blame; the one who applies first gets the divorce, and often the defendant does not appear against the plaintiff.

There is hardly a week but there is an application for a divorce. Virginia City is truly the city of divorces, and the cause I have just stated is one great reason for it.

Another is, men are apt to neglect their wives for business. They leave their wives to the society of other men. They are running wild over stocks, while other men are playing the "agreeable" to their wives, and finally run away with them.

The husband then discovers his mistake; but, alas! too late; his bird has flown.

He then applies for a divorce, or, taking the law into his own hands, follows the man who has destroyed his happiness, and blows out his brains. I have heard of such cases in both Nevada and California. Often two lives are lost instead of one. But in the best circles it is settled by a divorce, and perhaps before three months have passed, each one has secured another partner, and they will both meet at the same ball, and dance in the same set as friendly as though they had never had any trouble; and you would never imagine they had been man and wife.

Now, reader, I am not handsome, and am conscious of the deficiency, yet I flatter myself that I am not ugly-looking, and have even been told by an admirer that I was *passably good-looking.*

I used to tell a lady friend, when conversing with her on the subject of matrimony, that if a man could not admire me for myself alone, he should not be deceived by fine clothes and paint.

Now, Mrs. Reader, don't you go to thinking I never had an offer, for I have had several, one being from a merchant. Now see how business-like he popped the question. He came to bring me some goods. As he stood in the door, looking around, he said: "Do you own this place?"

I replied that I did.

He said: "It is a fine little property." He stood a moment as if in deep thought, and then turning to me, said: "I wish the Lord you would marry me. I have got four or five children, and I have not time to take care of them.

I want a good, smart woman to bring them up—some one that will be kind to them."

I told him if that was the case, he had better get some one else, for I would not do for a stepmother. I was afraid I should abuse them.

"I guess not," he said. "I have heard you were just splendid—humor Charlie to death. Now, I want just such a woman for my children."

Oh! yes; I am pretty good to Charlie; he is my own, you know; but I dislike other children, and would be apt to be a cross stepmother.

"Well, you won't do for me, then, for I won't have my children abused by any woman. But I don't believe a word you say. I guess you are only gasing."

I had done a great deal of trading with this gentleman, and always got goods cheaper than at any other place. But the first time I called there after the above conversation, I found he had raised on his prices. I suppose he did not intend to sell cheaper than his neighbor, with no prospects of a wife.

Well, who blames him ? Not I.

Another offer, or almost one, was from a young Englishman. It was the first winter I lived in Virginia City. I had but a short acquaintance, having done some sewing for him. He was rather good-looking, and was bigoted enough to think he could get any woman to marry him by asking her.

He called one evening, and said: "Why didn't you tell me when you moved? I have been looking for you for the last six weeks."

I told him that I did not think it necessary to give an account of myself to anyone.

"Well, I have some very important business I wish to see you about."

I was quite surprised, and waited to hear what he had to say.

After a little hesitation, he said: "Well, I am on the marry." (That was the old country way of speaking.) "I think I know a lady that suits me."

Well, why do you not go and ask her? I do not see that I can assist you, for I never break nor make matches.

He laughed at me, and said: "Let me tell you what kind of a woman I want. She must be an American, and good-looking; one that knows how to do all kinds of work; one that can keep her own house, for I can't afford to pay $40 a month for help."

Get a Chinaman for $15, said I.

"I don't want any filthy Chinaman in mine. I don't care for a young girl; I would sooner have a widow about twenty-five or thirty."

I now began to see which way he was drifting.

I said: Would you, indeed? What a pity I am not *fifteen* years younger. I might stand some chance!

"How old are you?" said he, as though I were in duty bound to tell him.

Oh! too old for you, altogether—forty-five.

"I don't believe a word of it. I took you to be about twenty-five."

Well, you see appearances are often deceitful, said I.

"F-o-r-t-y-fi-v-e!" said he.

Yes, said I.

"'Pon honor?" said he.

Yes, honor bright, I replied.

"Well, that settles it," said he, reaching for his hat; "I don't mind marrying a woman about my own age, but I don't want one quite so old. Good evening!"

And this did settle it, for he never called again.

Remember, reader, I only said forty-five. I did not say years.

Another man came and took a room at my house for a month. After he had been there a week, he came one day

and rapped at the sitting-room door. I opened it, thinking, perhaps, he had called for something I had left out of his room, and stood waiting to see what it was; and to my astonishment he came in and sat down, and asked me if I owned the place. I said I did.

" I heard so," said he.

I expected the next question would be, Do you want to sell? But no such question came. His next words were: " Well, you want to get some nice man to take care of it for you. I heard you were a widow, and came and took a room on purpose to get acquainted with you."

Well, sir, said I, I am afraid you will have your labor for your pains. I made this property, and I think I can take care of it without the assistance of any man. Good-day, sir! said I, holding the door open for him.

The next day he called and paid me my week's rent.

He had his trunk by the handle dragging it along.

Are you moving? said I.

" Yes ; I am off."

I thought you wanted the room for a month.

" Well, I did ; but you know I have been terribly disappointed."

Indeed! said I. Perhaps you will have better success the next time you go fortune-hunting.

This is about the way one-third of the people of the coast propose and are accepted. This is the reason why their honeymoons end in a divorce. It is no trouble for a woman in any class of society to get married, especially if she is from the East.

She stands ten chances to one against a native Nevadan, for the most of them know nothing about work. Their parents give them a good education, fit them for teaching, and then dress them to make good matches. A good match with them means a man with money.

Now, this is a very foolish thing, for they may marry a

millionaire to-day, and in six months they will be the wife of a poor man. Ask them how it happened, and the answer will be, dealing in stocks, or gambling—as often one as the other.

The schools of Nevada are a grand success. They believe in a good education, and they employ good teachers; giving them good wages. They also have fine buildings and grounds. The Fourth Ward school-house is the finest school building in Virginia City. It is five or six stories high. It is built both of brick and wood. Its rooms are all large and airy, nicely ornamented with pictures and engravings, and pots of flowers decorate nearly every window. The house is kept in perfect order by the janitor. It is situated on C Street, nearly opposite my house.

Parents take a great deal of interest in visiting the schools. Their exhibitions and public examinations are very fine, and well conducted. Professor Flint, a New Yorker, presided over the High School of Virginia City for several years. He is one of the Board of Education at the present time, and is well liked by all. He is famous for getting up spelling classes, and giving premiums to the best spellers. The premiums are from $5 to $25. All who choose can join the class by giving 50 cents admission fee. Lawyers, doctors, and all the business men of the place generally join, but the scholars always win the prizes.

My friend's only son, a very fine young man, and highly educated, generally attends these spelling matches, and whenever he does, he always wins the prize. Her eldest daughter has also received a fine education, and is a highly educated young lady. Miss Ida, aged ten years, is her youngest, and a family pet, and I trust she will make as good a woman as her mother.

The wages of teachers are from $60 to $125 per month; but when I first went to Nevada, they were much higher than at the present day. In California they are still lower.

CHAPTER VI.

Finishing the House and Furnishing it—The Settlement with the Builders—
Lodging-House Trials—The New Law Firm—The Big Fire—Sale of a
Mine—Trouble of Getting My Pay.

THE reader will remember that somewhere in the first
of the last chapter I commenced building. I will now
show how we progressed and finished it.

Instead of its being finished in a month, as they agreed
to, they were three months building it, and it was not yet
done.

I got them to give up the contract, and finished it myself.

But they had finished off the store and all the upper part
of the house, save the lining and papering, which I did
myself.

As fast as I got a room papered, I furnished and rented
it, until the whole house was full.

Then I went down stairs, and did the same to the private
part of the house, and got it ready to move into myself, for
I was then living in my small house, which was moved on
the back part of my lot at the time they first commenced
working on the place to grade out for the house.

I was lying very sick with inflammation of the lungs. I
was quite low for several days, and was so nearly gone one
day that they called in the neighbors to see me die. I was
choking, gasping for breath. One ran against the other,
not knowing what to do. I could not speak. But Charlie
saw me looking towards the table. He looked to see what
it was I wanted A bottle of camphor and hartshorn lini-

ment stood there. His senses came to him at once, and he caught it up and emptied a third of its contents on my lungs, took his hand and rubbed it into my lungs, till I breathed as natural as ever.

I relate this little incident to let people who are attacked with this complaint know what to do. I had been using it all the time; but when I was taken so bad I had been asleep, and the girl went through the room, and left both doors open, and this left me in a draught, and I awoke up so bad I could not speak; but for my boy's quickness in reading my thoughts, I must have died. But I soon got better, and sat up.

They now told me they were ready to move the house; if I would go into one of the neighbors, they would move it.

In about three hours I did so, and in fifteen minutes a man came and told me they had commenced moving it, and found they could not, and they were setting the things on the sidewalk, or any place they could find to set them, and that the Piutes and Chinamen were packing them off.

My boy was off to school, and there was no other way but for me to go to work and take the things up to the top of Silver Street to B Street, and pack them in the house of a friend; and they were three days putting up the house again.

As soon as they got it up, I had to go and line and paper it before I could move into it. This took me two days more; and when I got settled, I found that many of my things had been carried off.

I lived here while they were building the new house, then I moved in, and rented the little one for $25 a month.

I rented the stores for good prices, and my house was full at good rents.

I had agreed to pay $125 a month on the house. When they gave up the house, the bill was over $3,000 and the bulkhead was not built, nor the sewer dug. I also had to

pay for all the water pipes being put in, and for the pipes on the outside of the house, which cost me an enormous sum. There was no brick chimney in it.

This was a way they had of building on the Comstock— a way I did not like. And after the big fire, I had two nice brick chimneys built from the ground to the top of the house, after my pipes had cost about $75, for I was constantly having them repaired. They never put them up substantially, and every wind blew them down.

I have two receipts in my possession now to show that I paid $25 at one time and $15 at another—both storms occurring in the same month—making $40 a month for pipes. I thought this a pretty heavy tax just for chimneys, when a brick one would only cost $60.

I had $125 to make out every month, besides these extra bills to pay. My paper and lining came to nearly $360, and then I had all the paint for the inside of the house to pay for. I hired a man to do some of the painting, and some of it my son did.

The most—or at least half—of my furniture I paid for in making ticks at "four bits" and "two bits" apiece. The top mattresses were "four bits," while the straw ticks were but "two bits."

Perhaps the reader would like to know how I managed to do it, for I had twenty-six beds to make up, and rooms to take care of, and all the washing and ironing to do. Well, I can tell you, it was pretty hard. I got up early. While many of my neighbors were sleeping, I was doing up the work of those roomers who had gone to work on the six o'clock shift. If it was Monday, I would pick up all of the dirty clothes together, then I would come down and get my breakfast, do up the dishes, and then sit down and make four or five ticks before dinner-time. After dinner I did up the rest of my work up stairs; then, as some of my roomers used to say, I would sit down and make

half a dozen more ticks, just to rest myself, and after sup-
per would make another half-dozen ticks, sheets, or pillow-
slips, just as it happened.

I took one day to washing and ironing. And this was no
small job, I assure you, for most of the roomers had to
have both sheets taken off the bed every week, and three
towels each week to every person.

There were repairs constantly to be made, but I managed
to keep up with the whole of it by working nearly every
night till twelve and one o'clock.

You may think I might have hired a girl. I will simply
say I could not afford to pay from $35 to $40 per month for
a girl when I had to pay $125 on my house, besides making
payments on other bills. It cost me something like $1,700
to furnish my house, and then I had always had another
bill of expense ever since I bought my place and kept
roomers.

I had boarded and lodged a girl or woman just for fear
of the public opinion, as I did not wish to be talked about
as many women were who kept lodgers for a living, who, I
really believe, were better than those who talked about
them.

Now, this was pretty hard on me. Board was $1 a day
without lodging, and they had to have a bed to themselves,
for I could not work hard all day and sleep with an old or
sick person. One of the parties who staid with me, more or
less, for four years was both old and sick.

The other party was a girl about my own age, but she
did not keep her room to suit me. So their room, as well
as their board, was a dead loss to me.

The old lady was naturally very smart, and when able to
do anything, went out to sewing. Her name was Garbit.

When not able to work, she staid at home, but always
wanted to do something. She was scrupulously neat, and
often helped me if I was sick; but at other times I would

not let her, as I did not think she was able. Sometimes she boarded herself. She did so most of the last year that she had a room by herself at my house. I liked her very much. But the girl, when she was there, hardly ever lifted her hand, but sat with her feet in the stove from morning till night—always in the way.

At one time I had four women rooming in the house, and thought I might get rid of her for a spell, as I had no place for her to sleep, unless I gave up my bed to her, and slept on a sofa, for she said she would not sleep there. Besides, she was always quarreling with the roomers if they came to the kitchen after water, and left the door open, and all the talking I could do would not change her course. So one day I told her I thought of marrying one of my roomers whom she was in the habit of scolding.

" Well," said she, " if that is so, I won't stay another day." And she packed up her things and went away, and got a place to work, thinking to spite me.

My friends had quite a laugh over this.

She was gone a year when, one day, she came in crying, and said she had no home to go to, and I happened to have an empty room. I told her she could stay, but she must not meddle with the roomers again.

She did not for a period of three months, after which she was as bad as ever.

One day I spoke to her, when she said : " I am not afraid of your turning me out. You can't fool me with another story about getting married, for I know you have no notion of it."

She was now determined to get rid of two of my lady roomers, one of whom had been in the house over two years, and had also roomed with me on A Street, and moved to C Street with me when I first bought—one of the kindest-hearted little women I ever met. She had always stood over me like a sister when sick. And now

this girl was determined to drive her out of the house. I told her she might pack her things and take them away on Monday. This was Sunday.

I said that I never stooped to quarrel, and I wouldn't have it in my house.

But Monday came, and she went off. I put her things on the porch, and locked the door. When she found it out, she came and took them away.

This was but two months before I came home. I had given her a home, at different times, for five years. But if I had it to do over again, I would board no person just for the speech of people.

My minister said to me one day, when I was telling him how hard it was to have to board and lodge one person for nothing, in order to keep from being talked about (for I always regarded my character as the apple of my eye): "Let them talk; they do not buy your bread and butter. Do what conscience tells you is right, and let them talk if they choose."

I have firmly made up my mind, if ever placed in similar circumstances again, to act on his advice, and would have done so before, perhaps, only I did not think it would be quite right to get her to stay when I had no other woman in the house, and then send her off as soon as I did have one.

And another great reason for not sending her off was because I had entered into a solemn compact with my Maker, that if I prospered in my business, I would never turn the needy from my door. I kept it very sacredly, unless this one act might be called breaking my vow.

I only mention this to show the reader the many ways I had for using money, for you see that to board one person a year was equal to giving $365 a year.

The first year I paid the parties that built the house $1,400.

Rents now went down, and times became so dull that men quit rooming and went to "cabining" themselves in every old cabin they could find. And roomers were so scarce that it was hard work to keep my house full. Yet I managed to make the payment every month.

About this time I received the sad news of my sister's poor health, and I determined to go home and see her. But in order to do this I would have to raise the money on a mortgage.

This I could not do, according to my contract, without first paying for my house in full.

I now went to an old friend, who belonged in the lodge with me. He advised me to go to the Virginia City Savings Bank and obtain a loan of money enough to pay them off and go home with.

I went and obtained a loan of $2,000, and when I came to pay them off, I found that, instead of owing them $1,600, Mr. French's partner had gone and taken out more insurance policies on the house, and forged my name in doing so, or got some person to do it for him. At any rate, my name was signed to them. I told him it was forgery, but he only laughed, until Mr. French told him he had burned his fingers, when he looked rather serious.

The insurance cost over $50, I believe; but I was so indignant that I canceled the papers at the insurance office, and got back $8.

He was so greedy that he had got ahead of himself; for if the house had burned, neither he nor I would have got anything, for he had taken out $500 more than the first policy. Now, this was against the rules of all insurance companies. If you take out more insurance, you are bound to let both companies know it, and he had failed to let my insurance agent know anything about it. After I had got this all straight, I found he had deeded my place away to a man from whom he had borrowed money. The deed had

not been recorded. I could not see the need of its being recorded as long as it was given up. But, to suit the bank people, I had to get the deed recorded, and then make him give me a deed, and have it recorded also, each deed costing me $3 to get it recorded, and $5 for the one I had made. After drawing up a mortgage and note, and paying $25 to have them recorded, and had finished settling up with them all, I had just $45 left.

Of course I could not go home on $45, so I inclosed $40 of it in a letter, and sent it to my dear sister, hoping it would reach its destination in time for her to know I had not forgotten her, although I had not the means to come to her, much as I knew she wanted to see me. Although separated from her so many years, my heart was ever with her and my dear affectionate parents, from whom I had been separated so long, hoping, wishing, praying I might soon meet them, especially my invalid sister and mother.

TO MY MOTHER.

In all this world I cannot find
One half so dear, or half so kind
As thou hast been to me ;
My dearest mother, I speak of thee.
And though in different climes I roam,
Far distant from my native home,
Thy kindness ne'er shall forgotten be,
Still, dearest mother, I'll think of thee.
Think who, when an infant, fed
And supported in her arms my tender head,
Imparted to me a parent's love,
And led my thoughts to God above.
Oh ! sweet mem'ries of childhood days,
Ye taught me of the lowly Jesus,
In gratitude my prayers to raise,
For the sins from which he saved us.
But now these days with thee are o'er,
Still to thy cares are added more.

For then no danger was I in
Of being led in the paths of sin.
I love you mother ; it is true;
How ardent is unknown to you.
My love, the same was blind to me,
Until your form I could no longer see;
But when thee, like time, shall wear away,
Shall thy lessons prove fruitless, say?
Not so ; ingratitude can never rest
Where true honor erects her throne within the breast.

These lines, written at the age of fifteen, while in Oberlin, Ohio, at school, were recalled to mind in my hours of trial and desolation.

I became more convinced than ever that a child can never truly appreciate a parent's love or the many responsibilities resting upon them, or even know the strength of their own love, until separated from them by land and sea.

I had made great calculation on visiting home and the dear ones, and had pictured the happy event of our reunion ; but now my cup of bliss was dashed aside. Despair took the place of hope, and I could not help sitting down and crying over my bitter disappointment.

I expected to have only $400 left. Of course I could have had Mr. French's partner arrested, but I was not able to pay a lawyer more than I could get back just for the sake of satisfaction; that would never do. And the guilty went unpunished. Besides, I did not wish to make Mr. French suffer for his partner's fault.

I now had the interest on the $2,000 to pay, the city and county taxes to pay, and a tax on the mortgage, besides other incidental expenses on the place; but the year of the big fire the taxes were very high.

That summer everything had been so dull that there seemed to be no money in town, and I saw some very hard times, and probably would have seen much harder had it not been for two very kind friends.

The Hon. C. C. Stevenson and E. W. Watkins, both of home, came to my aid, lending me large sums of money until such times as I could pay them. Both these gentlemen were strong temperance men, and belonged to the same lodge with me.

Brother Stevenson has done more for the temperance cause than any other man on the coast.

Mr. Watkins was also a very active member.

Although I received loans from these friends, it was still very hard for me to get along and meet all my expenses, for I had my house full of unpaying roomers, who expected to get work, and would then pay up. As they had always paid promptly, I hated to turn them off; so they remained, and I had the work to do, besides working hard every moment to run the sewing-machine to earn enough to live on, so that what little I did get in rents could go to pay debts.

I often worked so hard that I have fainted and fallen to the floor, or when I arose in the morning, would fall back on the bed in a fainting fit, and lie there until Charlie would find me and bring me to.

Charlie was in the telegraph office, but only got $30 a month.

This did not pay his expenses, for he was attending an evening writing school, which cost him $25 a term. He attended two terms, but the third term Mr. Dow, the teacher, offered him for nothing if he would come. He thought a great deal of him, and knew he did not have a fair chance with the rest of the scholars, for he was in the office so late before he could get away to school.

I think I saw the hardest time that summer of any while I was on the coast. Having so much money to pay out, and hardly any coming in, I did not know which way to turn, everybody wanting their pay, for they thought I was getting rich. If I could have convinced them I was not, I might not have been so hard pushed as I was.

But I would not complain to them, for I knew the opinion prevailed I was coining money, when, in fact, I almost needed the comforts, or rather the necessaries, of life.

Charlie used to call these times the "blue days." He declared we lived poorer than when we had no home of our own and lived in a rented house. He declared there was not a family in town that did not live better, whether they had a house or not.

Then I would tell him the darkest hour was always just before day.

In these dark hours I would go to my dear old stand-by friends, Mrs. Beck and Mrs. Rawson, and borrow money to meet any sum I had promised, to prevent being sued, for I did not like to have the name of being sued for debt. They always helped me out.

At one time I was sick in bed, and my interest money fell due. The rent of the store just paying it, the people in the store thought it a good time to strike for lower rent They came to me and said they would move unless I low ered the rent $5.

I did not know where I could get the money, and knew I must have it, so I told them I would let them have it.

When they brought me the receipt to sign, they had underlined it with these words: "And we shall have it three months for this price."

I was indignant at this, and refused to sign it at first.

It would have been well for me if I had never signed it, as the reader will see hereafter. I did not then see my way clear. And I thought I could stand $5, and let them have their own way.

The next week came the big fire, and there was hardly a business place left in town.

I was offered $300 a month for my store if I could get the parties out. I went and asked them to let me have it for three months, and I would give them a room to store

their furniture and their goods, and also a room in which
to live. I also told them they could have the use of the
store after this for two months. But they would not give
it up, but wanted to know who the parties were, that they
might rent it themselves. I told them they could not rent
it without my consent, and I was quite sure I would not.

My roomers all wanted to stay. They said they would
pay up, so I let them remain.

About this time the California Bank failed (if it could be
called a failure), and the Nevada Bank commenced calling
in its loans, and I, with the rest, was notified to pay $500 of
my indebtedness.

This was quite a sum to raise on a half day's notice, and,
as I did not like to ask any person to loan so large a sum
without security, I decided to give a new mortgage, and
take up the old one.

I went down to consult with Mrs. Beck about the busi-
ness, for we always confided our little troubles to each
other.

I asked her if she knew of any person from whom I could
borrow the money.

" Yes," said she, " I know a person who will let you have
it. He is the best man in town."

Who is it? I asked.

" My old friend, Tommy Frechill," said she.

If you think he will let me have it, send for him to come
here, for I will have to raise the money by ten o'clock to-
morrow.

She sent for him, and he came. She introduced me to
him.

I made my business known to him. He loaned me the
money—being $1,800 in gold coin. He took a mortgage
on my place for the amount.

I think I would have to try a little longer than two hours
to borrow as large a sum as that in the East.

The fact is, the people of the coast always know how much each other is worth by the records; and if a person applies to another for a large sum on security, he knows, without your telling, whether you have a good title, and if he has money to let, he can tell you in five minutes.

Mr. Freehill has ever since proved a kind and valued friend, and, as Mrs. Beck said, the best man in town—a man of good principle and integrity.

Three months before the fire I had seven rooms empty, but now I had a chance to rent them all at good prices. I got from $20 to $30 apiece for some time; but for some of my double rooms, with two beds in, I got only $12, because I would not do as many of the people did. I would not raise on my old roomers, which I ought to have done, for I did not get my pay from many of them, and it was a good chance to get rid of them.

So the big fire did not do me much good, only the filling up of the empty rooms. My house was packed full. I had to make up sixteen straw ticks, fill them, and put them on my garret floor to accommodate the homeless. Then I moved all of my single and three-quarter beds up there after three weeks, and bought new ones for the first floor.

My friend, Mrs. Rawson, was burned out. I offered her rooms, but she would not take them because I would not charge her for them. She lost everything she had, save a few things she had on. It was a big blow to them, for it will take years to replace what they lost.

My friend, Mrs. Beck, lost twenty houses, but still had eight left. Mr. Beck had two left, but lost the contents of three stores, furniture, bedding, and dishes. I think between them they must have lost $100,000, perhaps more. I think they, with many others, will long remember the twenty-sixth day of October, 1875.

The fire did not come within three blocks of my house, yet my friends and roomers kept constantly sending me

word to stay by my house, for there was no knowing how soon the fire might reach me, or it might be robbed by Chinamen or others, as it seemed to be the order of the day.

I was thus kept at home all day, when I might have been of use to my friends. I had two women boarding with me, but neither of them would stay. Both wanted to go out and view the fire, but they had no friends in the part of the town where the fire was. However, I was compelled to stay myself.

After the fire it was duller than ever, except carpenter work, and this was overdone, for nearly everybody built two and three stories high, till every house in town was a lodging-house.

Mrs. Beck had half of her twenty houses built in less than three months, and before the end of the year she had them all completed.

She only had a small insurance on three of her houses.

I will not dwell on this fire longer, for I never look back to those few months directly after the fire but my heart aches for those suffering poor people who suffered at that time.

The rich ones did well enough, for if they were burned out, they had the means to buy more, and did.

I will now write something about my own affairs.

Just before the big fire I met with the law firm of Brandsom & Stuart. They offered to take my business, and push it right along, for one-third of all they could hunt up outside of what I then had already found, except the Kentucky stock. They were to have one-third of that, too.

I went to Mr. Drake and asked him if he was willing to give up the case, as he seemed to be so busy.

He was perfectly willing to let them take it. I took my papers to them, and they immediately cited Mr. Waters before the court and questioned him, but did not make out

anything. They were still in hopes of getting something,
when my friend, Mr. French, came up from Silver City and
told me that a company from Silver City was taking out a
patent on the Atlantic claim. This was situated on my
mill-site, and I also owned one hundred and twenty feet in
the claim.

He said he happened to see the notice in the Silver City
paper, and thinking I did not take that paper, had come up
to let me know about it.

"You had better see to it at once, or you may be too
late," said he.

I went immediately to my lawyers, and told them to put
in a protest. Mr. Stuart said all I had to do was to jump
aboard of the afternoon train—for we had a railroad now
from Virginia City to Reno, although it was the most
crooked road ever made—and go down to Carson City,
and Judge Watts would make me a protest.

I thought Mr. Stuart ought to know what to do. So I
jumped aboard of the train and went down. I got there
about nine o'clock at night, the rain descending in a drizzling
shower. I went straight to the judge's office and told him
my business. He said: "I think you are too late; I will
see."

He looked at his books, and said: "No; you have got
till day after to-morrow at twelve o'clock; but you have
got to have several abstracts, and I think you had better
see a lawyer here in town, and find out what you do want.
I will go with you."

He took his umbrella and went to half a dozen places
with me, but every place was closed up. I began to think
we would not find one open. At last we found a lawyer
who was just going home. It was a rainy night, and they
had all shut up and gone home, but this one soon told me
what I must do. The judge told him to give me a list of
the papers I needed. He did so—two of which I was to

get in Dayton, one in Silver City, one at the recorder's office in Virginia City, and the other was a map to be drawn by a surveyor. He promised to meet me at Brown's office at one o'clock, but failed to do so.

After I completed my arrangements made with him I went to the hotel, got supper, and then went to bed, after telling the landlord to call me for the first train. This started at half-past three o'clock. At the appointed time I took the train, and arrived in Gold Hill at six o'clock sharp. It was scarcely daylight, and not hardly a person to be seen.

I intended to take an early stage to Dayton, but found there would be none till ten o'clock. I could not wait for that, because I had too much to do and too much at stake. I had to search the records in both Dayton and Silver City. There was but one way for me to reach Dayton, and that was to foot it.

And I started on my pedestrian trip without breakfast, for it was too early to get any.

The distance from Dayton to Gold Hill is eight miles, if I have not been misinformed. I walked the entire distance in one hour and a half, making a mile in eleven minutes and two seconds. I thought this pretty fast time for a new beginner. I knew if I lost half an hour I would be too late.

I found the recorder I wanted, and the recorder promised to copy them and send them to Carson City by ten o'clock the next day, if he had to hire an extra; and he kept his word.

I left Dayton by nine o'clock for Silver City. Here I came near having a failure, for the recorder was sick in bed; but when he heard it was a lady who wanted to see him, he requested me to come in, and directed his clerk to bring his books to him. He told him on what page to look and find the papers I wanted. He did find them, and I got an abstract of them. It was the names of the locators of the claim.

I then went up to Gold Hill, in hopes of getting the 'buss for Virginia City, but was a little too late for it. I was so tired I could not go on till I had rested myself.

I went into some of the stores and looked over some of their goods, just to pass away time, hoping a 'buss might pass. But no such good luck. I waited half an hour, but none came.

I then started out, but met an old friend, who wanted me to help her select some goods. She said she had come down from Virginia City to trade, because she could do so much better here.

I told her I had not time.

"Oh! I will not be ten minutes," said she.

Well, I will wait ten minutes.

The ten minutes amounted to half an hour before I was aware of it.

I now told her I must go.

The 'buss had not yet come. I walked on till I reached home, very tired, and nearly starved. I went in and got something to eat, then went to the recorder's office and got the papers I needed. I then went to Mr. Brown's office to get my map, and found the lawyer had not waited for me, but had gone back to Carson City.

I also learned he was employed on the other side, and had agreed to meet me just to gain time over me; but it did him no good, for I was on time with my papers to head him off.

I now went to my lawyer and told him what I had done, and that he must go to Carson City that afternoon, for I only had till twelve o'clock the next day.

"Well," said he, "I will be ready to take the five o'clock train."

We went down to the depot, and found there was no train going before morning. We now went home, agreeing to start early in the morning. We took the morning train,

and reached Carson City at half-past nine o'clock. We had some distance to go before we reached the office, and it wanted fifteen minutes of ten. We had barely got seated, when in came a man from Dayton with the papers the recorder had sent. He was about ten minutes ahead of time.

I now put in my protest. I then came home on the one o'clock train. I was now so completely tired out that I laid in bed a whole day to get rested.

This put a stop to the company's getting a patent. They now came and offered to settle with me.

My claim on the mine came to nearly four thousand shares of the stock, and they agreed if I would take it, to pay all the expenses I had been to for the protest. They paid $100 down, and gave me their notes for the stock.

One of the company wanted me to let him have it for $3 a share, in thirty days. He wanted my word he should have it, and I gave it; but when the thirty days were up, they neither brought the money nor stock.

I wrote several letters, and then they came up and wanted me to give them more time.

I gave them thirty days more, then I told them they must settle.

The president of the company gave new notes, and backed them himself, and when the time was up, he sent his son to get me to wait till he came up. His son said he was on the way, and would be there by six o'clock and pay me if I would not protest the notes. But they had already deceived me too much for me to be cheated again, for I was sure he was not coming at all; but I thought he wanted me to let the time slip by for protesting, which was in banking hours. It was nearly three o'clock, and the bank closed at four, so I told him I would meet him at Bronson's office at five o'clock, and see if his father had come.

As soon as I got rid of him, I went straight to a notary and got my notes protested, and when I met him at five o'clock, he said his father had not come, and he did not know what to make of it.

Well, it does not make any difference as long as the notes are protested, said I.

He whirled around as if stung by a bee, and said: " Protested! Did you protest the notes?"

Certainly I did; you know it is best to be on the safe side.

He was so surprised and disappointed that he scarcely knew what to do, but finally stammered out: " Well, there was no need of that; father will pay it if the company will not."

Well, if he does, there is no harm done.

"Yes, but it looks bad to have a note protested," said he.

Well, said I, it looks worse for me to lose all my interest in the mine without getting any pay ; and if the company are afraid of their name, they should be more careful of their word—and it is a larger sum than I can afford to lose.

After the notes were protested, I could not get a settlement with them for nearly eleven months. He sent me $40 for interest, then would not do anything more.

They finally got in debt, and I was afraid they would break, for they were all heavy in stocks, so Mr. Aitkens told me. He had lost his meat market by a fire, so I got rather frightened. My lawyers had managed to get part of their pay, and they wanted the rest.

I had given them one-third of the amount for which I sold in the notes I had received, and they had taken less than the face of the notes to get their money, therefore I began to think they took but little interest in the affair. Besides, I heard my parents were failing in health, and determined to sacrifice something on the notes before I would stay from them any longer.

I settled up with them at a great sacrifice, and finally got rid of the Atlantic Company—as big a set of rogues, in my opinion, as ever walked the streets of San Francisco, of which Charles H. Aitkens was chief. I would not take his word under oath, not even if he had no interest in the case.

I write this from experience, and from personal experience I judge them.

If anyone doubts it, let them try a deal with them, and if they do not cheat you, it will be because you are too smart for them.

I will copy some of their letters here:

SAN FRANCISCO, August 19, 1877.

MY DEAR MADAM:

I am sorry that I have to ask you to grant us further time, so as not to put the company to useless expense in commencing suit, for I think in a very short time we shall have two or three men that have promised to take hold of the mine and work it, they say, within the next sixty days. Now I thought that I would have been able to assist you with some money, but I have had the misfortune to get burned out, and lost nearly everything I had. The company ow s me over $4,000 now, but I want to see you paid before I expect any money for myself. Now, if we don't succeed with these parties, I shall try and borrow money on the whole mine and get you paid. It will not help you to get your money any sooner to commence suit, as the company has no money at present, and you would only hurt their prospect for getting the money by your suing. I shall do all I can in the next thirty days to raise you the money, and I think that I will be successful; and if I am, you will get your money the first that is paid; so, for you to be in a hurry now, it will do no good, and only injure your prospects and views. But if you will give us a little more time, you will get your money all right. You ought

to do so, for had it not been for me you would not have
had anything but your stock, and that is not worth much
at present. But if we are let alone for a little longer, we
will come out all right, and you will get your money. Write
and let me know if you will grant us the time, and oblige

<div align="center">Your friend,</div>

<div align="right">CHARLES H. AITKENS.</div>

208 Ellis Street, San Francisco.

<div align="right">SAN FRANCISCO, October 22, 1877.</div>

MRS. MATHEWS:

I received your answer by letter from your son. Now it
is no use for me to say that I can ever pay you the amount
of your notes that you claim. The mine is not worth it.
And there are so many claims against it that I cannot pay
them. My claim against the company I have assigned over
to my creditors, as I owe a great deal of money here, and
don't see my way clear at present. The balance of the cred-
itors in the mine are willing to take fifty cents on the dol-
lar cash, so if you are willing to take $1,000 in gold coin
for your claim against the mine, let me know by telegraph,
and you can have the money within one week; but if that
won't do, you can do what you think best. I shall have to
borrow that amount, but shall do so if you will accept of
that proposition, and shall bring you the money before the
month is out, or by this day week. It is the best that I can
do; so let me know by telegraph if you will take that offer.

<div align="center">Respectfully yours,</div>

<div align="right">CHARLES H. AITKENS.</div>

P. S. You can make what you can of the mill-site after
the company starts up again, if they do; but they will
never start again unless they can settle the amounts stand-
ing against them in the way, and your mill-site will be of
no use to you. There is about $3,000 of wages due the
men in the mine, and that is about as much as the mine is

worth, and that will have to be paid first. So you see there is no chance then for you to get any money there, and I am sorry to say that I have not got the means to pay you; so do as you please; but I would advise you to take what the company offer you, as it is not my money but the company's, and that is the only way that they will settle. So answer by telegraph what you will do.

<div align="right">C. H. AITKENS.</div>

I have a note of agreement in my possession, given by Mr. Aitkens, to be paid in a hundred shares of Atlantic stock, to be delivered in six months.

As soon as we settled, he told me he would not pay it. I went to San Francisco to see him, but he refused to pay it. I called on the company, and they told me they had sent me the full amount of my notes, and they could not help it if I had settled for less.

Now, when he came to Virginia City he told me the company were so badly in debt that they could not nor would not pay me but so much; but they did, all the same, for I would not settle at their price. I did not get much over half what my notes called for in money, and three hundred shares of stock. The one hundred shares he owed me on a former settlement.

I also made him give me his word and honor that the stock which he gave me when we settled up should not be assessed, and I in return had promised to keep it out of the market till they were done pooling it.

Before I reached San Francisco the stock was assessed 25 cents on each share. This would take about $75 to pay it, or about twenty-five shares of stock.

I was then ready to leave for the East, and did not want to bother. I gave the stock to Mr. Drake for his kindness in writing up my administration papers.

Before six months the stock sold for $3 per share; and if he did not sell it, it is his own fault, not mine. If they

took part of the stock for assessment, they could not take the whole.

This one instance will show the reader there was no reliance in his (Aitken's) word.

But mark me, the mine will never do them any good—at least the part they cheated me out of—for God will mete it out to them as they mete it out to others. I am content to leave them in His hands.

Before I have done with them, let me tell the reader how Mr. Aitkens tried to deceive me with the spiritual humbuggery of his wife.

He told me his wife was really a wonderful woman; could tell me anything I wanted to know.

I told him I would like to see her, although I took no stock in spirits.

He said : "I will go right down and bring her up."

He did so. I took them into a private room. As soon as I had closed the door, he said : "Now ask her any question you want to know, and she will tell you."

"Wait," said his wife, "till I get fixed all right and go into a trance, for I am a clairvoyant, not a spiritualist."

She then sat down in a chair, and truly, I could hardly keep from laughing in her face. She commenced rubbing her hands, and passing them several times over her face. Next, she commenced shaking her head to and fro, and from side to side, winking her eyes, and jerking her hands and feet, till I really imagined I was in a school-room, where the children were playing "Queen Dido's dead."

Lest some of my readers may not know how this little game is played, I will give them an insight.

The children all sit on a bench. The first one says, "Queen Dido is dead." The second one then says, "How did she die?" "Doing just so," says the first, shaking her head. The question is repeated and answered till the head,

feet, and hands are in motion. And the whole crowd resembles so many jumping-jacks.

Well, now, the clairvoyant scene I am about to describe was as near like this as two pears are alike; for I often caught her husband imitating her without seeming to know what he was doing. His head and hands went about as fast as hers.

Her neck began to twist and turn in every shape, like a person in a fit of hysteria, or perhaps like a chicken swallowing dough.

Finally, she called out, "ready!" and settled back in her chair very quietly.

Her husband said: "Now she is ready; ask her anything you like. Oh, she will surprise you!"

And I was very much surprised, for the first question I asked her was, if she could see my brother.

She said: "He is here, going to talk with you; now listen!"

She said: "Go home; don't worry about me; I am not worth minding. I am all eat up here," at the same time placing her hands on her stomach. " I killed myself drinking; I was of no account; I did not have anything; and you will never get a cent; you had better go home right off; don't bother any more. That is all I have to say."

And immediately she passed her hands over her face, and opened her eyes.

"There," said he, "didn't I tell you she was wonderful! Don't you see how true she told everything?"

No, sir, said I; she has not told me a single word that is true; she will have to guess again. On the other side of the wall I heard a suppressed giggle.

"Why, she told you your brother killed himself drinking, and that is true, isn't it?"

No, sir, said I; not a drop of any kind of spirits ever passed his lips (that smothered laugh again).

He seemed surprised, and turning to his wife, said : "I thought Mr. and Mrs. Waters both told us he drank himself to death."

"So they did; I am quite sure," said she.

Now, reader, they had previously told me that they knew these parties only by sight, and now, in their eagerness, they had acknowledged that they were simply repeating what they had told them, but by some blunder they had got the story wrong.

I was thoroughly disgusted, and when they offered to have her go into another trance and see what else she could see, she said: "Perhaps it was another person that came to speak instead of your brother."

I told them No; I had enough for one day.

They then took their leave. I have never seen her since, nor do I wish to.

I suppose he had no intention of paying me, and that is why he had the spirit advise me to go home.

I give him credit for the ingenuity of his spirit plot, if he only had sense to have carried it on without bringing himself out. It was a great pity to spoil all her fine acting by one blunder. It was a real shame.

A laugh came from a roomer in the next room, who had listened to the spirit revelation, and found it very amusing, as he afterwards told me.

CHAPTER VII.

Description of Virginia City and its Inhabitants—The Secret Societies—Water
Company—Gambling—The Centennial Fourth.

I WILL now give the reader a description of Virginia
City. It is situated on the east side of Mt. Davidson,
and also at its base, taking in the whole ravine or flat be-
tween it and Sugar Loaf Mountain, Cemetery Hill, and
County House Slope.

Cemetery Hill is a rise of ground north-west of Sugar
Loaf, and north-east of Virginia City.

County House Slope is another hill directly east of Vir-
ginia City, and south of Sugar Loaf. Sugar Loaf is also
east of Virginia City. It takes its name from its resem-
blance to a loaf of sugar.

The streets of Virginia City are graded out of the side
of the mountain. The cross streets are very steep. It is in
the form of a basin on three sides, sloping from north-west,
and south from the mountains that surround, and the rise
of ground at the north and south ends.

The north end is called the Gygar Grade; the south end
the Divide, being a hill which separates it from Gold Hill.

Virginia City was first laid out in alphabetical order, com-
mencing with A, B, C, and so on. After it was laid out a
few years, people began to build higher up the side of the
mountain.

The first street above A Street is called Howard Street;
the second, Stuart; the third, Summit. I suppose they
thought they had got as high up as they thought they

could stand it to live. But there are now several streets higher up, the names of which I do not know.

The cross streets are as follows: Bridge Street, Bullion Ravine Street, High School Crossing, Silver, Flowery, Smith, Taylor, Union, Carson, Sutton Avenue, Mill Street, Andes Avenue, Nevada Street, Gygar Grade, and a host of other cross streets, whose names, if they have any, I do not know, as I never lived in that part of the city.

Nearly every house, on some streets, is two stories high from necessity. One story faces the street, while the two stories of the same building face the center of the block. Or, take a building running from B to C Street, you will find one story on B and two on C Street. A house three stories on B Street is four stories on C Street, one story being half under ground on B, and lit by heavy glass lights in the sidewalk. Yet there are many places where houses are free, on all sides, from banks.

The eastern portion of the city is more level.

The Chinamen have the most level part of the city above I Street. This part of the city is called Chinatown, for here is where they first settled in the city. Here is where they have their stores and opium dens.

Virginia City had some fine buildings before the fire, nearly one-third of them brick, but the fire took both brick and wood. The ruins of the brick buildings were fearful to behold after the fire. Three and four-story buildings stood swaying backwards and forwards in the heavy gales of wind. Every day would find some of them tumbling down.

But the city is now built up with much finer buildings than it had before the fire, for the handsomest part of the town was not destroyed, or a portion of it. They have many nice buildings now.

The court-house on B Street is an elegant building; also the Miners' Union, and Pioneer Hall.

Bonanza Hill, situated on South B Street, has some lovely buildings.

All the best livery stables are kept on B Street.

C Street has all the banks and telegraph offices. The Masonic and Odd Fellows' halls, Wells & Fargo's Express office, books and stationery stores, dry-goods, grocery, and provision stores, are all mostly on C Street, as well as nearly all the drug stores, gambling dens, and whisky mills; and of the two last mentioned, there is no end to them. It always seemed to me that every fourth door was a saloon of either one or the other kind. All of the most popular restaurants are on this street; also National Guard Hall. It is the main street in the city, and the business part of the town.

D Street was the condemned part of the city, being a street that no decent person lived on, at least but few north of Taylor Street. The south end is all occupied by respectable people.

There is no end to physicians, druggists, dentists, and lawyers, and they are scattered promiscuously over the city.

The International Hotel is an elegant brick building, extending from C Street to B Street. It is, I believe, six stories high. It is nicely furnished, and well conducted.

There are a great many meat markets scattered over the city, but C Street has the largest number, having some fifteen or twenty as fine markets as there are found in the United States. They take great pains in fixing them up in a very tasty and ornamental style on all holidays. It would do you good to drop in any of them, and see the nice fat meats of every kind used, trimmed off with roses and artificial flowers, cut out of tissue paper, with their great display of elks and bears' heads. I think it quite as much of a sight as anything in the city on those days.

I do not mean to say that there are none of the places I have mentioned to be found in any other street but C

Street, but only a larger portion of each kind is found there than on any other one street. It is much larger than any other street.

Virginia City was built up, after the big fire, in a very short time. The people of the Comstock are no drones. The fire started at six o'clock in the morning and everything burned north of Taylor Street before three o'clock. Several of the inhabitants had the frames of buildings put up the same day.

After a small fire I have often seen workmen putting up buildings over the still smoking ruins. This was quite a common occurrence.

I have been told that the top of Mt. Davidson is three miles above the lowest street of Virginia City. Not having measured it, I cannot vouch for the statement. The people always keep a flag erected on its highest pinnacle. When I first went to Virginia City they had a wooden pole for a flag-staff, and many of the inhabitants had their names cut on the staff. They now have a fine iron staff erected at great expense to the city.

I visited Mt. Davidson three times while in Virginia City—twice in summer, and the last time in winter. Mrs. Burkhaiter, of Dutch Flat, was visiting Virginia City, and having never visited the mountain, was desirous of doing so before she returned. It was in winter. The snow laid thick on the mountain. The crust was so thick we could walk on the top. We took a lunch, and when half way up the hill, had to stop and eat we were so exhausted, although we did not go up the steepest side, but went up the ravine above Taylor Street, and passed around to the west side before we began to climb to the top.

On the west side is a number of shafts, which were sunk some years ago by a man who, report says, was crazy, and sunk a fortune in sinking these shafts in search of gold. In the summer any person going up can see these places and

avoid them, but in winter the snow nearly covers them, so that a person going up as we did would think them little hollows in the ground. We were climbing along up, when I commenced sinking in the snow. In an instant I knew where I was, and cried out, I am sinking! I was in the snow to my waist, when my friend caught me and jerked me backwards, and dragged me out so I could help myself, and after that we were more careful. We did not attempt to cross another hollow.

We finally reached the top, finished our lunch, wrote our names on the staff, and then descended the eastern side of the mountain. This is the steepest side. We took our way home. I could never be persuaded to go again.

Companies often meet up there and have picnics, and enjoy them very much.

In going up the mountain you can hardly breathe after you have gone half the distance, the atmosphere being so light. There is such an acute pain passes through your ear that it seems as if a heavy weight was pressing both sides of your head at once. By taking water with you and drinking it frequently, you will travel with more ease.

One could view the entire city with a glass, but to the naked eye everything was very small, people looking no larger than mere children. Some small ones would be scarcely visible. But with a field-glass you could have a lovely view of the whole city.

The streets of Virginia City, Gold Hill, Silver City, and Dayton, and, in fact, every mining town, are literally paved with gold and silver dust.

I have heard many old miners say they had no doubt anyone might make a good living by working the dust in the streets the same as they did the tailings from the mills, and I do not doubt it myself. You can pick up good pieces of quartz from the dirt hauled on the streets to fill up mud holes with. Good specimens are found every day.

The Spaniards go about with sacks, picking up speci-
mens from the streets or dumps or mountain-sides—any-
where they can find them. Then they have hand-mills to
crush them with.

Yes, reader, every step you take there is on gold and
silver.

Most of the mining machinery, mills, and hoisting works
are on and below D Street. Many of the old works were
on B Street when I first went there, but these have all been
taken away, and new ones erected below D Street.

Many of the old shafts remain uncovered or unprotected
by rail or fence. Every little while a skeleton is found in
some of them.

The city ought to look after this as much as any other
nuisance, and make each company secure its own shafts,
but they never seem to give it a thought.

Sometimes the ground caves in where some mine has
not kept its shafts and tunnels in good condition; and
where they come too near the surface it often breaks
through.

I was talking with a lady in her house, and heard ham-
mering going on under her house. I asked her where it was.

She said : "They are putting in new timbers in the mines
down under the house."

You could hear them as plainly as if they were in the yard.

One large two-story store went down on the Chollar
ground the year before I went to Virginia City. Fort-
unately, no one was in it at the time, as it was in the night.
Everything took fire, and was destroyed. I was told that
the smoke came up out of the pit for days. It was both a
dry goods and grocery store. It was completely swallowed
up, not even the chimney being visible. It left the man
who owned it quite poor.

I know several places where the ground is cracking open
beneath houses.

You Eastern people would hardly fancy this, but Nevadans do not mind it.

I will now give the reader an introduction to the inhabitants of Virginia City. They are the same as all other mining towns, composed of all classes, and they are of every nationality under the sun. Americans, Scotch, Irish, English, French, Germans from every German State in the Old World; Spanish, Mexicans, Norwegians, Italians, Piute Indians, and John Chinaman—he being the worst of all, and is truly the curse of the Pacific Coast. But of him I will speak hereafter.

The miners are principally Irish and English from Cornwall; but there are some of all nations in the mines.

The Germans and Jews generally take the lead in dry goods and second-hand furniture stores. The Irish and Americans lead in the grocery stores, and Americans and Irish are generally the bankers and brokers.

The Germans and Irish are decidedly the richest people; the English the poorest.

Yet I often wonder at it, for there are so many Cornish miners here, and hard-working men; but drinking and gambling are the cause of two-thirds of the suffering in Virginia City.

The Americans there are neither one thing nor the other, but enter into everything there is going. They are great speculators, and often go through with all they have in one mining excitement. They do not get disheartened, but go to work again.

I think the English and all foreigners get discouraged sooner than the Americans do. They are too restless to mope around over a loss. I do not think there are as many to be found among the Americans who go insane over their losses as there are among the foreign class. Most of the English, French, and Irish generally do as the Chinamen do. When they get rich they start for the old country to

spend their money, and this is one of the greatest causes of
hard times in America. The money should be spent where
it is made.

The people of all nations in California and Nevada live
about ten years faster than the people of the States do.
They live very high, eating the richest and best food in the
market, at all hours of both day and night, both in season
and out of season.

Two-thirds of the inhabitants of the city board at res-
taurants, many of them with whole families of children,
three and four in number. The male portion of a family
generally get up and go to the restaurant, eat their break-
fast, and go to work at six and seven o'clock; and the
miners especially. At ten and eleven o'clock you will see
the ladies go stringing into the restaurants with their chil-
dren.

Men sometimes get a chance to eat two meals a day with
their families; but if they do, they are in big luck, for a
lady who eats her breakfast at ten and eleven o'clock, as
many of them do, can scarcely start in on a Virginia City
restaurant dinner before one or two o'clock; then she does
not want to eat again till seven or eight o'clock in the even-
ing, and miners and business men want to eat their meals
when they come from work.

How would you Eastern ladies like taking children out
in cold, stormy weather, or else carry a plate of food home
to them, and have it cold when you reach home with it.
This is a common occurrence; and if persons boarding
are taken sick, their meals are sent to them. Even those
families that do board themselves, when they want a square
meal, as they call it, go out and get it; and nearly
everybody goes out on Sunday and the holidays to one meal.

Board at a high-toned, or, in other words, at the first-
class restaurants is $1 a day, or "four bits" a meal; but
you will get everything that the market affords, and the

market of Virginia City affords everything that grows which is fit to eat, and a thousand and one things which are not fit to eat—thinks that I do not think were ever intended to pass human lips, and have only been brought into the food-list by epicures who could not get different dishes enough to suit their perverted tastes. I never saw people like them, as a class; they wanted so many kinds of rich dishes to eat at one meal. They are not only epicures, but gormandizers.

Every restaurant table groans with food of every kind gathered from every kingdom on the globe. From eight to twelve different kinds of vegetables, and nearly as many kinds of meat, are on the table three times a day. Cakes, and every kind of pastry and puddings, you will find; there are also fruits from every country and clime.

There is just one trouble—that is, their filthy China cooks; but many of the best restaurants fortunately have abandoned China cooks, and employed good respectable white people in their place.

The expensive tables which they set is the secret of so many restaurants breaking up, for many of them have debts amounting to $300 and $400 a month; they will lose on the same men they have been feeding so high.

There is scarcely a month but from one to three restaurants break up, and are sold out at auction on an attachment, and a new restaurant is started in its place, only to soon meet a similar fate.

Within the last two years there have been three or four "two-bit" restaurants started in Virginia City. They are on a different plan. You only get two different kinds of meat, and two kinds of vegetables; pie or pudding, and tea or coffee—a sort of lunch, not a square meal.

You always get the best kinds of fruits, candies, raisins, nuts, and wines, on Sundays and all holidays, in all the best restaurants and boarding-houses.

They take from a half to an hour and a half time eating.
Everybody works on time there, and when his time is up,
you will see every man dressed in his best, promenading
the streets, looking at the stock-boards which are hung in
every broker's window, bank window, express office, and
many saloons and groceries; and around every one of these
men and women are gathered as thick as bees on clover.
And about half-past seven and eight o'clock you will see
every lady going to the theater, or to some hall to hear a
lecture, or lodge of some of the many different orders of
which Virginia City can boast.

The people of all nationalities are about the same in prin-
ciple and disposition. I never was in a community where
people were more hasty either in word or deed. It is said
the climate is the cause of that. If they have anything to
say, you generally hear it right to your face. No matter if
it is good or bad, whichever party it does not suit draws a
six-shooter or knife, whatever happens to be in his posses-
sion, and goes for his opponent, and if he is not a dead man
in five minutes, it is simply because his position does not
allow him to get a good aim.

If you ask a favor, they either grant it, or tell you at once
they can't or won't.

In California and Nevada men and women are very gen-
erous; they will divide their last potato with you, or give
their last " bit " to a charitable cause; and not many even
stop to inquire whether it is for charity or not. Some even
go so far that if they see a man or woman coming towards
them with a subscription list, their hand goes into their
pocket like magic, and out again full of coin, and by the
time you have reached them, what money they can spare is
counted out and handed to you.

I never saw such liberal people. I think the working-
class is the best to go to for subscriptions of small amounts,
or for benefits and tickets. There is not one day in the

year, unless it is the Sabbath, that you do not see men, women, and children selling tickets. There are generally from ten to twelve different tickets on the streets at the same time for sale; and frequently you meet three or four gathered around one man with different tickets. If he takes from one he must take from all, or he can go no further until he does.

The miners say that they have to shell out $6 or $7 a month for tickets; and then if a person is killed in a mine, they all have to pay $1 to the subscription list for the widow; or if he is single and poor, to bury him decently, providing he is not a member of a lodge. Many of them give more than $1.

I have been told by my roomers that it was seen in the papers that such a mine gave $200, $400, or $600, meaning the big stockholders, when the mine never gave a cent, but just kept $1 out of every man's wages, and be obliged to put up with it or be discharged.

Now, is it any wonder, when a miner is so severely taxed as this, that he cannot pay his board and room rent, especially if he happens to be a drinking man or gambler, as many of them are? His landlady stands no show at all. He calls these debts of honor; but a debt for provisions, house rent, or board is not a debt of honor, and is of little concern to him whether it is paid or not.

I said the people were generous, and would give their last dime, and take their chances in getting another. If, by a turn in stock, or other marvelous turn in fortune, you should win $10,000 in a day, and the same person who had given you his last dime could cheat you out of it by any kind of a bargain, or by gambling, brokerage, or any other way, he is sure to do it, and never so much as say "Thank you."

A great many people never think of paying a debt unless compelled to do so. I have over $700 of bad debts on my books now.

Another thing many of the people do. If they hire a house, they are bound to get the worth of their money, for they will take no care of the house or premises. Others, when they leave, will tear down partitions, tear off baseboards, take out windows and doors, and carry them off. Some will tear down any part they can and carry it off.

A Jew rented my store of me for $60 a month. The contract called for gold coin. When he came to pay me the first month's rent he had $5 in silver, and induced me to take it by paying the discount. Next month he had $10, and the next month $15 ; but the month following he had $25, and was not willing to give any discount. He was in my store when I left. I had been gone but a few months when he told my agent to lower his rent to $50 or he would leave.

When the year was up, my agent notified me of the fact. I returned the word, " Let him leave."

When he left he took down partitions in two places; he also tore away two doors—one he put in himself, and one that had been in ever since the house was built. He was to leave all the improvements in the house just as he found them. He did neither, but took everything he could tear loose from the house.

When I went back the house was a perfect wreck inside, and a more filthy den I never entered. I cleaned nearly a whole week on the house in order to get it so a white person could live in it. I caused several loads of oyster-cans, old rags, and feathers to be hauled away. It cost me considerable to repair and paper it anew.

Now I could have handled this Jew pretty severely with the law, but I had no time. I had only made a flying trip there, and was in a hurry to return. So I went to his store, my friend, Mrs. Beck, accompanying me. I told him I wanted him to settle with me for the damages. He ordered me out of his store, using the most obscene language

to me. His wife joined in, and used as indecent language as he did. I was thoroughly disgusted, and left their store, being glad to get rid of their tongues.

They escaped justice because my time was too precious to waste on them.

Dealing in stock is a species of gambling, unless you thoroughly understand the business. If you go on mere hearsay or guess-work, or by your broker, it is ten chances to one if you do not lose all you invest, and perhaps more. People generally deal after this fashion: They visit a broker's office, and ask what is the best to buy. Often the broker declines to give his opinion, and sometimes he tells you for your good, and sometimes for his own. When for your good, you make every time; when for his, you lose. If he advises you to double up on your stock, you are pretty sure to lose, for stocks go up and down so fast that you can hardly keep up with them. To double up on stocks is to "pond" what you have paid for, and get more on credit; if stocks go down, your margins go down, too. Your broker then calls for more "mud," which means money. I do not know from whence this word started. If you cannot put up more money, he sells you out, and you are left without a cent—sometimes hundreds and even thousands of dollars in debt.

These are the cases that try men and women's good sense, for if fortune has not given them a pretty good supply of sense, those who have lost all are pretty sure to take a drink of laudanum, or end their lives with a revolver, or, what is still worse, go insane, and are packed off to Stockton, in California. They have no insane asylum in Nevada at the present time.

Perhaps it is the broker's fault, perhaps your own. It is as apt to be one as the other, for there are some brokers who have no conscience, although you will see them in church every Sabbath. I have met some four or five of

this class, and but for them I should have had thousands of dollars that I have lost through their dishonesty.

Then I have met others who were truly honest. When a person has failed through his broker, and blows out his brains, the broker is sure to say: " Poor, foolish man; he did not know how to deal in stocks, and yet he would not let them alone!" And if a charitable person goes in with a subscription to raise money for his widow and orphans, he gives very willingly and liberally, too—all the way from $1 to $25.

No one blames him for robbing the man, but all praise his liberality. Such men as these give very liberally in churches when they are trying to raise money to pay off debts of the church. They are called good, liberal people; and so they are, as far as giving is concerned.

I speak from experience, for no person in Virginia City ever went out with more subscription papers than I have unless it was my friend, Mrs. Beck. I think I learned it of her.

I never saw her equal (and do not believe she has any on earth) for hunting up the suffering and sick, and alleviating their wants. Many are the times she has sent me word to come and spend the evening with her, and when I got there she would have a basket and bundle so large she was ashamed to carry them through the streets by daylight, and so sent for me to go with her, after dark, to some out-of-the-way place, perhaps a good mile off, to a destitute family.

Well, I never refused to go with her, no matter how tired I was, for I knew she was equally as tired. She did more work in a day than any other three women in the place, after leaving out two.

Some called me her shadow, others said she was my "right bower;" but I think she was the "queen of hearts." I never saw a lady who had a bigger heart, or one more capable of feeling for the poor.

She has often had such large bundles of clothes over which she has spent her time to make for children, that we had to put them into a large clothes-basket, and carry it between us. Many such a load we have carried after ten and eleven o'clock at night, so that we would not meet so many people.

Sometimes we have found people way up on the mountain-side nearly frozen, their houses being nearly snowed under in some of our sudden storms, and nothing in their house to eat.

I remember on one Sunday morning we found three families in this condition on the mountain-side, and we could get nothing from the relief committee that day, so she went to her private store-house, and filled three large baskets, and a man from one of the houses came for one, and she and I took the other two and went and relieved their present wants.

The next day we called on the treasurer of the relief committee, and laid the case before him. He turned to Mrs. Beck, and said: "You just go around and hunt up poor folks on purpose, and there is no need of it. We are nearly out of funds."

She told him she could not help that, he must give her $20 for each family. He did so, and we got the merchant from whom we bought the goods to take up the load. We went along to see that each family got the right things. We received $5 of the order in money, and bought some shoes and stockings and flannels for the children.

On some of the coldest days we have ever had there she has had me out, for these were the days she always took. She said they were the days they would be most apt to suffer.

I think she gave from $600 to $700 every year, for benevolent purposes, from her own pocket, besides as much more that she collected. Then there was the time she gave

to running around and hunting up these cases. She would sit up many nights till twelve o'clock making over clothes for children, for she said if she gave the garments to the people as they were, it was ten to one if they ever made them over. She used to say that half of the women had not sense enough to make over any garment, and it was no use to give it unless it was made over and mended.

I think she spent one-half of her time in the interest of the poor.

At the time of the big fire a widow was burned out near Mrs. Beck's. Mrs. Beck and another lady went around and collected money to buy lumber to build her a house. They got the principal part, as far as the money would go, then she made up the balance from her own lumber pile. She then wanted nails and spikes, and they went around again. They came to my house to see what I would give. I had a lot of nails left from my house. I gave her these, and she took them right along, and said they were as good as money, and she carried about ten pounds of nails over half a mile to the woman. She got a man to put up the house and finish it; and afterwards the woman showed her gratitude by trying to cheat her out of several feet of ground.

It often seemed to me she bestowed charity on very ungrateful objects, but she seemed to enjoy giving to the poor more than they did in receiving it. It seemed to be pleasure above all other enjoyments for her.

She was a great church-going woman, but did not hesitate to attend any place of social amusement that was not detrimental to good morals.

She enjoyed a lecture, theater, ball, or party as well as any lady in Virginia City. She always had her family go to everything that came along of any importance, and not only her family, but I have known her to have eight or ten in a drove, taking them to some place of amusement. It

was people who could not afford to go that she took in, always footing the whole bill.

I never made a practice of going to theaters if I owed a debt, for I thought my money did not belong to me as long as I owed a cent, and I could never be coaxed into going. I would let my child go, for I knew his young days were his best, and would be more capable of enjoying it than when older; and Mrs. Beck, knowing that I deprived myself of pleasure to meet my debts, would either send me a ticket or come after me to go with her and the children, as her husband was always in the store till late; and always after the theater would go to a restaurant, and there the whole crowd of us would have lunch. If I offered to pay, or even attempted to pay my own part, she would not allow it. She was the smallest by nearly a head, but she was "boss" most of the time.

I do not think I would ever have enjoyed my life in Virginia City as I did had it not been for her. She was as lively and affectionate as she was generous; and would make fun for one person, or for twenty. One could not help having a good time where she was.

We used often go to Silver City. We would walk down and ride back—a distance of five miles. We would walk races, and run races, and I could beat her on the race, no matter which kind, every time.

We used to go to a great many picnics, especially the California picnics, for they had all sorts of athletic sports going on, which we always enjoyed. Both ladies and gentlemen took an active part in these sports. She and I used to shoot at the bull's-eye, or knock the pipe from the mouth of the wooden soldier, and sometimes scale his nose and win our "two bits," or hit the swinging man and win the cigars.

We always enjoyed the picnics, as all the Virginia City people did. There were generally from two to four a week,

from May to October, every church and society having
one, and all the military companies.

I do not think it possible for any other city to have more
different societies than Virginia City. Every society has a
lodge, and some of them, like the Masons, Odd Fellows,
and Champions of the Red Cross, have branch lodges of
different degrees. Some members have taken all the de-
grees, and belong to all the lodges, while others have taken
but one and two degrees.

I think these are the only three lodges that have degrees.
The "Champions" is a life insurance and temperance so-
ciety—I think one of the finest temperance orders ever
started. Its regalia is very handsome, being black
velvet, trimmed with silver bullion fringe and lace. The
aprons have a red cross in the center, and if you are a de-
gree member, your apron has as many stars attached to the
cross as you have taken degrees. (I have taken all the de-
grees ot this order.) Officers have also wide velvet sashes,
with solid silver emblems. Some of the lady officers wear
ribbon scarfs of red, white, and blue.

I joined this lodge when it first opened, and was a mem-
ber until I left. So was my son. I never enjoyed any place
while in ,Virginia City as I did in the lodge-room of the
Sons and Daughters of Temperance, and the Champions of
the Red Cross.

Some of our best and smartest citizens belonged to the
temperance societies. The Good Templars and the Band
of Hope are also well represented.

There were other secret societies—the Knights of Pythias,
the Order of the Red Men, and Anti-Chinamen. The largest
order, I think, is the Miners' Union. It is a very large and
well-organized society, and about the richest society, too.
It has a large brick building, one-half of which it nearly
always rents to the other societies. The lower hall it
uses itself. It forms a larger procession than any

other one order, unless it is the unpaid fire department of Virginia City. Before it disbanded, I think its procession was a full quarter of a mile long.

The miners are the hardest working people of Virginia City, for they not only work physically but mentally, having to be constantly on their guard for fear of accidents. It is a constant strain upon their nervous system. It is really the biggest part of their work.

If I were a man, I would rather work for 50 cents a day on the surface than for $4 a day thousands of feet below. And getting this paltry sum is begrudged them by capitalists.

This society has done more to keep up Virginia City than all the other societies combined, for it keeps up the price of the white laborer.

If wages go down lower than they now are, the prices of provisions and dry goods of every description will have to fall, too, or miners cannot possibly live; and if provisions and dry goods go down, railroad companies will have to come down on their rates (which, by-the-way, are at present enormous, and ought to be looked after by the Government); if they are not reduced—and wages are in Virginia City—people will be obliged to move away, as everything used in the city, either to eat, drink, or wear, is imported from some other State.

So you see, if wages are lowered, Virginia City will go to naught, and be abandoned.

The Miners' Union Society works both for right and might.

They work hard for their little old $4 a day, and they mean to have it, although they have to fight for it. I do not think they will ever work for less, nor will they let the Chinaman do so. They do not use their money rigging out their members in gaudy trappings. They have a simple badge, of about four or five inches, of blue ribbon fastened

to the lappel of their coats. I think there is something
printed on it, but I have not been near enough to them to
see, as I have only seen it in the procession; but they are
an organization to be proud of.

The military companies of Virginia City are perfectly
magnificent in their dress parades. I do not know the names
of but few of them—the National Guards, Washington
Guards, Irish Brigade. The Emmett Guards is a grand
company, and its members look splendid in their blue suits
and dark green feathers. They all have lovely costumes,
and make a grand show.

The fire department of Virginia City is, and always has
been, a grand success. Before the fire of '75 it was com-
posed of six large companies, named from No. 1 to No. 6.
Nos. 3 and 4 were situated on B Street; Nos. 2, 5, and 6 on
C Street. They were all good, large companies. One could
hardly tell which had the finest turn-out, but I think No. 6
generally took the lead.

After the big fire the city bought out all the companies
but No. 6. This company still holds its independence, and,
I have heard, is generally ahead of the paid department.

My cousin held the office of chief for nearly two years
before the fire. He had some brilliant bonfires while he
was in office the first year; but it was generally acknowl-
edged by the citizens not to be his fault, but the city's, for
not providing water. But after the big fire he succeeded
in getting hydrants put in every street in the city, at cer-
tain distances apart. They also got more water tanks—
quite a large number of them—and fire hose houses put up
near most of the hydrants, with plenty of hose.

He had often told the board of aldermen it needed
these things, but it seemed to think it an extra expense.
But after it had lost thousands of dollars of private
property, besides all the city had lost, it awoke up to the
reality and necessity of these things, and he had his way.

A few blamed him for the fire, but all the sound-minded men said nothing but a cloud bursting could have saved Virginia City, as it took fire at five o'clock in the morning, and the water was turned off.

The Virginia City Water Company always turned the water off at five or six o'clock in the afternoon, and did not turn it on till six, or after, in the morning, just as it happened; but after the city was burned it was not allowed to turn it off.

That morning it had not been turned on, and they had to go off several miles on the mountain and turn it on before they could get water enough to save the city. The fire had got a good headway, for the water in the few cisterns on the main streets was soon used up.

Had the water been turned on, nearly every private house could have been saved, especially where they stood in yards by themselves, for nearly all had rubber hose to attach to their pipes.

This would certainly have backened the flames till the engines could have reached them.

As it was, the city was half burned before the engines could get water. Some of the engines were burned in the streets.

Well, after everything was over, the city thought it would be less expensive to pay the firemen, and they made new arrangements, my cousin retaining his place as chief until he got everything about the fire department in perfect order, except the telephone arrangement. That, I believe, Chief Brown, his successor, has put in shape. I think the ex-chief shook the bush, and caught the bird, for about a month after he came in office, I read a notice something like this: "Chief Brown has succeeded in getting the fire department in perfect working order. He can blow a little whistle on C Street, and arouse his department on B Street."

I heard several speak of his getting the credit of the work done, but he said the books showed who did it.

I think my cousin must have been something of a favorite, for while in office he received from the fire department a solid silver trumpet, nearly a yard in length, handsomely ornamented, with his name engraved on one side (which I was told by several of the company cost $100), as a token of respect to its chief. He also received a handsome silver lantern. The globe was handsomely embossed glass, with the words "Frank McNair" on one side, and "Chief" on the other.

The Virginia City Water Company has its office on B Street. In early days it gathered the water from old tunnels and passed it into large tanks. But in the last few years it has laid a pipe from a lake situated in the Sierra Mountains and brought the water over the top of Mt. Davidson into Virginia City.

This plan was first suggested by one Pinchshaw, a Jew, who was said to be about half crazy. When he proposed bringing the water to the city in this way, he was pronounced wholly insane, and people went about the streets laughing at his wild fancy of bringing water forty miles in pipes; but three years later the company had pipes laid, and brought the water in precisely the same manner as he would have done could he have got assistance.

The company has $1 a week for water from small families; from larger houses, hotels, restaurants, etc., it has much larger sums. Laundries, saloons, and the city have to pay it very high rates for water. My house used to bring $12 for each month, and the third month $15. If you have a dozen houses, and you have them all empty, you will have to pay the water bill just the same as if you were using water every day in all of them, unless you go and beg and plead with it, then it may give you the water on one house, and charge you for the other eleven

If you have but seven, it will charge you for six and let the other go free. It will try to make you think it has done something very magnanimous, when, in fact, you have to pay this or have the pipes cut off; and when your house is again filled, you have to pay $5 to have the pipes attached. So in either case it gets your money.

At this way of doing business it is no wonder that the heads of the company can afford to take the money they have wrung from the hands and hearts of the poor people, and spend it in Paris and London, and marry their children to noblemen.

It is no wonder there are so many poor people in America when capitalists gather up the gold and silver by the millions, and take it to foreign countries to enrich themselves, instead of leaving a part of it where they make it.

I think the people of Virginia City ought to do something to compel the water company to stop this very unjust act of cutting pipes, or compelling poor people to pay for what they never had. It is a shame for the city to allow it.

The people of Virginia City are great gamblers. Two-thirds of the city gamble. The gambling dens are perfectly magnificent in style. They are gotten up to attract people to them. Some are kept very orderly, while others are not.

They have a very good law in Virginia City to prevent young men from gambling. Every young man under twenty-one years of age is prohibited; and if he is allowed to gamble in any saloon, the proprietors can be held accountable for the act. But it lacks good officers to put the law in force, for half of the boys from twelve to twenty-one in the city gamble. It is astonishing how this law is violated by nearly everybody. Boys from twelve to fifteen have already acquired such a passion for gambling that they will pawn any article of jewelry in their possession,

such as rings, pins, sleeve-buttons, and even their sister's gold watch and chain.

I knew one of the finest boys in Virginia City to do this, so great was his appetite for gambling. And yet their parents will not put the law in force.

At one time, when my son was but twelve years old, he had just drawn his wages, and was on his way home from the *Chronicle* office. Some of his mates called him to a child's gambling den. They had what they called a stick game, I believe. They bought a stick of candy for $1, with the inducement held out to them that they might get $3 or $4 wrapped up with the stick.

The proprietor had been there about three months swindling the boys in town out of all the money they could get. He had let some boy win $5. This was enough to set every boy wild with the hope of gain. Charlie had $14. He went in and bought one stick, but lost, and, like older gamblers, wanted to win it back. He bought another, and lost again. He then got excited, and bought until he lost $8. He then turned and fled from the place, for fear of losing the rest of his money, for the man kept telling him to try again—he might gain the next time, perhaps.

He came home and laid his money on the table by me, and said: "Mamma, I have done something awful; I have been gambling."

I asked him where. He told me the place, and how much he had lost. I told him to come with me. I went to the den and told the man to refund the $8 to my child. He denied ever seeing him, and ordered me out.

I told him I would go, but I would come again with a power he did not dare to disobey.

I then went to the district attorney, Mr. Thomas Stephens, and asked him if there was not a law to protect children from being swindled. I stated the case to him. He said

there was, and he would see that they were protected every time. There was a complaint made to him.

He wrote a note to the person having the den, ordering him to refund the money to Charlie, and also to the other boys he had robbed, or he would have him in the lock-up before four o'clock. It was now about eleven.

I took the note and went back. As I entered the building, I said: You see I have kept my word. *Here is my authority.*

He took the note and read it, and, turning to Charlie, said: "Come in here and get your money."

He went in the office part, and I heard him say to Charlie as he counted out the money: "You d—d fool, what made you tell your mother? If I ever catch you around here again, I will kick you out!"

"You may," said Charlie, "if you catch me here again."

As we came out of the office, I told him it would not be very healthy for him to touch my boy, and it would also be well for him to refund the money to the other boys before the time expired. I told him I would know whether he did or not, for I was well acquainted with them all.

About four o'clock I happened to pass that way, and the place was empty. He had packed up and left town, as he probably had no idea of refunding the money he had swin-. dled the boys out of. He saw by the note that Mr. Stephens meant business. And he did. By his promptness in this case, Virginia City was minus one villain. He was never heard of there again.

Virginia City is a very hard city in which to bring up children, for all classes drink, high and low. They keep beer by the keg, and wine and other spirits by the case, in their houses. Nearly all play and gamble. Two-thirds swear, and the other third uses by-words of every kind— some very laughable ones—while others use coarse and rough ones.

It seemed very odd to me to hear people in the best social circles of society in the city betting their "bottom dollar," or their "loose change," or "your sweet life," or "all your stock that is not in soak," and such like expressions in large assemblies of people. Yet it was never noticed any more than if you had said " Thank you," for nearly everybody uses by-words.

I do not think anyone ever enjoys life better than they do. When they go anywhere, which is every night in the week, they go for a good time, and they manage to have it, too.

The ladies, as a class, never allow anything to prevent their going anywhere they wish to. Sick children and sick friends never keep them. Of course there are exceptions; but if they can get anyone to take care of them, they are off to the theater or dance.

The men are just as bad. They will bury a friend in the afternoon, and go to a dance the same night.

If persons die, they will bury them in style. The funerals in Virginia City are conducted differently, and are superior to any I ever witnessed, and also larger than I ever saw in any other place.

Nearly every man and woman is a member of some lodge, and generally of three or four—not unfrequently of seven and eight different organizations. If he or she is a Mason or Sister of Rebekah, then that order takes the lead, then the Odd Fellows; then the Knights of Pythias, Pioneers, temperance orders, military companies, and so on, the company of which he is a member following first.

If he is a member of the Miners' Union or Mechanics' Union, large bodies—or at least one-third—of them turn out. If he is a member of the fire department, then each company turns out, the company to which he belongs following first. The society he chooses generally takes charge of the body, and it is taken to its hall. It is buried from the

hall or church, seldom ever from the house. It is a very imposing sight to see one of these funeral processions, extending from one end of C Street to the other. Some of them have as large processions as ever turn out on the Fourth of July (our great national day), which is the greatest day in the year to a resident of Virginia City. It does not seem to make any difference with foreigners, as they all seem to enjoy it alike.

I suppose it is because the people of every nation living there have their own national day, and are allowed to celebrate and enjoy it as well as we do ours, and are never molested.

All have grand processions passing through the streets, but none can compare with our glorious Fourth, for then every order turns out to its last member.

Let me give you a description of our Centennial Fourth, a day long to be remembered, not only by the people of the United States, but especially by the citizens of Virginia City. I do not think it possible for any other city in the United States to present a better turn-out than did Virginia City and Gold Hill on our Centennial Fourth.

It was a lovely day, and not very sultry. The sky was clear, and the sun shone out in all its splendor, as if in honor to the day.

The procession commenced forming at eight o'clock on B Street, the military companies being first in full dress parade; then came the Masons in every order, and in their different styles and colors of regalia; the Knight Templars, Order of Red Men, and so on.

Their regalias were trimmed with gold and silver fringe, from an inch to one finger in length—the best bullion fringe, and lace to match.

Beautiful solid silver and gold emblems ornamented their badges and regalias.

Then came the Odd Fellows with their lovely regalias, and their different lodges.

Next came the Miners' Union, then the noble firemen with all their carriages of state, each one containing a young girl dressed as a Goddess of Liberty, and each one trying to outdo the other. Their dresses were made of red, white, and blue ribbon, a quarter of a yard wide, stitched together with ribbons that would stand alone.

Sometimes a little boy, dressed as an old man, occupied the seat; but the beautiful canopies that covered their heads were made of silk flags and wreaths of artificial flowers, some of these wreaths costing from $5 to $15. There were six of these carriages. Their engines were also as bright as scouring could make them, and trimmed with beautiful, expensive, flowers; and every fireman who carried a trumpet had it tucked under his arm, with an elegant bouquet placed in the head.

After this came each company following its own carriage.

Next to this came the chariot carrying Columbus. The carriage was very handsomely ornamented, and his costume was very ancient.

Next to this was the carriages containing the girls who represented the States, all dressed in white, with ribbon sashes of every description, all waving banners and flags, and singing the "Star Spangled Banner."

Then the next team was a printing press, throwing out its papers, as it went along, to the people following the procession.

After the press came a quartz-mill; after which a representation of miners working the drill in the mines. They were dressed in overalls and shoes and miners' caps. This was all the dress they wore in some of the mines. They do not even wear as much as this.

A company of Indians were also in the procession, dressed in battle costume, paint, and feathers.

The "Horribles" brought up the rear. The "Horribles" are the same that the Eastern people call "Fantastics," only both animals and men are represented, being the most grotesque objects ever witnessed.

I was told the procession occupied three streets.

Nearly every Yankee invention of any consequence was represented in the procession.

This celebration was very expensive to the city as well as private individuals.

After the procession was formed they marched down Sutton Avenue to C Street, then up C Street to the Divide.

In front of the Chollar office the oration was delivered; also some very fine speeches from several of our smartest citizens.

They then marched down B Street to the court-house.

All the people in the city not in the procession were on the balconies of the buildings on B and C Streets, or on the sidewalks, following the procession.

After the procession disbanded, free dinners, given by the different organizations, were in order.

The fire department had a dinner such as it always gets up. It never calculates to be outdone on its suppers by any other organization.

The most of the people then went home for a little rest before the evening entertainments commenced.

There were two or three balls that night, and fire-works. That day and night passed off very pleasantly without a single accident, and by five o'clock the entire city was wrapped in slumber, except the watchmen. The balls did not hold as late as common, the people being tired out with the public exercises.

The Centennial Fourth was voted a grand success by everybody.

There were no spirits sold in the city on that day. They never sell any on the Fourth; and if a man is caught intoxicated on the street, he is put in the lock-up.

No one dares to sell it; but men who are bound to have it, get it the day before. They are not allowed to sell it on election or town-meeting days; and if an Indian is ever caught intoxicated, he has to tell who sold the liquor to him, and whoever he is, he has to suffer the penalty of the law.

As I have said before, there are a great many gambling saloons, and about two-thirds of the male inhabitants are gamblers.

There is no city in the States so given to this vice as Virginia City. St. Louis can't begin with Virginia City for gambling and drinking.

It is an every-day occurrence to see men, and even women, lying on the sidewalk, or policemen dragging them off to the station-house. Sometimes well-dressed and respectable-looking people are found in this awful condition.

I heard a friend say he saw a woman who had once been one of the aristocracy of the city, but who had given way to this disgusting habit until she would lie down on the sidewalk anywhere, waiting for some one to pick her up. He saw her in this condition about twelve o'clock one night. He tried to get her up; told her it was no place for her, when she said: "It is best for everybody to go right along. Let everybody enjoy themselves as they have a mind to."

"But," said he, "you will freeze here!"

"Well, never mind," said she; "it's my pie."

"Well," said he, "it won't be yours by morning; you may have to eat bread and water."

"Well, that's good enough, so you enjoy it," said she.

As she could not be persuaded, he went on and left her, entered a saloon, and took a drink himself. He needn't deny it, for I know he did.

How do I know he did?

Reader, did you ever know a man that went around with his mouth and pockets full of spices and brandy smashers

who did not drink at every bar he came to? and the more highly perfumed his breath, the greater amount of whisky he can drink?

Well, I was speaking of saloons. They are kept open all night, and some are never shut. Where there is a partner, one keeps open through the day, and the other the night. If any one of them is ever shut, it is early in the morning when the miners have gone to work on the seven o'clock shift, and those who are off work at that time are gone to bed, and the citizens who have been up all night in the drinking and gambling saloons have also gone home. There is no one left to sell to except the policemen, who have got enough by this time to last them till the doors are opened. Under these circumstances they can afford to shut up for three hours; but that is about as long as any of them are closed in a day.

There are more spirits drank here, taking all kinds, than in the Eastern cities.

There are a great many killed in these saloons; but it is very seldom that the deed is committed by the owners. It is done by those who are made insane by spirits or by heavy losses.

Another thing which is a disgrace to Virginia City. Many of the men support more women than the law allows them. They live after the Salt Lake style, only they are not as honorable as old Brigham was, for he married all his wives according to his religion. Here they marry but one, and the unmarried ones are always dressed the richest.

This class of women is always very kind-hearted, and gives liberally to any charitable purpose, and is always ready to assist the poor and suffering. It seems as if they wish to atone for their many sins by doing all they can by way of charity, for " charity covereth a multitude of sins."

There is a large class of these poor, misguided people in Virginia City. Sometimes a good citizen, wealthy and respectable, marries his wife from some one of these corrupt houses, and he seldom ever regrets his choice. He builds her up to be respected and respectable. I have heard of several cases. More of such men would make Virginia City better.

There are churches here of every denomination, except the Universalist. All have their own churches except the Unitarians or Liberalists, as they term themselves. They hold their services at the National Guard Hall. Each church is well filled every Sunday.

The Catholic Church is a magnificent brick building, and richly as well as handsomely decorated with fine oil paintings, engravings, and statuary. They had a very fine one burned. They have built the present one since the fire.

The Episcopalians and Methodists were also burned out. These three churches are situated on Taylor Street, below D Street.

The Baptists have their church on the east side of C Street, while the Presbyterians have theirs on the west side, nearly opposite.

National Guard Hall is on Smith Street.

The China "Josh House" is in Chinatown.

I do not know where the Jews hold their meetings, but somewhere in the north end of the city.

After all of these crowded churches are out, most of the men go off to their work, unless it is those who have money enough to hire their work done.

As far as work is concerned, there is no Sabbath there. The mills, mines, and machine-shops are always going.

You will see all sorts of teaming going on the same as any other day—sixteen mule or horse-teams hauling quartz, wood, or coal through the streets, just as it happens.

While you are listening to the sermon you can also hear the snap of the whip, or the oaths of the driver as he beats his poor beasts, who are stuck in the mud, on Taylor Street, in front of the churches.

All through the winter and spring it is very muddy on this street, as the upper part of the street is in a ravine, near Mt. Davidson, and takes the whole drainage off the mountain.

The saloons are all open the same as any other day. Yes, these whisky mills have to run as well as the quartz mills, which they cannot afford to shut down. It costs too much, they say, to get them started again. This is their excuse for never shutting them down.

A person passing through Virginia City would imagine he had lost the day of the week, when he sees ten or fifteen quartz wagons, and as many more of wood and freight, and the constant sound of the pumps and engines, and the running to and fro of freight-cars, which are being loaded and unloaded—it is enough to make anyone forget the day of the week.

The people of Virginia City are more dressy than any place I ever lived in. I candidly believe many of them go to church simply to show their fine costumes.

I have said that Virginia City had nice buildings, but did not tell you how many of them are finished off. Before the fire there were but few houses, except the brick and stone, that were plastered. They are all ceiled overhead with fine ceiling. The sides are rough-boarded with coarse factory sewed together, and tacked on, being stretched very tightly. These cloth walls are then papered the same as we do our hard-finished walls of the East. A cheap house is finished overhead with cloth ceiling. Some of them whitewash it overhead instead of papering it. Some nail strips of boards an inch wide, every three feet apart, to hold the cloth from sagging.

Go into such a house, and you will imagine it a first-class house, so nice and cozy it appears. But you just sit there till one of those gentle breezes called "Washoe zephyrs," of which Virginia City is so famous, sweeps down the mountain-side, and you will be surprised to see the walls flap back and forth, and the whole walls literally alive with moving mirrors and pictures, especially where a family group of cabinet-size pictures are hanging—have them all moving at the same time, and you imagine yourself surrounded by spirits. I remember the first time I witnessed such a scene I was very much alarmed. I was at the house of John Mackey, and also on the third day after I landed in Virginia City. It was in Mrs. Hungerford's sitting-room. I was all alone with my child. While I was sewing, I heard a rustling like the trailing of a silk skirt. I looked around to see who had entered the room, but saw nothing. I went on with my sewing, but soon heard it again. I looked again, with no better success ; but the third time I stopped sewing, determined to see if it was a person or a ghost, when Charlie, who had been watching, too, discovered the pictures moving, and cried out : "O, mamma, the house is going to tumble down! Look there ! "

I looked in the direction he had pointed, and there everything on the walls were swinging. At first I did not notice the cloth, and wondered what could make it. If I had been a spiritualist, I should have thought the spirits had taken possession of the house ; but I was not, and naturally thought it was an earthquake, especially when I saw the walls all bulging out. Springing up, I caught Charlie in my arms, and ran down stairs. I met Mary, the cook, and told her the walls were tumbling in up stairs. She ran up stairs, and soon returned laughing, and said it was only the cloth on the walls. I went back up stairs satisfied it must be as she had said, or I should have heard a crash.

I went and examined the walls, and found they were common rough boards, first covered with cloth tacked on, then papered over, and the wind getting behind them, blew the cloth out from the wall until it struck the backs of the pictures, and this set them to swinging; but it was truly a ghostly sight, for they swung to and fro, the different shades and shadows on the faces making them look very ghastly.

Houses made like this burn more readily than hard-finished houses, and since the fire they ceil a great many overhead instead of putting up cloth. The reason of their building the houses in this cheap way is because they have so many fires that they cannot afford to put up the best kind of a house to rent, and then get burned out.

People who rent out their real estate in Virginia City get but little returns in comparison to the expenses of repairs, county and city taxes, water bills, and other city expenses. Then they have no good laws to protect them against bad debts. If a man has nothing to pay you with, you cannot turn him out without a notice ; and if he chooses, he can stay until he gets another house, and if he does not try to obtain another house, it is all the same, for you will have to wait. At least lawyers have told me so.

I will now leave Virginia City and its inhabitants alone for a time, and describe to the reader the towns about Virginia City.

CHAPTER VIII.

Gold Hill—American Flat—Silver City—Dayton—Sutro—Carson City—Empire City.

I WILL now give you a description of Gold Hill. It is situated, like Virginia City, in a ravine, the main street being in the center of the ravine, and the streets climbing the mountain-sides on either side of it. It is very compact, having but little room to build. The top streets are three and four hundred feet above Main Street. Nearly all the business is done on this street. It is the longest street in the place. It has closed up with the Divide, which unites Gold Hill and Virginia City, and extends along the road to Silver City for a long ways, and is called Lower Gold Hill, it being as thickly settled as any part of the place. Main Street gets all the drainage from the hill-sides and from the Divide on the north, and is certainly the filthiest street for a city I ever saw. Persons always have to hold their nose while passing through there on a warm day. I have heard many people of Virginia City complain of it, yet the Gold Hill people do not seem to mind it. I suppose it is because they are used to it. For all of their filth, it is generally very healthy. It has some very fine buildings, especially its school-buildings, of which it is very proud; and it has a right to be, for they are fine three-story buildings, several in one collection, and a nice large yard, but no trees.

American Flat, to the south of Gold Hill, was once laid out for a city. It has a very fine site for one, being a very

large, level plain, surrounded by hills on every side. I think it has been some day a large lake, but by some earthquake or other cause of nature, it has been drained, and is now a beautiful flat.

There are not at present many buildings there, many of them having been moved away, while others have gone to ruin.

They found the mines at this place did not pay, there being so much base metal mixed with the ore, and for a time the mines were abandoned. Then the people moved away, some taking their houses with them, while others were left vacant, and soon went to ruin.

At the present time many of the mines are being worked with new machinery. The machinery of early days was not of sufficient power to crush the ore.

This is why so many of the inhabitants moved off. At present several good mines are in working order.

Silver City is two miles from Gold Hill, to the south-east. When I first visited it, it was quite a smart town. It is also built in a ravine, and is a great milling town, but it is fast going to seed. Where once stood boarding-houses and mills, now stand ruins of old stone buildings, all grown over with sage-brush. The place has been visited by many destructive fires.

In going from Gold Hill to Silver City you pass through the Devil's Gate No. 2, so named from the projecting rocks, or after the man who owned the toll-gate, which was situated at that point. I am sure I do not know which.

Dayton, seven miles further down the ravine, is a pleasant little town. It is well watered by running streams. Nearly every person has his own well. Here they raise trees and flowers, everybody having his own garden. It is the county seat of Lyons County. Being visited by many destructive fires, it is not at present in a very flourishing condition.

The inhabitants are very quiet. I never heard of a fight during the three months I was there.

Sutro is a smart little town, which seems to be going ahead of all the other places around it. It has sprung up in the last seven years under the influence of Mr. Adolphus Sutro, a very smart, shrewd, energetic gentleman. He is the founder and owner of the far-famed Sutro tunnel. He does not seem to know the definition of but two words in the English language. The words are " I can't," and "you shan't." His mottoes seem to be : " Go ahead," and " Nothing shall stop me."

Some eight years ago he conceived the plan of running a tunnel into Mt. Davidson, under Virginia City, and draining the mines. The tunnel is thousands of feet below the city,and is seven or eight miles in length, and perhaps longer.

He met with opposition on all sides. Large mine and mill-owners opposed him bitterly, and but very few in Virginia City gave him encouragement. He was obliged to go to other cities and countries for assistance.

San Francisco offered him some assistance, but much opposition. He then applied to the Government at Washington. It gave him a patent, and assisted him to a certain extent. He thcn visited Europe, and got rich capitalists to assist him. When he got everything arranged to suit him, he pushed his work ahead very rapidly. He was to have $2 royalty on every ton of ore taken from the mines after his tunnel was completed, no matter whether taken through his tunnel or by the hoisting works of the mines. He was to have all new ledges he discovered while digging it. I do not remember the whole of the contract. Well, after he had pushed ahead and got it nearly ready to drain the mines, some of the companies tried to back out of the contract ; at least I judge so by the papers. But I believe he has held them to their contract, and the mines are now being drained of their immense quantities of hot water.

He went to a great deal of expense, trouble, and labor, but finally succeeded. I hope and trust he will reap the benefit of his industry. If there were more men like him in Virginia City, the place would be better off.

I think, with many others, he is the best progressive man on the Comstock. If he had become discouraged and dropped his plans after a few years, some of the rich mining capitalists would have taken up his plan and carried it out as he has done—just as the water company took up Mr. Pinchshaw's plan of bringing the water over the mountain.

But he did not happen to be one of the giving-up kind, consequently he, instead of another, is enjoying the benefit of his industry.

Carson City is the capital of the State. It is a very pleasant, quiet town, there being no mines or mills near it. It is well watered by Carson River, and other little streams. Here everybody has fruit, flowers, and gardens. Everyone has a well, and seems to live and enjoy life. It is a good business place.

It is a favorite resort for picnics from Virginia City and Gold Hill. These two places unite in all their public entertainments.

The Capitol and Orphan Asylum are splendid buildings. The State Prison is also here, but several miles out of the city. The Mint is a very large, fine brick building of three or four stories. It is quite a sight to one who goes through it for the first time.

Governor Blasdel's residence was a fine old place, well shaded with trees.

Carson City is about eighteen or twenty miles from Virginia City. There is a good stage road, also a railroad, which was built some three years after I went to Virginia City. It is called "Sharon's Crooked Railroad." It has six or seven tunnels. I think the road is just double the length of the old stage road.

Senator Sharon is one of the best men that ever lived in Virginia City. He had a heart for every poor person who went to him, and I think most of his charities were given in secret. I have been to him several times with Mrs. Beck, soliciting charity for the Virginia City poor, and he never sent us away empty-handed, not only giving us all the way from $10 to $25 every time we called, but he sent two and three cords of wood to some lone woman at different times. He, like one or two others I have mentioned, ought to be held very dear in the hearts of the poor of Virginia City. He did more than any man in Virginia City to keep the place up. The mines were nearly all kept open and very lively while he had the control. He spent large sums of money where he made it. He was once acknowledged to be the money king of Nevada. I believe he used large sums of his money in trying to save the California Bank, which he did. But for him the bank would have been closed to-day, for he is, perhaps, as rich now as some who make a bigger spread by going to the old country. He is a very quiet man, and one well liked by all.

This is the opinion I have formed of him from personal experience and from responsible citizens.

The most of the wood burned in Virginia City and surrounding towns is floated down the Carson River from the mountains around Carson City. From Carson City it is shipped aboard of the cars and brought to Virginia City.

There are many little villages along the railroad from Virginia City to Reno embowered by shade trees, and surrounded by beautiful gardens.

Empire City is one of the oldest of the teeming towns on the Carson River.

Having now finished the description of all the towns around Virginia City, I will wind up this chapter with some of my private affairs.

In the fall of '75 I was confined to my bed for six weeks, nothing ailing me except being worn out with hard work. I had not only my work to do, but a great deal of private business on my hands, which weighed heavily on my health. It was after I had got the sad news of my sister's death, and could not go home to see her. I do not think I knew what I was doing half of the time.

I will give you one or two instances of my absent-mindedness. One day I wished for several things from down town, and started out to get them. Among the rest was a bedstead which I intended to call and order sent home on my way back. Well, when I was ready to go home, instead of going in the store and ordering it, I went up to the door, selected one that suited me from the number of bedsteads that stood outside, and, would you believe it, I picked up the foot-piece and started off up the sidewalk on C Street with it in my arms—it being all I could do to carry it—and never noticed my mistake until I happened to meet a friend who thought I had gone crazy. He asked me where I was moving to. Well, I would not let him know I was not conscious of what I was doing, so I said: I guess I will lose this bet, for I cannot carry it any further, and turned back. I carried the bedstead to the door. There the merchant stood looking after me, and laughing, for he knew it was a fit of absent-mindedness.

I simply told him, when I reached the door, that I guessed he would have to send it up, for it was too heavy to carry.

"I thought you would tire out," said he, "before you got far."

Well, I paid for it, and it reached home before I did.

Another day I went into a store, bought some goods, took out my purse, emptied the money out, put the money in my pocket, and handed the empty purse to the merchant, took my parcel, and started off. As I reached the door the man said: "Did you intend me to keep this?"

I looked back and saw the purse. I put my hand in my pocket, and there felt the money.

This was the way I went around the house working, scarcely conscious of what I did, and eating nothing, until my strength was all gone.

Many a day one of my lodgers, a fine little lady, has made a bowl of oat-meal gruel, and brought it to me and made me drink it, for she knew I did not eat anything half of the time. I had no appetite.

I would drink the gruel to please her. I worked in this way until one morning I got up to dress myself and fainted, and laid on the floor until this lady came down to get some water, and found me lying there. It was the first warning to me of a six weeks' fit of sickness.

I had a disease called the "shingles." It was brought on by overwork.

It resembles fever in symptoms, but is very readily known by a dark purple belt passing around the body about the bottom of the waist. It is said if the bel-meets, that a person never lives. I do not know how true this is; but the belt had nearly closed before I discovered it.

The lady who found me on the floor was a Catholic. She discovered it first, and was so frightened, lest it would kill me, that she took off her gold ring, blessed it, and then crossed me all around the waist with it, and repeated prayers over me, thinking to cure me by faith.

After she had done, I asked her to steep some hops, and sprinkle them with ground mustard and cayenne pepper. I told her the ring might be good, but the poultice would be better. She did as I requested, and the next day there was nothing left of the belt but a brown streak. But I did not leave the bed in four weeks, nor the house in six; for after I got up I could only walk by taking hold of chairs and pushing them before me.

About this time Judge Branson came and told me he wanted me to go to the court-house to acknowledge some papers. I was not able to go, and two of my friends supported me between them, each taking an arm. When I reached his office, he assisted me to the court-house and back again to his office, where I rested for a short time, and then started for home alone, holding on to the guards of the show-windows on C Street until I reached my house. There I laid down to rest.

It always seemed as if Charlie was taken sick as soon as anything ailed me.

While I was sick at this time, he was engaged in a "benefit." One night, after a rehearsal, he went to see one of the young ladies home, but as he reached her door, he dropped down, so severe was he taken; but he soon got up and started home, much against her wishes, as she wanted to give him something to relieve him.

He went about forty rods by holding on to houses which he passed. He finally reached a saloon-door, and could only say "pepper," when he fell to the floor.

He was picked up, his face bathed, and his hands and feet chafed to restore him to consciousness. Some kind of spirits with Jamaica-ginger were stirred up and poured down him. In a few moments he revived, and commenced vomiting. He soon grew better, but it was a long time before he was able to go home. It was two o'clock before he reached home. He came and put his arms around my neck, and said: "O, mamma, I thought I would never see you again! O, how I prayed I might live to see you!"

His hands were icy cold. He then told me how he had been. It was a severe attack of bilious cholic, the first he had ever had. It was caused, I think, by jumping immediately after eating his supper. He has since been subject to these spells.

I had scarcely recovered from this spell of sickness when

the big fire came, and everybody being thrown out of boarding-places, all that had houses left had to take as many to room and board as they could accommodate, and then many had to sleep out of doors. I took about forty roomers, but could only take eight men day-boarders.

One night, after we had finished our suppers, Charlie started for the telegraph office, but meeting some of his school-mates, who were coasting on Silver Street, north of our house, they asked him to have a ride.

He said: "No; I am in a hurry;" but being persuaded, he took one ride over a dump of snow which they had piled up for fun. He went to the top of the hill, which is very steep; but when he reached the dump he was going at such a fearful rate of speed that the sled struck it, and he was thrown four or five feet into the air. He threw out both hands to save himself, and as he came down he struck the ground with such force that he broke his right arm at the wrist. He got up, and came into the house holding his hand.

The boarders were still sitting at the table. He came up to the table, still holding his hand.

"Catch hold of this, boys," said he, "and pull it in place."

He thought it was unjointed. They did get hold of it, and pulled it in place. They held it there until the doctor came, who said it was both broken and unjointed. The boys finally pulled it in place. The doctor said if they had not done so, it would have been hard to set it, for it was a bad break.

Charlie had just been promoted to the position of receiver, and being anxious to keep his place, he went to work with his left hand and got the books in shape for another boy to work with.

In three days he was off to the office again with his arm in a sling.

On the day of the fire he helped save some trunks, containing stock, jewelry, and other valuables, which were in the California Bank at the time, and which were burning. They belonged to a gentleman who was lame. He and his friend, Gus Nye, entered the burning building through the window. As they took the last trunk out, the building fell in.

The boys got pretty well heated up. And all the rest of the day he was riding through fire, under the burning buildings, on horseback, carrying dispatches, and helping to put up wires, as the old ones were all burned down. He inhaled so much hot air and smoke that his lungs were severely injured. He has never had strong lungs since, nor has he seemed to enjoy good health. I am very much afraid he never will. He was very unfortunate as regards his own health.

While there the work which he did was always of the kind that exposed him to all kinds of weather and danger.

When he had his paper route, he was constantly in danger of walking into old shafts, for a sudden storm would rise up, and increase so rapidly that the snow would nearly blind him. Although he wore a cap which covered his entire face and neck, excepting places to see through, he was still unable to protect himself.

One night he was walking along B Street, with his arms full of papers, when he noticed a large black spot in front of him. He stopped suddenly, and looking down, found himself on the brink of a cave which had fallen in since he had passed over it not an hour before. One more step would have been fatal to him, for it was a fearful big cave. Had he fallen in, he probably would never have lived to come out or even reach bottom.

Speaking of falling into pits and caves reminds me of a circumstance which took place about seven years ago. I started to go to the lodge one night. It being quite early,

I found none of the "Champions" there. I just stepped around the corner to A Street to call on a friend.

When I came out of the house it was quite dark. (I cannot see good after dark, having once been blind, although my sight seems good by daylight.) Some of the neighbors had been digging a water ditch, and had neglected to hang out a light. The ditch was about three feet wide and four feet deep. However, I walked straight into it.

As I felt myself going down, I threw out my arms to grasp something, for I thought I was sinking in a cistern. The streets are filled with these cisterns for the use of the fire department, and they are sometimes left open by mischievous boys or by accident. As I threw up my arms, I struck the opposite side of the ditch, and clung to the ground for dear life. I felt with my feet to see if I could touch water. They came in contact with the pipe in the ditch.

I knew, then, it was a water ditch instead of a cistern. I now began to wonder how I should get out. While the fright lasted I did not discover I was hurt. But now, as I began to move and try to climb out, I found I had hurt myself severely about the neck, shoulders, and lungs. I managed to crawl out and get to the corner of Piper's building, on Union Street, where I rested a few moments, and then helped myself by the building until I reached the hall. One of the "Champions" assisted me home.

The next day I suffered very much with my neck. I could not turn my head.

Mr. Parsons, an old friend, and reporter for the *Evening Chronicle*, happened to call. He asked me what ailed my neck. I told him I had broken it by falling into a water ditch.

And what did he do but walk down to the *Chronicle* office and tell them I had broken my neck. That same evening it appeared in the paper. He thought it would be a good

joke on me. (It was just like one of his old bachelor's tricks.)

Our minister saw it, and hastened up to see me, as many others of my friends did. As he entered the house he found me washing dishes, and putting away my supper-table. He looked surprised. Said he: "I have come up expecting to officiate at your funeral, and here you are at work as usual! I see how it is; you cannot find time to die any more than you cannot find time to marry."

I told brother McGrath I thought very likely he would get cheated out of both jobs.

He said: "I presume so; it is just my luck."

He was a very fine man, but his bump of mirthfulness sometimes got the start of his reverential faculties. He could no more resist laughing at a good joke than a drinking man could help stopping and looking into a saloon-door as he passed.

While I kept lodgers I had some singular people to deal with. If my roomers were sick, I took as good care of them as though they were of my own family.

One night a man came and engaged a room. When I went up stairs in the morning to do up my work, I found his door open. Thinking he had gone out, I went in and commenced making up one of the beds; but as I turned to put the clothes on his bed, there he lay. I turned to go out, but he called to me, saying: "I am very sick."

I turned back and asked him what ailed him.

He said: "Pneumonia."

I asked him if he wished for any particular doctor.

"I don't want any of the d—d tribe around me. Three of them got at a friend of mine on the Divide last week, and killed him in just three days, and they shan't kill me; if I must die, I will die a natural death."

I asked him if he would take something that I would give him.

He said: "Yes, anything, for they tell me you are better than half the doctors in town."

I gave him some hot composition, put a hot stone to his feet, and sent a man up to bathe his lungs in camphorated liniment.

In a short time he was sweating. This broke his fever, but the horrid cough hung on for over two weeks before I mastered it. One day I went to carry him his dinner, when I found him sitting up, all dressed, in his cold room, and it was midwinter. I asked him what he got up for.

He said: " I feel pretty well, and am going out."

I told him to go back to bed for at least three days, for he was not out of danger.

This frightened him, and when I went up for the dishes he was in bed. He now grew better very fast, and soon was able to go out to his meals.

He had been sick a little over three weeks when, one morning, I went up to his room and found him gone, bag and baggage. A note lay on the stand directed to me.

I opened it, and read as follows: " Dear madam, I am much obliged to you for your kindness to me during my sickness. I am sorry, but I am going to leave for Gold Hill, to be nearer my work. I hope I may be able some day to do you the same favor. When I get some money I will pay you."

The money never came.

A book agent roomed at my house. He froze his face, and erysipelas set in. He was a fearful sight. He would have no doctor, but was willing to take anything I would give him.

I carried his meals to him three times a day, and dressed his face. When he was better, he exposed himself and had a relapse, and I had to go over the same trouble as before. When he got up the second time, he started for San Fran-

cisco. Before he left he paid his rent, and then asked me what my bill was for nursing him.

I told him I never made any charges for doctoring my roomers, but if they were able and willing to give me any-thing, I always took it.

" Well, you have had so much trouble with me, I feel as though I ought to give you *something.* *Here is 50 cents.*"

I told him I would not take anything.

" Oh, yes; take it for the medicine," said he. " You used two boxes of salve, didn't you ? "

Yes; but no matter.

" Well, I will buy another box of you to take with me, since you won't take the 50 cents."

I rolled up one and gave it to him.

" How much is it ? "

Two dollars, said I.

" Oh! that's too much."

Well, then, do not take it; that is the regular price, and I cannot sell it for less.

" Won't $1.50 do ? "

No, sir, said I; and put the box back on the table.

He stood a moment, as if considering, then went up to the table, laid down the $2, took up the box, and went off without so much as saying " Thank you ! "

There were several large boxes in the yard in which he had received his books.

After a little time he came in, and said : " There's half a dozen boxes in the yard I will sell you cheap. They are worth 50 cents apiece; but I will sell you the whole lot for $2, if you want them. If not, I will sell them to Mr. Ryan."

I told him I did not care for them.

He was gone about half the forenoon, when he came back and said he had disposed of four, and he guessed he would have to leave the other two.

I think a lodging-house the best calculated to annoy and fret a person than any business one can engage in, for you are nothing but a watchman, night and day.

The fires, lights, and doors all have to be looked after, as men are coming home at all times of the night, and some of them intoxicated; for men who are habitual drunkards will often take a glass too much.

A stranger, whom I took in during the night of the fire, came home a few weeks after quite intoxicated, and shut his wash-woman in his room. She commenced screaming. I heard the fuss, and ran up stairs and ordered him to open the door. He refused, and I called assistance.

He then opened the door, and came out with a woman's muff in his hand, and a revolver just peeping from the end, pointing towards me.

One of my boarders came to my assistance, and drew his own revolver, and ordered him to leave the house. He was sober enough to know that if he fired he would be shot, too.

He went away using some very abusive language, but I told him never to come back again.

In a few days he sent for his things. He owed me $20, which, of course, I lost.

When I lived on A Street I rented a suite of rooms to a couple of ladies, as I supposed, but I soon found they were actresses in a melodeon theater. I told them I could not keep them any longer. Their month was only half up, and I refunded them the balance of their money. They asked permission to leave their trunks until the next day.

The next morning I went over to Mrs. Beck's house, as I had charge of it while she went East. I had not been there long before a friend called, and said: "Do you know your parlor window is down, and it looks like a storm?"

It was not down when I left. I will go and see what is the matter, said I.

When I reached home, I found the window down, and marks of feet upon it. I unlocked the door, and went into the part I occupied. I passed through the parlor to the bed-room. The door stood open, and there lay a man in bed, snoring loud enough to shake the roof.

I stepped to the door to see if I could see anyone to call to my assistance. Mrs. Smith, a lady who lived across the street, was the only person in sight. I beckoned to her, and she came over.

I told her some one had entered the house through the window. She said she saw him, but thought it was some roomer who had lost his key. I told her to wait a moment. I took my pistol from under my pillow, went to the door and called to him. I called several times before I succeeded in arousing him.

I pointed the pistol at his head, and told him I would give him five minutes to leave the house. He was terribly frightened, and begged me not to shoot. I had scarcely returned to my room before he was there, too.

He offered me $30 for the room.

I told him I did not want his money, for I would not keep a lodger who would crawl in people's houses in that manner. I asked him how he dared to crawl in my window.

He said he was drunk, or he would not have done it. He said the ladies were his friends. He was very sorry, and wished I would take the money, and call it square.

I showed him the door, and never saw him after that.

This was the second time I had drawn my pistol. I did not intend to shoot, but only to frighten him. I could have had him arrested, but I did not care to go into a police court again.

I merely mention these few cases to let the reader see some of the trials we who keep lodging-houses have to put up with.

It is no small trial, I assure you, to be obliged to take all

of your goods out of your house into the street eight or ten times a year on account of fires.

In a large lodging-house it is a great deal of work, even if your house is not burned, to put them back and arrange them as they were before—nailing down carpets, putting up stoves and beds, are no small chores.

While I was on A Street there was a large fire which commenced in a planing-mill on D Street, near Taylor Street. The Methodists lost their brick church. Nearly all the buildings on Taylor Street, from D Street to A Street, were consumed. The fire then turned down A Street to within three doors of where I lived.

I took up my carpets, packed up my clothes and bedding, and carried them to Mrs. Beck's yard, two blocks below me. Then Charlie and a friend carried out a new sofa I had just bought a short time before, and left it on a cross street.

As soon as the fire was out sufficiently so that I knew it would not reach me, I put down my carpets again, and put everything in order.

I now went to look for my sofa. It was gone. I looked about three hours, when I discovered it in the back yard of a Jew, who lived on A Street between Taylor and Union Streets.

I asked him how it came there.

" I put it there for safe-keeping ; I thought some one might steal it," said he.

I thought this looked very much like theft, as he was a stranger to me.

After all was settled and I had retired for the night, I heard two of my roomers going in and out constantly all night, and wondered what they were about.

When I came to do up the work in the morning, the floor was covered with old letters, as though they had emptied their trunks. I took hold of the handle of one, and found

I could not raise it. I had moved them several times before, and there never seemed to be anything in them.

I now judged they had been stealing at the fire. I think I was right. That night one of them left, owing me $8. When I discovered this, I watched the other one, thinking perhaps he might give me the slip, too. And sure enough, about ten o'clock, he came with an express wagon to take away his trunk. But I would not let him have it until he paid me.

He gave me a ten-dollar gold piece. I had to go across the street to get it changed. When I came back, I noticed, he had dropped the curtain. After he had gone, I went to roll it up, and found he had torn it from top to bottom, merely out of spite, I suppose, because he did not get off as cheap as his partner had.

Letters that I found on the floor of his room proved him to be a thief. It seemed he had stolen his father-in-law's gold watch and chain, and his wife wrote him, begging him to return it. She said she would rather go without the money he had promised her.

While on A Street I took another roomer. When he was brought to me, he had to be carried into the house from the sleigh. He had a broken jaw. His friend said he had been stopping at a boarding-house, but the lady who kept it did not have time to give him any care. He could not eat solid food, but only such as was in a liquid form, and had been nearly starved to death for want of such food.

" I would like to have you try 'and see if you cannot recruit him," said his friend, "as I have heard you were an excellent nurse. As he can take but a small quantity of food at a time, it will be necessary to have it prepared the oftener."

I told him all should be done for his friend that could be done.

He said: " It will be necessary for him to have an easy chair to rest his head against."

I told him I had no means of getting one.

"Oh, well, I will pay for it," said he, giving me $6, the price of the chair.

His friend took me aside, and said : "Spare no pains with him. He is a rich man, able and willing to pay for any trouble. You will lose nothing. He may make you a present of a couple of hundred dollars."

He was at my house a month, and received every possible care, having food prepared four or five times a day. At the end of two weeks he had recovered strength sufficiently to walk down town. When he left he paid the rent, deducting the price of the chair. He then asked me what I charged him for cooking.

I told him "Nothing."

He said : "You are very kind, I am sure. How much did the milk come to that you bought for me?"

I told him he had had two quarts a day.

The milk came to $6.50. He gave me $7 in silver, and, as I could not make the change, he said : "Keep the change; I have been a great deal of trouble to you."

Now, as I had expected a present of $200, and it had dwindled down to 50 cents, my feelings naturally rebelled. I was about to ask him to wait until I went out and got the change, when, on second thought, I was convinced that such an act would have no more effect on a man of such a penurious disposition than pouring water on a goose. I pocketed what little there was, and let him go.

Another fire occurred near me on C Street during the last summer I lived in Virginia City. I was attending a funeral on B Street, directly back of my house, when I heard the Norcross whistle, and knew there was a fire near us. I stepped to the door, and saw a building in flames in the same block, and only four doors from my house.

I ran home, and went to packing up my goods. I had packed but two or three bundles, when the whole house

seemed filled with people. Mr. McCutcheon seemed to be leading them on. He and Mr. McGrath advised me not to take down my furniture, but only tie up the bedding, " for," said they, "you have friends enough here to take out every article after the fire reaches the house."

The bedding, however, was packed in sheets—some ten or fifteen bundles—and Mr. McCutcheon standing by marking my name on each bundle.

I had also locked my trunk, and set it out on the porch. Some friend, who thought the house could not be saved, carried my trunk away some distance, and left it on the street in charge of some boys.

As soon as Mr. McCutcheon discovered it was gone, he went and brought it back, and placed a guard over it, that it might not be carried away again without his orders.

Mr. Beck was also there with his whole force and an express team, and carried away several bundles to his store, which were returned to me after the fire.

The rest of the things I did not move, as word was sent me that there was no danger, as the fire was under control. My friends now set to work and helped me put the house in order.

I now had time to look around upon the crowd, and found every face there was that of a friend.

Now many more who had just returned from out of town, or had been engaged fighting the fire, as many of the citizens were, came pouring in to congratulate me on my narrow escape. The house was thronged until nine o'clock.

It was at this time that I learned how many true and valuable friends both Charlie and myself had in Virginia City. There were not less than fifty people there helping me during the fire. A dozen or more of them were boys—Charlie's mates—who worked like little heroes.

When left alone that evening, I could not help shedding

tears of gratitude over the discovery of so many warm-hearted friends.

And if perchance some of them who assisted me happen to read this book, they will know that the services rendered that day will ever be gratefully remembered by me, though in a distant land.

CHAPTER IX.

Incidents of My Life Continued.

ONE of the most annoying cases I ever had was that of a woman who came to me one night and said she was starving. After she had eaten what I gave her, I asked her why she did not go home. Have you had any trouble with your husband? I asked.

"Have you not heard that he has applied for a divorce?" she asked, in return.

I told her I had not.

She now told me all of her grievances. I had once lived across the street from her beautiful home, and thought her a very nice woman, although report said she drank. I never saw her drink a drop.

She told me he had turned her out of doors with but $10 and her bed. She had sold the bed to pay room rent, and her $10 being used up, she had not tasted food for three days.

I gave her a room, and the next day called on her husband. He said what he had done was to frighten her from drink. He said if she would stay six weeks at my house without drinking, he would pay me, and take her back.

He wanted me to call in occasionally and let him know how she got along.

In the course of six weeks I called twice. I told him she was doing well, and had not tasted a drop. At the end of the time I called again. He then said he had made up his

mind to quit her, and would not give a *cent* to save her life.

"Turn her out on the street if she won't pay you," said he.

I told him she had nothing to pay with.

" Yes, she has plenty of jewelry—two diamond rings, a gold watch, two or three chains, and diamond ear-rings, and either one of the latter is worth more than enough to pay you."

I went back and reported to her what he said. She seemed to feel perfectly broken-hearted, and cried most of the time, day and night.

"Never mind," said she; "let me stay with you till after the suit, and I will pay you some way."

I told her she might. But from that day she never seemed to be the same person. I think her troubles turned her brain. I never had a good night's rest after this. She wanted a light burning, and would not let me sleep. She would sit and talk about her husband the entire night.

The case was postponed from time to time, and was in the courts nearly a whole year. She did not drink a drop, while in my house, that I know of; but I found some morphine powders once or twice in her bed.

The case was finally decided against the poor woman, and she was left destitute. I could not turn her out until she saw some way of supporting herself.

One day two ladies, who had been keeping a private laundry, called, and said they would like to find some one who would buy them out. They would sell their whole outfit for $15.

I thought this a good chance for my roomer, and advised her to take the business. She disposed of some of her jewelry, bought them out, and went to work.

Before she left I said to her: How is it that you, as well

as others, admitted that you drank, when I lived near you a whole year and never saw you drink?

She said: "I knew you were a strong temperance woman. I liked you, and did not want you down on me for drinking, so whenever I saw you coming, I dropped the curtain, and kept out of sight, if I had been drinking."

Well, said I, if I had known that, I would never have dared to go into court as a witness for you, for fear people would think I was not telling the truth. I was quite annoyed.

"No," said she, "no one would ever think that of you. Your principles are too well known for anyone to think you would screen a person you really thought drank spirits."

Well, now, you have staid sober a whole year; and if you will go to work and support yourself, and not drink any more, I will always stand by you and be your friend. She promised to do so.

Before she went away she said: "I want to pay you for all of your kindness to me; but only for you, I do not know where I should be to-day."

I had given her a receipt in full after the court had decided she should have no alimony. I therefore told her the bill was settled.

"No," said she; "something tells me I shall never have another opportunity of paying you."

She went to her trunk, took out her case of jewelry, and presented me with her diamond ear-rings.

"Take these," said she; "they will just about pay you for my board and lodging and the $25 you loaned me to carry on my suit."

I told her she might need them herself.

She said: "I might as well pay an honest debt rather than fool them away, as perhaps I shall; but they will never half repay you for all your kindness to me."

She showed a more honest heart than the man who had turned her into the street to starve.

She went away, and commenced her work. She stuck to it a month, remaining perfectly straight. I called on her several times, and always found her at work. Some time during the second month she yielded to the temptation of drink. It soon became a common report that she had given herself entirely up to its influence.

I learned this from a reliable source, and discontinued my calls to her house.

If I took the rings as pay for board, lodging, and the $25 I loaned her, they would cost me just $534.

The reader can reckon for himself—a room for $15, which was very cheap after the fire, and $1 a day for board, and $25 in money. Then there was the annoyance of being kept awake. I would not be hired to do it again for twice that sum.

The first time I visited San Francisco I took them to a first-class jeweler. He said: "They are second-hand; you cannot get as much for them as though they were new. They are worth $500. They probably cost much more."

I do not think she knew their real value, as they were a wedding present from a friend.

When men give wedding presents in California and Nevada, they are princely gifts.

There does not seem to be any misers there. They think nothing of giving Christmas and New Year's presents worth from $100 to $200, a nice diamond ring, pin, or a gold watch and chain. The Christmas-trees are loaded with costly gifts.

I think the people there do all they can to make the holidays as pleasant for the children as well as the older people. The people there seem to think more of their children than you do in the East. You hardly find a parent but is kind to his little ones. I think it is owing to the lovely climate.

They have mild, pleasant, summer weather a good portion of the winter. I think I have stated that we have no thunder or lightning there, but I believe it rains sometimes

in Carson City and Reno, near the rivers. I have seen it
sprinkle once or twice in Carson City. The evenings are
very pleasant, hardly ever being very dark, for the sky
seems one sheet of bright stars; so when there is no moon,
it is still quite light. One can always enjoy these bright
nights without fear of damp feet, for we never have any
dew there.

But with all this lovely weather the mountain-tops are
covered with snow the year round.

This is why our summers are visited with terrific winds
in Nevada, especially in Storey County. They come sweep-
ing over Mt. Davidson, dealing destruction to everything
in their path. It is quite common for houses to be blown
down or unroofed in one of these storms. Tin roofs will
lie rolled up on every street-corner.

The first winter after I went there they had a fearful
storm. It took a lady from the sidewalk, carried her about
three rods, and dashed her against an engine.

I was relating this circumstance to a lady, who said:
" That is nothing. I saw a man sawing wood on a piece of
sidewalk that was fastened together perfectly solid The
sidewalk was taken up and carried two or three hundred
feet through the air—the man sawing wood all the time,
and never let up."

I could hardly give this credit. But I have since heard
the same story from several persons.

The Virginia City people never allow any person to get
the start of them on a good story. The one who tells the
last has the advantage of the rest.

This reminds me of a good one told by Mrs. Beck about
her father-in-law. She said he wished for a barrel of sugar
very much, as he was entirely out, and, keeping store, he
dispatched to the firm with whom he was dealing at the
time. His dispatch read thus: " I want a barrel of sugar
the worst kind."

224 *Ten Years in Nevada.*

She says his order was filled to a letter, for when the
sugar came it proved to be the worst kind, black and dirty,
not fit for sale. He wrote to them immediately to know
why they sent him such sugar, as he could not sell it.

They wrote back telling him he had sent for the worst
kind of sugar, and they had filled the order, and did not see
why he should grumble.

He was obliged to keep the sugar, and take the joke;
but when he sent again, he was careful to say, "send imme-
diately."

Nothing will grow in Virginia City except it is irrigated.
Nearly every house has a hose to water its yard. You
Eastern people, with your splendid yards and flower-gar-
dens kept free from weeds, would laugh to see the Nevad-
ans nursing pig-weeds and every blade of grass that chance
produces in their yards. It is true, I have seen many nurs-
ing common weeds. They will sow wheat or anything
that will cover the dust, and water it with as much care as
you would a bed of geraniums, or any other choice plant.

There are no trees on any of the surrounding mountains,
all having been cut off in early days for wood and timber
for the mines. A very few scrub cedars and pines remain.
The mountains are covered with sage-brush as well as the
plains. There are no wild flowers, save a few wild daises
and thistles. The thistles are a bright red, and their blos-
soms resemble the Scotch thistle.

There are several gardens around Virginia City and
American Flat, but they are all cultivated by irrigation—
that is, by digging large ditches around and through the
gardens. They are all owned by Spanish, French, and
Chinamen.

The sage-brush grows from one to three feet high. In-
dians and Chinamen cut it for fire-wood. They also use the
stumps of cedars that have been cut down. The mount-
ains near Carson City and Washoe are covered with them.

They will take eight or ten jacks and a sack of rice, go into the mountains and stay for days at a time gathering stumps. These they will continue to pile upon the backs of their jacks by means of a small wooden rack, made in the form of a saw-horse. These are held in place on the jacks' backs by means of straps or girths, which are fastened so tight as to cause the poor animals pain. Some of them always show the mark when turned out. They then load them, putting as much on those little jacks—not larger than a yearling—as you will draw at a decent load on a one-horse democrat. You would scarcely believe what I tell you without seeing it. The Chinaman takes his poorest jack and starts ahead, clubbing him all the way to make him keep up, the others following him, in Indian file, at a snail's pace. They take these stumps to Chinatown and cut them into very fine stove-wood. They then fill their racks with stove-wood, putting on from twenty to thirty sticks. They then lead the jacks around from door to door, and sell the load for $1. Sometimes, if it is a small load, they will take "six bits."

You will see these wood-merchants scattered all through the city every day in the week.

They also carry their vegetables in the same manner.

There is one thing that the Chinamen do which is a help to the city. They keep the rags, bottles, and old cans pretty well picked up.

The bottles they use, and the cans they melt in order to get the solder. There are wagon loads of old tins in their neighborhood that they have melted. I do not know what they do with the rags, unless they sleep on them, as there are no paper mills in Nevada. There is one, I believe, in San Francisco. I have been told so, but I did not see it.

The people of Virginia City are very hard on their horses—that is, in the way they drive them. They are always on the run or trot, up hill or down, it matters not

which. You never see a horse driven slowly. You can
sometimes hear the poor animals breathe three and four
rods away. They nearly all breathe as if they had the
heaves.

They wear them out very fast; but I think, as a general
thing, they feed them well, as they all look fat. You hardly
ever see one horse driven; there are always two and four
to the livery rigs. There are a few express wagons with
one horse, but mostly two. The 'busses are driven with
three to four spans. The quartz wagons have from eight
to sixteen spans of horses, but they have two and three
large wagons attached together loaded with quartz or wood,
and all managed by one man. They have one span in front,
which they call leaders, and which seem to know just where
to go. These wagons are very strong. It would take a
whole set of democrat wheels to make one wheel of a quartz
wagon. These wagons all have brakes with a long iron rod
attached. This is fastened to the wagon near the right-
hand of the driver, so that he can reach it in a moment.

There are some of the finest livery rigs I ever saw. It
is impossible to tell who keeps the best; but I think Gear-
hart goes ahead. He is a very liberal man, and always
buys tickets for charitable purposes.

The winters are generally very short, but while the sleigh-
ing lasts, they improve the time, and just coin money by
letting teams at $10 and $15 an hour. This is rather ex-
pensive sleigh-riding, but it does not seem to make any dif-
ference. You will see them flying in every direction.

I asked a man in the East how he would like to pay such
a price to take his girl sleigh-riding.

He said: "She would stop at home a long time before I
would pay such a price."

He asked how they ever laid up anything. I told him
they never laid up anything; they spent all as they went
along. And so they do. If a man lays up anything there,

it is because his income is more than he can spend, or he makes a sudden turn in stocks. It is not often laid up in any other way.

I think teaming is the hardest work done, next to mining, in Virginia City. When a man gets to his stopping place for the night, he has all his teams to care for. By the time one man has taken care of fifteen or twenty horses, it is between ten and twelve o'clock, and he is completely tired out. (You who have but one and two horses to care for know how it is yourself.)

I will now return again to stock-brokerage.

In the year of '73 I took $300 and went to a broker and told him to buy me " Best & Belcher " at $1. He said : " It is not a good buy."

What is ? I asked.

" ' Franklin' is a buy. It is $2 now. It will be $5 in a week," said he.

But a friend tells me " Best & Belcher " is going to $25 before long.

" I guess you will have to wait some time. She is only in a pool," he replied.

I took Mr. Hegan's advice, and bought one hundred shares of " Franklin." I put it in without limit, and when I called for my stock, he said that I had to pay $3 for it, as it had gone up $1. I kept this stock six months waiting for it to go up. But instead of going up, it dropped to $2, and remained so two months, when it went up again to $3. I now rushed down and sold it, after doing without the use of my money eight months, and losing my percentage of buying and selling.

At the time I bought this the " Best & Belcher," which I wanted but did not buy, went up from $1 to $25 in one week.

Had I bought the three hundred shares which I first ordered, I would have had $7,500, making a net profit of $7,200.

Several times I have been advised in the same manner, and allowed fortunes to slip through my hands. After I became more way-wise in the tricks of stock-brokers, I declined taking their advice, and have since had better success in dealing in stocks. But all brokers are not dishonest. There are some very fine men in Virginia City who are brokers.

At another time I lost a fortune through a whim, as my friend, Mrs. Wallen said. I had $81 with which I intended to purchase a sewing-machine. Forty dollars of this sum I had borrowed of Mrs. Rawson, and was on my way home, when I met a friend, who advised me to buy "American Flat" stock, and said it was only "two bits" a share, and would go to $25 before a week.

I told my friend I had $80, but a part of it I had just borrowed. If I used it for stock, Mrs. Rawson might think I had deceived her, and think I had borrowed the money to deal in stock instead of paying for a machine. So I did not buy it. It did go to $25 before the week was out, and thus I missed $8,100.

I have been posted many a time when I could have made fortunes had I had money to invest at the time I received the information.

Whenever I did not have money to invest, I advised my friends to, but some of them would never buy unless I told them where I received my information. But this I would never tell my best friend, because it would not only prevent my getting another post, but would injure the parties who informed me.

One young man made $400 on my recommending him to buy certain stock.

Another made about the same sum by buying "Chollar," but did not follow my advice clear through, for as soon as he sold, he invested his money again in " Wild Cat," and lost all his money but $30, and $7 of that sum he insisted

upon my taking. He said he intended to have given me more if he had not lost it all.

I got most of my posts on stock in the shape of presentiments. I visited the mines in my sleep. I passed through all of the lower levels, tapping their richest veins.

I have visited the rich ore chambers of the "Ophir," "California," and "Union." I have seen them where their walls were apparently sealed up, but they were transparent to me in my nocturnal vision.

I have also seen rich bodies of ore in these mines, which have not yet been discovered by man, and, were I down in the mines, could point out their exact locations.

My dreams have never failed me, not even since I returned East, for I was visited by one of these nocturnal visions just before the big rise of the "Sierra Nevada," in the summer of '78.

At the time of my dream this stock was but $3 a share, with $1 assessment. So you see the stock was really worth but $2.

My dream told me the stock would go very high, and gradually drop to a low figure. It would be highest in September and lowest in December. I was so impressed with the dream that I immediately wrote to my friend, Mrs. Beck, to buy "Nevada," or anything on the north end of the Comstock.

She did not buy when I first wrote, but waited until "Nevada" reached $100, and then she loaded up.

"Nevada" continued to go higher till she reached $300, and instead of her selling at this figure, as I advised her to do, she took the advice of another, and held it for a still higher figure.

Well, it was the same old story—the stock broke, and she was sold out on her "Nevada."

This reminds me of what her little five-year-old girl once told me.

We were speaking of stock, when she came running up to me, and said: " I will tell you how to deal in stocks."

I took the child on my lap, and said: Now, Ida, tell me all about it.

" Do just as my ma does; buy when it is way up, and sell when it is way down."

We all had a good laugh over Ida's advice; and I do not think Mrs. Beck has heard the last of it to this day.

Speaking of stock brokerage by dreams remind me of many happy evenings I have spent at Judge Noyes'. They would sometimes have card parties. (They were quite fashionable in Virginia City). As my boy always accompanied me, I would never take part in the card-playing, not because I thought there was any harm in playing for simple amusement, but I did not like to play before my child, as I did not think him old enough to distinguish the difference between gambling and playing for an evening's amusement. So I chose to wait until he was old enough. I could never be induced to play with them, for I never believed in parents setting an example before their children which they did not wish them to follow.

They would tell me if I did not play, I must tell their fortunes. About eleven or twelve o'clock we had our supper; then my share in the evening's entertainment came in, for I told their fortunes by the cup. I have told ten and fifteen in an evening. I generally rattled off whatever came into my mind first. But the strangest part of it was whatever I told them always came to pass, and sometimes within twenty-four hours after I had told them.

They would always acknowledge what I told them was true, if it were of the past. If it were of the future, they awaited the result of my prophecy. I have even told some of old mining claims they had recorded in early days, and which they had forgotten, and furthermore told them where they would find them recorded.

They have denied knowing anything about it. I told them to wait, and before twenty-four hours they would have an offer, through the mails, for their claim.

I advised them not to sell, but take in a partner and work it themselves. Before the time expired they received the offer. They then thought it worth while to search the records, and there they found what I told them was true. They then followed the rest of my advice, and the " Lady Washington" was the result of one fortune.

I have told certain lawyers that they would have an application to take the same case from the different parties concerned. I have told them which side to take, and they won their case. They would acknowledge they had already had the offers, and were undecided how to act.

I used to predict serious accidents in the mines and on the streets. Sometimes I would tell them several would happen the same day or week. I did this to frighten them away, as fortune-telling became quite a nuisance. But somehow everything would happen just as I predicted. No matter whether it was accident, tragedy, fire, runaway, smash-up, or town scandal, it was all the same, and they would immediately return for another fortune.

I now thought to get rid of them by charging a high fee, and refused to tell for less than $5, and, to my surprise, they would lay the money down before me; but I would never touch a cent of their money, for this would have been acknowledging myself a fortune-teller.

When I saw money was no object, I told them then and there that I would never tell their fortunes again, and they knew when I said this, it was of no use to come again.

I do not claim to be a fortune-teller; but if I had set up the business, I would have made more money than I did at keeping lodgers, but I never believed in such humbuggery. What I did was pastime and amusement.

I do believe that people are sometimes gifted with so

lively an imagination that they are capable of conjuring up almost any circumstance; for I often saw the things passing in my mind that I saw in the cup, and have described some very singular as well as serious and comical things which have come to pass.

While I am writing, a very singular scene presents itself before me. A man has a small, dark trunk in his possession. There are valuable things in it which do not belong to him. He often visits it—in the year 1882. That trunk is destined to be his death in some way, and his death will be recorded in one of the daily papers of Virginia City.

This scene comes up so vividly before me that I cannot help recording it.

I have said the big fire did me but little good, neither did it, for I lost on my eight boarders $417. One of my boarders was taken sick, and when he could get no relief from doctors, he decided to go to the hospital. He owed me $75, and he did not wish to make the bill larger, with no prospects of paying.

After he had been there two months the doctor said only a change of climate would help him.

A lady-nurse, who was stopping at my house, called little Annie (she was a small person, but had as big a heart as ever beat in human breast), got up a subscription list, and went around and raised money enough to send him to San Francisco. She had $15 left, which she gave him for medicines.

I gave him a receipt in full for his bill, for I knew it worried him. He was a very hard-working young man, and I believe strictly honest. His partner owed me $98, but could get no work. I got him a job, at which he earned $20 to get him out of town to a place where he could get work. He promised to send me what he owed me as soon as he earned it But he never sent the money. Perhaps he never got work. He was a very agreeable young man, and I thought honest.

Two other men went away owing me three months' board besides their lodging. Another one I boarded about a year, and took it all in work. In fact, I did not have but one boarder whom it paid me to keep. We called him the "flying Yankee." I never saw him walk unless in the house. Outside he always ran. He was a real, live Yankee, and was as full of fun as he was of business.

He was an agent from the East, selling machinery to the mines, and at enormous figures, and used to come into the sitting-room evenings and tell us what big bargains he had made through the day.

He said: "When I was East, I used to tell my mother and wife of my big trades, and now I shall have to tell you and Mrs. Wallen, or I shall die, for I must tell it to somebody."

I never saw anyone who seemed to enjoy a good bargain better than he did. He used to say: "I am just coining money every day."

He sent home large drafts of money four and five times a week. He was never contented when in the house unless doing something. He would peel potatoes or apples, and cut nearly all the wood burned while he was there, and many other little chores about the house.

He paid $18 a month rent, and $1 a day for his board. All the roomers thought his company was worth his board. After he returned East he recommended a friend, who was coming to Virginia City, to stop at my house. I thought this very kind in him.

His friend came and staid with me as long as he stopped in town. He seemed a very nice man, but was not as pleasant as the "flying Yankee."

We have some very bad men in Virginia City as well as good ones. It is a very common thing to have a citizen stopped on the streets of a dark night and made to hold up his hands.

One man points a six-shooter at his head, while another one goes through his pockets. Respectable ladies have sometimes been knocked down and robbed.

There was a young man there who had made fun of people holding up their hands, and declared no one would make him do so.

His sweetheart and her sister, and his own sister, who was fond of practical jokes, determined to try his courage.

The first time he asked the young lady to go out for a drive, she had her choice of the roads, and chose the American Flat road, which was quite lonely. Her brother and the other young ladies dressed in disguise and went out to meet them as soon as it was dark.

As he was driving along he heard the word "Halt!" His horse was seized by the bit, the muzzle of a pistol thrust in his face, and told to pile out. After he had left the carriage, he was told to throw up his hands.

He did so. They went through his pockets, taking his watch and chain, and other valuables.

They now turned to the carriage and told the young lady to hand over any jewelry she possessed. He begged they would not frighten the young lady. They paid no attention to him, but took all that she had.

They then said to him: "Pile in and git!"

He was quite willing, and did not wait for a second bidding.

When he was gone they took a nearer road and reached home before he did.

I was told he received all his things in a package, accompanied by a note, warning him never again to say he would not throw up his hands.

The joke was too good, for it soon leaked out. After this he was never heard to brag of his courage.

I give you the story exactly as it was given to me.

When I had lived about one year in my own house, I **was**

troubled with my teeth, and had three of them extracted. At the time I had them drawn, they did not bleed much; but some three days after, I lifted something very heavy, which caused the blood to rush to my head. This caused the cavities in my gums to bleed very freely. It was some time before I could check it.

When I retired for the night I told Charlie if he heard any noise in my room in the night, to come in. But he is a heavy sleeper, and did not wake during the night. About three o'clock I woke up strangling, and my mouth full of blood. The bed seemed wet and damp around me. I managed to strike a light which stood near my bed, when I discovered the pillows and sheets around me saturated with blood. I managed to take off the cases and roll the dry end of the top sheet around the pillows. I now reached to the table and got some towels and a table-cloth which laid there. The latter I used for a sheet, and the towels I spread over the pillows. While I had been doing this I was also holding alum and salt in my mouth (which I had placed near my bed before retiring). With this I succeeded in checking the blood, and laid back on my pillows. Feeling very faint, I rapped on the wall at the head of my bed for Charlie—his bed being on the other side—but failed to arouse him.

I then became deathly sick; having swallowed so much blood while sleeping, I now commenced vomiting. This caused the blood to rush to my head again, and flow in a stream from my mouth. I now gave up all hope, as I was unable to leave my bed or call for assistance. It was now nearly five o'clock.

But hope revived. At this moment the door opened, and Charlie came out of his room. A wash bowl of blood stood by the bed-side, saturated towels and pillow-cases laid scattered over the floor, the bed was also one gore of blood, and the crimson tide was still flowing from my mouth.

As his eyes took in the scene, they dilated with horror. He rushed to the bed, and seizing my hand, which was icy cold, exclaimed: "Oh, my God! Ma, you are bleeding to death like the poor man did on C Street!"

He was speaking of a butcher who had burst a blood vessel by lifting a quarter of a beef, and who died on the sidewalk before assistance could reach him.

He took a towel, wet it in cold water, and laid it about my neck. He now ran to the door of my only roomer, and said: "Get up quick, my mother is dying! Build a fire, put on the tea-kettle and the flat-irons! Hurry, hurry! I am going for a doctor!"

Dr. Greene being the nearest, he went for him. The doctor said it was hemorrhage of the gums, and he would have to get a dentist.

He then went after Dr. H——, who said: "Tell your mother to come down here, and I will give her something; I don't feel well, and can't go. I think I am going to have the fever."

"But, doctor, my mother is dying! I want you to come quick," said Charlie.

"I can't," the doctor said.

"Well, then, give me the medicine," said Charlie, "and I will give it to her."

"No; it is poison, and you might give her too much," replied the doctor.

Charlie began to mistrust that the doctor's head was a little muddled by hot toddy, although he claimed to be a Son of Temperance.

Charlie, now thinking the doctors might all be too drunk or sleepy to be aroused, came running back home, not having been gone over twenty minutes.

The cold water he had placed about my neck had the desired effect, for the blood had almost ceased to flow.

I was very cold, and Charlie placed the flat-irons all

around me in bed. He then said: "I could not get a doctor to come," and turning to the roomer, said: "What shall we do?"

Before the roomer could speak, he added: "Oh! I know what to do now." And suiting the action to the word, he came to the bed, tore open the quilt, took out some cotton, made three little wads, and saturated them with cinnamon oil. He then came and pressed them into the cavities of my gums.

This was heating to the gums and caused them to swell and hold the cotton in place. He had often used this for his teeth, and knew it benumbed the gums, and thought it would stop the bleeding. He is a good nurse, and quite a physician in the Thompsonian line.

He saved my life by this little act; for half an hour longer would have ended my days. I can call to mind many other instances where his care and thoughtfulness saved my life.

I will here relate some little anecdotes concerning him.

When Charlie was about twelve years of age, he, like the other little boys, had his sweetheart. One day he caught one, Monnehan, sending a note to his girl. He immediately challenged him to mortal combat, giving him the choice of weapons, and also the place of meeting.

Monnehan replied on the opposite side of the note: "We will meet at the race-track with knives or pistols."

This was sent in school hours. After school Charlie lost the challenge.

A gentleman finding it, and thinking it a serious affair instead of a joke, as it was intended, took it to the *Chronicle* office and had it published.

He said: "Such boys ought to be looked after before they kill each other."

The boys thought it a capital joke on him. I have since heard them laugh several times over their sham duel.

Charlie was quite full of fun when a small boy, but would

never do anything he thought there was harm in, for he had nothing wicked or willful in his nature. He was also very truthful.

One day, at noon, he and several other boys about his own age put some pepper on the stove. When the teacher went to call the school, she could not enter the room. She threw open the door, and asked if some one would not go in and raise the windows. No one seemed willing to venture. About this time Charlie came from his lunch, and seeing what they had done, he rushed in, holding his breath, and threw open all the windows.

After the room was thoroughly ventilated, she called the school to order, and asked the scholars if anyone could tell who put the pepper on the stove.

A girl spoke up and said she thought Charlie Mathews and the other boys (naming them) did it.

The teacher asked her why she thought so.

" Because I saw them all go into the school-house by themselves."

The teacher now turned to the boys, and asked each one separately if he had put pepper on the stove. They all, expecting a sound whipping from both their teacher and parents, denied it. It so happened that every boy, excepting Charlie, was the son of a trustee.

Charlie was the last one she put the question to. He electrified the whole school by acknowledging he did it.

" Who helped you ? " asked the teacher.

" No one helped me," said he; " I was alone when I put it on."

" Do you think anyone else put any on ? " again asked the teacher.

He said : " The Blakely girl might have put some on."

" What makes you think so ? " asked the teacher.

" Because I saw her go in alone just after I did ; and I judge her as she did me."

The teacher said: " It is quite a righteous judgment."
She also said: " I am satisfied others put pepper on the
stove besides you; but since you take the whole blame on
yourself, and say you did not see anyone else, I believe
you, and, for your truthfulness, will forgive you, and dismiss
the case."

Mrs. Somers was a very sensible lady, and believed in
encouraging truth in children by kindness, rather than pun-
ishing them for any little misdemeanor after they had
frankly acknowledged it.

Would there were more such teachers in our public
schools.

When Charlie related the story to me—for he always told
me his little faults—I explained to him how dangerous such
tricks were, and also told him he had laid himself liable to
the law.

Charlie and his mates were quite fond of hunting and
fishing. One day he and Sammie went off fishing to
Washoe Lake. The boat they took proved to be a leaky
one; and when they were some distance out on the lake,
the boat began to fill.

He said to Sammie: " Pull for your life for the shore,
while I bale her out."

" What with ? " said Sammie.

" I will show you," said he, taking off a new hat he had
just bought the day before, and commenced dipping away.

" Oh! you will spoil your hat," remarked Sammie.

" Better do that," said Charlie, " than sink in the lake. I
can't swim."

" Goodness ! " said Sammie; and he fairly made the boat
fly till he reached the shore.

They did not try fishing any more that day; but went
off in the mountains hunting game. They returned home
that night with two rabbits, the fruit of their day's labor.

I asked Charlie how he spoiled his hat.

He said : " It is not spoiled ; it is just the thing for the theater," and away he ran with it to his room.

In one of Charlie's hunting expeditions, he and his friend, Gussey Nye, got strayed away from the rest of their company ; and as they did not reach camp as soon as the rest, the boys thought they had given them the slip and gone home. As soon as they had got their suppers, they broke up camp and started home.

Charlie and Gussey were still in the mountains, but were soon driven into camp by a sudden snow storm ; but behold ! when they reached it cold and hungry, there was nothing but the bare ground.

" The boys have gone and left us," said Gussey ; " we will have to foot it to Virginia City."

" We can't go eleven miles in this storm to-night," said Charlie, " but we can reach the cabin, two miles from here, by dark ; so let us be going."

Before they reached Virginia City they gave out three times, and then laid down to rest. They would soon get up and start on their journey ; for to give up they knew was to freeze to death in the snow. They finally reached the cabin, where they went in and fell exhausted to the floor. The man who owned the cabin knew the boys, covered them with blankets, and gave them warm tea to drink. After awhile they recovered, and ate a nice warm supper which the man had prepared, and then all turned in for the night. The next day being fine and clear, they started for home, at which place they reached some time in the afternoon just as the boys were about to start back after them, for they had sent to my house for Charlie. I told the boy who came that he was off with a hunting party. When the boy told them what I said, they sent him to Nyes', and received the same answer. They now became alarmed, and were just going out to find them as the boys appeared on the scene, when they all set up a shout of welcome. They

told Charlie how frightened they had been when they found the other boy had not come home.

I think this cured Charlie of his love for hunting, for he never went again.

Gussey Nye was a very nice boy, and of one of the best families of the place. He and Charlie were almost like brothers, being inseparable. Their tastes in sport were very much alike, therefore always agreed, although both were very quick-tempered. If Gussey became angry, Charlie laughed; if Charlie's anger was aroused, Gussey laughed. This was their way of settling disputes. Gussey had a little brother whom I think Charlie loved as well as he could have loved an own brother. He was run over by the cars, which caused his death. This was the first corpse that Charlie ever went voluntarily and looked at. He was a sweet child, and no wonder Charlie loved him.

Charlie was very orderly about his room until he commenced acting in the theater; and then it was enough to break one's neck to get through his room. In less than half an hour after I had done up his work, books, papers, and wardrobe would be scattered promiscuously over bed, table, chairs, and floor, especially while he was learning to do lightning changes.

I did not wish him to go on the stage, but he seemed to prefer it to any other profession. And as I do not believe in forcing children against their will to any trade or profession, but to let them do what they are most capable of, I let him have his choice.

I will now leave Charlie and his doings for awhile, and return to the description of Virginia City and some of its curiosities.

The cemeteries of Virginia City are almost as numerous as the different orders.

The Masons, Odd Fellows, and firemen have their ground. Wilson & Brown have theirs for the benefit of those who

do not belong to secret orders, and who do not wish to be buried in the city grounds. The Catholics and Jews have theirs. These grounds all join, or are all in the immediate vicinity of each other.

They are very handsomely laid out, and are well kept and irrigated, nearly every grave having choice plants and flowers. The yards are all supplied with water tanks and hose, and a man is constantly employed to care for them.

The Gold Hill cemeteries are also very nice. The monuments and tombstones here, as well as in Virginia City, are some of the finest I ever saw. My brother is buried in the Gold Hill Cemetery.

The County House has still another on the slope just back of its building. The Chinese grounds join this.

When the Chinamen bury their dead, they place food, candies, etc., on the graves for their gods to eat while watching over them. After their funerals are over, and they have gone back to Chinatown, the Piutes go out and eat up the provisions, making a regular feast on cold hams, turkeys, and chickens. Sometimes they would get caught, and a fight be the result.

The curiosities of Virginia City are many in number.

One of them is a sheep, owned by a man who keeps a livery stable. It will go every morning to the nearest saloon, put his fore paws upon the bar, and bleat for his morning dram. After he is waited upon he will go out of the door, look up and down the sidewalk until he sees some old friend coming. He will then go and meet him, and follow him about until he gives him a chew of tobacco, when he will walk off to the stable and lie down. He is a fine, fat fellow, and quite intelligent-looking.

Another curiosity is the whipping-post, erected in 1876 for the punishment of men who were in the habit of whipping their wives.

One justice there would never sentence men to be tied

to it and whipped, although many were guilty of whipping their wives. It was a large post the size of a man, with a cross piece; it is simply a cross about six feet high. For this reason the justice was nicknamed " Holy Moses."

Another curiosity is a fence owned by the same man who owns the sheep. It is over twenty feet high, and has to be braced by long timbers joined on to his house to keep the wind from blowing it down. This fence was put up to keep his neighbor's wife from looking over—a woman scarcely four feet high.

If the house on one side takes fire, the one on the other side will be in no danger, for no flames can scale its top.

I think if he takes it to the next Centennial, he will be sure to secure the first prize.

After I became acquainted with Mr. French, I asked him what became of the man that murdered my brother.

He said: " He ran away."

Did you, or anyone, offer to arrest him?" I asked.

"No," said he; "we were going to, but Charles would not let us. He said, 'Let him live and repent. His dying will do me no good. I do not believe in legal murder.' And Elgin did repent, so I was told; for he was seen four years after your brother's death, and he was a walking skeleton. He said he thought Charles a desperado like himself, or he would never have shot him. I tried to persuade Charles, but he wouldn't hear a word of it."

When I heard this, I determined to let the murderer go, since it was my brother's dying request.

I wrote immediately to my parents, informing them of what I had heard, and asked them what I should do.

They wrote me to respect my brother's wishes.

I afterwards learned, through a man styling himself his friend, that he was in Virginia City, and about starting in business.

He then said: "Do you intend to do anything about arresting him?"

I suppose he wanted to let him know if I did.

I said: I do not intend to go and hunt him up; and as long as he keeps out of my sight I will not arrest him, since it was my brother's request. But if he comes *here*, he must take the consequences, for he and I can never live in Virginia City at the same time unless he is a prisoner.

He said: "I saw him not fifteen minutes before I came here."

I then said: I will give you $25 to point him out to me.

He said: "No, I will not do that; but I will see him, and tell him what you say, and find out whether he intends to stop. If he does, I will let you know."

He also said: "Elgin was secreted in a lodging-house at American Flat, the night of the murder, till after twelve o'clock. The same parties furnished him with team and provisions, and run him off into the Washoe Mountains, where he staid all winter."

I never heard of anyone there by the name of Elgin, and think his friend must have warned him to stay away.

Mr. Jones, the milkman, also told me that Charles requested the people to let the man go.

My brother was very much opposed to hanging, even when quite a young boy. He thought imprisonment for life quite sufficient for any crime, and it seems he carried out his principles to the day of his death.

As I have said before, my brother had no bad habits when he left home, and I wished to see if his life in Nevada had changed him. I asked Mr. French if he became wild or dissolute, as many do out there. I asked him if he ever used profane language or gambled.

He said: "No, he never gambled, but he often played checkers for amusement; and the nearest I ever heard him come to swearing, was one day when I was unloading

whisky at my store. I saw him coming, and told the boys
I would have some fun with him. When he came up I
asked him to give us a lift on this barrel. ' No,' said he;
' I will not touch it. I would sooner send the soul-destroy-
ing stuff to h—l.' Now that is the nearest I ever heard him
come to swearing."

The reader will see by this that he neither gambled,
drank, nor used profane language.

What happiness to me to be able to send back such tid-
ings to his parents !

It was a great consolation to them to know that their
darling son had died possessed of the same principles they
had instilled into his mind in youth.

Now, what could a young man, possessed of no bad hab-
its, be doing for seven long years, and not be worth any-
thing ?

Mr. Waters says "he had streaks of good sense above
the average."

I have a statement in my possession, written by one, Mr.
Carter, whom I sent to Mr. Waters to make some inquiries
about my brother. The statement says that "Charles was
a very simple fellow, and did not know much."

This does not seem to correspond with the above state-
ment.

I called at their house one day, and made myself known
to Mrs. Waters.

She said: "Seems to me you have been a good while
coming round."

I told her I had called to see what she could tell me
about my brother.

"Well," said she, "he died three days after he was shot.
I took care of him all the time he was sick. He didn't suf-
fer a bit. But you needn't worry yourself, for he couldn't
live, no way ; he was in the last stages of consumption. I
made him some medicine for his cough, and used my own

money to get it. It only cost 'two bits,' but he said he hadn't the money to buy it. And I loaned him money to buy a suit of clothes, as he had not a decent suit in which to go to Lincoln's funeral till he got them; and they came real good to bury him in, if they were cheap."

I asked her what they were.

She said: "Just common brown tweed."

The above conversation she rattled off, hardly stopping to breathe, as though she had purposely committed it to memory for the occasion.

Now Mr. Waters had written "he was a man weighing somewhere near two hundred."

I do not exactly remember the figures. And also said "he was in good health generally."

At his examination he also said: "I loaned him money to buy a suit of clothes."

In one of his letters he says: "I loaned him money to buy a nice suit of clothes in which to appear at Lincoln's funeral procession, but he told me they were stolen from his cabin some weeks before his death."

Now, reader, who spoke the truth, think you? or could it be possible both bought him a suit of clothes for the same occasion?

If so, how much more generous Mr. Waters was than his wife, and how very fortunate that both suits were not taken!

Perhaps you think as I do, that neither of them told the truth, for I have Mr. Scott's affidavit, in which he states that he spent two weeks at the house of Judge Watson, where my brother boarded, and saw him every day.

He said: "He was dressed in a good business suit the night he came there, and all the week; but I noticed Sunday he dressed up in a nice suit of black. He also had a silver watch and black cord."

He said: "I had a long talk with him when I found his

name was McNair, as I was acquainted with all his relatives at Dansville and Mt. Morris, in Livingston County, N. Y." (Mr. Scott is now living at Canaseraga, Livingston County, N. Y.)

Mr. Scott's story tallies exactly with Captain John Day's, ex-surveyor-general of the State of Nevada, who said he was dressed in a nice suit of black when he came to get him to survey the mill-site.

Mr. Scott saw him in '63, and he was killed two years later.

Others, who knew him at Todd's Valley and Gold Run, told the same story, that he always dressed up on Sunday. He would never work on that day for himself or anyone else.

I was not only told this by those who knew him, but I learned it from his private papers. There were several contracts for running tunnels, each one to be run so many feet each day of the week till the work was completed, Sundays excepted.

Mr. French also said he always dressed well.

I did not find as many people in Virginia City who were acquainted with my brother as I expected, as people move around so from place to place. I found a great many people in different parts of California who knew him. I have a great many letters from these people, and all speak in the highest terms of him.

One said: " His death was the result of his exalted patriotism, which was superior to the more cool and calculating politician."

My brother was like myself; he never allowed obstacles to hinder him from accomplishing anything he undertook. In his diary I read an account of his swimming the Platte River. It was when he was *en route* for California. It seems his cow got away from him in the night, and swam to an island in the river.

While the rest of the company were preparing breakfast, he went to look for his cow. When he found her, she had a young calf by her side. He picked the calf up in his arms and swam back to the shore, leaving the cow to follow. When he reached the shore, he said he presented a very laughable appearance in his coat of ice, which he soon replaced by a dry suit.

From all that I learned while searching out his affairs, I am satisfied he was not a poor man, but was the owner of a large estate, the whole of which I have not succeeded in getting into my possession, but hope to the next time I visit the Coast.

I think my brother must have displayed a great deal of pride in dress to have appeared in a suit of brown tweed at the funeral of the savior of our country, when every miner dresses up in a nice suit after his work is done for the day. I cannot see how he came to be so far behind the other miners as not to keep a decent suit.

Reader, I don't believe a word of his not having a decent suit, neither do you.

Speaking of brother Charles reminds me of an anecdote related by my brother Hugh when he was down from the West. He said Charles had a balky horse, and he said to him one day, "Why don't you get rid of that horse?"

Charles replied: "I cannot; no one wants her."

"That is because you let everybody know she is balky," said Hugh.

"Well, what shall I tell them?" asked Charles.

"Don't tell them anything," replied Hugh; "if they do not ask you, let them find it out themselves."

"And get their neck broke!" exclaimed Charles. "Well, I shan't do anything of the kind. You are a pretty Methodist to give such advice!"

Hugh said that after studying the thing over, he began to think Charles was right.

CHAPTER X.

Chinatown and John Chinaman of Virginia City.

CHINATOWN, of Virginia City, is like Chinatown of every other city of the Coast—a loathsome, filthy den. It is enough to breed cholera or any other pestilential disease.

It is situated at the north-east end of the city, on a part of the only level ground in the place, and might be made the handsomest part of it were it not for this filthy race of people. All the drainage of Virginia City is allowed to pass through their place in streams of filth over the surface, and is conducted in ditches to their gardens, to irrigate them, instead of buying water.

It is in the immediate vicinity of the Alexander Brothers' milk ranch, which, together with their own filth, makes it almost impossible for white people to pass through without holding their handkerchiefs to their noses.

A person wishing, for curiosity, to make a visit to their town, and go through all of their dens, ought to have his clothing and head thoroughly saturated with bay rum and camphor. A person ought to carry a bottle of carbolic acid in one hand and a pail of chloride of lime in the other, to insure himself against catching some loathsome disease.

I never visited any of their places in Virginia City except wash-houses and the brick store, and their "Josh House." The brick store is owned by a rich Chinaman, who is the head man of one of the companies. The store was well

filled with groceries—any amount of rice being done up in
sacks. They also had large quantities of hams and bacon,
and all kinds of foreign nuts and dried fruit. There was no
end to their variety of candy, but the most loathsome kind
to look at, and in taste, too. I do not know how any per-
son can eat it. They have one kind which seems to re-
semble fat meat cut in slices, and preserved in sugar till it
is all candied over on the outside.

I wonder what kind they fed Anna Dickinson on? I
think if she had seen some of the sights I have seen, she
would not care to be entertained by any more Celestial
gentlemen. I think they are the filthiest set of people I
ever met.

I have stood in my door and looked through a kitchen
window, which opened into my yard, and have seen them,
with a fork, take a rat from a kettle in which they were
cooking it for boarders, bring it to the window on the fork
to cool, then strip the flesh off with their teeth, and then
throw it in my yard. I examined it to make sure I was not
deceived.

When I lived on G Street I was not over thirty rods
from this town. I could stand on my back porch and see
them skinning rats, but could hardly believe it—when I
was told that that was what they were doing—till I went
down and passed by the steps where they were at work.

I have been told that a rat pie is a great Christmas
dish with them. They hold their Christmas the same as
we do. They generally keep up Christmas and New Year
a whole month. They build a large ring in the street, like
a race-track, only no larger than the street will allow.
They then take fire-crackers and join them together by a
fuse, and when the entire ring is complete, and it is dark,
they set fire to it; and every instant one of these goes off or
explodes, or as fast as the ring is burned up, another train
is laid. This is kept up day and night the whole time. Also

large bunches of fire-crackers are tied to their doors. This is done, they say, to drive the devils away. They have a very merry time at this season of the year.

Their "Josh House" is the only place they seem to take any pride in. It is their place of worship. They keep it very neat and nice. There is a curiously-built altar at one side covered with heathen gods, of all sizes and kinds, both wood and iron. It is arranged very tastefully, and ornamented with all kinds of china toys, some of which are very handsome.

They show great skill in making toys, especially bird and butterfly-kites; but I never heard of any useful invention.

They learn the American language very readily.

I copy here a letter from the *Chronicle*, written by one of them to a gentleman of Virginia City:

HONG KONG, May 30, 1879.

MR. WEBBER & GUMBERT,

MY DEAR SIR: On the a few months ago I left you in Virginia City for I to China returned Home and give my visit to your all family for my information I may state also I will come back within six months the useful of request my father & mother order I believe. See you again please give my compliment to see you with many obliged.

I am sir your most friend. You treats me very much kindness how shall I compensate you. Owing to your happiness I have to ask you to do me favour to look out a situation for me you very well keep it memory. When you have do a suitable berth you will send my word.

TOPSY.

They also will do all kinds of our work. They will scrub and clean, or tidy up a house as nice as any American, but the most of them are slow. They will do everything you tell them to do if you stand over them or watch them; but if they can slight anything, they are sure to do it.

Any person employing them never knows what he is eating. They are always tasting the victuals, especially soups. They will take up a dish, eat what they want of it, and back the rest goes in the kettle. Those who know how, make very nice pastry—that is, if you know not how it is made. Their pastry is very tempting-looking; but when you see them take milk in their mouths and spirt it over the bread, biscuit, and pies, instead of using a swab of white cloth, as Americans do, I think many of you Eastern people would hardly fancy their mode of basting pastry.

They are just as filthy about many other things they do. I had a good chance to see many of their filthy habits. Washing their feet in the dish-pan was a common occurrence. They are regular eye-servants. I asked a lady why she employed them.

She said: "They will do things for us I would not like to ask a white person to do; besides, they never tell any family affairs like white girls do; but they tear my clothes to pieces, in washing them, faster than I can make them."

Nearly every house among them is a wash-house, and each one is but one story. The tops of the houses are covered with a floor, raised level on the peak by placing pieces of timber on the slanting part to raise the floor to the level with the peak, then around the four edges of this place is a railing four or five feet high. The longest sides have holes bored through, and ropes run across, all one way, about two feet apart, where they always dry their clothes. They are generally good washers and ironers.

They have in their houses large barrel-tubs. These they let cold water run into constantly, and at the same time it is running out in another direction. This keeps the suds clean all the time; but they waste a great amount of water. They gather their clothes in a wad, and strike them on a board with such force that it takes the dirt out of them, but it takes the garment to pieces at the same time.

If they can get a river to wash by, as they can in most of the California towns, they get a large boulder by the side of it, or a barrel, block, or box, anything solid. They then soap the clothes, dip them in the river, and then strike them on the stone, or whatever they have, and continue this till the garment is clean; they then scald and rinse them, and hang them up.

They are good hands to do up starched clothes. They always sprinkle their clothes with their mouth, taking nearly half a pint of water in their mouth at once. I have seen them sprinkle three large garments with one mouthful of water. The most of them sprinkle them as they iron them, such as dress skirts; and all the while they are ironing, one will hold the water in his mouth, every few moments spirting it on the dress till it is finished.

But who wants to wipe his mouth, face, or eyes on a handkerchief, towel, or napkin, or lay his victuals on a table-cloth, that a Chinaman has spit on, when perhaps, at the same time, he is nearly dead with some loathsome disease, so that his face is one corrupt mass?

Who wishes to take the chances on such things?

I do not think Henry Ward Beecher could have seen much of their doings to have been so taken with them, or else he must be in his dotage. He may be a splendid lecturer, but he is certainly not a scientific inspector of Chinamen. What he could learn in a few days in San Francisco is not like ten years of every-day observation in a place where you meet hundreds a day.

They are a very quarrelsome race, always fighting among themselves. It is unsafe to pass through their quarters after dark. There are in Virginia City two parties, and they are hardly ever at peace. They cause the city a great deal of trouble and expense.

Beecher says they are a very harmless people. There must be a superior race of them in San Francisco, for I

have heard of two or three murders that some of them have committed in Virginia City. One was a colored cook, a very peaceable man, who was stabbed by an under-cook.

If American people were ever cursed by anything, it is by this miserable, thieving, murderous, licentious, filthy, pestilential race of heathens.

There are many reasons why they should be banished from the land, if there is a law to do it; and if there is not, Government should revise its statutes, and make one as speedily as possible.

First, because they are a very treacherous race, and any-one does not know what moment they will turn on him in his own house. I remember when I was at Mrs. Burk-halter's, at Dutch Flat, of one coming into her kitchen and demanding money of her, and of her calling me into the room because she was afraid of him. He had only worked a short time, but demanded pay for a month.

She told him if he staid there the month out, she would give him pay for a month.'

He would not, and thinking she was alone, would scare her. When he saw she was not alone, he left.

Another reason is for their awful thieving. No one knows when they will rob the house and leave. You can't always stay at home; and if you go, you have to take your chances.

The third reason is their awfully filthy habits. All they want is two rooms, one to wash in, the other to iron, eat, and sleep in. They have their table reach from one end of the room to the other, with a curtain around it.

Under this table they pack ·the dirty clothes they have gathered from fifty or a hundred people, perhaps half of them sick people, with half a dozen kinds of fevers, and other infectious diseases.

Well, when it is bedtime they crawl into these dirty clothes and sleep. I was told this, but could not believe

it. The party who told me this went to a wash-house, rapped at the door very early, and receiving no answer, opened it. The room was still, and nothing but the curtained table to be seen. When we called out John—for that is the name all Chinamen go by—a Chinaman raised the curtain, and asked what we wanted. We asked him if he could do some washing for us. At this the curtain was raised in different places till I counted eleven heads.

Their spokesman, who seemed to be boss, said : " Me get up soon, thenee you comee. I ketchee washee."

As they lifted the curtain, I could see that the filthy clothes they had gathered the day before were used for their bed.

In a little while we went back, and they were all eating rice and drinking tea. So the bed answered for a table.

I counted four of them with faces perfectly disfigured with swellings, another with an ulcerated sore face, being one mass of corruption, and two in the last stages of consumption; yet they all ate and slept together. I was told that they sometimes slept on the top when there were too many to sleep below.

The stench that came from that room when we first opened the door was enough to breed an epidemic in the month of January. I only wish some of the Eastern tourists, who are so taken with them, could have inhaled one breath from that den; and it is the same in every washhouse.

The fourth reason is the way they are breaking the wages of the honest, hard-working man by their cheap labor.

They can afford to work cheap when they live on comparatively nothing.

They can live on a pound of rice a day, and a little tea ; and if they can't, they can steal the rest. They are very fond of ham and bacon; these they can steal from restaurants and groceries. They are also fond of chickens and

any kind of poultry; and if they cannot steal them, they will buy them.

There was an old fellow among them who had stolen so many that he was called "Chicken-Charlie," and there was scarcely a week but he was in jail.

A cook and two dish-washers will steal enough from one boarding-house in a month to last them all winter, if they happen to get discharged.

They are very fond of soup of any kind. They eat with a small whalebone a foot long, which is made in an oval shape, while the other is square. They hold three or four of these in each hand, and by very rapid movements of the hand, they sling their food into their mouths with these sticks which they hold, so that the square points all come together and form a sort of scoop. They can eat soup or rice, or any solid food with them more rapidly than you can eat with a knife; and all the time they will keep up an unceasing chattering at their meals. It is a perfect babel.

It is quite a sight to see them eat with the chop sticks I have just described.

The poor white laborers have no show where they are, because as long as rich capitalists can get their cheap work they will do so. A white man with a family cannot live on rice and stealings. He has to pay from $12 to $20 for wood, $25 for coal, and from $10 to $50 for a house a month; 3 and 4 cents for potatoes and apples; $1 for a pound and a quarter of butter; 10 cents a pound for beans; 25 and 35 cents a pound for beef; 12 and 15 cents for sugar, and other groceries in proportion.

Now, if wages are put down, what is he to do?

There is but one way for him to do, and that is, do as the thieving Chinamen do—be locked up from their families two-thirds of the time, and let the city support them, or let them starve.

The Chinamen have no families in this country, or at

least but few of them have. They say the respectable women do not come to this country. But I do not think the Pacific Coast will tolerate them much longer. I see that they are not allowed to enter Leadville. Would it were so all over the United States!

There is another reason why they should be banished. Our little daughters are not safe under the same roof with them, as Virginia City, Gold Hill, Carson City, San Francisco, Sacramento, and other places on the Coast can testify to.

Some of the best and most respectable people of these places have had their feelings lacerated, their hearts filled with anguish, on account of the sufferings brought upon their little children, all the way from four to twelve years of age—mere babes ruined for life.

Go ask these heart-broken parents if they would have them stay, you that are so anxious for China slaves.

Their answer would be, banish them, now and forever!

If you think I am overdoing this picture, go search the records of the San Francisco, Virginia City, Gold Hill, and Carson City papers. There you will find things recorded too horrible to be mentioned here, and too sickening to be repeated. I only wonder at the forbearance of these crushed parents.

Again, there is still another reason. They have commenced intermarrying in our nation.

These moon-faced creatures will in a few years, if things are not changed, ruin our country.

Another great reason they should be banished is to prevent their bringing the leprosy on our nation. There are several well-known cases in San Francisco where some of them sit on the public streets and ask alms of the people, and I have heard of two white cases already.

How long, think you, before this baneful disease would sweep through the entire length and breadth of our glorious America?

I have seen them carrying baskets of clothes on the main streets, through large crowds of men, women, and children, when their faces looked as if the flesh would drop off one part, while the other was as spotted as an adder, with blue and white spots, and the stench as you passed them would make you carry your handkerchief to your mouth and nose till they were lost sight of in the crowd.

Now, such a person is not safe, and ought not to be allowed on the streets. If the board of health would look a little after these Celestials, they would prevent a great deal of the contagious diseases of Virginia City.

I do not think it safe to wear clothes of their washing, for they are as apt to wash their own clothes with yours as any other way. It is just as safe to wash in the same basin with them. I do not and never did take such chances on my life.

There is not a city in the United States visited by more travelers than San Francisco. How long, then, would it take to spread this loathsome disease?

Another reason we do not want them is they never leave a cent of the money they get in this country, but carry it all off to China, draining our country of its wealth, impoverishing the land, and with their cheap labor starve our white people until they are driven to crimes of the deepest dye.

This is so, and there is no gainsaying it. The people of the Pacific Coast know it is the living truth.

The Chinamen, I am told, pay no license for washing, but a poor, little, half-starved, bare-footed, half-naked boot-black, with a face, heart, and conscience as white as the best of you law-makers—he who earns enough to keep from starving—has to pay a license, or is locked up.

If a widow with half a dozen children starts any of them out with a basket of fruit, candy, pop-corn, and so forth ; or a poor one-armed cripple in the same business, they, who

can make a living in no other way, have to pay out all they can get for quarterly license, or are lugged off to jail, while the moon-faced Chinaman engages in whatever he will, and goes free.

Is it any wonder that our jails and prisons are filled with men and boys, who might, if allowed a chance to make an honest living, and encouraged in industry, or business of any kind, grow up to men of honor, and be a blessing to the community?

Here is a study for you law-makers. For their sakes, as well as for the good of the public, let the boys and girls engage in any kind of business they may chose to make a living at without a license, until they are of age, and they will bless you, and God will bless you; and if you will and must keep the Chinamen here, make them leave a part of their money here by paying license.

Again, their opium dens, which seem to defy all police power to break up, are a nuisance, and are also ruining our people, for many have become slaves to this most destructive habit.

Not only men and women visit the opium dens, but I am informed, by good authority, that girls and boys visit them, and often have to be helped home by their companions.

Girls and boys, from twelve to twenty, are daily being ruined by this opium smoking.

I never visited one of these dens, but have had them described to me.

A table sets in the center of the room, a dish of opium upon that, and long pipes for each smoker is dipped in this, and they lie on bunks around the table and smoke till they become unconscious.

After a person once smokes, he has created an appetite for a vice that he has no power or wish to refrain from.

You who are so far from these scenes of vice have no idea of the baneful effects of this pernicious habit. It is

utter ruin to smoke the first pipe, for there is but one way to keep them from it afterwards, and that way is the walls of an asylum.

The Chinamen are of a low, groveling nature, and will take any amount of abuse, and even a whipping, before they will lose their place; but they are sure to avenge themselves afterwards in some way.

The Chinamen, like the monkey, are very apt in learning all our ways. In fact, I think they are Darwin's connecting link between the white man and the monkey, for they seem to possess all his craft and cunning, and revengeful spirit.

And now I have set the Chinamen before the people in their own true Celestial light. I have not exaggerated in the least.

Let those who doubt me go and spend five years—just half the time I did—and they will come away converted; and I will warrant not a man of them will ever cast his vote for a man who is in favor of allowing them to come to this country, but will do all in his power by talking, voting or lecturing to keep such men out of office.

The people of the Pacific Coast, as a mass, will never vote in favor of the Chinaman to go west of the Divide on this Continent.

I warn you poor working-men of the East to save yourselves and families while there is yet time, or in five years more you will see these Celestials come pouring down over the eastern side of the Divide like a herd of buffaloes. Then you may look for other means to support your families, for the paltry sum you now get will be reduced still lower.

You now get from $1 to $1.50 for a day's work, and many get but 50 cents; but when your cities and towns are swarming with filthy Chinamen, three to every cord of wood, cutting it for 50 cents, grabbing at every chore to be done, reducing the price of labor on all public works, crowding you entirely out, or compelling you to work with them, at

the risk of your life, for the same pittance they receive; when you are compelled to do this, I say, or see your families starve before your eyes; when even your girls, who are trying to assist you to bring up the younger members of your family go out to work and bring home their wages; when they are driven out of the dish-water by China labor, and compelled to beg in the streets, or do worse—then, O, then, it will be too late!

Now, my readers, this is no idle talk, for these things are not far off, if Chinamen are allowed to continue their emigration to this country.

Then work to keep them away. There is yet time. Cast your vote every time for a man of good sense, who will work for the interests of his country.

They say we cannot prevent them from coming; our Constitution allows them to come; we cannot help ourselves, and we cannot go contrary to the Constitution.

Can't we? Well, now, let us see.

First, I would like to ask for what and for whom was the Constitution of the United States framed? Was it for the benefit of foreign nations, or for the people of the United States?

Let history answer.

A convention of deputies from the States of New Hampshire, Massachusetts, Connecticut, New York, New Jersey, Pennsylvania, Delaware, Maryland, Virginia, North Carolina, South Carolina, and Georgia, at a session beginning May 25, and ending September 17, 1787, said:

"We, the people of the United States, in order to form a more perfect Union, establish justice, insure domestic tranquillity, provide for the common defense, promote the general welfare, and secure the blessings of liberty to ourselves and our posterity, do ordain and establish this Constitution for the United States of America."

Now, what is plainer than this?

If the great and wise men who formed the Constitution formed it for their own and their posterity, as they said they did (and not one of us doubt it), they intended to abide by it, and not allow other nations to come here and usurp our rights and privileges, and endanger our peace and happiness. No! the Constitution was formed for the express benefit of "Uncle Sam" and his children.

Foreigners were only allowed to come on the conditions that they were to be governed by our laws, and act exactly as "Uncle Sam" and his family did; and even then, if they did not promote the welfare of the country, secure the blessings of prosperity to him and his family, he did not want them here.

Now, do these moon-faced tramps promote our welfare or secure liberty or happiness?

Not a bit of it. They are taking our liberty and our living from us. Then out with them, you law-makers, and at once !

But you say again, the Constitution allows them to come.

Then change the Constitution, I say. If you cannot get rid of the Chinaman by the Constitution, do it by the Declaration of Independence, which was formed eleven years and two months and thirteen days before the Constitution was thought of.

The Declaration says we are endowed by our Creator with certain inalienable rights; that among these are life, liberty, and the pursuit of happiness; that to insure these rights, governments are instituted among men, deriving their just powers from the consent of the governed; that when any form of government becomes destructive of these ends, it is the right of the people to alter or to abolish it, and to institute a new government. A little further on it says it is our right, it is our duty, to throw off such a government, and to provide new guards for our future security.

Now, what I would ask is plainer than all this.

Let us desert the Declaration, and see what it does mean. It says we are endowed by our Creator. That means the people of the United States.

It tells us to make laws to secure our rights, happiness, and liberty; and if these laws are not sufficient to secure these ends, to throw them away and secure new ones for our future security.

Now, is our life, liberty, or happiness safe while the Chinamen are allowed to go rampant over our land wherever they choose, and deal pestilence to all, and famine to the poor? This is what their coming among us means.

Again, the Declaration says in substance, if not in words, that if our grievances are too great to be borne, submit facts to a candid world. Now this is just what we propose to do.

If we can alter our Constitution in one clause, we can in another.

Abraham Lincoln found a way to change it and free the colored people; why cannot President Hayes change it again, and free us from the Chinamen?

This is a subject that demands the immediate attention of both houses, and they will have to give it their attention sooner or later.

May God speed the time, and direct them in their judgment.

CHAPTER XI.

The Snow-Sheds.

I HAVE often been asked by Eastern people what the snow-sheds were.

For the benefit of those who have never visited the Coast, I will say they are long sheds built over the railroad, to protect it from the heavy snow-storms to which California is subject, especially in the Sierra Mountains. Were it not for these sheds, the roads would be blockaded half of the winter season. They are used all along the line of the road in different places up to the Rocky Mountains, wherever the road is most subject to drift.

These sheds are constantly getting burned. Sometimes two and three miles of them will lie in smoking ruins from one fire. I remember one morning, before it was scarcely light, of being aroused by a din of voices, tools, and shuffling of lumber. The cars were standing still, and seemed full of smoke. I could hardly breathe. I inquired the cause, and was told that several miles of sheds were burned and lay in ruins upon the track, which must be cleared off before we could proceed. They had burned during the night, having caught fire from some passing train.

The roofs of these sheds sometimes break in beneath the weight of snow on them, and thus blockade the road for two or three days at a time. Before these sheds were built the road over the Rocky Mountains was often blockaded with heavy storms.

The reader will doubtless remember, some twelve years ago, when the emigrant trains were snowed in, and the passengers came near starving. This was before snow-sheds were built.

Although California is such a lovely climate, there are many places where it has fearful storms, the snow often falling fifteen and twenty feet deep in Sierra County, and at Donneyville, near Donney Lake. I have heard many of my friends say they have traveled thirty and forty miles on snow-shoes, over snow ten and fifteen feet deep, where it was impossible for a horse to go. This was the only way that they had to get to towns and villages from the mountains to obtain food, or trade of any kind. The snow-shoe is a long, slim piece of timber about eight feet in length, two inches wide, and half an inch thick. It is polished very smooth. It turns up at the front end like a sled-shoe. It is fastened to the person's shoe by means of screws and straps, the foot being placed in the middle of the shoe. I have been told that persons can travel as fast with them as they can with a horse, for they do not cut in the snow but glide smoothly over the crust. The shoe being so long, and running so swift, it takes them over ditches and caverns they could not possibly pass in any other way. I heard one lady tell about coming down the mountain one day at such a fearful rate as to jump an old mining shaft four feet wide, which was nearly covered with snow, and came near going into it.

The snow will fall in great depths on the mountains, while the valley of Lower California and all along the Coast are teeming with flowers.

It is very nice to enjoy the beauties of summer and winter the same day. I could stand on my porch and look in any direction and see snow all the year round, from January to dog-days. It was always to be seen on the mountains.

I have heard several of my intimate friends say they had
lived in Sierra County when the snow was so deep that the
one-story houses were completely snowed under, and the
two-story ones were covered up to the top of the upper
windows. They had to go out of these upper windows
and sink shafts in the snow down to their doors and win-
dows to let in air and light, hoisting the snow in large
buckets. After this was done, they would run tunnels to
their barns to feed the cattle. They also run tunnels from
one street to another, and from one house to another all
over the village, or cross on snow-shoes to the upper win-
dows in order to get to stores and groceries. They said
these snows would last from one to two months before they
melted away. But the snow is not as deep as this every
year.

I think I would sooner pitch my tent in the beautiful val-
leys where I could raise two crops a year, and always see
the green grass and beautiful flowers, and where I could
pick strawberries in January, and enjoy the other delicious
fruits of this Garden of Eden. I think I should prefer
these luxuries to running tunnels through snow-banks. In
the valleys where there is no snow, it rains nearly all the
winter. This is the time the crops grow best.

The ranchers can raise two crops a year on the same
ground. It is a great country for cattle, sheep, horses, and
poultry of every variety. I was told by a lady that she
had sold eggs and poultry to the amount of $1,000 in a year.
This was in early days when hens lay at six months old.
Most of the soil is sand or gravel loam, of a reddish cast.

It was a sight worth seeing to go out to the surface mines
and see them, with their hydraulic pipes, washing down
banks two hundred feet in height. They cut a niche in the
bank at one end, and separate a piece about three feet wide
from the main land, and then play the pipe on this till it is
all washed away. The gold settles to the bottom. Large

pieces of ground often fall suddenly and cover the miner. He is buried in a living tomb. Some are dug out alive, but generally they are crushed or smothered before they are dug out. Many a poor man loses his life in this way.

Writing of big and sudden storms reminds me of one that visited Virginia City in 1854. It commenced in the afternoon, and before morning the snow was three feet in many places. Everybody had to get the snow from his house to keep it from crushing in, while men received $1 an hour, for several days, for shoveling snow. The weather changed, and the snow began to melt and slide on the mountain-side. It came down in avalanches, and buried up several houses, which had to be dug out. But few people were hurt. I believe one sick lady and two children were dug out in one house, the woman being dead, but the children alive. This was said to be the biggest storm ever had in Virginia City, but not a sign of it remained at the end of a month; but a boat would float in the mud on the streets.

CHAPTER XII.

IT was about the 1st of April, the year '77, that business in Virginia City came to a state of stagnation, hundreds of men being out of employment.

The mines and shops were thronged every day with men asking for a job to keep themselves and families from starving. The single men were every day being discharged, and men with families taking their place; and some of the single men were noble enough to volunteer to give up their place to friends who had families.

Carpenter and other shops were also thronged hourly by men looking for work to keep the wolf from their door. Grocery men and merchants, and all business men, were sought after for a job twenty times a day.

All the different offices in the city were overrun by applicants, but to no purpose. There was no show anywhere.

Nearly all the mines were shut down, and rich stockholders would not open them till they got ready, and that would be when every small stockholder was obliged to sell his little hoard of stock, which he had been holding for a raise, to keep his family from starving.

Many had bought when they were quite high, and now they were lower; they hated to sell till they could get their money back. But the rich ones determined to make them sell, and they would not start up the mines, under one pretext and another, till they were frozen out.

In the meantime the streets were filled with starving men, women, and children. Oh, how the people needed a Sharon then to reach out a helping hand! But they had not. By their miserable ingratitude towards him in public affairs, he was giving them a good letting alone.

He lived in San Francisco at this time, where he was probably appreciated.

As I said, the streets were thronged, and still the people kept pouring in from the East. Men could not go to and from their places of business without being importuned to give "two bits" for a lunch, or "four bits" for a square meal.

All cried out against it, for this constant call for "four bits" half a dozen times a day was draining their purses. Business men said it took all their profits; miners said they gave away half of their wages.

The newspapers were filled with complaints. The rich men, or at least some of them, said: "Shut them up for vagrants!"

But the jail was soon full of them. This raised city expenses.

Everybody was afraid the city would be burned for the sake of plunder. The people asked the city to do something. Houses were being broken into every day, and people knocked down and robbed. It was an every-day occurrence for men to be met by a masked mob and made to hold up their hands while their pockets were searched.

The city was fast becoming demoralized, and yet no one put forth a hand to save the city from the calamity which threatened it.

I for one could not sleep at nights for fear the city would be burned, and spent a good part of every night on my upper porch, looking for fires.

Mrs. Beck was at my house one day, and we were speaking of the amount of poor people on the streets, when she

said she was afraid the city would go some night, and she had heard many express the same opinion.

I said I had been afraid for some weeks, and there had been scarcely a night that I have not been up to my lookout to see if I could discover a fire anywhere in the city.

She said she wished something might be done to relieve the suffering.

While we were yet speaking, a man came out of the kitchen of Mr. Ryan's restaurant carrying a barrel of dry bread, and put it on his swill cart for the milk ranch.

"Look!" said she, "at those loaves of dry bread being dumped into that cart. How the hungry would like to have them! Just see the stuff that is wasted from one house, and it is just so all over the city! Why could not some one go around and gather it up, nice and clean, and spread it in some place, and let the hungry go and eat what they wanted."

I said it would be a good plan, but some would keep others away, while they carried all off themselves. If it could be gathered and nicely sorted, and served up properly on plates, it would do a vast deal of good. For instance, have a soup-house, like they have in Chicago.

"That is just what Mr. Beck said yesterday," replied Mrs. Beck. "The city ought to start a soup-house for the poor."

She sat thinking very seriously for a moment, then turning to me, said: "Well, why can't you and I do it, if no one else will?"

All right, said I. Where will we have it?

"Well," said Mrs. Beck, "there is my carpenter-shop on B Street, and the man is just using it temporarily. I will tell him I want it; I only get $15 a month for it, and I can afford to lose that much for two or three months. I do not think we will need to run it any longer than that, for times will get better. It is all settled about the house. Now, if

you have any work to do, I will help you, and then we will go out and see what we can do."

I told her the work was all done, and I was ready to go with her at any moment. I put on my things, and we started out.

"Let us first get us a book, and then go around to the restaurants and take down the names of all who will give us their cold victuals," said Mrs. Beck. "After that we will go to the merchants and get them to give us their wilted vegetables."

We did this, and nearly every restaurant promised to save us its provisions in baskets, which we were to leave for the purpose.

The merchants also agreed to save us their vegetables, and some searched over their stores and gave us all their broken packages of pepper, tea, soda, spices, and other groceries.

"Now," said Mrs. Beck, "let us go to Mr. Beck and tell him we want him to send a good large stove, seven or eight tables, and all the odd chairs he can spare; and while we're there we will look out the dishes and have them sent down."

You talk as if you were sure of the whole thing; perhaps your husband will not let us have them.

"Oh, yes he will! Beck is the best man in town about any such thing. He always gives me all the cracked dishes I want to give to any poor person. You know niched plates are just as good to bake on, and saves the better ones."

After we had selected the dishes, and ordered them sent with the other goods, we now procured a book and started out for subscriptions. We took down the names of all parties who were willing to donate towards the lunch-house. We received subscriptions all the way from "two bits" to $4, and two or three subscriptions of $5 each.

Among the restaurants that donated with a liberal hand were Fitz Myer, Flowshoots, New York Bakery, Mrs. McDonald, Johnny Young, Charlie Leggett, W. B. Ryan, John Miller, of the American Exchange, and a host of other restaurants, the names of which, if I ever knew, I have forgotten.

"Now," said she, " we must have some one to help gather up the food, and a dish-washer."

I said there was an old man stopping at my house who had no boarding-place. What can we afford to give him?

" I do not think we can afford over $20 and board him," said Mrs. Beck; and there is a girl stopping at my house who wants a place, and I will hire her. I think I can get her for $30, and she can board and room at my house."

Well, if you will furnish lodging for the girl, I will for the man, and he can board at the lunch-house.

That night we saw both parties, and secured their services, and paid them from the money we had collected. This took $60 of our money. After we had run the house a few days, we discovered it was worth more to do the work than we at first anticipated, and we concluded to add $5 more to the girl's salary.

The most of our subscriptions were of 50 cents each, consequently did not count up very fast. The miners and many mechanics could not afford to give more than this, as they had from two to three applications a day for charitable purposes.

Business men averaged from $1 to $2.

The bonanza ring never gave us a dime; they said they had given to the relief society all they could afford. Other men had given to that society all they thought they could afford, yet they had a few spare dollars for us.

In taking up a collection, we found some very noble women. If they did not have money to give, they would give us old clothes; and many a man, woman, and child

got a good warm suit, if it was soiled, through their be-
nevolence.

Mr. C. C. Baker & Co., also E. G. Baker and Hatch Bros.,
gave us very liberally, and all the merchants with whom
we traded let us have goods at reduced rates. We bought
a firkin of butter and a half-barrel of sugar to commence
on. But the most liberal of all who assisted us were the
butchers of Virginia City. Each and all extended a liberal
hand. They furnished us with more meat than we could
possibly use in the lunch-house; but we never allowed it
to go to waste, for we knew plenty of poor people in town
who needed it, and were always glad to get it. We did
not forget the Sisters' Orphan Asylum in our distributions.

The markets on the Divide always brought their meat to
us, as they said it was too far for us to send. They some-
times brought us three and four large champagne baskets
full, for which we were very thankful.

I will now show the public how we managed to feed four
and five hundred people three times a day from our lunch-
house.

Our man took a basket and pail, and went to each house
separately. All the cold meat was placed in the bot-
tom of the basket, on a clean paper. The basket was
then filled out with dry bread, unless there was meat
enough to fill it, in which case he returned the second time
for the bread, cake, and pie. The tin pail was for coffee
dregs, which we gathered from the different restaurants.
These we mixed with a little fresh coffee boiled up, and
strained off into a large boiler. We generally did this in
the evening, and had it ready for use the next day. We
always had this nice and hot, with plenty of sugar and
milk.

Alexander & Brother were very liberal in their donations
of milk, leaving us from one to two gallons daily.

A Sierra Nevada milkman was also very liberal.

We always sorted our provision as fast as it was brought in to us. Every slice, and half slice, that would do to set on the table was laid by itself. The smaller pieces were saved for hash and soup. We frequently had two and three bushels all broken for soup. Before filling a plate with soup, we would put a handful of bread in each one.

The meat was next sorted. Everything that could be cut in slices was saved for cold meat for the tables. When our meat was done, we lifted it from the boiler, and all the bits of cold meat that we had trimmed from the other were added to the soup. This made it very rich.

We now filled the boiler with different kinds of vegetables. When this was done, we added rice or barley, and we had an excellent soup. We always seasoned it highly with pepper and salt. We changed the soups every day, having vegetable or bean soup every other day. We always gave them plenty of vegetables, both cooked and raw.

Our pie and cake were also sorted and cut into small pieces, that every person might have a piece.

We got quite a quantity of pies and cakes from Mr. Miller; also baked beans and pork.

Fitz Myer also sent us large pans of beans and pork and puddings, which we dished out for dessert the same as we did our pies.

Our breakfast hours were from six to nine, dinner hours from twelve to three, and supper hours from five to seven o'clock, and sometimes later. We always had everything prepared for breakfast the night before; and when breakfast was about half over, we commenced making preparations for dinner; and through the dinner hours, we were making preparations for supper.

If we had any soup left, we never threw it out, neither did we keep it to sour. We could always find plenty of Chinese and Piutes to give it to. There were from fifteen to twenty of them daily hanging about the door at meal times.

We had from ten to fifteen visitors daily to try our soups and coffee. All who tasted it pronounced it the best they had eaten in the city. Among our visitors were doctors, lawyers, ministers, and newspaper reporters—the latter always recommending our soups and coffee by giving us a neat little puff in their paper.

We had seven large tables, each covered with white spreads or marble oil-cloths, and always looked neat and clean. The people were always waited upon as if they were in a paying boarding-house. We had men, women, and children.

Women sometimes came bringing their whole families with them.

For breakfast we had coffee, bread and butter, cold meats, hot potatoes, and hash. They generally consumed three bushels of hash daily; but, reader, it was not "boarding-house" hash, but a superior article of our own manufacture. It was composed of all the fine meat and vegetables of the soup, finely minced with bread and potatoes, and highly seasoned with pepper, salt, and onions, and warmed up from the rich marrow gravy taken from the top of the soup.

For dinner we had soup, vegetables, cold meat, bread, baked beans, pork, and coffee.

For supper we had the same, with the addition of cakes, pies, and puddings.

There were some sickly people, and some were quite old. For such as these we saved any little knick-knacks we chanced to get. We also kept tea on hand for such as did not drink coffee.

We did not get all the bread given us we needed, but had to buy about $3 worth every day. We generally bought all the bread each baker had left over from the day before. By taking this we got it for less than half price, and it went much further than new bread.

We took some four gallons of grease each day from the
top of the soup. This we gave to poor families, and they
clarified it for shortening. We kept three boilers con-
stantly going with soup and coffee, and a large reservoir
of hot water to add to them whenever the case required it.

Our floor was scrubbed every day after dinner, the board-
ers taking turns to do this, as well as to fill our water bar-
rels, and cut and bring in our wood, for our hired man had
enough to do without doing this.

We had to be there by half-past five o'clock in the morn-
ing. I lived a half-mile away, but Mrs. Beck lived on A
Street, directly back of the lunch-house, which was on B
Street.

Several restaurants were closed out while we were run-
ning the lunch-house, and we received some very liberal
donations. From some of these we received a half-barrel
of corned beef, a half-keg each of farina and hominy, and
four gallons of molasses; this we used on the hominy and
farina, which we made into pastry puddings.

Our tables were well supplied with pepper, salt, mustard,
vinegar, and Worcester sauce.

To cook all these victuals, and wait on five hundred peo-
ple most of the time, and only three to do it, was no small
chore. Besides, we had our own house-work to do; but I
had a girl stopping at my house who assisted me some,
while Mrs. Beck's daughter helped her.

While the men were eating their dinners and suppers,
we were constantly filling pails and baskets with soups and
other provisions.

While the girl was busy doing up the dinner-work and
preparing for supper, Mrs. Beck and myself went out col-
lecting money. This was the only time we could get to
collect money; and we have often walked so far and so fast
that we have found our feet blistered at night, and some-
times were so tired we could not sleep at nights.

The men, as a general thing, were very orderly. After they had finished eating, they would quietly pass out and give their place to others.

After clean dishes were placed on the tables, and they were replenished with food, each table would immediately be filled with new-comers.

The men generally came sober, as it was one of the rules of the house to admit no intoxicated person. We had, however, three who would drink. They were nicknamed by the crowd " hog number one," " hog number two," and " hog number three," from the fact of their sitting at the table till they had been reset and refilled with men six or seven different times. Either of them would eat more than any four men in the house. They were all very large men.

The first two days I gave every man all the coffee he wished. After that we would give no more than three cups.

We had to work very hard, but we enjoyed ourselves for this reason—we knew the hungry were fed, and while they were fed, Virginia City was safe. Then there were so many different kinds of people, that it became a great study for us as well as amusement, for some of the men were very lively, and were constantly making speeches at which we could not help laughing.

They were most always telling over old Virginia City stories of '49. We learned their opinion of the bonanza ring by the wishes and threats they made against it. It would make your hair stand on end to hear some of them. This showed we were right as far as the safety of the city was concerned. We used often reprimand them for it.

There were three men who were bound they would drink and still come there and eat. I did not propose to wait on men who did not have more respect for us or our house than to come in a state of intoxication to their meals. So I told these three men that they could have no more meals unless they came sober.

One said: "It is not as you say. I guess the city has something to say about it. My friend, Jim Fair, gave $2,000 to run this machine, and I have got just as good a right here as anybody."

I saw he was quite intoxicated, and did not make him any reply till he was done eating. I then told him not to come there again in that condition.

But at noon he came back worse than ever. I would not let him in. But Mrs. Beck said: "Let the poor fellow have something."

No; I will not allow sober men to eat with a man in his condition, and the dreul was running down his chin.

I took him by the arm and led him out of the door, and told him when he came back sober he could have something to eat, and not before.

He walked up and down before the door for about an hour, every ten or fifteen minutes poking his head in the door, and asking: "Am I sober enough yet?"

I kept telling him No; not till all the rest were done eating. I then let him in, and he was quite sober. After he had eaten his supper, I said to him: This is the last time I will give you anything to eat if you come in this condition.

He never came again intoxicated, and I had no further trouble with any of them about drinking.

As the first month drew to a close, we found we had used all of our money, and Mrs. Beck was out of her own pocket $86. We went around with our book for a second subscription, but not over ten people would pay the sums set opposite to their names.

This we took to pay the man and girl for staying two weeks longer.

We then notified the men that we would have to close up for lack of funds.

You see we were supporting eight or ten families outside of what came to the lunch-house, supplying them with all

the bread they consumed, and we never had less than three baskets of bread to buy extra, as we did not have bread enough given us.

The last three weeks we run the lunch-house we sold tickets enough to supply us with bread. These we sold to merchants, brokers, and other business men; and when men came asking for money for a square meal, they would give them the lunch-tickets, and direct them to us.

They would come in, sit down and eat, but would always keep their tickets out of sight, unless we called for them. Somehow they got the impression that we were going to charge them after awhile, and would have their tickets to fall back on.

When the few dollars we had collected gave out, we closed up, giving every man a large chunk of corned beef, or mutton, just as he preferred, which he packed off to his cabin.

We had all of our corned beef on hand—about two-thirds of a barrel—which we had been saving for the men, when we broke up. All the other provisions on hand we divided among them.

The last week we kept the lunch-house open, about a hundred young men left the city to look for work.

We put up a lunch for each one—enough to last two or three days.

About three hundred of our boarders were old towns-people, broke, and out of work. Many of them were cripples; the rest of them were tramps, women, and children.

I told Mrs. Beck she could not afford to support the whole town, and I could not afford to help her; my time was all I could give.

After the men had taken all they wanted of meat, pepper, and salt, we divided what remained among poor families, and closed up. We were pretty well tired out. We were

often so tired, after closing for the evening, that we could not go to the theater or other places of amusement.

While running the house some of the men seemed very grateful, and would always thank us or bless us as they went out after every meal. One day I heard one man say to another, "What makes you thank those women in there? It's no thanks to them that ye git something to eat; the relief society hires them."

"Is that so?" said he. "Thin bejabers they git no more thanks from me. I thought they bought it thimselves!"

This conversation took place outside, and I stood by the half-open door where I heard it.

When they came in and were seated, some man said: "There is not better set tables in the city; at any rate the victuals come on the tables in better shape, and taste better."

"An' shure, they might afford to give us good victuals. It don't cost thim anything!" The relief society hires thim; Mackey and Fair pays for the grub."

This was said by one of the men who had been talking outside.

An American, who knew better, said: "You are mistaken."

He said: " No, I am not; Tom Finnegan just told me so; and I'll be d—d if I'll thank anyone again. I have my opinion of anyone who has to be paid to feed a few starving men."

Some of the men told him to shut up, or they would put him out; and after dinner I heard them explaining it to him. The next day he came, and was as humble as ever.

Some of the men who came there had been worth several thousand dollars a few months before, but had lost all by the fall of stock, and had not "four bits" now to get them a meal.

One poor fellow who, a few months before, had driven fast teams, had been so long without eating that he did not dare to eat, but only drank a cup of tea, and after awhile he came in again, but only ate a piece of cake and drank a cup of tea. At supper-time he ate quite heartily. We had several cases like this.

We were very sorry to have to close out, for these poor people seemed to feel it very much. If we could have procured money to pay our help, we would have tried to run it the second month. As it was, we were obliged to quit. With the thanks of some and the praise of many, all declared the lunch-house had been a great help to the city.

AIDING THE KANSAS SUFFERERS.

When Kansas and Nebraska were suffering from the grasshopper invasion, we were notified of it by the churches as well as by the papers. One of the churches gathered up three boxes and sent them off, and the word went out that they had received all that they needed; but the papers soon brought us another story.

They told of their destitute condition, and that men were obliged to make coats of quilts, and plow in their bare feet. The express companies promised to forward any boxes which were made up for them free of charge.

Mrs. Beck and myself started out to gather up all the clothes we could. We declared we would not stop as long as the express companies would take them.

We sent fourteen boxes that we gathered up in the city, both for men, women, and children, of all sizes and ages.

After we got all we could here, we then went to Gold Hill. Here we gathered two large wagon loads. These clothes we carried in our arms from the upper streets down to Main Street, all we could possibly carry at a time, till we gathered them all from the side-hill streets.

When we had got them all down to Main Street, we hired two teams, and sent them to Virginia City. The next two days we spent in packing and sending them off. We found we had eleven boxes. After we had sent seven of these, which, with the others sent, made twenty-one, the express companies refused to send any more. As we had four boxes left, we sent two of them to a town where we had heard they were in great need of aid.

The other two boxes we sent to two women, who had written informing us of their destitute condition, after we had sent one box to their town. Upon these four boxes we had to pay the express charges. We always sent two boxes to each town—one filled with men and boys' clothing, and one filled with women and children's wear.

We worked so hard gathering these clothes that our arms were numb for days with the big loads we carried down the hills in Gold Hill.

Our acquaintances used to call us the rag-pickers. We sometimes were praised, and often blessed for our deeds of charity, by the citizens, and sometimes by the papers. But this never afforded us half the pleasure our conscience did, or the many letters of thanks we received from the different towns in both Kansas and Nebraska, and from the parties who were appointed to receive them, and from postmasters and private individuals; sometimes from individuals who had received an old coat, or dress, with a five-dollar gold piece sewed up in the pocket, accompanied by a request to let us know if they received it.

We thought the best things were generally given to favored ones, and the poor were turned off with the worst. So in the very worst garments we often placed small sums of money to make up for the old garment. We often got returns from these, telling us how much good the money did them.

We also bought and begged garden seeds from the seed

stores. Merchants often gave us quantities of tea and coffee. We always marked these to be given to some sick person or chronic tea-drinkers. Several sent us saying they were suffering for things, and wished we would send them a small box.

After we could get no more things to send, Mrs. Beck wrote to them, and sent $5 in each letter, telling them she could get no more clothes. I sometimes wonder after all we two went through with, working and begging for the poor, that we have had so much bad luck.

But again, I think it must be for some wise purpose, and instead of fretting, and making everyone miserable around me, I call to mind these very true and wise verses, which it would be profitable for us all to remember :—

" IT NEVER PAYS."

" It never pays to fret and growl
 When fortune seems our foe ;
The better bred will push ahead,
 And strike a braver blow.
 For luck is work,
 And those who shirk
Should not lament their doom,
 But yield the play,
 And clear the way,
That better men have room.

" It never pays to foster pride,
 And squander wealth in show ;
For friends thus won are sure to run
 In times of want or woe.
 The noblest worth
 Of all the earth
Are gems of heart and brain—
 A conscience clear,
 A household dear,
And hands without a stain.

" It never pays to hate a foe,
 Or cater to a friend ;
To fawn and whine, much less repine,
 To borrow or to lend.
 The faults of men
 Are fewer when
Each rows his own canoe ;
 For feuds and debts,
 And pampered pets,
Unbounded mischief brew.

' It never pays to wreck the health
 In drudging after gain ;
And he is sold who thinks that gold
 Is cheaply bought with pain.
 An humble lot,
 A cozy cot,
Have tempted even kings ;
 For station high,
 That wealth will buy,
Not oft contentment brings.

" It never pays : a blunt refrain,
 Well worthy of a song,
For age and youth must learn this truth,
 That nothing pays that's wrong.
 The good and pure
 Alone are sure
To bring prolonged success,
 While what is right,
 In Heaven's sight,
Is always sure to bless."

After the big fire of Virginia City the Kansas sufferers, being grateful for the aid we rendered them, sent $400 to the Virginia City Relief Society, saying they had this much left in their treasury, and they did not know what better use they could put it to than to send it to those who had extended such a liberal hand to them in their hour of great need.

Mrs. Beck and myself being aware of the fact, and knowing we were the only ones that sent boxes of clothing to their relief, save the three small boxes sent by the Episcopal Church, applied to them for two or three friends who had been entirely burned out, saving scarcely an article except what they had on at the time. These same parties had been very liberal in giving us when we were filling our boxes.

Now, reader, would you believe it! we could hardly get an old coat for a poor man who happened to be in his shirt-sleeves at the time the fire broke out, and who, in trying to save his neighbor's goods, had lost all of his own, even to his last coat.

Mrs. Beck went six times before she succeeded in getting a coat, which was not as good as several which he had given us.

I would advise the public if they are ever called upon to send relief to Virginia City to send it to Mrs. Beck; and I will warrant them that a few favored ones will not get more than their share, but will be equally and judiciously distributed among all. I don't doubt the relief society does a great deal of good, but, like the law-makers, it spends too much time legislating over each article that it gives, for every one has to give his opinion whether the party is worthy or not.

When I first went to Virginia City the Howard Relief Society had entirely run down, and there being a large number of people in town who needed assistance, Mrs. Beck and myself spoke to the Rev. McGrath about it.

He said he would try and start a society immediately, and in less than two weeks after he had quite a society formed.

After awhile some of the members of the old society joined, and in some way they managed to give the society the old name, and everything is now conducted on the old

plan. But I do not think the poor people have received the same amount of benefit they did the first winter, as McGrath spent about two-thirds of his time in looking after the poor, and often took money from his own pocket to supply their wants.

Speaking of the poor of Virginia City reminds me of the doctors there, some of whom would take your last cent in an exorbitant fee, while others would not only give their fee, but also gold from their pocket for extras or delicacies for their patients, which the relief society did not feel able to give.

Dr. White was one of these doctors, and he would always give his patients what he thought was necessary, if he had to pay for it from his own pocket. I took care of a good many of his patients, and I ought to know.

Drs. Webber, Atchinson, and Packer were also very kind-hearted men, and may Virginia City be blessed with more like them.

We will now leave serious subjects, and introduce to the reader the Piutes of Virginia City, as my book will hardly be complete without them.

They are a race of Indians who live in and around Storey, Washoe, and Lyons Counties. They seem very harmless, as they never molest any of the whites, and are quite civilized, many of them living in shanty houses, and having their cook-stoves, and one or two I have known to have spring mattresses. They put their blankets and furs on them, making quite nice little beds.

They gather up large piles of sage-brush for wood. They all dress like the whites.

An Indian's hobby is a plug hat, with a feather, while a squaw's is a pink calico dress, with two or three flounces. Some of them have learned to sew, and can make dresses very good. These dressmakers make a good deal of money in making dresses for other squaws.

Some are good washers, and will do up starched clothes very nicely. This they have learned from the whites, for whom they have worked. The squaws are quite industrious. They are always ready and willing to wash or do any kind of work for you; but they want their price.

The male Indians hardly ever work. They go around and engage large piles of wood to cut and saw. They set the price on the labor, and then go off till the squaws have cut the wood, while they are gambling or strutting about town. But they are always sure to return at meal-times, as this is always included in the bargain. Their whole family have what they want to eat, and they will never commence their work till you give them their breakfast.

If you tell them to go to work before breakfast, they will say: "Me want biscuit; me heap 'hoggeydie,'" which means I am very hungry.

The Indians and squaws are both great gamblers. They will form large circles on the ground, where they will sit and play for hours.

They play poker, euchre, and whistle-jack. The most of them talk good English, and some of them swear like pirates.

Many of the ladies hire them to wash and clean house, and will give them quite nice dresses which they have cast aside; but they always give them some money, or they are not satisfied.

It is really comical to see a Piute squaw trailing her silk dress; and it is only when she is high-toned enough to wear such garments that her husband will condescend to walk behind her.

At other times they will go ahead and leave their squaws to bring up the rear with their load.

Some of the girls and boys are quite good-looking. Their cheeks are always painted red.

The girls wear their hair banged like the American girls of the present day, only much longer, coming just to the

end of their nose, and hangs in a vail over their face the most of the time. The rest of their hair is long, and hangs down upon their back. The old women and men part theirs in the center, and let it hang on either side of the face, and ornament it with shells, pieces of tin, brass, feathers, or beads; the latter of which they are very fond.

These Indians resemble the Chinamen very much, for they have the same black hair and eyes, yet their eyes are not all as almond-shaped as the Chinese. They never shave any part of the head or face, while the Chinamen shave all the lower part of the head in a complete circle, leaving only a small tuft of hair on the crown of their heads. This they braid in a long strand down their back. Their social position seems to depend upon the length of this braid. It is often lengthened out by long strands of black silk; and not unfrequently they are seen dragging a full yard upon the ground, after being wound once or twice around the head.

The Indian wears his cut just to the shoulders. The Indians converse very readily with the Chinese when they first land from the ships. It is believed by many that the Indians are Chinamen, who in ancient times had crossed over the isthmus into Russian America. The fact of their talking with them is pretty good proof. Many of their words are the same. One word that both parties often use is, "No savvy," which means I do not understand, or " I savvy," I understand.

The Spanish, Mexicans, and negroes also use this word for the same meaning.

When the Indians work for you, they will do their work well. After they have cut a large pile of wood they will carry it into your shed with as many of the chips as you like; they will then sweep up the rest, and carry it away to their shanties in bags to burn, leaving the ground so clean that you would never imagine a wood-pile had been there.

One day, as I was going along the streets, I saw a squaw carrying a parlor cook-stove on her back. It was tied around her waist by a rope, and to her head by a strap passing around the forehead. This strap always supports the principal part of the load. She also carried a baby in her arms. Her husband, a great stalwart Indian, was walking beside her, carrying their little one-year-old papoose, till he got tired; he then put it upon the top of the stove, and told it to hang on. He then folded his blanket about his shoulders, and strutted ahead of her, as if he was a king and she his slave.

A man passing at the time tried to shame him. He replied: "Me gentleman. Me no work. Squaw work."

Captain Bob, their chief, was a great person among them. He took great pride in a plug hat, white shirt, and linen coat.

The squaws go to the mills, where the hot water is pumped from the mines, to get water to wash with. It is very nice and soft. Some of the white people also get this water to wash with.

They dry their clothes on the sage-brush which grows about their camp.

Many of them own horses. One squaw told me she owned thirty horses and ponies. They have some pretty good ones.

The Indians go up to a place called Walkie River, in the fall, to hunt and fish, and also to gather the pine-nuts (which resemble our acorns), which grow in great abundance there. They are very nice, and are kept in the groceries to sell, as we do chestnuts. They buy them of the Piutes, in the fall, after they come back from their hunt.

Immediately after their return, they commence their fandango, which they keep up every night for several weeks.

It is a sort of dance. They generally select a large, level piece of ground, and inclose it by a fence of sage-brush.

On the outside of this fence they do all of their cooking. Through the center of this ring is a wide, well-beaten track. On this track the dancing is done. The girls dress in their best, some in white, some in silk; but the most of them in red, pink, or blue. The signal for the dance to commence is for the best singer to start on the track and commence singing and dancing. He will sometimes sing for half an hour before another Indian will start. But after the second one starts, the others will follow suit, both men and women.

There is no sense to their singing. It is a sort of sing-song, hum-drum noise, with an occasional howl.

They seem to enjoy it very much. They are very proud whenever the white people visit and take notice of them, especially at their fandangoes.

I think the whites enjoy it quite as much as they do. Large parties often go out to see them and join in the dance.

I went one night with Mrs. Beck and three other friends; but I must say I enjoyed the foot-race back more than I did the fandango.

They always have a feast at these times, and you can see them packing provisions all day long out to their grounds for their evening entertainment. These Indians seem to be quite a temperate tribe. They are also very virtuous. If anyone of the squaws leaves her husband and goes off with another man, he follows her.

If he gets her, she is bound to a stake and burned, her husband sitting before her on the ground, with a few of the braves, watching her burn.

A case of this kind occurred while I was there, about five miles out of the city.

As soon as the white people heard of it, a reporter went out to see what he could learn.

There he found a few charred bones chained to a stake, the embers still smoking about the stake.

Had the whites known it in time, they would have prevented this horrible act.

When they do anything like this, it is always done secretly.

Although their discipline leads them into such cruel and barbarous acts, they are otherwise a very quiet, well-behaved tribe. I never heard of any disturbance between them and any white person during the whole time I was there.

The only difficulty I ever heard of their having was between them and the Chinese, on account of the latter eating the provisions off their graves.

I will wind up this chapter by the writing of letters; as I have said, this was one of my vocations while teaching the colored woman. I used to write all of her business letters. For this she paid me extra—50 cents to $1, just as she happened to have it by her.

I often wrote business letters for others. But the letters of friendship and love were both paying and amusing, for I was allowed to write what I chose to, and then I piled on the love in great agony; but somehow I always suited the people better than when they worded them themselves. I never set any price on this kind of work, but was always paid very liberally, having received as high as $3 for some of them; if I said it was too much, the party would say: "It is worth every dime I gave you, for it will touch the heart, if anything will. It is just splendid."

Then I had the fun of reading the answers that were received, and some of which were very amusing. I give here an extract from one of them:

DEAR JENNIE.—You will have to hunt another chap, for I have married Martha Brown. She is not as good-looking as yourself, but she has heaps of money, and we have gone to housekeeping in good shape. So good-bye.

BILLY.

CHAPTER XIII.

The Comstock and the Mines.

I HAVE often been asked since I returned East if the Comstock was not the best mine, and who owned it.

I will now explain to my readers that the Comstock is the name of a ledge of gold and silver quartz, extending from the north end of Virginia City to the south end, and passes on, through Gold Hill and Silver City, to the east. The ledge seems to split at the south end of Gold Hill, and branches off to Silver City and American Flat.

This ledge was named after the man who first discovered gold and silver in Virginia City.

Just before I came away I made inquiries about the man Comstock, and was told the following story. I will give it to my readers as it was related to me; and if it is not strictly true, I am not to blame. I have no doubt but it is true:

Comstock was a miner of early days. He was poor when he discovered the ledge. He was rather a reckless man, but would have done well had he stuck to his ledge, and drank less. But he was foolish enough to sell his mine, which he had located on the ledge, to a man for his handsome wife, a horse, and a silk handkerchief, and $2,000 in gold coin.

He hitched up his horse and started for Carson City with the woman he had bought. At Carson City she jumped out of a window and ran off. He got her back,

but she left him again. He became disheartened, and gambled off his money, and is to-day a poor man, if living.

This was told me by an old Comstocker, Mr. Brown, who roomed at my house.

So the Comstock is simply the lode, lead, vein, or body of ore running the entire length of the mountains on the side of which Virginia City is situated.

The thousand and one mines of Virginia City, Gold Hill, American Flat, and Silver City, comprise the Comstock. There are two mines, called the north and south Comstock, but they are both what are termed "wild-cat." A "wild-cat" mine is one that is situated on the outskirts of the ledge, and is supposed to be of no real value, but goes up on the merits of good mines.

To give you the names in this work of all the mines would be impossible, for they would fill a volume by themselves.

I will merely mention some of the oldest and best: Belcher, Imperial, Yellow Jacket, Empire, and Crown Point. These are the best of the Gold Hill stocks. California, Lady Washington, New York, Overman, and Justice are Silver City stocks.

American Flat, Woodville, Baltimore, and Knickerbocker are American Flat stocks.

Chollar, Potosi, Ophir, Union Consolidated, Julia, Gould, Curry, Mexican, Best & Belcher, Sierra Nevada, and Exchequer are Virginia City stocks.

The Raymond, Ely, and Eureka are California stocks. These are only a few of the choice mines.

There are hundreds of others, many of which are very valuable. It is really enough to tire one's patience to go through the entire list of the stock-board.

Many of the mines are worked together of late years. A large number have been consolidated. It seems as if they were always in a quarrel if they did not consolidate.

The mines I have mentioned have all had their day of excitement, and which have caused the death of many people.

All have been bonanzas at some time, but most of their upper levels have been worked out. It has been impossible to work the lower levels on account of the immense quantities of hot water with which the mines have been filled for the past few years.

I have often been asked how the mines were worked. I will tell you exactly as I have been told by dozens of good miners, and from responsible people who have visited the mines.

I cannot speak from personal knowledge, because I have never been below the surface of the mines, although I have visited nearly every mine and mill of any account on the Comstock. I have examined the magnificent machinery, engines, and pumps, but confess I never had the nerve to visit the lower levels, for I knew I never could stand the heat.

To start a mine, a man surveys and stakes out his ground, and with pick and shovel digs a shaft, the same as a well is dug, only it is square instead of round; it is then walled up with planks and heavy timbers.

When the miners throw out the dirt as long as they can over their heads, they then put up a windlass, and hoist the dirt in large buckets. These are generally worked by horse-power.

The shafts are generally dug till they strike a body of ore, and then timbered up. They then run a tunnel in as far as their location goes, after which they either sink a new shaft or commence a new tunnel on the opposite side, or as far as their claims go in that direction.

They continue to sink shafts, and run tunnels and cross-cuts, thousands of feet below the surface.

This they call prospecting the mines, or finding how wide

and deep the ledges are, and also their length. But before they do any work, more than to dig for a ledge, they take out a United States patent, and name the mine.

After this they put up hoisting works, which are run by steam.

A man, unless he is rich, and can work his mine by hiring help, always takes in two or three partners. They then set to work and run tunnels and crosscuts, as I have before stated. As soon as they find the length, breadth, and thickness of the ledge, they commence hoisting out the ore, till they have large cavities, which are called chambers; these they timber up for ore rooms. When the first level is nearly worked out, they commence hoisting the ore from the second level to the chambers of the first. In this manner all the levels are worked.

Sometimes these ore chambers are filled with the best grade of ore, and sealed up. This is kept in reserve for such a time as they wish to create an excitement.

When very rich veins are struck, they are also sealed up, and capitalists go to work and break the stock, in order that small stockholders may become excited and throw their stock into the market, when the capitalists immediately buy it up.

They then go to work, take out the rich ore, and raise the stock to an enormous figure—perhaps make a bonanza of the mine.

People again become excited, and buy in at these large figures, and when the capitalists get unloaded, they report a "horse" in the mine. A "horse" is a body of clay. The people again become frightened, throw the high-priced stock into the market without a limit. This causes a crash, and stocks go to nothing, or at least to very low figures. The mining ring immediately load up again; and the next news is there was no "horse" at all. They will pretend that some person raised the report to injure

the mine. But for some time people are very shy of buy-
ing in this mine.

Large masses of ore are left in different places to sup-
port the ground above. Timbers of all sizes are used in
the mines. The chambers, from floor to floor, are from fifty
to sixty feet deep. Every level has its shaft, incline, and
tunnel. The ore is raised to the upper levels by means of
steam engines placed in large tanks; the water is also
raised in these tanks in the same way. These tanks are
fastened to large wire ropes, called cable-cord, which is
made of fine wire, woven or braided together. It is
very strong and durable. It is then wound and unwound
from large iron beams, by aid of the steam engines, with
which every mine is supplied. Some of these engines are
of enormous size. The deeper the mine the more heavy
the machinery ought to be.

Old mines often sell off their machinery, and buy heavier.
A great many different kinds of machinery are used. There
are also several styles of pumps; some are used above the
ground, and some down in the mines. One is called the
donkey-pump; it is worked by donkeys under ground. I
do not know how they get these animals down in the mines,
but think they take them down on the cage, as they do the
miners. They have regular storehouses down in the mines.
They work by candle light altogether. A miner's candle-
stick is a sharp iron, about a foot long, very sharp at one
end, with a round, flat ring at the other, large enough to
hold a candle. The sharp end is then thrust into the rocks
or timbers, or in the sides of the mines.

In many of the mines the miners cannot strike the pick
more than three blows before they have to go to the cool-
ing station and stay double the time they are at work.

The cooling stations are where they have a free circula-
tion of air. These stations are on every level. They have
large tanks or reservoirs to hold the water that is pumped

from one level to another. These vats are often full of boiling water. In many of the mines the water is so hot that if a person slips into one of these tanks, he is generally scalded to death before he can be rescued.

If he is rescued alive, it is only to linger a few days, suffering the most intense agony, till death relieves him of his sufferings. He is often so completely cooked in the scalding vats that the flesh drops from the bones while taking him out. His suffering and agony is terrible to witness.

The heat of the mines is very great. In some mines it is almost unendurable. In such mines it is almost impossible to work, while in others they can work without such excessive heat.

Miners are brought to the surface almost daily from overheat.

There is scarcely a day in the year that there is not from one to two funerals among the miners; and I have known of there being five in one day.

There are a great many different causes of death. Sometimes death is caused by the caving in of rock, or by falling into the scalding tanks, or, by a misstep, by falling hundreds of feet down the shafts or inclines.

Sometimes the rope which holds the cage gives way, and several men are killed by the fall. In such a case there is not much hopes of any lives being spared, for they are generally dead before they reach the bottom.

Often machinery breaks and causes their death. Sometimes the hoisting of the car too fast carries it up into the sheaves; such an accident as this generally causes the death of all on the cage.

When men are overheated in the mines, some will return to work on the next shift, and others are laid up for several days.

I have had several roomers affected in this way, and were

under the doctor's care, one being out of his head for days.

I do not think I can give my readers a better description of the miners and everything connected with them, than making a few extracts from the *Evening Chronicle*, which is a very reliable paper, as it always keeps good reporters, who are always well posted on all mining matters:

"VIRGINIA CITY, July 14.

"On the 1,756 level we have commenced to lay a line of 13-inch pipe, which will be continued through the Consolidated Virginia, Best & Belcher, Gould & Curry, and up the Gould & Curry, joint winze, to the Savage 1,600 level, then south to the Sutro Tunnel connection. This pipe will also be laid north through the Ophir and Union, and will eventually be continued to the Sierra Nevada and Union shafts. This pipe will be used to convey the water from this and the aforesaid mines to the Sutro Tunnel, until the main Sutro drift is completed.

"On the 1,850 level the joint consolidated drift has been discontinued, and we have commenced drifting north and south in the vein formation. Owing to indications of water in the C. C. & C. shaft, we have been drilling the past week. This hole will be put down 150 feet, and if water does not come in, sinking will be resumed. Work on the 900 bob station is completed, and we are now engaged in excavating a tank station above the 1,650 level. This tank will be used in connection with the system of pipes now being laid to connect with the Sutro Tunnel. The water above being caught up, and that below being pumped up to tank, from which it will pass through the pipe into the tunnel before mentioned. W. H. PATTON,

"Superintendent."

"'OLD HAYSEED' IN THE MINES.

"'Bout Fourteen Miles Under Ground How is this, Farmer Treadway?"

"Farmer Treadway, of Carson City, was in Virginia City a short time ago on a visit, and he brought with him an old farming friend who had never seen the mines, but who wanted to see them. Permission was obtained, and the old chap went below. The boys lugged him into every drift, winze, and crosscut in the mine, and was pretty well worn out when he got out. Dan De Quille met him soon after, and got the whole story of his trip, as follows:

"'Yes,' said the old man, 'I went in, and went clear to the bottom. When I went down thar to the Consolidated Virginia works, I made up my mind I'd see it all—that I'd go as far into the bowels of the yearth as it was possible to git 'thout diggin' any new holes. I'd never bin in a mine afore, and might never go agin, so I told 'em I'd just take in the whole show. When that thing at the top of the shaft, what they call the "cage," give its fust little jog down, I jist thought the bottom had dropped out't the whole country for miles around.

"'Steam and hot air was pouring up like we was hangin' over a big pot of boilin' water. The guid to the lower country grinned at me, and said: "Hold fast!"

"'I was holdin' fast, but I held faster. Down, down, down we went, seein' nothin' but flashes of light, and flashes of dark, and hearin' nothin' but the buzzes of noise and the buzzes of silence, as we passed by the winders cut in the sides of the upright hole we were fallin' through.

"'I ain't easy skeered, but I thought we might be goin' down some faster than the business we were on required, so, sez I: Hez the trace chains broke, the belly-bands busted, or the breechin' giv way?

"'It's all hunkey,' sez the man, an' we then went on about a mile further before thar was any conversation of interest.

" 'It begun to seem to me like we was gittin' past all' the good stoppin'-places. Even if that air rope we was a spinnin' out behind us, as a spider spins his line out at his tail, was all "hunkey," as the feller called it, I was afeered there was no end to it, and we might go right on through to Chiney.

" '·I begun to try if I could think of any prayer among them of my airly days that would kiver the case, when the thing we was a-ridin' on stopped with a bump, that snapped my teeth together, and made me feel up in search of the top of my head.

" 'We'd struck bottom at last. How many miles down it was I don't know, but I guess about fourteen—mind, I'm only givin' you my impression, gentlemen, I tuck no measurement down thar below.

" 'At first a great blaze of light blinded my eyes, and I felt like an owl out of his hole in the middle of the day.

" 'Come along, sez my guide, and we went into a big country tavern-looking place that they said was the station. It looked a good deal like the inside of some of them stations they us't'r hev up in the Sierrys on the Henness Pass road. Thar was boxes o' taller candles settin' about, rope, boxes o' sope, barrels o' whisky, gin, merlasses, vinegar, and other sich stuff, I reckon, but I seed no regular bar.'

" 'There was lots o' fellers thar that seemed to belong close about, but nobody said, "Take a drink!"

" 'We soon left them onsociable cusses, and went out into the open country. All lighted up it was, for mor'n a mile round with candles, lanterns, an' bonfires. It was as fine a lumination as I ever seed anywhar. Jist as I was admirin' of it, I heered several cannons go off, one after another, somewhere up the valley, and I sez to a crowd of men we met: "Who's elected?"

" 'What?' sez he.

" 'Is the percession movin' this way,' sez I.

" ' Percession?' sez he, looking puzzled.

" 'Is it under way yit?' sez I.

" 'What under way?' sez he.

" 'Then I drapped on it that he was one of the defeated party, and was takin' no stock in the jollification; so we went on up the valley.

" ' Men was at work in the fields all about, and trains o' cars was runnin' in all directions. The country seemed to be very thickly settled.

" 'It was summer down thare, and the weather was devilish hot. The doors all stood open, and the folks had nearly all ther clothes off—the men, I mean; the women and children I didn't see—all kept inside, I guess.

" ' We went on up country 'bout four miles, keepin' the main road most of the time. We stopped at several stations. Everybody was a-drinking ice-water—blamedst people for ice-water I ever seed. Plenty barrels and kegs around, too, but nobody ever offered to treat, but all swallowed ice-water for dear life.

" ' While I was watchin' these proceedins' I heerd more cannons go off. Sez I to one of the fellers that had some clothes on half way between his head and feet: Temperance celebration, sir?

" ' All cold-water men down here,' sez the feller, grinnin'.

" ' I see; at first I thought it was on account of your 'lection,' sez I.

" ' I see he was a man inclined to be friendly, and I asked him how his ore crop was this season.

" ' He grinned, and sed: "Above the average."

" ' Where is it raised; anywhere in the neighborhood?' sez I.

" ' No; it's all raised out that way,' and he pointed down the valley.

" ' Next we got on another of them kind of railroads that

stands on end, and went to a settlement about three miles
below. The weather was hotter than it had been up in the
valley. I sez to the guide: I think we'll have a shower.

" 'Not now,' sez he; 'we'll give you a shower when we
go above. Allers git a shower when you go out.'

" 'What he meant I don't know, for I saw no rain that day,
though at times there was a good deal of thunder over-
head.

" 'The last place we went to was the Geysers. All was
bilin' hot in that section. Thar was nothin' thar but hot
rocks and bilin' water, and steam and yearthquakes; so we
didn't stay long. We seed only half a dozen or so of naked,
half-starved settlers thar that was camped on a small island
by a big bilin' spring, which they was trying to pump dry.

" Thar may be finer sections of country down thar than I
seed, for as I got thar in the night I didn't go far out in the
settlements; but for hot weather it beats Aryzona all holler.
I wouldn't live thar if they give me a thousand acres of the
best silver-bearin' land they've got. That is, I want noth-
ing to do with silver farmin', and wouldn't stop in sich a
place to dig the crap if it was aledy raised ripe, and ready
for the hoe."

This is a pretty correct description of the inside of the
mines, although he describes it as a farming country.

"TAPPING HOT WATER.

"A Singular Occurrence in Julia Mine—Narrow Escape of a Miner.

"At the Julia mine, last Wednesday, a powerful stream of
hot water was struck in the crosscut on the 2,000 level. A
Burleigh drill was set to drill a hole in the face of the cross-
cut at a point about two feet from the bottom. When the
drill had advanced about two feet in the rock, a tremendous

ɔurst of hot water from the hole occurred. The steam
was equal to twenty-four miners' inches, and was scalding
not. It spouted to the distance of several feet diagonally
across the drift, spreading as it flew, till all the open space
was filled with the scalding spray and steam. The steam
also filled the end of the crosscut where the man who had
been running the drill stood. He was held a close prisoner,
as he could not pass out through the jets of boiling water;
and even in his prison he was in danger of being suffocated
and cooked by the steam and heat. He would probably
not have escaped alive but for the drill. He opened the
exhaust-valve and allowed the whole head of compressed
air to rush out in a full and steady stream, and this not only
furnished him pure air to breath, but also cooled and pro-
tected his head, and the whole upper part of his body. His
fellow-workmen were soon aware of his perilous position
for the roar and rush of the water could be heard a great
distance; but they could no more pass into where he was
than he could pass out.

"Finally, the men went out and procured some heavy
gum boots, reaching to the hips, and large and heavy gum
coats. Guarded by these, one of the men dashed in through
the steam and scalding spray, carrying to the prisoner a
like outfit.. Shielded by their heavy gum clothing, the pair
rushed forth and waded out along the drift. The miner
had his legs pretty badly scalded. The water is still pour-
ing in, and at last accounts was slowly gaining on the
pumps."

"A SUBTERRANEAN OVEN.

"THE SAVAGE MINE NEARLY AS HOT AS HADES.

"A Well-baked *Chronicle* Reporter Relates How He Was Cooked in the Depths, and Describes Some Interesting Things on the Lower Levels.

"Yesterday afternoon E. R. Cleveland, of Bodie, and a *Chronicle* reporter accompanied Superintendent Gillette into the Savage mine, for the purpose of examining the great heat reported to be issuing from the levels lately drained of hot water. While the party were waiting their turn to descend, a miner came up with nothing on but a pair of overalls, shoes, and hat, his skin looking as though it had been parboiled. The superintendent inquired:

" 'How are things getting on below?'

" 'Oh, very well, sir, hevrything is hall right, but hit is very 'ot there now,' answered the man.

"THE FIRST STATION.

"In a few minutes the party were rapidly descending the shaft, which was so full of hot steam as to produce at first a feeling of suffocation. The shaft has a strong upcast, and has always been hot, but is hotter now than ever before. The steam comes up in a blinding volume, which increases in temperature until the landing place, 1,300 feet from the surface, is reached. Here there is still much visible steam, although the atmosphere feels dryer and hotter than any yet encountered. A sense of horrible confinement, from which there seems no escape, and in which there must be a constant struggle to keep from falling exhausted, seizes the visitor, and is not dispelled until he enters the cooling-room, where the mouth of an air-pipe, coming from the surface, strikes him as a grateful blast from the north pole. Without retreats of this kind the miners could not work at all. They are obliged to remain longer in the cooling stations than at

the picks and shovels, so debilitating is any exertion in such a temperature."

This gives the reader an insight of the intense heat of the mines, and what the poor miners have to endure in them.

" THE HEAT IN THE INCLINE.

"After attaining a comfortable condition in the cooling-room, the party entered the incline giraffe to go to the 2,100 level, the part of the mine last drained. The heat in the incline appeared half as great again as that encountered at the station. It felt dry, and was consequently very hard to bear. The iron sides of the giraffe were so hot that they could scarcely be touched without burning the flesh. The heat seemed to come fairly out of the rock on all sides, while a perceptible hot draft proceeded from the bottom of the incline. Each had a large piece of ice in his hand to use on his pulse, arms, neck, or to hold in proximity to his mouth whenever the hot air appeared to burn the lungs when inhaled. Thus provided, the giraffe was rung down. It descended rapidly until within about fifteen feet of the 2,100 level. The heat increased with every foot until the station was reached. Here it was so intense that all felt themselves wobbling when they rose to get out of the giraffe. An air-pipe close to the landing-place furnished temporary relief, while a bucket of ice-water near by was sought with greater eagerness than ever a prominent citizen did the nearest bar-room after a night's spree.

" The way from the giraffe down to the 2,100 level was by a ladder placed between the moving Cornish pump on one side and a donkey-pump on the other—a position from which, if one fell, he must either be killed outright or horribly mangled. The ice which the party started with had by this time all melted away in their hands."

The suffering of this intense heat is every-day life to the miner.

"TERRIBLY INTENSE HEAT.

" When the level was reached, a stratum of heat was entered, such as might come from hell itself. The sensation was no longer that of general oppression, but of the danger of being absolutely burned, instead of the feeling extending through the whole body; it was confined to the skin and the lungs, which seemed to be fairly scorching. When the level was entered, the breath was for an instant taken away.

"A nearly naked miner, who saw the party going in, cried out: ' Don't stay there a minute. It's too dangerous!'

" His warning was unnecessary, for no sooner had all entered than one began to make his way out. The others at once followed, and lost no time in getting to the air-pipe and the ice-water, a few feet above in the incline.

" 'You think this is hot,' said a miner who had come there for breath, 'but you ought to have been here before the blow-pipe was put in.'

" THE WRECK OF THE FLOOD.

" The 2,100 level has been so hot since it was drained last Monday that no one has been able to enter it further than to step into the mouth, as the party on this occasion did. Yet it is cooling off slowly. It is nothing like so hot as it was on Tuesday. The party remained long enough to see the wreck made by the flood when the water was allowed to rise last April, after the Sutro Tunnel compromise. A car, a small engine, a few picks, shovels, and drills were observed a few feet from the mouth, but no one approached to take a better view. The remaining puddles of water are scalding hot, and are as carefully avoided as though they were pitfalls. The water in the incline is fifteen feet below this level, and is going down slowly.

" OTHER HOT PLACES.

" The party ascended from the 2,100 level, which, al-

though hot, is comfortable when compared with the temperature a hundred feet below. One point on this level, in a lateral drift running towards the Gould & Curry, is as hot as any other part of the mine. A winze extends from this drift down a hundred feet, which is full of hot water. In order to shut off the heat coming from this winze, a bulkhead was some time ago put in a short distance from the winze. The vicinity of this bulkhead is now as hot as the 2,100 level—so hot that no one can remain there more than a minute, and yet poor miners are begrudged their $4 a day.

"A PHENOMENON IN VENTILATION.

" The drift connecting with the Hale & Norcross on this level displays an interesting phenomenon about midway between the two mines. The drift connects with the lightning drift, running to the Combination shaft, at the Hale & Norcross incline. There is a strong current of cool air coming from the Combination shaft which meets the hot air of the Savage at the point mentioned. The result is to convert the hot air into visible steam, which fills the drift for about fifty feet. The point of contact of the two currents is as clearly marked as it would be in the case of opposite colors joined together. The temperature is equally distinct. In a distance of twenty feet one passes out of an oppressively hot atmosphere to a comfortably cool one, or *vice versa.*

"COOLING OFF.

" The exact temperature of the heated portions of the mines described has not been ascertained since the late increase of temperature, but the water is said to be about 150 degrees Fahrenheit. The effect upon the visitor is to so thoroughly heat him that when he reaches the surface, where before he descended he was sweating in the heat of the day, he feels as though he had suddenly been trans-

ported to the regions of fr st and snow. Cold shower after shower is scarcely sufficient to cool the body. It takes at least half an hour and the application of floods of cold water to reduce the temperature to a normal condition, after which, however, one feels more vigorous than before."

Fire very often occurs in the mines from various causes. Sometimes it is by the miners' carelessness with their candles. Sometimes from their underground blacksmith shops, or an explosion of giant caps, nitro-glycerine, or giant powder, and sometimes incendiaries; but the latter case seldom happens, as the mines are well watched.

I do not know that they have proven a case, but it has been thought some of the fires occurred in this way. When a fire occurs, many people are suffocated by the gas.

If any portion of a mine is not worked for several days, or kept thoroughly ventilated, gas accumulates, and then takes fire. When this occurs, it is generally so sudden that miners have no chance to escape.

As soon as it is ascertained that there is a fire in or about the mines, the bells are rung, and all the whistles blown at the different mines, which warn all the miners below, and they are all hoisted as quickly as possible to the surface, and are not allowed to return till the fire is out, and all is safe.

A miner always takes his life in his hands when he takes his dinner-bucket and starts for the mines, for he does not know whether he will ever return alive. Sometimes he hardly enters the mine before some fatal accident occurs which ends his existence. There is not an hour that they are not in danger of some kind.

They are all aware of this, but do not seem to mind it. Some are even forewarned of their fate; but, instead of heeding it, they will take their pails and walk straight into the jaws of death. Some will even tell their friends that

they do not expect to return alive, and yet, after all, they endure it in both body and mind.

Capitalists are trying to cut down their wages from $4 to $3, and are even trying to fill their places with the miserable Chinamen, in order to compel them to comply with their terms; but this the Miners' Union will never hear to.

They never have, and I do not think they ever will allow a Chinaman in or around the mines; neither will they allow him to cut down the wages.

They are a very large, resolute, and determined body of honest, hard-working men.

There is a large amount of rich ore taken out of each of the mines daily.

I will here again quote a few items from the *Chronicle:*

" CALIFORNIA. VIRGINIA CITY, May 31.

"C. P. GORDON, Secretary.

" There have been extracted during the past week 1,098 tons of ore."

" CALIFORNIA. VIRGINIA CITY, July 14.

"C. P. GORDON, Secretary.

" There have been 1,467 tons of ore sent to the mills the past week. On the 850 level of the Joint Consolidated Virginia, west drift has been extended 39 feet; total length, 229 feet. The material is softer, and shows some water."

The following is from the *Chronicle:*

" Twenty-five car-loads of ore are daily shipped over the Virginia City & Truckee Railroad to the mills on the Carson."

Another item shows you how nobly the miners work to rescue their suffering companions, or restore their dead bodies to their friends.

CHAPTER XIV.

The Mines Continued.

"RECOVERING THE DEAD.

'The Victims of the Imperial Fire—How the Bodies of Crocker, Donohue,
and Perry Were Found—Horrible Sights in the Bullion Incline—
Herculean Labors of the Miners—Scene at the Shaft's
Mouth.

YESTERDAY morning the bodies of the three men suffocated in the Bullion mine, on Tuesday night, were found by Superintendent Schultz and his party. It was four days from the time the fire alarm sounded to the time when the bodies of the dead were reached. During this period Superintendent Schultz has been indefatigable in his work of subduing the fire and looking for the dead.

"THE LAST BULKHEAD.

" Four bulkheads had been put in, as previously described in the *Chronicle*, and on Thursday Mr. Schultz, with a gang of men, went down the Imperial shaft to reach the Bullion incline, and put in the last bulkhead.

"A *Chronicle* reporter accompanied the party. The route from the Imperial to the Bullion incline lay along the 1,840 drift of the Bullion, a distance of 2,700 feet. The drift for a long time had only been used for ventilation, and was in a bad state of repair.

"When the men started, they knew full well what their errand was, and calculated the chances of their never com-

ing back alive. They took with them several pails of water, and about one hundred pounds of ice. In addition to this, each man was provided with a small bottle of ammonia and a sponge.

"The sponges are used to tie over the mouth when the wearer is in proximity to foul gases, and are saturated with ice-water.

"If a miner feels faint from inhaling the gases, the ammonia revives him. A sudden cave was looked upon as liable to spread the gas.

"In putting in the bulkhead in the Bullion mine, Mr. Schultz proposed to shut off the gases coming from the winze, and then the current of air from the 1,840 level, entering the incline above the bulkhead, would free it of bad air, and enable him to explore the incline above that point. The journey through the 1,840 drift was something fearful. The mud and water was knee-deep in many places, and the bottom of the drift was strewn with loose rock, old pipes, broken timbers, and dismantled bulkheads. Above, the weight of the rocks had forced the timbers out of place, and their jagged edges came nearly half way to the floor. The sides were crushed in in a similar manner, and as the men advanced, they stumbled over the obstructions, floundered through the mud, and crawled on their hands and knees.

"THE INCLINE REACHED.

"The incline was finally reached. At the station was an air compressor run by steam. By leaning over the platform the smell of gas was plainly discoverable, and a faint trace of smoke swept up by the draft. The men placed sponges over their faces and lowered themselves down. Instantly their candles were extinguished by the foul air; again and again the lanterns were lowered, and went out instantly. The next thing done was to order the men back on the platform and disconnect the air pipes. Two pipes

passed that point, and after considerable labor they were disconnected, and this gave a fresh supply of air, While this was being done the men worked with the sponges over their mouths, and these were kept saturated with ice-water. S me placed pieces of ice the size of their fists in the hollows of the sponges, and sucked them. Part of the time they were in the incline, and the sponges becoming impregnated with the gases, had to be wrung out every five minutes. The men drank two gallons of ice-water in half an hour.

"THE GAS INCREASING.

"After about an hour's work the gas in the incline seemed to be increasing, and the heat was frightful. Orders were finally given to leave the place and go back to the Imperial cooling station. The men availed themselves of the order at once, and returning to the Imperial, remained there an hour, and after recuperating, returned again to the station with timber and canvas for the bulkhead. This bulkhead was constructed only with great labor, and was finished at one o'clock yesterday morning. Two compartments had to be bulkheaded. Timbers were laid closely together, just below the floor of the station. These were covered with canvas, and clay thrown over the canvas. The heat was so intense that the clay had to be wet with a hose. After everything was secured tight about the bulkhead, the gas still escaped, and a spray hose was put down through the bulkhead. The shower of water from this kept back the gas, and in half an hour the atmosphere was comparatively pure. This took until nearly three o'clock in the morning, and when the incline was considered safe, two men were sent up to the 1,600 station.

"PERRY'S BODY FOUND.

"A gang of six men were next sent down the Bullion shaft at seven o'clock in the morning. On reaching the

first station of the incline, on the 800 level, they found the body of Perry. It was lying on the last sill, and within seven feet of a cooling station. He was evidently trying to reach this station when he was overtaken by the gas. His lantern was found about one hundred feet below in the incline. The body was much swollen and discolored. It was sewed up in a canvas sack and taken to the cooling station.

"THE LAST BODY FOUND.

" Search was next made for the body of Crocker. It was found thirty-five feet below the 1,200 level. The dead man's back was supported by a center-post, and his legs were resting on one of the sills. He appeared as if he had been struck, and fallen as found. Like the others, the body was swollen and discolored. The face was so much so that it had a ludicrous expression. The body was placed in a canvas sack, and soon afterwards an improvised car was sent down from the head of the incline, and the bodies of Donohue and Crocker taken up and laid by the side that of Perry.

"THE BODIES BROUGHT UP.

"At one o'clock yesterday afternoon Perry's body was brought up the Bullion shaft. Quite a crowd of his friends and associates were gathered in the hoisting works at the time. The cable crawled over the sheave at a snail's pace, as is usual on such sad occasions. The crowd gathered closer about the shaft as the cage came in sight. When it landed, the father-in-law of Perry stepped forward and asked for the remains of his relative. The body was turned over to him and taken away. About midnight the other two bodies were brought up. The crowd at the shaft was not so large—only the near friends of the deceased being present. When the cage stopped, the sight was not wanting in ghastliness, as the glare of the engineer's light fell full upon the canvas sacks. They were taken off the cage

and laid side by side. Soon after the secretary of the Miners' Union claimed the body of Crocker, and the coroner took charge of the remains of Donohue.

"HOW THE MINERS WORKED.

"During the past four days the men about the Bullion have worked ceaselessly in the recovering of their comrades' bodies.

"Henry Blight, J. J. Brooks, and A. N. Baker worked twenty-four hours each on a stretch in getting out the bodies. Foreman Manyfreed did double duty nearly all of the time. The inquest on the bodies of the deceased will be held to-night. Donohue was a single man. The other two men were married, and had families in Gold Hill."

"A FALL OF THREE HUNDRED AND TWENTY-FIVE FEET.

"William Eddy Killed in the Combination Shaft on Sunday Morning.

"About one o'clock on Sunday morning, William Eddy, employed at the Combination shaft, was killed by falling from the lightning drift to the bottom of the shaft, a distance of 325 feet. His duty was to watch a water tank, which was about fifty feet from the shaft. He was missed about a quarter past one o'clock, and a few minutes afterwards he was found at the bottom of the shaft in about three feet of water. He was immediately taken on top and a physician sent for, who pronounced his injuries fatal. He was not badly hurt externally, but his internal injuries placed him beyond all hope of recovery. He did not speak after being brought to the surface, but was most of the time apparently conscious.

"HOW THE ACCIDENT HAPPENED.

"No one saw Eddy fall, but it is generally supposed tha'

he fell asleep and walked into the shaft. For some weeks past he had been complaining of drowsiness, and would sometimes fall asleep while watching the tank. A miner who has no active hard work to do is apt to feel sleepy where the atmosphere is hot and impure. It is therefore believed that while in a somnambulistic state he walked into the shaft. In falling he must have reached the bottom without hitting the sides. He had a rubber overcoat on, and this is supposed to have acted like a parachute to check the fall, while the three feet of water in the shaft also helped.

" Eddy was about twenty.three years of age, a native of Cornwall, unmarried, and had a father employed at the shaft. The inquest will take place to-night."

The reader will see by these clippings the different ways and means by which miners meet with shocking deaths. Often when they fall down these shafts and inclines nothing remains to be carried to the surface but a mass of broken bones and pieces of flesh; not even the limbs are whole. Often they cannot be recognized by their friends, and often no one is allowed to see the remains but the coroner and undertaker. Those who meet with death in the mines, and have no family, are always taken directly to the undertakers when such a case occurs. You will often see two undertakers going after the same body; the one who gets there first gets the job.

––––

"A FALL OF ONE THOUSAND THREE HUNDRED FEET.

––––

"A MINER DASHED TO PIECES IN THE SAVAGE SHAFT.

––––

"Fearful Death of Nicholas Dickmon—The Result of a Blunder Somewhere—Particulars of the Horrible Affair—Statements of the Engineers and Miners.

––––

"This morning there was another fatal accident at the Savage mine. Just as the six o'clock whistles were blow-

ing Nicholas Dickmon was, by a blunder, precipitated to the bottom of the shaft from a point about fifty feet from the surface, falling fully 1,300 feet, and meeting instantaneous death. When his body was recovered by the men working below, it was mangled beyond the possibility of recognition. The left arm and right leg were severed from the trunk, the abdomen was shockingly lacerated, and the head was utterly annihilated. The body was gathered up, piece by piece, and placed in a sack, in which it was carried to the surface.

<center>" HOW THE ACCIDENT OCCURRED.</center>

"T. K. Johnson, the working companion of Dickmon, and who was himself injured by a singular explosion of gas from the pump column a few days ago, related the particulars of the melancholy occurrence as follows : ' He and the deceased, with two other men, were taking out a column of wooden boxes in the compartment of the shaft adjoining the pump compartment. These boxes were used to force air into the mine for ventilation, but are no longer of service. The men had done a good shift's work, and were just taking out the last box before quitting. They all felt in good spirits at the result of the night's labor, everything having gone on very smoothly. The boxes were hoisted to the surface by a small capstan engine. The adjoining compartment of the shaft to the south, which is provided with a cage, was used for hoisting the men as the work progressed upward. They had already got within about fifty feet of the surface.'

<center>" THE FATAL BLUNDER.</center>

"Johnson had been ringing the bells all night. But one bell-rope was used—that in the cage compartment. The signal to hoist the cage was three consecutive taps; that to hoist the boxes one tap, an intermission, and then three more in succession. They had loosened a section of the boxes fifteen feet long, and fastened it to the cable to hoist.

One man was in the box compartment standing on the wall-plates to guide the box when it started upward. The other three, namely, Johnson, the deceased, and a man named John Champion, were on the stage. The deceased and Champion were leaning with their backs against the wall-plates and their feet upon the stage. Johnson rang to hoist the box, and called out to the man in the box compartment, as is usual in the mine, saying : ' One and three bells gone !' Instantly, and to the unspeakable horror of those upon it, the cage was hoisted, throwing the feet of the two men leaning against the wall-plates upward, and letting them slip backward between the cage and the timbers. Champion caught one of the braces of the cage and saved himself, but Dickmon fell to the bottom of the shaft, as stated. Johnson, who was standing upright on the cage, instinctively grasped the bell-rope as the cage started, and rang to stop. The engineer obeyed quickly, and the cage moved only about four feet. Had it proceeded further, the fate of Champion must have been the same as that of Dickmon.

"WHAT THE ENGINEER SAYS.

" Two engineers were on duty when the accident happened—one having charge of the cage-engine, and the other the engine to hoist the boxes. John Stout, the engineer who hoisted the cage when the signal was intended for the other compartment, declares that he heard three consecutive bells distinctly, and no more. The man at the other engine also says that he heard only three. These statements stand against that of the man on the cage who pulled the bell-rope.

" The chief engineer of the works explains by saying that sometimes there occurs a hitch in the communication, by which, when four bells are intended, only three are heard. He noted this a few days ago when he was on duty himself at one of the engines. The balance-box would catch, and the first pull upon the rope would only free it, instead of sounding

the first bell. This he regards as the only explanation to
be offered of the fact that the rope was pulled four times
and the bell sounded only three.

"WHO THE DECEASED WAS.

"The deceased was a German, aged about thirty-one
years, and had no relatives in this city, nor in this country,
so far as at present known. He was a member of the Odd
Fellows' Society, and the Miners' Union. His body was
taken to the rooms of an undertaker on South C Street.
An inquest will be held at six o'clock this evening. John-
son says that when the deceased found that he was falling
into the shaft, he uttered not a word, but looked at him in
such a way that he will never forget it. The flag over the
Savage works floats at half-mast to-day in mourning for the
terrible accident."

The Mechanics' Union is a society which sprang into ex-
istence a few months before I left Virginia City.

I will copy a few of their doings from the *Chronicle*, to
show the public how fast they have grown in power and
strength :

"FIVE DOLLARS A DAY.

"The Mechanics' Union Out in Strong Force.

'They Demand Five Dollars a Day for All Skilled Laborers.

"Colonel Gillette Interviewed at the Savage Mine.

"The Bonanza Mines Next Visited by the Mechanics.

"Nine Four-Dollar Men Forced to Quit Work To-Day.

"At eleven o'clock this morning a procession, composed
of about 250 men, led by William E. Chandler, and with the
American flag in the van, filed out of Miners' Union Hall,

on B Street, and along B to Taylor, and thence to C Street, along which it proceeded south. The men walked two by two, and not a word was spoken by which the object of the out-run could be made known. On reaching Flowery Street the procession turned down it to D, and proceeded to the side track in front of the Savage works, where it halted.

"Messrs. A. F. Mackay, J. D. Loyanchan, and S. Wilkins then left the ranks, and walked into the time-keeper's office, at the Savage shaft, where they were received by Superintendent Gillette, and invited to be seated. A reporter of the *Chronicle* was also present.

"Mr. Mackay and Colonel Gillette then had the following conversation:

"THE OBJECT OF THE CALL DISCLOSED.

"Mr. Mackay—'According to previous notice, we have called upon you in behalf of the Mechanics' Union of Storey County, to respectfully ask you to comply with our demand.'

"Superintendent Gillette—'What is your demand?'

"Mr. M.—'We stated it plainly when last we called upon you.'

"Supt. G.—'And I answered it plainly, too, but you misconstrued it.'

"Mr. M.—'I beg your pardon, sir; we did not. You said you would comply with our scale of prices, and you failed to do so. You pay what you call skilled carpenters $5 per day, but those who square timbers only get $4. They must get $5. All carpenters who go down in the mines must get $5.'

"Supt. G.—'I'll tell you what I'll do, and this must be final—I'll discharge all my wedge-makers, and keep one man underground at $5. All others will get $4.'

"Mr. M.—In that case, we will ask you to sign this agree-

ment.' (Handing him an agreement of which the following
is a copy.)

" ' I, —— ——, superintendent of the Savage mine, here-
by agree to pay all engineers who are running surface
hoisting engines not less than five ($5) dollars per day, said
day to be not more than eight (8) hours in twenty-four (24)
hours. I also agree to pay all engineers and mechanics
otherwise engaged than as above specified, including tim-
ber-framers and tool-sharpeners, not less than the same rates
established for the past five years in Storey County.

" '(Signed,) —— ——

" ' VIRGINIA CITY, June 14, 1878.' "

" Supt. G. (*excitedly*)—' You've got my final answer now.
I'll not sign that. I'm d——d if I shan't suffer death before
I'll do it! I can't do any more without consulting with the
president of the company.'

" Mr. M.—' In that case, sir, we demand that you imme-
diately put your carpenters at work for $5 per day. This
does not include wedge-makers, as they need not be skilled
laborers, but we do include roller-makers.'

" The boss carpenter was now called in. He said that he
received $6 a day, and that he received instructions a day
or two ago to pay $5 after the 15th.

" The committee insisted that this order should be en-
forced instantly, and a member asked :

" ' Have you any $4 a day men in the mine ? '

" ' No ; they are all on top.'

" Mr. M.—' It is understood that you will not allow any
more to go to work for $4 '

" Supt. G.—' No, sir. Every man about these premises
will get the wages you demand, viz., underground, $5 ; on
top, $4.' ' The last probably refers to what are known as
unskilled laborers. The committee and superintendent evi-
dently understood each other, though the reporter did not.)

" The committee then returned to the body of the pro-

cession, and made their report, which was substantially that the superintendent of the Savage had agreed to comply with their demands, but that he had referred the agreement to the president of the company to sign. The report was received with a cheer.

"AT THE BONANZA MINES.

" The Union then re-formed its ranks, and proceeded along D Street to the Consolidated Virginia works. By this time there had been large accessions to the ranks, so that fully 500 men were in line, and as the head of the procession halted close to the hoisting compartment of the works, the end was still on D Street. The men were all cleanly dressed, and every way respectable in appearance, peaceably disposed evidently, but determined. The same committee left the ranks and entered the superintendent's office. Assistant Superintendent Patton received them, and provided them with chairs, when Mr. Wilkins made their business known. He then continued:

" ' We received your letter, and presented it to the Union. Not being satisfied with its contents, the Union determined to present their demands in person. Here is a contract which we desire you to sign.'

" Mr. Patton (after reading the contract)—'Why don't you state your demands plainly? For instance, your prices for carpenter work. The prices which have been paid for the last five years is very indefinite. I've paid and am paying all the way from $6 to $4.50. Just write down your demand, please, and I'll consider it.' (The contract was substantially the same as that presented to Superintendent Gillette, but, agreeably to Mr. Patton's suggestion, it was amended so as to read, that 'the wages of all carpenters, blacksmiths, engineers, and machinists shall not be less than $5 per day.')

" Mr. Patton reiterated that he was paying carpenters $5 and $6, and added:

" 'That's all I can say on this subject, gentlemen. Mr. Fair, as you are aware, is very sick, and I don't want to trouble him about this business; and I cannot do more without communicating with the trustees. In fact, I have done so already, expecting you would not move in this matter before the 1st of July, the date publicly announced by yourselves. I intended at that date to be ready to give you a final answer.'

" Mr. Mackay—'We did not intend to act before, but things have shaped themselves so that we had to act at once.'

" Mr. Patton—'I can do no more at present, and if you will not wait for the 1st of July, when the trustees have considered the matter, you can do what you choose.'

" Mr. Wilkins—'We do not feel bound by that notice.'

" Mr. Patton—'If the trustees ratify the communication sent you yesterday, we will act upon it at once.'

" Mr. Wilkins—'How soon will they act?'

" Mr. Patton—'I don't know, but our action will depend entirely upon theirs. My impression is they will agree with my suggestion.'

" A PEREMPTORY DEMAND REFUSED.

" The committee now retired to the adjoining room, and returned presently, and Mr. Wilkins said:

" 'Mr. Patton, under the circumstances we have to ask the names of those that are working for less than $5 per day. If you choose to discharge them and hire others, or to reinstate them at $5 per day, you can of course do so. But they shall not work for $4 a day any longer.'

" Mr. Patton—'This is taking snap judgment, and going back on your notice.'

" Mr. Wilkins—'We are not bound by our advertised notice.'

" Mr. Patton—'Very well; do as you see fit.'

" Mr. Wilkins—'Is that final?'

" Mr. Patton—' That's my answer.'

" Mr. Wilkins—' In that case we have nothing to do but report. Good-day, sir !'

" Mr. Patton—' Good-day, gentlemen !'

" IN THE CARPENTERS' SHOP.

" The committee then walked out of the office and into the carpenters' shop, where they were met by Augustus Riegles, the foreman, of whom they asked :

" ' How many men have you got working for $4 ?'

" ' I dont know ; you must see the time-keeper,' was the reply.

" ' Very well, we shall see for ourselves.'

" The committee then walked to the carpenters at work, and, addressing each individual, asked :

" ' What wages are you getting ?'

" ' Four dollars.'

" ' Pick up your tools and fall in with us !'

" ' All right.'

" Four men were found who admitted they only received $4 a day. When they had joined the ranks, Gus Riegels was informed that it was the desire of the Union that he should not replace these men with $4 men. He replied that he had nothing to do with hiring hands.

"AT THE C. & C. SHAFT.

" The ranks were then re-formed, and the Union marched through the works to Sutton Avenue, when it turned towards the C. & C. shaft, reaching the works about ten minutes past twelve o'clock. All the day men had gone to dinner. It was therefore agreed to remain until one o'clock, and in the meantime a committee was dispatched to the California pan mill, where it had been reported the blacksmiths only got $4 per day's work. The committee soon returned, and reported that the Union's rate of wages was paid. When the whistle blew at one o'clock, the carpenters

were interviewed in the same manner as those at the Con-
solidated Virginia works had been, and five $4 men were
ordered to 'fall in,' which they did. The procession then
marched back to Miners' Union Hall, where it was dis-
banded.

"The regular meeting of the Union will be held to-mor-
row evening, when the situation will be fully considered.

"THE MECHANICS' STATEMENT OF THEIR CASE.

"While the Union was waiting for one o'clock at the C.
& C. shaft, the *Chronicle* reporter obtained from B. F.
Hazeltine and others their explanation of the movement,
which was as follows:

"Last March the wages of mechanics at some of the
mines were reduced, and a number of skilled laborers were
discharged to make way for unskilled laborers at lower
wages. This appeared like a preconcerted attempt to re-
duce wages all along the lode. It was therefore deter-
mined to organize a Mechanics' Union, and on the 25th of
March a preliminary meeting was held, at which it was
agreed that all mechanics should join the Union. The
Union was fully organized in April with about 130 mem-
bers, and its membership increased to above 500. This, it
is argued, proves the necessity for the Union and its popu-
larity with the working-men. On the 29th of April a com-
mittee was appointed to call on the superintendents, and
request them to adopt their scale of wages. As a rule,
they agreed to do so. Among those who did so was Col-
onel Gillette, superintendent of the Savage; but when his
men were paid off on the first of this month, they were
only paid at the old rates. This was made known to the
Union, who thereupon held a special meeting, at which the
situation was thoroughly discussed. Some were alarmed,
and all agreed that if they waited until July 1st it would
be too late for action that month, as far as wages were con-

cerned, and by August there might be no need of a Union. It was therefore agreed to take 'time by the forelock,' and act at once. But first, letters were sent to several of the superintendents. The reply of Mr. Patton not being satisfactory, the action taken to-day was determined upon, with the result above stated. The Savage was the first mine visited, because they claimed that Superintendent Gillette had not adhered to his agreement.

" THE CORRESPONDENCE.

"Following is the letter referred to in the interview between Mr. Patton and the committee of the Mechanics' Union. The Union's note is also published, in order that the readers of the *Chronicle* may read Mr. Patton's letter understandingly.

"THE UNION'S NOTE.

" 'MR. JAMES G. FAIR, *Superintendent Consolidated Virginia and other mines :*

" ' DEAR SIR.—As it is possible that you do not clearly understand the demands of the Mechanics' Union of Storey County, we herewith most respectfully submit our demands.

" ' *First*—We demand not less than $5 per day for all mechanical work in or about the mines under your supervision, such as carpenters, blacksmiths, and machinists' work, and all tool and pick-sharpening and timber-framing to be considered mechanical work ; and

" ' *Second*—All engineers running surface-hoisting engines to receive not less than $5 per day, said day to be eight hours and no more; and other engineers running mill or pumping-engines to not receive a less rate than has been paid on the Comstock during the last five years.

" 'An answer over your signature is earnestly requested to-day, on or before four o'clock P. M.

" ' By request of the Mechanics' Union of Storey County. All of which is respectfully submitted by

" ' S. WILKINS,

" ' *President of Mechanics' Union, Storey County.*

" ' VIRGINIA CITY, June 12, 1878.'

"THE REPLY.

VIRGINIA CITY, June 13.

" ' TO THE MECHANICS' UNION OF STOREY COUNTY:

" ' GENTLEMEN.—I am in receipt of your favor of 12th instant, and have noted contents fully. In reply, I would say that there are no men at work at any of the mines that are in my charge who are not receiving wages in accordance with your request, except twelve timber-framers, now working at the C. & C., and Consolidated Virginia shafts. This reduction has been made with these timber-framers, together with the reduction of many other expenses, in and around the mine, at the demand of stockholders, through the home office, who complained bitterly of the heavy expenses attached to the mine.

" ' I preferred to make the reduction of wages in this class of work rather than to do the work of framing timbers by machinery, which I shall be obliged to do in case you continue your demands. This would greatly reduce the number of men employed. Any change from the present course would necessitate my consulting with the trustees at the home office, as Mr. Fair's health will compel him to resign all official connection with mines in this State during this month. His present condition is such that I cannot consult with him regarding the minor details in and around the mines.

" ' Very respectfully,

" ' W. H. PATTON, *Assistant Superintendent.*' "

The reader has now a pretty thorough description of the mines, how they are worked, and how they are managed. They can also see how the Miners and Mechanics' Unions stand up for and maintain their rights. In my next chapter I will return to my own and my son's private life.

CHAPTER XV.

Our Lives Continued.

IN the summer of '77 Charlie did not seem very well for several weeks, and then came down with typhus fever, which was prevailing in the city at the time. I think he caught it through my nursing a sick friend.

He was attacked very severely, but I succeeded in breaking his fever at the end of the first week, and as soon as he was able to sit up, I sent him down to the bay. He went in company with some of his friends who were going down. Here, too, I learned how many friends my boy had, for the crowd that accompanied him to the depot was immense.

San Francisco agreed with him, for after a few days he gained rapidly. At the end of the second week he accepted an engagement in the California Theater. He was gone three months, when I wrote to him to come home, as I was going East.

He telegraphed back: "You will have to come after me. I am sick."

When I received the dispatch, I immediately commenced preparations for the journey, and five days later landed in San Francisco. As I stepped from the cars to the platform, I stopped a moment to consult the dispatch for the number of his lodgings, when some one touched me on the arm. I looked around, and there stood Charlie—a walking ghost, if there ever was one.

I took his arm, and we walked along slowly, till we reached his boarding-house.

I was told here he had been very sick. The lady also said: "He commenced playing about the second week he came to the bay, and has kept it up till within the last three weeks when he ought to have been in bed most of the time. He grew so much worse that the last night he played he was carried from the stage, as soon as the curtain dropped, by some of his friends, brought here, and placed in bed. He has been under the doctor's care ever since, till he got your letter, which acted like magic. He was so rejoiced to think he was going East that we could not keep him in bed another day." (He was stopping at the house of a Mrs. Devine, aunt to his friend and old schoolmate, Edward Devine, who roomed with him at the time. They were all very kind, and gave him every possible care.)

After they had all told their story, Charlie laughed and said: "Well, mother, I made a hit, for the character I took was a drunken noblemen, and I was so sick I could hardly stand or speak; my tongue was thick and husky. In fact, I acted like a drunken man. Everybody thought I acted the drunk to perfection; so you see it was all for the best."

He had kept his illness from me all this time, hoping from day to day to recover. He did not wish me to know of his illness, for he wished to return again to the stage, and he knew I would forbid his playing as soon as I heard of it.

After one day's rest I settled his bills, bought our tickets, and started for Virginia City. His round trip to San Francisco and back to Virginia City cost $330.

I found he was not able to take a long journey, so we stopped in Virginia City one month. I now went to doctoring him myself, and by the time I was ready to go East, he was quite able to travel.

I had my store and small house rented. The upper part of my house I left in charge of a lady friend, Mrs. Epley, till my agent could rent it. I sold the goods that had cost me $1,700, for $400.

One hundred dollars' worth I sold at private sales, and the balance to my old friend, Mr. Jackson.

At the time I settled with the Atlantic Company, I saved out what I needed for present expenses; the rest I invested in California and Consolidated Virginia stock, and left it with the rest of my stock in the hands of a broker, with instructions to my agent to draw the dividends for me.

We now bid adieu to all our kind friends, and started East. It was the 8th of January, but very mild weather, there being scarcely any snow till we reached Omaha, except while crossing the Rocky Mountains, where we found considerable.

The plains were dry and dusty in many places. In numerous parts of Nebraska, Iowa, and Illinois we passed large fields of corn, potatoes, and other vegetables which were not yet harvested. We had a very pleasant trip, meeting with no accidents.

We had a very nice lunch put up (thanks to our many kind friends), which consisted of jellies, honey, pickles, cold turkey, baked chickens, corned-beef, dried beef, cheese, bread and butter, sponge jelly, fruit cakes, sardines, and cove oysters, and quite a variety of other edibles. We also had tea, which we steeped on the stove in the cars.

The lunch was put up by my friends Mrs. Rawson, Beck, Calvin, Seltzer, Epley, Dunlap, and Gates. My butcher, Mr. Williams, also made me a present of about ten pounds of dried beef. I suppose he thought I was going off to camp out for the winter, for it lasted us nearly all that time.

We journeyed very slow on account of Charlie's health, stopping at many places to rest over night, as he was not able to stand a through journey; besides, I wished him to see the country, as he was too young to enjoy it much when we went out.

We reached Buffalo at five o'clock in the morning. As there was no 'buss or street-car at this hour, we thought we would walk to my sister's, as we wished to get there as soon as possible, and resume our journey in the afternoon.

When we were nearly there we met a policeman, who very kindly showed us the house, it being too dark to see the numbers from the sidewalk.

The family were not up, but my sister came and peeped out of the window, saw us standing there, and guessed who we were. As soon as she unlocked the door we were in each other's arms, and both wept for joy to think we were again with each other.

The rest of the family were soon up, and we had a good old-time reunion.

Breakfast was soon over, and we sat down to enjoy ourselves. The events of ten years were scarcely told on each side before it was time for an early dinner, and to start for the train. At one o'clock my sister was ready to accompany us.

We took a street-car, and in a few moments reached the depot. We were soon seated in the cars, the train moved out, and we were speeding on our way towards our home—dear, old home.

As we drew near Warsaw, the train began slacking up, and finally stopped. I inquired the cause, and found it was a snow-drift on the track. They said we would have to wait half an hour before it could be removed, but it was a full hour and a half before we were again under way.

We were now rejoicing to think we were not detained longer, and congratulating ourselves of the prospects of soon reaching Nunda. Imagine, then, our disappointment, for the train stopped again before we reached Castile station.

We were snowed in, and were told we would be detained five hours; but, as good luck would have it, we got off in three hours. We had no more drifts, and soon reached Nunda, where the stage was waiting for the train.

Our luggage was soon stored away, and we took our seats in the stage. The whip snapped, and the horses started off on a trot.

My anxiety to reach home now amounted to almost pain, which grew more intense every moment. I could scarcely control my feelings, so long did it seem before we drew rein at the dear old house.

I was the first to leave the stage, and, leaving Charlie to look after the baggage, I went to the house.

I was met at the door by my father, who folded me to his heart in a fond embrace. As soon as he released me, I went to my dear mother, who was lying sick in bed. She had been sick about six weeks, but my return seemed to give her new strength, for in a few days she sat up. But alas! my joy was soon turned to pain. My mother took a fresh cold, and was again taken down to her bed when I had only been home five days, and for weeks we all thought we must part with her.

My sister and myself sat up with her night and day for six months, and then family sickness called my sister home, and I was left for two months alone with mother. She was now so she could sit up; and when the warm days of June and July came, she walked out to see her flowers.

We were all encouraged about her health. Although she was able to walk about the house, she had very restless nights, and I never allowed her to be alone one moment.

My mother thought a great deal of her grandson Charlie, and he whiled away a great many hours in reading and acting for her amusement. His poetical talent seemed to amuse her most of all.

We had been home about eight months, and were just beginning to enjoy ourselves after my mother's recovery, when things began to go wrong in the West.

When I left there I had a handsome fortune invested in stocks. My income was just $200 a month. I left orders

with my agent to send me the money monthly, as I wished to use it in the East.

I did not get any for some time, and then only in small postal orders—which were sometimes two months in reaching me—one of which was lost, and I had to wait for a duplicate order. I do not know why letters containing post-office orders should be so long in reaching their destination, while a common letter will go through in seven days.

I knew it was not my agent's fault from the date of the letters. I received a few hundred dollars, and then he stopped sending, and did not even write for a long time. I thought he had been putting the money in the bank, and wrote to him to buy me fifteen shares of Consolidated Virginia stock, which had dropped to $20 a share.

My next Western papers showed me that Consolidated Virginia stock had again dropped to $12 a share. I wrote to him to buy fifteen shares more of Consolidated Virginia. He now wrote that he had bought the stock at both these figures, as I had ordered. He also told me he had borrowed money at the bank, and bought the first lot; had "ponded" the stock for the second lot. He said: "I used the money to buy Ophir. If I lose on it, I will make it up to you."

It seems he had got what he thought was a good post from some of the bonanza employees, and went to dealing in stocks at my expense—a thing he never did, and never will know how to do.

He has been broke half a dozen times by the business; and it seems he was not satisfied with this, but thought he would try and break me; if he did not succeed, it was not his fault. I think he tried hard enough.

The old adage is "Trouble never comes singly." In my case it was true, for the Consolidated Virginia stopped paying dividends; California dropped off $1 of hers;

Ophir also took a fall from a very high figure down to $40.

My agent had been at his old trick—doubling up on stock, and was sold out on his Ophir.

About this time the man who rented my store sent me word that he would move unless I came down $10 a month on the rent. I sent him word to move, as he had not lived up to the contract since the first day it was drawn.

He did move, and took a part of the house with him.

My house was vacant several months before I got another tenant.

California now gradually dropped down from $36 to $7, and then dropped off her last dollar dividend. Everything was dropping. The brokers began selling off my stock to pay for the borrowed money, as well as the stock bought on credit.

My agent had got things so mixed that he did not know what to do, so he stopped writing to me entirely. I had fifty shares of Exchequer which had cost me $5 a share. I had held it eight months waiting for a raise. It came, but the brokers had sold it only two days before it went up to $11, and kept stocks that were constantly falling. This is a broker's trick. After all the stock which they had sold, I was still in debt about $100. This I learned from my banker. I had become scared at my agent's silence, and wrote to the bank to know how my account stood. The information it sent me determined me to go West, for I saw my stock was nearly gone, my store empty, and I was only getting $45 a month for both houses.

I had written several letters for money, but had received no answer. I tried to borrow money in the East, but could not. I wrote to my friend, Mrs. Beck, telling her I wanted money very much with which to go to Virginia City.

The return mail brought me a letter containing a draft for the amount of money I needed (she having traveled the road so often, knew exactly the amount I needed.)

When I saw the draft, I could not help shedding tears over such pure, disinterested friendship.

I now sent for my sister to come and stay with my parents till I returned.

I then bid adieu to all my loved ones, and took a Western-bound train. In eight days I landed in Virginia City, taking all by surprise but my friend Mrs. Beck.

My friends were as glad to see me, I think, as I was to see them. I think my agent was quite as glad to see me as any one, as he had become so entangled that he wanted me to help him out of his difficulties.

I sold some more stock, and paid up the borrowed money, got my stock free, and took it to another broker, and told him to let no person draw money on it again, agent or no agent.

I would not have my readers think that I for one moment doubted the honesty of my agent, for I did not; neither did I think he had got "fool in the head," as the Indian doctor said when asked what ailed his patient, who had the softening of the brain. But I did think he had stock on the brain, and had not a good, general business tact. I never knew a chronic old bachelor who did have. Perhaps he was affected by the climate. I suppose if I had left all the stock I had with him, he would have soaked the whole amount in Ophir; but, fortunately, I did not. Consequently I have a few hundred shares left yet which, with the remnant left of what he had, will be a little fortune by itself if I hold it for a raise, which I intend to do. My home and mill-site in Virginia City is still left, and some property belonging to my brother. So I am not broke, or, as some think, lost all my property. I have allowed the public to think what they chose, as I wished to gratify a whim of my son who, before coming East, said: "Mother, if there are any pretty girls in the East, I may take a fancy to one; and if I do, I have an old-fashioned notion to be loved for

myself alone, and not for my money. If you have no objections, we will make people believe we are poor after we have been home a few months. We will make it appear we have lost our stock. This will test our friendship." I told him I had no objections. After a few months some of our stock fell. We could now say we had lost, and tell the truth; but we left it to the tongue of the mischief-makers to say how much, for we knew they would get it enough every time.

About this time things began to go wrong in the West, and our losses did prove heavy. Our bad luck commenced in reality. Charlie began to look quite blue when the dividends were cut off, and the rent lowered. He said it was nice to play poor to test friendship, but to be poor was another thing. A good share of the stock "ponded" for Ophir was his. I told him not to worry, as I would divide with him. He said he thought it must be a judgment on him for his deception. I told him it was no deception; it was simply a test of friendship; and although we were often cramped for money, he stood it like a hero. We never repented the test. Often our postal orders would not reach us on time, and we were obliged to borrow money, which was almost the next thing to impossible. Yet a few friends stood by us; these we shall not forget hereafter. Those who left us we do not want. My store was still empty. The woman who had the upper part of my house, together with the small one, had got my agent to reduce the rent $15. She had threatened him if he did not, she would move out. He, not knowing what else to do, had let her have it at her own price.

I now tried to sell my house, and offered it for $8,000—about one-half of what I had been offered at the time of the big fire. A man agreed to take it at this price as soon as he sold his Nevada stock. It was then $300 per share. I advised him to sell, and offered to take it at these figures.

No: he wanted more. I told him he would never get it; it would drop before two weeks. I tried to persuade him to save himself.

"What do you want of it if it is going to fall?" he asked.

I will put it in to-day, and sell it, I replied.

"Well, I guess I will keep it another week, and I will make profit enough on it to pay you for your place."

If you wait you will never buy it, said I.

Well, he waited, but the brokers did not let him wait long. It was the old story—he had doubled up, and they sold him out. Some of his stock he had bought for 75 cents a share, and now refused to sell for $300. I think he earned his loss. Any man who is not satisfied with $299.25 clear profit on one share of stock earns his poverty, and ought to eat sage-brush.

When Sierra Nevada made such a big break, everybody in Virginia City was broke, too. Nobody wanted to buy—nobody wanted to rent. I was obliged to leave it with my agent to do the best he could with it.

After receiving a nice lunch from the same kind friends who had prepared the one for my previous journey, I bid them all good-bye, and started again for my Eastern home.

I had a very pleasant journey over the plains, enjoyed it much more than I did when I went out in the fall, for then the prairies were on fire in a great many places. For three days and two nights we were passing through fire on either side of the track. We had to keep the windows down, and doors closed. The window glass was quite hot most of the time.

Occasionally we would pass over quite a space which had been burned before. This gave us a chance to get a breath of fresh air, and the cars a chance to cool off. In many places it was one sea of flame from the track off on the

prairies as far as the eye could see. The passengers were afraid the cars would take fire.

"Well, Bridget," said our friend, Mike, to his wife, "if they burn us up, we will sue the company, so we will."

"Ouch, Mike, you fool, an' how could we be afther doin' that whin we're kilt intirely?"

We saw several buildings near together at a great distance off. A barn was nearly consumed, but the flames had not reached the house. People were going to and fro, carrying out furniture. Men, women, and children stood huddled together near the house. I have no doubt they were all consumed by the flames, for we could see no way for them to escape, unless they were surrounded by a streak of plowed ground; but this we had no means of discovering, as they were so far off. It was dreadful to see them standing there, and we no power to save them.

I was glad when we left the burning plains and struck the mountains. It was supposed the fire caught from the cars.

When I came back in January, I saw the ruins of many burned buildings. The grass is about three feet high; and when large tracts of it takes fire, the flames will reach from ten to fifteen feet. I think this ranche must have been ten miles off, for the persons we saw passing back and forth looked like mere children.

You can see a great many miles in a straight line on the prairies. It was the Nebraska prairies that were on fire.

There has been a vast amount of improvement along the line in the last ten years. The little cloth-tent settlements which then dotted the plains are now flourishing villages and cities of two and three-story buildings; many of them are of brick and stone. Wherever the ground is tillable they have large fields of grain, young orchards, and fine gardens. The country is fast filling up, many of the towns having a population of 12,000.

In the eastern part of Nevada they have opened many mines near the track, and in some places they are working salt mines quite extensively. I saw large quantities of salt piled on the platforms near the track ready for shipment.

Provisions are not near as high along the line now as they were when I first went out. A person can get a square meal now for 50 cents, or lunch for 25 cents, for which, ten years ago, we had to pay $2.50.

Almost everywhere east of Nevada you will meet women and children selling provisions. They will come on the cars at every station. Here is where you will find prairie chickens nicely baked. Half a dozen will pass through the cars at one time with large pans full, each one trying to undersell the other. After they have sold all they can for 50 cents and 25 cents apiece, they will pass through and sell double the quantity for the same price. If they have five or six left after supplying the crowd, they will lump them off to some passenger for 50 cents, and he will immediately divide them among his fellow-passengers.

Nothing of note occurred until we reached Council Bluffs, where we were ten minutes late for the train, and had to stop over for the night. We started in the morning at daylight. We had only gone three miles when we met a man who was flagging the train, which was immediately stopped. We learned that the bridge over the Missouri River had been burned during the night, or the end of it next to Council Bluffs; and had we not been flagged just as we were, some of us, if not all, might have found a watery grave. We were detained five hours while they were repairing the bridge.

I was very fortunate in escaping accidents. Had we not been detained at Council Bluffs over night we would have been in an accident at the Junction, two miles west of Chicago. By being detained by the burning of the bridge, it made us behind time all the way through, which fortu-

nately prevented our being in a collision at Buffalo, which took place between a freight and passenger train about three hours before our arrival. The remainder of my journey was soon passed, and I arrived safe at home after an absence of three months.

I found my mother apparently quite smart. She had sat up a part of each day during my absence. The rest of the family were quite well.

I had been home hardly a month before my brother Hugh came to visit us from the West. He had not been at home in fifteen years. I heard the stage drive up, and thinking it was company my son expected, went to the door.

There stood my brother. Although it was quite dark, I knew him, as we had been expecting him. I showed him into the sitting-room, and then stepping into mother's room, said, speaking as calmly as possible: "We have got company, mother; I think Hugh has come. We had been very careful of bringing her sudden or exciting news.

She seemed to take it very calmly.

I then showed my brother in; and after the greeting was over we all sat down and had a very pleasant visit, mother seeming to enjoy it as much if not more than any of us. She would sit up every night quite late, which I was very much afraid would tax her strength; but she seemed to think not, and said she enjoyed sitting up with us.

My brother had only been home four days when I was called away on business. When I returned home at night, I found my mother lying in bed very sick, and my father in a great state of excitement.

We sent for a doctor, but she grew worse every day till the morning of the fourth day. I saw a change come over her. I immediately sent a dispatch to my sister in Buffalo, for she had gone home immediately after my return from the West.

My dear mother grew worse every hour, and at five

o'clock in the afternoon of the 24th of February she left us for that better land where there is no sickness, suffering, or sorrow.

Her death was very sudden and unexpected to the family, as we all thought she had been improving for several months, and she seemed so much better after Hugh's return.

We all felt it very much. It was a bitter blow to me, who had been separated from her so many years, to lose her so soon after my return.

My father also took her death very hard, and was taken sick two weeks after, and was confined to the house for three months.

He remained out of health till some time in August, when he began to improve.

Just after he was able to sit up, a friend wrote to me, saying my broker was about to leave town, and I had better look immediately after my stock. I sent for money, but did not get as much as I expected.

This decided me to send Charlie out, but I sent him too late to save my stock—at least my bonanza stock—for I still own quite a quantity of other stock, which may in time turn out to be bonanzas.

I shall long remember the years of '77–'78. The greatest trials and troubles I have ever been called to endure were in these two years. May I never have another such a season to endure. After all we had suffered in Nevada of sickness, toil, privations, and hardships; being many times swindled and robbed; meeting with heavy losses in stocks and bad debts; and the long separation from my friends— all were very hard on us.

When we left Virginia City I thought our trials were over, for I now had enough for myself and family to live on without ever lifting our hands to work again. But it seems our cup of sorrow was not yet filled; for alas! our

greatest trials and troubles were yet to ccme after we reached home.

But, reader, after all I have suffered in the land of sage, I would much rather live there than in the East. for several reasons. First of all, my health was much better there than here; second, if I dealt with a person, I knew what to expect. I like a person better who will show his hand than a sneaking hypocrite with whom I do not know how to deal. Third, if I transact my own business, I can make more money in three months than I can in the East in a year; and I never saw the time while there that I could not borrow from $1,000 to $2,000 on one day's notice; and the parties lending it would never think of asking me about my indebtedness, or how much property I owned, if it was a small sum of $200 or $300, or less. My word was always quite sufficient for them. But I find it a common practice in the East for persons to inquire into your private affairs if you only wish to borrow $5 of them.

As I have said before, there are no misers or penny-mites in Nevada. Even the bonanza men, who are the hardest crowd to get money out of on a small scale, are sometimes princely in their donations for charitable purposes.

And if we live out our money fast, we make it fast.

Now, kind reader, if I have given the Western people a worse name than they deserve, I have done it unintentionally. If I have given any too much credit (which I doubt), it is because my love for them has blinded me to their faults.

If I have seemingly spoken too highly in praise of my son, the reader will pardon a mother's pride in an only child; and though I may never meet again any of my kind Pacific friends, let them ever bear in mind that though absent they are not forgotten; that the garden of my heart has ever been kept green by the blossoms of their love, the memory of each and all their many acts of kindness be-

stowed on me, a stranger, while sojourning in their land of sage and silver.

And now, in return, may God's choicest blessings rest upon them and theirs forever more.

Kind reader, with many thanks for your patient indulgence in any short-comings in this narrative, we will also bid you a kind good-bye.

"ENDURANCE.

"How much the heart may bear, and yet not break !
How much the flesh may suffer and not die !
I question much if any pain or ache
Of soul or body brings the end more nigh.
Death chooses his own time ; till that is sworn
All evils may be borne.

"We shrink and shudder at the surgeon's knife—
Each nerve recoiling from the cruel steel,
Whose edge seems searching for the quivering life,
Yet to our sense the bitter pang reveal
That still, although the trembling flesh be torn,
This, also, can be borne.

"We see a sorrow rising in our way,
And try to flee from the approaching ill ;
We seek some small escape—we weep and pray—
But when the blow falls then our hearts are still.
Not that the pain is of its sharpness shorn,
But, think, it can be borne.

"We wind our life about another life—
We hold it closer, dearer than our own ;
Anon it faints, and falls in deathly strife,
Leaving us stunned, and stricken, and alone.
But ah ! we do not die with those we mourn !
This, also, can be borne.

"Behold, we live through all things—famine, thirst,
Bereavement, pain ; all grief and misery ;
All woe and sorrow ; life inflicts its worst
On soul and body—but we cannot die.
Though we be sick, and tired, and faint, and worn,
Lo ! all things can be borne."

THE END.